More praise for

MIDNIGHT'S FURIES

▼.▼.▼.▼.

Named one of the best books of 2015 by Amazon, **Quartz,**
Shelf Awareness, *and the* **Daily Beast**

"A clear, accessible, and compelling account of the events during Partition . . . The book succeeds because of gifted storytelling. It is through his vivid description of small moments that Mr. Hajari transforms an overwhelming event into an intimate experience . . . A gripping, skillfully crafted account of an awful period of South Asian history. It deserves a wide audience." — *Economist*

"It has often been said that this is the golden age of nonfiction books. As if to prove the validity of that statement, Nisid Hajari has offered us *Midnight's Furies,* a compelling read, both dramatic and suspenseful . . . With the sensibilities of a novelist, Hajari artfully draws portraits of the various historical personalities involved, making the book thoroughly engaging." — *Seattle Times*

"[A] fast-paced new narrative history of Partition and its aftermath . . . One of [the book's] virtues is its more balanced portrait of Jinnah." — William Dalrymple, *The New Yorker*

"Hajari's book is a superb and highly readable account of not just the mayhem, but the political machinations that preceded Partition, including the three-way negotiations between Britain and the leaders of what were to become India and Pakistan." — *New York Review of Books*

"Hajari offers a ringside view of history with compelling psychological portrayals of those who made it . . . The politics of 1947–48 is so chillingly contemporary that it induces a sense of déjà vu." — *Times of India*

"[Hajari] has a riveting story to tell and he tells it well . . . The strength of this book is in its narrative, its marshalling of facts, and its objectivity in presenting them." — *The Wire* (India)

"[Hajari] frames the events surrounding Partition like a Greek tragedy, with epic, larger-than-life figures . . . [He] succeeds in vividly depicting the psychological scars that have dogged Pakistan and India." — *Shelf Awareness*

"A well-researched tale of the last years of colonial rule on the Subcontinent . . . We could well be in the midst of a deadly thriller; Hajari maintains a tension that would please a novelist." — *Open*

"Ideal . . . An authentic account of what led to Partition and its riots . . . The research is impeccable." — *Business Standard*

"This harrowing tale of political miscalculation and misunderstanding is recommended for all readers of history, politics, and current affairs." — *Library Journal*

"A fine unwinding of an epic event." — *Booklist*

"Hajari skillfully picks through this perilous history . . . A carefully restrained and delineated account makes for chilling reading." — *Kirkus Reviews*

MIDNIGHT'S FURIES

MIDNIGHT'S FURIES

THE DEADLY LEGACY OF INDIA'S PARTITION

Nisid Hajari

Mariner Books
Houghton Mifflin Harcourt
BOSTON NEW YORK

First Mariner Books edition 2016

Library of Congress Cataloging-in-Publication Data
Hajari, Nisid, author.
Midnight's furies : the deadly legacy of India's partition / Nisid Hajari.
pages ; cm
Includes bibliographical references and index.
ISBN 978-0-547-66921-2 (hardcover) — ISBN 978-0-547-66924-3 (ebook) —
ISBN 978-0-544-70539-5 (pbk)
1. India — History — Partition, 1947. 2. India-Pakistan Conflict, 1947–1949.
3. Pakistan — History — 20th century. 4. Jinnah, Mahomed Ali, 1876–1948.
5. Nehru, Jawaharlal, 1889–1964. I. Title.
DS480.842.H35 2015
954.04'2 — dc23
2014034426

Book design by Brian Moore
Maps by Glen Pawelski/Mapmaking Specialists, Ltd.

Printed in the United States of America
DOH 10 9 8 7 6 5 4 3
4500787712

For my parents

CONTENTS

▼.▼.▼.▼.

India Before Partition

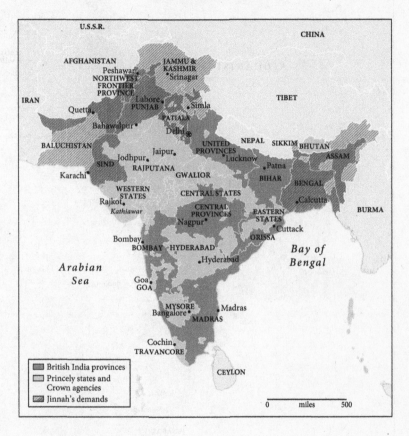

U.S.S.R.

CHINA

AFGHANISTAN

JAMMU &
KASHMIR
Srinagar

Peshawar
NORTHWEST
FRONTIER
PROVINCE

Lahore
PUNJAB

Simla

TIBET

IRAN

Quetta

Bahawalpur

PATIALA

Delhi

BALUCHISTAN

Jodhpur

Jaipur

UNITED
PROVINCES
Lucknow

NEPAL

SIKKIM

BHUTAN

ASSAM

SIND

RAJPUTANA

Patna

BIHAR

BENGAL

Karachi

GWALIOR

WESTERN
STATES

CENTRAL STATES

Calcutta

Rajkot
Kathiawar

CENTRAL
PROVINCES
Nagpur

EASTERN
STATES

BURMA

Bombay

BOMBAY

HYDERABAD

ORISSA

Cuttack

Arabian
Sea

Hyderabad

Bay of
Bengal

Goa
GOA

MYSORE
Bangalore

Madras

MADRAS

Cochin
TRAVANCORE

CEYLON

British India provinces

Princely states and
Crown agencies

Jinnah's demands

0 miles 500

Pakistan After Independence

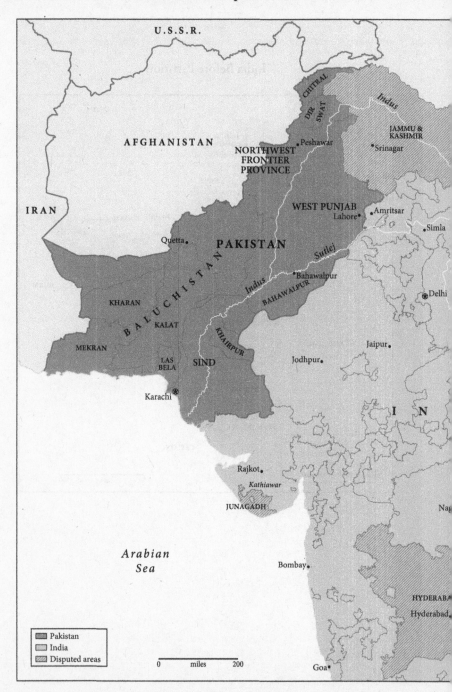

U.S.S.R.

AFGHANISTAN

IRAN

CHITRAL

DIR

SWAT

NORTHWEST
FRONTIER
PROVINCE

Peshawar

JAMMU &
KASHMIR

Srinagar

Indus

WEST PUNJAB

Lahore
Amritsar

Simla

Quetta

PAKISTAN

BALUCHISTAN

KHARAN

KALAT

Indus

Sutlej

Bahawalpur

BAHAWALPUR

Delhi

MEKRAN

LAS
BELA

SIND

KHAIRPUR

Jodhpur

Jaipur

I N

Karachi

Rajkot

Kathiawar

JUNAGADH

Arabian
Sea

Bombay

Nag

HYDERABA

Hyderabad

Pakistan
India
Disputed areas

0 miles 200

Goa

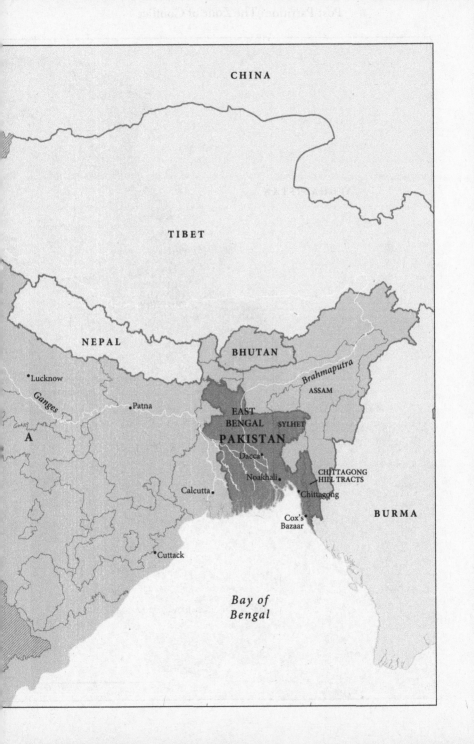

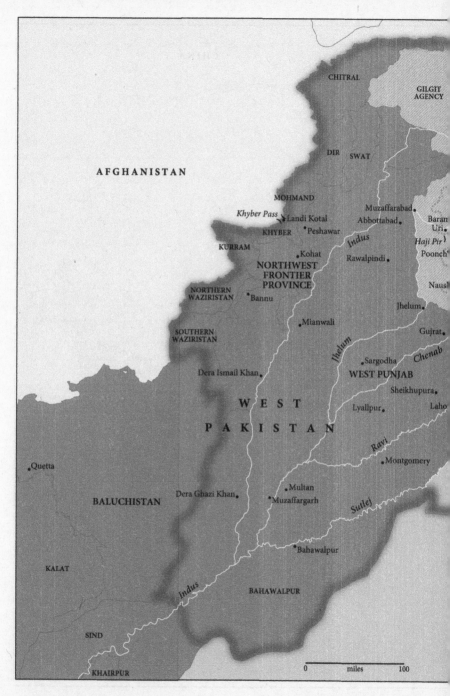

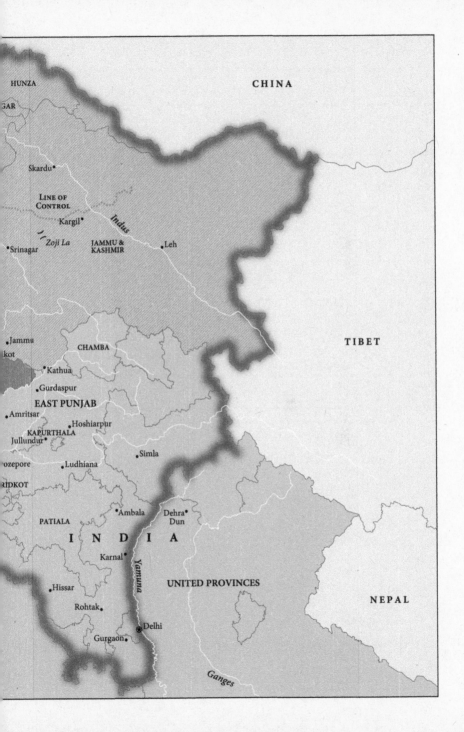

PROLOGUE

▼▼▼▼

A Train to Pakistan

AHEAD, THE JEEP'S HEADLIGHTS picked out a lonely stretch of railroad track. The driver slowed, then, when still about a third of a mile away, pulled over and waited. All around wan stalks of wheat, shriveled by drought and rust, trembled in the hint of breeze. Two turbaned figures emerged from the gloom, borne by an ungainly, knock-kneed camel.

At a signal the five broad-shouldered men in the jeep piled out. They carried a strange assortment of objects — a brand-new Eveready car battery, rolls of wire, a pair of metal hooks with cables attached, and three lumpy, unidentifiable packages. Moving quickly, they joined the now-dismounted riders and headed for the copse of trees that lined both sides of the permanent way. When they reached an irrigation canal that ran along the tracks, several of the men slid down its banks and hid.

Two others dashed forward. Each tucked one of the mysterious parcels against a rail, then carefully attached a wire to the soft gelignite inside and trailed the cable back to where the others crouched. A third man brought the pair of hooks over to a nearby telephone pole and used them to tap into the phone line. As he listened, waiting for word of the Karachi-bound train, his compatriots grimly checked their revolvers.[1]

The men were Sikhs, recognizable by their long beards and the turbans enclosing their coils of uncut hair. They had the bearing and burly physique of soldiers — not surprising given that their tiny community had long sent disproportionate numbers of young men to fight in the Indian Army's storied regiments. In the world war that had just ended

two years earlier, Sikhs had made up more than 10 percent of the army even though they represented less than 2 percent of the population.

The eavesdropper motioned to his comrades: the train was coming. This was no regularly scheduled Lahore Express or Bombay Mail. Onboard every passenger was Muslim. The men, and some of the women, were clerks and officials who had been laboring in the British-run government of India in New Delhi. With them were their families and their ribbon-tied files; their photo albums, toys, china, and prayer rugs; the gold jewelry that represented much of their savings and the equally prized bottles of illicit whiskey many drank despite the strictures of their religion. On 9 August 1947 they were moving en masse to Karachi, 800 miles away, to take part in a great experiment. In six days the sweltering city on the shores of the Arabian Sea would become the capital of the world's first modern Muslim nation and its fifth largest overall — Pakistan.

The country would be one of the strangest-looking on the postwar map of the world. One half would encompass the fierce northwestern marches of the Indian subcontinent, from the Khyber Pass down to the desert that fringed Karachi; the other half would include the swampy, typhoon-tossed Bengal delta in the far northeast. In between would lie nearly a thousand miles of independent India, which would, like Pakistan, win its freedom from the British Empire at the stroke of midnight on 15 August.

The Karachi-bound émigrés were in a celebratory mood. As they pulled out of Delhi, cheers of "Pakistan Zindabad!" (Long live Pakistan!) had drowned out the train's whistle. Rather than laboring under a political order dominated by the Hindus who made up three-quarters of the subcontinent's population, they would soon be masters of their own domain. Their new capital, Karachi, had been a sleepy backwater until the war; American GIs stationed there raced wonderingly past colorful camel caravans in their jeeps.[2] Now a boomtown fervor had overtaken the city. The streets were a roaring tangle of cranes and scaffolding, and the dust from scores of building projects mixed with drifts of desert sand. If the city could hardly handle the influx of new residents — "the difficulty of putting several hundred quarts into a pint pot is extreme," Britain's first ambassador to the new Pakistan remarked — a good-

humored camaraderie had so far smoothed over most tensions.[3] Ministers perched on packing crates to work as they waited for their furniture to arrive. Their clerks used acacia thorns for lack of paper clips.

To the Sikhs leaning against the cool earth of the canal bank, this Pakistan seemed a curse. The new frontier would pass by less than 50 miles from this spot, running right down the center of the fertile Punjab — the subcontinent's breadbasket and home to 5 million of India's 6 million Sikhs. Nearly half of them would end up on the Muslim side of the line.

In theory, that should not have mattered. At birth India and Pakistan would have more in common with each other — politically, culturally, economically, and strategically — than with any other nation on the planet. Pakistan sat astride the only land invasion routes into India. Their economies were bound in a thousand ways. Pakistan's eastern wing controlled three-quarters of the world's supply of jute, then still in wide use as a fiber; almost all of the jute-processing mills lay on the Indian side of the border. During famine times parts of India had turned hungrily to the surplus grain produced in what was now Pakistan's western wing.

The Indian Army, which was to be divided up between the two countries, had trained and fought as one for a century. Top officers — still largely British — refused to look on one another as potential enemies. Just a few nights earlier both Hindu and Muslim soldiers had linked arms and drunkenly belted out the verses of "Auld Lang Syne" at a farewell party in Delhi, swearing undying brotherhood to one another. Cold War strategists imagined Indian and Pakistani battalions standing shoulder to shoulder to defend the subcontinent against Soviet invasion.

Many of the politicians in Delhi and Karachi, too, had once fought together against the British; they had social and family ties going back decades. They did not intend to militarize the border between them with pillboxes and rolls of barbed wire. They laughed at the suggestion that Punjabi farmers might one day need visas to cross from one end of the province to the other.

Pakistan would be a secular, not an Islamic, state, its founder, Mohammad Ali Jinnah, promised: Hindus and Sikhs would be free to prac-

tice their faiths and would be treated equally under the law. India would be better off without two disgruntled corners of the subcontinent, its people were told, less charitably. "Division," as India's first prime minister, Jawaharlal Nehru, put it, "is better than a union of unwilling parts."[4] The fight to establish Pakistan had been bitter but astoundingly short — occupying less than ten of the nearly two hundred years of British suzerainty over India. Surely in another decade the wounds inflicted by the struggle would heal.

The Sikhs tensed as a long, low whistle from the train floated toward them. In the distance, they could see the engine's headlamp rocking gently through the fields. Their eyes followed its progress until the train rounded a last bend and the spotlight blazed up before them like a miniature sun, bright and blinding. They rose, surging with adrenaline. Seconds later the Pakistan Special's heavy black engine thudded over the spot where the gelignite charges lay, then its first bogie.

The Sikh holding the battery gripped the detonator switch he had rigged up to it. When the second passenger car was directly over the improvised mine, he firmly pressed down.

Nearly seventy years later, *Partition* has become a byword for horror. Instead of joining hands at their twinned births, India and Pakistan would be engulfed by some of the worst sectarian massacres the modern world has ever seen. Non-Muslims on one side of the new border in the Punjab and Muslims on the other descended with sword and spear and torch on the minorities who lived among them. An appalling slaughter ensued.

Gangs of killers set whole villages aflame, hacking to death men and children and the aged while carrying off young women to be raped. British soldiers and journalists who had witnessed the Nazi death camps claimed Partition's brutalities were worse: pregnant women had their breasts cut off and babies hacked out of their bellies; infants were found literally roasted on spits. Foot caravans of destitute refugees fleeing the violence stretched for 50 miles and more. As the peasants trudged along wearily, mounted guerrillas charged out of the tall crops that lined the road and culled them like sheep. Special refugee trains, filled to bursting when they set out, suffered repeated ambushes along the way. All too

often they crossed the border in funereal silence, blood seeping from under their carriage doors.

Across the Punjab, the limbs of thousands of corpses poked from shallow graves like twigs, gnawed on by wild dogs. Estimates of the dead range widely yet are universally shocking. Not long afterward, one British official, working off casualty reports and his own inquiries, put the number at 200,000.[5] Others, claiming to factor in those who had died of disease and hunger and exposure, insist that more than a million perished. At least 14 million refugees were uprooted in what remains the biggest forced migration in history. Western Pakistan was virtually emptied of Hindus and Sikhs; the Indian half of the Punjab lost almost all of its Muslims. The conflagration stands as one of the deadliest and most brutal civil conflicts of the twentieth century, unrivaled in scale until the 1994 massacres in Rwanda.

Yet like Rwanda, the riots were relatively confined in time and space. The worst killings lasted only about six weeks. While the chaos spread throughout most of western Pakistan and great swathes of northern India, much of the rest of the subcontinent was not directly affected. Today Partition is a horrific memory for millions — but it is just that, a memory.

What truly continues to haunt today's world are the furies that were unloosed in 1947 — the fears and suspicions and hatreds forged in Partition's searing crucible. In those few weeks, and the few months that followed, a dangerous psychological chasm would open up between India and Pakistan. Leaders on both sides would suspect their counterparts of winking at genocide. Their mutual mistrust and scheming for advantage quickly brought their infant nations to the brink of war, and then ignited shadow contests for control over the kingdoms of Hyderabad in the south and Kashmir in the north. In less than a year, the Indian and Pakistani armies would confront one another on the battlefield.

Buffeted by this whirlwind, Pakistan quickly developed a deep-seated paranoia about its larger neighbor. The idea that India might strangle the Muslim state in its cradle seemed entirely plausible. Groaning under a tidal wave of refugees, its economy and bureaucracy near collapse, Pakistan could hardly have resisted. That existential fear has only deep-

ened as the two nations have fought several skirmishes and two more open wars — the last of which, in 1971, broke off Pakistan's eastern wing to form an independent Bangladesh.

Today, anxiety about the "India threat" drives the Pakistani state's most destabilizing behavior, in particular its use of jihadists as tools of state. Since the late 1980s, the Pakistan Army's ruthless Inter-Services Intelligence agency (ISI) has cultivated several militant groups to bleed the Indians in Kashmir; foremost among them is Lashkar-e-Taiba, whose fighters carried out the bloody 2008 terror attacks in Mumbai (formerly Bombay). ISI support was similarly critical to creating the Taliban movement in the 1990s and to rebuilding it in the 2000s — in both cases, to ensure that Afghanistan did not fall under India's sway. Some ISI elements may even have protected Osama bin Laden before his death in 2011, counting on the threat from al Qaeda to keep open the gusher of military aid from the United States.

The nexus of militant groups that now infest the tribal areas along Pakistan's border with Afghanistan — some of them tolerated by the ISI, others dedicated to overthrowing the Pakistani government — has metastasized into a cancer that threatens not just Pakistan but the wider world. Several terror attacks in the West, and several foiled plots, have been traced back to jihadist training camps in the area. Pakistan's efforts to combat this threat have traditionally been halfhearted, focused mostly on the "bad" militants targeting the Pakistani state rather than "good" militants like Lashkar, who might yet prove useful in any conflict with India.

As its ultimate deterrent, Pakistan also continues to build the world's fastest-growing and most opaque nuclear arsenal. Islamabad has refused to sign a no-first-use pledge as India has, and indeed during their last serious conflict in Kashmir's Kargil region in 1999, there is evidence that Pakistani commanders considered deploying the weapons if Indian forces broke through their lines. An estimated one hundred warheads lie hidden around the country, some reportedly moved around by civilian vehicles to evade detection by the United States, which Pakistanis believe has developed contingency plans to seize them in the event of a crisis. Given the growing reach and brazenness of jihadist groups — whose targets have already included Pakistan Army headquarters and bases be-

lieved to house nuclear components — the vulnerability of these weapons is deeply worrying.

Indeed, in this one crucial sense the subcontinent has become the world's most dangerous place: the chances of a nuclear weapon falling into the hands of a rogue group, or of an outright nuclear war erupting, are nowhere greater than here. Partition's legacy is no mere colonial hangover. The unresolved sense of siege Pakistan has suffered since 1947, its fear that India has both the capacity and the desire to snuff out its independent existence, poses one of the greatest threats to the stability and security of today's world.

Although the subject of deep and often penetrating scholarship, the experience of Partition remains poorly understood both within and especially outside the subcontinent. On mice-infested library shelves in Delhi and Karachi, lines upon lines of moldering books pick apart the subject: academic histories, biographies, memoirs, collections of official papers, multivolume sets of correspondence, oral histories, poems, political screeds. Most are lamentably unread. Ordinary Indians and Pakistanis long ago settled on their own myopic and mutually contradictory versions of events, which largely focus on blaming the other side or the British for provoking the slaughter.

Meanwhile, the rest of the world barely grasps what happened. Traditional Western accounts center not on Partition itself but on the years of struggle that preceded independence. This is the heroic narrative celebrated in sepia-tinted movies like *Gandhi:* the tale of how an oppressed, peaceful people faced down an empire with only the strength of their moral convictions. The weeks of bloodshed that followed the transfer of power are treated as a postscript — an inexplicable and probably inescapable bout of madness uncorked by the lifting of British rule.

More recent histories have sought to capture the human toll of Partition using heartbreaking first-person testimonies. But such stories are necessarily granular and episodic, and often unreliable. In many ways, the rich canon of Partition novels and poems is a better source of insight into the killings themselves.

This book aims to answer a different question — not why the subcontinent was split, or who was to blame for the massacres, but *how* the experi-

ence of Partition carved out such a wide gulf between India and Pakistan. How did two nations with so much in common end up such inveterate enemies so quickly? Like the debate over what caused World War I, it is a conundrum that defies easy answers. Yet unlike World War I, this wound remains open today, and so the question is an urgent one.

The facts are not easy to piece together. The snowfall of memos and correspondence churned out by the British Raj more or less ends in August 1947. Early Indian and Pakistani records are thin and scattershot. In the first weeks and months after independence, chaos brought whole departments to a standstill. Rumor and hearsay infected even official reports. What files do exist often remain closed to researchers.

After more than a year in the archives in New Delhi, London, and Washington, D.C., I have attempted to reconstruct a narrative of events using a sort of demi-official record of the period: notes, letters, and diaries of politicians and military commanders; army sitreps; economic data; the reports of informants and freelance spies; embassy gossip. What these sources lack in clarity they make up for in urgency: one sees sharply how sleepless nights, bad advice, and geopolitical fantasies clouded decision-making on both sides of the new frontier.

The story features no easy villains — and few heroes. The very same men who led their peoples to independence — India's dashing first leader, Nehru, and his irascible Pakistani counterpart, Jinnah — would play a central role in creating the rift between their nations. And it must be said, they did so for the worst reasons: inexperience and ineptness, vanity, intellectual arrogance, unspoken prejudice, and plain, petty dislike of one another.

As Nehru philosophically noted after Partition had been formally decided upon, great events were underway and some of that greatness fell on men like him and Jinnah.[6] Yet they were only men, and, ultimately, it would be their all-too-human failings that helped to set their nations at odds. Only once those mistakes are properly understood and acknowledged, perhaps, will India and Pakistan begin to bridge the vast and dangerous gulf that still divides them.

MIDNIGHT'S FURIES

Fury

T HE LETTER HAD TO CHASE Jawaharlal Nehru across
northern India. On 6 August 1946, a clerk in Delhi had typed
out the message on thick sheets of cream-colored stationery, the
words "Viceroy's House" embossed on each page in a crisp sans-serif
font.[1] That "house"— a modern palace, really, with its 340 rooms and
nearly 5,000 staff (including families) — had been designed by Sir Ed-
win Lutyens to stand atop Delhi's Raisina Hill as the fulcrum of power
in British India.[2] Its delicate sandstone screens and helmet-like Mughal
chhatris, or elevated pavilions, recalled long centuries of rule by one set
of foreign conquerors; its Greek columns and classical dome those of
another. The letter had been dictated by the home's current occupant,
the Briton who stood in for the king-emperor as near-absolute ruler
over the subcontinent's 400 million souls. It was addressed to the man,
the *Indian,* who would soon replace him.

From Delhi a courier bore the missive 400 miles south and east to
the ancient town of Allahabad, nestled at the confluence of the Ganges
and Yamuna rivers. Nehru had grown up here and a few days earlier had
returned to visit. His childhood home, built by his father at the end of
the previous century, was impressive in its own right. Lined with grace-
ful white columns, it had been one of the first houses in India to receive
electricity — and one of the first Indian homes in the neatly manicured
European section of Allahabad. As a child, Jawaharlal had done cannon-

balls into its two swimming pools — indoor and outdoor — splashing the grave and eminent lawyers who worked with his father in the early years of the Indian independence movement.[3]

Unfortunately, by the time the courier reached the house — named Anand Bhavan, "Abode of Happiness"— Nehru had left. He was headed to meet the rest of the current nationalist leadership in the fly-bitten village of Wardha, another 400 miles further south, deep in the heat-blistered heart of the Indian plains. With a weary sigh, the courier followed.

The letter that the messenger was carrying was phrased in the careful bureaucratese that plagued all correspondence within the British Raj, but its message was dramatic. In essence, the viceroy was offering to replace the handpicked Executive Council through which he governed India with a new body selected and led by Nehru, president of the country's biggest and best-established political organization, the Indian National Congress. If the viceroy would not quite become a figurehead, he would no longer be an autocrat like his predecessors stretching back to the days of the British East India Company. For the first time, representatives of the Indian people would govern India.

The urbane Nehru was well-cast for the role. His Kashmiri Brahmin ancestors had long served as ministers to the Mughal princes of northern India. He was famously handsome with high, aristocratic cheekbones and eyes that were deep pools — irresistible to his many female admirers. Daily yoga kept his body trim and skin smooth; with a simple cotton cap covering his bald spot, he could pass for a man much younger than his fifty-six years. Although disdainful of superficialities, he took great care with his appearance. Each day a fresh rose adorned his long, sleek doublet, or *achkan*.

Well into middle age now, Nehru retained the same coiled energy he had exuded as a firebrand in his twenties, not long out of Cambridge, when he had packed volumes of Proust on his frequent trips to His Majesty's jails. He could still quote Shelley and Walter de la Mare by heart. Yet in his speeches he also spoke to the yearnings of millions of illiterate, grindingly poor Indian peasants. To them he represented all the possibilities they imagined for freedom.

For the past thirty years, Nehru had fought beside Mohandas K.

Gandhi — the mystical, septuagenarian Mahatma, or "Great Soul," of the Indian freedom movement — to liberate India from British control. When the two men first met in 1916, soon after Gandhi had returned to India from living in South Africa, construction had not yet begun on Viceroy's House. British India remained a land of whiskey sodas and dak bungalows, of tiger hunts, pig-sticking, polo, and pantomimes. From its first established commercial links with India in 1608, Britain had built the subcontinent into the beating heart of a worldwide empire. Its power and presence looked eternal.

The great civil disobedience campaigns led by Gandhi and Nehru — his most beloved disciple and designated heir — had called the empire's bluff. They had proven that unless the European imperialists were willing to resort to brute force, they could not rule without the consent of the governed (or at least, of the rapidly expanding Indian political class). Three times the Mahatma had called millions of Indians out into the streets in nonviolent protest. Each time British rule had survived but emerged with less authority, both moral and actual, than before. For the past decade, with the exception of the war years, the political debate had largely centered on how and when to transfer power to Indians — not whether Britain should.

Where Gandhi's loincloth and incense-wreathed chanting sessions evoked India's long past, Nehru symbolized its future. As a child, English tutors — handpicked by his doting father — had instilled in him a lifelong fascination with science. Studies at Harrow and Cambridge had nurtured an appreciation for Western philosophy, as well as political and economic theory. By far the most cosmopolitan of the Indian leaders, Nehru had during the interwar years become a fixture among the international left. He was nominally a pacifist, like his mentor Gandhi, but nationalism, not pacifism, was his lodestar. In essays and long-winded oratories he framed India's struggle as part of a great awakening around the world, a progressive force sweeping aside the sickly empires of the West. He spoke of five-year plans and scientific farms, of building great dams and smoke-belching factories. Leaders of independence movements across Asia sought his counsel. A year after Hiroshima, he seemed poised to lead India to the forefront of the postwar world's rising powers.

In June 1946, Gandhi had engineered a fourth term for Nehru as president of the Congress Party, the longtime vehicle of India's freedom movement. The Mahatma had himself declined to hold any official position in the party for over a decade. With a new age dawning, he wanted "our Englishman," as he affectionately dubbed the suave and worldly Nehru, to steer India's final transition to independence.[4] The viceroy's letter would crown Nehru's ascent.

After an exhausting overnight train journey, then a bumpy bus ride from the railhead at Nagpur, the courier finally reached Wardha on the morning of 8 August. Foreign correspondents visiting Gandhi's ashram there for the first time could scarcely believe that the high command of the nationalist movement led their revolution from this snake-infested backwater. "Wardha had few charms," wrote one American reporter. "The water was polluted and you had to drink it purpled with permanganate. . . . Malaria was widespread, and the sticky, oppressive heat killed many people annually. The soil was sandy, the landscape flat and uninteresting." The collection of mud-and-thatch huts that made up Gandhi's ashram — "a cross between a third-rate dude ranch and a refugee camp" — lay a few miles outside of town, reachable only by horse-drawn *tonga.*[5] When they gathered in Wardha for meetings, as they had on this day, the Congress leaders conferred in a simple, two-story bungalow owned by a Hindu industrialist. That's where the courier hoped to find Nehru.

The Congress president, however, had still not shown up. His colleagues had expected him early that morning; they waited, sipping their *chai* and gossiping as the merciless sun rose higher and higher. One of them took charge of the viceroy's letter and sent the exhausted messenger on his way. At noon they sat down for lunch in an interior courtyard, sitting cross-legged in the dust with their metal trays, just as Wardha's humblest citizens would.

The illustrious Nehru was not among them because he was watching a young boy die. His train from Allahabad had been delayed that morning, and after he had finally disembarked, he urged the driver who had picked him up to speed down the country roads toward Wardha. Fields of puffy cotton whipped past on either side. Suddenly the chauffeur slammed on the brakes, hurling Nehru forward and raising a swirling

cloud of red dust. He felt as well as heard "a sickening thud," Nehru later wrote.[6] Stumbling out of the car, he found a village boy, maybe five years old, groaning on the roadside, his stick-thin frame bloody and mangled. The child's parents were stunned as much by the sudden appearance of a nationalist icon in their tiny hamlet as by the tragedy; Nehru had to argue desperately with them to take the boy to a hospital. The child died in the backseat as they raced to the nearest clinic.

Nehru did not pull into Wardha until two o'clock. He leaped out of the car, disheveled and distraught, and brushed past a *sari*-clad hostess waiting to drape a marigold garland around his neck. As his concerned colleagues gathered around, he recounted the morning's tragedy, his eyes troubled and hollow.

After he had narrated his tale, one of the Congress leaders handed him the viceroy's sealed letter. They were eager to know its contents. Talks over the formation of a new government had been going on for weeks now, and the Congressmen had a good idea what the missive might say. As Nehru reached for the invitation that would redeem the great struggle that had defined each of their lives, his comrades could see drops of the dead child's blood on the sleeve of his white cotton *kurta*.[7] The world for which they had fought was finally coming into view. But from this point on, as generations of Indians and Pakistanis were to discover, death would be its most constant companion.

Nehru did not celebrate — and not only because of the accident. He and the normally voluble Congress leaders ignored reporters' queries and instead spent the evening monopolizing Wardha's one telegraph machine, firing off cables to Delhi. They had been arguing for weeks over how and whether to join the administration. Would this new government be treated as a proper cabinet — what Nehru called a "provisional national government"— rather than a rubber-stamp council? Could the viceroy still veto his new Indian ministers? Who would control India's foreign policy? What about the Indian Army?[8]

Having spent nine of the past twenty-five years in the Raj's prisons, Nehru had good reason not to trust the British. He was friendly with several members of the Labour Cabinet in London, including colorless Prime Minister Clement Attlee ("a sheep in sheep's clothing," as his pre-

decessor, Winston Churchill, was once thought to have sneered).[9] All of them professed their eagerness to liberate India. But their actions had yet to match their words. Nehru thought the British leftists an especially "muddleheaded lot"— more infuriating in some ways than Churchill's jingoistic Tories, who at least were straightforward adversaries.[10] The Labourites approached the question of Indian independence like lawyers, deliberate in their actions and ever mindful of constitutional proprieties. The transitional government the viceroy was proposing in his letter seemed to Nehru a typically timid advance: India would be freer than before, but not quite free.

Named viceroy by Churchill in 1943, Viscount Archibald Percival Wavell of Winchester and Cyrenaica was a solemn, one-eyed field marshal renowned for his early victories over the Italians in the Libyan desert. In temperament he could not have posed a greater contrast to India's heir apparent. Where Nehru's rhetoric overflowed with melodramatic imagery and potted Marxist theory, Wavell had a disconcerting aversion to conversation.[11] At his first meeting with the French general Charles de Gaulle, the two men stared silently at a map of North Africa for several minutes. Afterward Wavell allegedly grunted, "I like that man. He doesn't talk."[12] The viceroy loathed politics and politicians, and saw himself more as a steady, benign regimental commander, responsible for the welfare of tens of millions of simple Indian peasants. The moody Nehru, on the other hand, burst into tirades at the slightest provocation, particularly at any reminder of Britain's overlordship.

But Wavell was also a realist, as his official reports and thoughtful journal show. He clearly understood that the British Raj—that implausible, byzantine structure of British military officers, district commissioners, magistrates, tax collectors, irrigation engineers, police inspectors, tribal agents, and other officials who, alongside thousands of Indian colleagues, administered the vast subcontinent—was close to collapse. The war had halted the flow of British recruits into the once-legendary Indian Civil Service; incumbents had worked years without leave, and many were nearing retirement. The young British conscripts who had flooded into the country to fight the Japanese now wanted to go home. They weren't interested in suppressing legions of Congress

protesters; in fact, some British units had already mutinied at the slow pace of demobilization.[13]

Britain itself was broke. India, the Jewel in the Crown, was no longer the fabled storehouse of rubies and spices that had helped to bankroll England's rise as a world power. During the war His Majesty's Government had instead racked up huge debts to India — more than $6 billion (almost $80 billion in today's dollars) — for the soldiers it had sent to the deserts of North Africa, the boots and parachutes produced in its factories, the care and feeding of British troops battling the Japanese in Burma. After the war the government had had to beg for a $3.75 billion loan from the United States; the money had been approved, after months of difficult negotiations, only in May 1946.[14] Having just granted the Philippines its independence, the United States did not now intend for its dollars to be used to prop up a dying empire. Whether financially or politically, Britain could no longer afford to rule India.

After he had dispatched his letter to Nehru, Wavell had begun to put the finishing touches on a stark document he called his "breakdown plan." The paper argued that unless Attlee's government could come to a peaceful agreement with Indian leaders about how and when to transfer power, the British would be forced to evacuate the subcontinent, bit by bit. The current British-run government in India, Wavell declared, would not last more than another eighteen months.[15]

A lifelong officer, the viceroy also appreciated one further point that the distrustful Nehru had missed. Freeing India had become vital not just to Britain's bottom line but to its global strategic position. The Red Army had begun menacing Turkey and northern Persia. That very week, cold warriors in Washington were preparing orders for a bristling naval taskforce, led by the new supercarrier USS *Franklin Delano Roosevelt*, to steam into the Mediterranean as a warning to Moscow to watch its step. Not even a year after the end of the Second World War, a third was looking like a very real possibility.

A draft report by the British chiefs of staff underscored the importance of having India as an ally in any such conflict. The subcontinent's factories and recruiting grounds could churn out a nearly inexhaustible supply of men and materiel. From Indian shores, naval forces could

dominate the entire Indian Ocean region.[16] Already the Pentagon had begun asking the British about gaining access to air bases in northwest India, from which U.S. bombers could attack Soviet industrial centers in the Urals.[17]

By the same token, Washington and London were both keenly aware that if India joined the Soviet camp, the country would pose a major threat by cutting Britain off from its eastern possessions. If Russian warships could steam out of Bombay or Karachi, they could easily blockade the vital Persian Gulf. Communist agitators had not yet made much headway among the Indian masses. But strikes had lately been roiling India's biggest cities, and millions of Indians had been thrown out of work by the closing of war-related industries. The Congressmen dashing off cables from Wardha had been lucky: telegraph clerks had been back on the job less than twenty-four hours after a strike had snarled communications all over the country.

Held against its will, dominated from London, roiled by a fierce and well-organized liberation movement, India would likely become, as Wavell put it, "a running sore which [would] sap the strength of the British Empire."[18] If Britain could manage an amicable transition, on the other hand, the subcontinent could become an indispensable link in the emerging anti-Soviet cordon. British troops could come home, where they were desperately needed to rebuild the country. India, Wavell felt sure, held far more potential as a free and willing ally than as a resentful subject nation.

Although Nehru and Gandhi remained wary, the battle that had consumed them for the last three decades had been won. Their goal — what the Mahatma called *purna swaraj*, complete self-rule — was now Britain's as well. The imperialists weren't fighting them. Other Indians were.

On paper, Nehru had much in common with Mohammad Ali Jinnah, the most powerful Muslim leader in India. Both men were Anglophiles, barristers trained at London's Inns of Court. Both were more comfortable in their precisely accented English than in their native tongues. Although not a defiant unbeliever like Nehru, Jinnah enjoyed a nightly drink, which of course is forbidden in Islam. He showed up at mosque only to give speeches, not to pray. Both were proud, rigid men — and

dangerously thin-skinned. Each was surrounded by admirers and syco-
phants, and yet each was, in his own way, painfully lonely.

In the flesh, any similarities disappeared. Nearing seventy, Jinnah
was as frail as his rival was vigorous. A lifelong two-pack-a-day cigarette
habit left him gasping for breath at times, and more than once he had
had to take to his bed for weeks at a stretch on doctor's orders. He car-
ried only 140 pounds on his 6-foot frame; cheekbones jutted out of his
cadaverous face like the edges of a diamond. His hair, which had once
been luxuriant enough to evoke comparisons to the actor Sir Gerald du
Maurier, had turned bone-white.

Where Nehru could rival Hamlet for indecisiveness, Jinnah was im-
placably determined. His frigid demeanor was as legendary as Nehru's
charm: "You do need a fur coat now and then!" one of Jinnah's oldest
friends said, jokingly, about spending time with him.[19] Above all the
Muslim leader was a supreme tactician, not a would-be theoretician
like Nehru. A monocle fixed to his eye, Jinnah excelled at the marathon
negotiations that Nehru despised — seizing upon every one of his op-
ponent's vulnerabilities, pocketing concessions, rejecting any chance of
compromise until offered more.

As president of the Muslim League, Jinnah now loomed as the most
imposing roadblock to Nehru's political ambitions. For the previous half-
dozen years, the Muslim leader had argued that his community — though
outnumbered more than three to one by India's Hindus — represented
a "nation" unto themselves rather than a mere minority group. "We are
different beings," he told one British interviewer. "There is nothing in
life which links us together. Our names, our clothes, our foods — they
are all different; our economic life, our educational ideas, our treatment
of women, our attitude to animals. . . . We challenge each other at every
point of the compass."[20] Jinnah insisted that the subcontinent's Muslims
be given their own independent homeland, carved out of the north-
western and northeastern corners of India, where they formed a slight
majority of the population. Though originally dreamed up by someone
else, the name of this nation would forever be associated with Jinnah's:
Pakistan, or in Persian, "land of the pure."

From the moment the League leader first started to contemplate the
possibility of a Muslim state, Nehru had been his most intransigent foe.

Over the past decade they had clashed, both on the stump and at the conference table. Nehru did not just resist the argument that Muslims constituted a separate people from Hindus; he scorned the premise of the idea. To him, the fact that Hindus and Muslims and Sikhs and Christians and Parsis and others had mixed together on the subcontinent for centuries was fundamental to India's identity. This was the country's genius, like America's — the ability to absorb and meld different cultures into a coherent whole.

The Congress leader blasted the very idea of basing a modern nation on religion, calling it "medieval."[21] He found it despicably ironic that the men crying loudest for a Muslim state were, for the most part, neither observant Muslims nor oppressed. Most seemed to be whiskey-drinking, wealthy landowners or businessmen. Nehru thought them cynics, looking to exploit the Muslim masses in order to create a land where they could preserve their feudal privileges. They lacked, he believed, even the virtue of conviction.

Although they had known each other for thirty years, the dispute between Nehru and Jinnah had become deeply personal in the past decade. The League leader represented "an obvious example of the utter lack of the civilized mind," Nehru had written during the war.[22] Jinnah reciprocated the sentiment. He considered the younger man's talk of India's spiritual unity and brotherhood of communities a load of mumbo-jumbo, and mocked him publicly as a "Peter Pan . . . who never learns or unlearns anything."[23] At best, Nehru was naive, Jinnah thought; more likely, he was prettying up a naked power grab to make it more palatable to his Western admirers.

Wavell did not believe in Jinnah's Pakistan any more than Nehru did. But neither could the viceroy in good conscience recommend that the British surrender power before Congress and the League had agreed on what would fill the vacuum. He hoped that if the two parties could work together in a coalition government for several months, they might rediscover common ground. Wavell envisioned six Congress nominees in the interim administration that Nehru would lead, five Leaguers, and three members of smaller minority groups.

Wavell suggested that before nominating his cabinet, Nehru should personally invite Jinnah to join the new government. In not so many

words, the viceroy was saying that the transition from empire to independence depended on the willingness of Nehru and Jinnah to make up. The fate of 400 million Indians hung on the statesmanship of the two men.

Dutifully, but without any discernible enthusiasm, Nehru wrote to Jinnah offering to meet in Bombay on 15 August 1946.[24] Although the viceroy had forewarned him, Jinnah feigned shock at Nehru's invitation, which was reported by the major national newspapers — all Hindu-owned and pro-Congress — as if it were a demarche from a head of state. "I know nothing as to what has transpired between the Viceroy and you," Jinnah replied archly. If Nehru was suggesting that he serve in a Congress-dominated government, though, it was obviously "not possible for me to accept such a position."[25]

This was classic Jinnah — prideful, biting, uncompromising. The posturing was intended more for his followers than for Nehru; as he often did, Jinnah released copies of his note to the press. The two men exchanged another public set of letters on the morning of the 15th itself. By that point, Nehru had arrived in Bombay. Finally Jinnah wrote resignedly, "As you have given certain explanations, with some of which I must not be taken to agree, and as you desire to meet, I shall be glad to see you today at 6 p.m."[26]

A scrum of reporters waited outside the gates of Jinnah's Bombay mansion as Nehru pulled up that evening, ten minutes early. After he had made a fortune at the bar, Jinnah had built himself a grand, white-washed home made of marble and fine stone on top of Bombay's Malabar Hill. Breezes off the Arabian Sea rustled the branches of the huge pipal tree that loomed over the front porch. Since his wife died seventeen years earlier, Jinnah had lived in the echoing manse with only servants and his acid-tongued, spinster sister Fatima for company. He spent most of his time in his first-floor study, which was lined with law books and piled high with papers in neatly arranged stacks. He and Nehru retired there now.

The Congressman later described their eighty-minute conversation as "quite amicable."[27] But he was tired and harried, and, in truth, neither man had any great desire for a rapprochement. Jinnah could not stomach the idea of serving as the younger man's deputy, nor would he

allow Congress to include any Muslims in their own quota of ministers. For his part, Nehru did not want the Leaguers in the government to question his authority or to slow the march to full independence from the British. "The swift limb of Congress should not be shackled," he declared imperiously.[28]

Dusk had just settled when the two men emerged and shook hands in the curved gravel drive for the benefit of reporters. A disappointed news bulletin on All-India Radio that evening made clear that the meeting had failed to produce a breakthrough.

The next morning, before he returned to Delhi, Nehru held forth for reporters. He looked exhausted, as though he hadn't slept. Still, he affected a cheery insouciance. The lack of agreement between Congress and the League did not worry him, he insisted, nor did the possibility that Jinnah's followers might try to topple any government he led. In that event, Nehru said, two outcomes were possible. On the one hand, if the administration showed weakness, it would quickly collapse. "On the other hand," he warned, "if the Government was strong, the [League's] movement would go down."[29] To many ears, it sounded like a challenge.

Nehru's comments — in his diary entry for 16 August, Wavell called them "as usual . . . stupid" — tossed a match onto dangerously dry kindling.[30] Jinnah had called for a series of rallies to be held around the country that very day, to kick off what he termed a campaign of "direct action" to win Pakistan. He did not specify what this campaign would entail: the threat itself seemed to be the point. Under Gandhi's leadership in the 1920s and 1930s, the Congress had extorted concessions from the British using mass street protests — what Jinnah called their "pistol." "We have also forged a pistol," he had told journalists when announcing his plan in late July, "and are in a position to use it."[31]

For weeks League hotheads had described the possibility of a Nehru-led government in apocalyptic terms. They had reminded their followers of the recent fate of Jews under Hitler. "The British-Congress Axis is formed and the rape of the Muslim nation is to begin in a more ruthless and criminal manner than Hitler and Mussolini dared in Europe," warned an editorial in *Dawn*, the newspaper Jinnah had founded. If

Muslims wanted to survive as a community, they had to be prepared to fight. The moment the British handed power to Nehru and a Congress-dominated government, "that will be the signal for the Muslims — to do or die," the editorial continued.[32]

Beneath the paper's hyperbole lay understandable anxieties. Muslims could plainly see that the British — who had long styled themselves the guardians of India's minorities — were rushing for the exit. Congress might be open to members of all communities, and Nehru himself had never displayed any hint of religious prejudice. But Hindus dominated the party no less than the country itself. If handed the reins of power, they would naturally favor other Hindus for jobs in the government, police, and military; in admissions to universities; in business deals; and in legal matters. They would control a battle-hardened, million-man army. Across India many Muslims were "angry, a little frightened, and belligerent," recalled American journalist Phillips Talbot, who was then based in Delhi.[33]

With no specifics to go on — the League's brain trust would not even meet to discuss the scope of "direct action" until early September, several weeks from now — Jinnah's lieutenants had been trying to stir up enthusiasm by issuing bloodcurdling threats. One ominously hinted, "Muslims are not believers in *ahimsa*," using Gandhi's term for his most sacred principle, nonviolence. Another declared, "We cannot eliminate any method [from consideration]. Direct Action means action against the law."[34] Anonymous leaflets appeared in several cities, showing a caricature of Jinnah brandishing a sword as he warned unbelievers, "Your doom is not far and the general massacre will come!"[35]

Tensions ran especially high in Calcutta, the teeming capital of Bengal, which was then ruled by a League government. H. S. Suhrawardy, Bengal's corpulent and ruthless chief minister, wrote in Calcutta's *Statesman* newspaper that "bloodshed and disorder are not necessarily evil in themselves, if resorted to for a noble cause." Suhrawardy was a Bengali Boss Tweed, filling his coffers as skillfully as any Tammany Hall pol while indulging his tastes for champagne, Polish blondes, and power (not necessarily in that order).[36] His moral compass tended to fluctuate in line with his political interests. Not so long ago, he had led joint Hindu-Muslim marches against the British; at one he and his Congress

counterpart had gallantly used the same League flag to wipe the teargas from their eyes. Then, in the spring, Suhrawardy and the League had triumphed in provincial elections. Now he vowed that if Nehru took over the central government, his huge province would not send a single rupee in revenue to Delhi.

Suhrawardy declared Jinnah's Direct Action Day—16 August 1946—an official holiday in Bengal so that Muslims could close up their shops, put down their tools, and take part in the demonstrations.[37] He planned to speak at a "monster rally" on the Maidan—the greensward at the heart of Calcutta—that afternoon, and he wanted a big crowd. Of course, Hindus, too, were expected to shutter their businesses as a mark of respect.

On Calcutta's commercial Harrison Road that morning, Nanda Lal rolled up the metal blinds of his popular snack shop, the East Bengal Cabin, as usual.[38] It was monsoon season; as he laid out a tray of milky sweets, the air clung to his skin and sweat-stained kurta like a damp rag. He first noticed something wrong when the cows sleeping in the middle of the road struggled to their feet to avoid an early-morning streetcar: the normally packed tram that clanged past was completely empty. Nobody was heading to work.

Instead, a half-dozen trucks followed, filled with angry bearded men carrying brickbats and bottles. For a moment Nanda Lal watched, frozen in place, as the thugs piled out and ransacked a nearby furniture store owned by a Hindu like himself. They tossed mattresses and chairs into the street and set them on fire. Then a hail of stones came pelting up the road toward him. Lal turned and fled.

Like all of India's metropolises, Calcutta hosted a large population of *goondas,* or roughnecks, both Hindu and Muslim. Since the League's victory in the elections, the Congress opposition had staged a series of strikes and business shutdowns in order to embarrass Suhrawardy's administration, using Hindu goondas to enforce the closures. Now, the Muslim goondas rampaging through Calcutta's streets also appeared to be operating under some higher command. Gasoline—which they used to set Hindu shops ablaze—was tightly rationed by the government. Calcutta's underworld gangs did not typically maintain fleets of trucks for transport.[39]

Elsewhere in the city, Hindus were on the offensive. Muslim laborers from the great jute mills across the Hooghly River had started flooding into Calcutta proper at dawn. At some bridges Hindus had built makeshift barricades to block them.[40] As Muslim marchers filed toward the Maidan, Hindus rained bricks and flowerpots down on them.[41]

British commanders in Calcutta had fully expected trouble, and they watched the incoming incident reports with concern but not panic.[42] In the past year, several anti-British demonstrations — including one led by Suhrawardy himself — had degenerated into riots. Mobs had attacked government buildings and vehicles, assaulted Europeans, and paralyzed the city by blocking off major thoroughfares. By contrast, today's sectarian street fights seemed scattered and aimless.

By early afternoon, the riots appeared to have died down. Tens of thousands of Muslims congregated on the Maidan to listen to Suhrawardy and other Leaguers rail against Nehru and the Congress. Some in the crowd carried huge banners bearing Jinnah's portrait; others gripped steel bars and lengths of pipe. Reports of what exactly the Bengali premier said to them are sketchy — the police neglected to send a transcriber to the meeting. Even before Suhrawardy finished speaking, though, the men with weapons had begun to slip away. As he concluded the meeting, Suhrawardy encouraged the rest of the crowd to return home peacefully, saying something to the effect that the police had been instructed not to harass them.[43]

Hindus later claimed that Suhrawardy's words were code, letting the crowd know they were free to loot and burn. Several marchers split off as they headed back toward the Hooghly River and joined the goondas ransacking the city's Hindu bazaars. Muslims would say those demonstrators were merely taking revenge for the abuses they had suffered that morning. Either way, Calcutta's police — only half of whom were armed — were quickly overwhelmed. By four o'clock, army signalers were flashing the code word RED to indicate that clashes had broken out all over the city.

Even at this point, as an after-action report by the acting army commander Lt.-Gen. Roy Bucher makes clear, nothing indicated that authorities faced anything more than uncoordinated street riots. British and Indian troops were mindful of how they had lost control of the

streets in earlier riots. This time, the main roads and critical intersections seemed reassuringly unaffected. Pending a formal request from Bengal's British governor, Sir Frederick Burrows, Bucher did not order his men out in force.[44]

Finally, the violence seemed to subside. Shortly after dusk a heavy thundershower cleared the streets. It was the holy month of Ramadan, and many Muslims had gone home to break their fast. Burrows imposed a strict curfew throughout Calcutta. He was confident the police would have the city under control before morning.

After midnight, however, something new spread through the humid, mud-slicked lanes of Calcutta's endless slums. Gangs of killers materialized in the gloom, wielding machetes and torches, even revolvers and shotguns. With ruthless efficiency they hunted down members of the opposite community. Where a lane of Muslim shanties crossed through a Hindu area, or a few threadbare hovels inhabited by Hindu families sat amid a sea of Muslim homes, the shrieking mobs woke the inhabitants, slaughtered them, and set their cramped, flimsy huts alight. Armored cars could not pursue the marauders into the warren-like slums, and on foot, small patrols would have been quickly overwhelmed. Police shouldered their batons uneasily and watched as flames licked the night sky.

The scale of the slaughter only became apparent in the daylight. Hundreds of corpses littered the streets on Saturday morning, 17 August, tossed out like refuse overnight. In photographs they look like gruesome mannequins, near-naked and beginning to bloat, their limbs tangled like rope. Vultures and pie-dogs ripped off great ribbons of their flesh. In previous riots, the victims — usually stabbed or beaten to death in hand-to-hand street fights — had typically numbered in the dozens. When he toured the city that morning, Burrows, himself a former Grenadier Guard, murmured that this carnage looked worse to him than the Somme.[45]

The city's goondas were exceptionally well-armed, thanks to leftover weapons caches from World War II, and were expert at fomenting chaos. Still, this was something new — a pogrom rather than a riot. Apart from one pitched battle that had broken out between Hindu and Muslim

students at Ripon College, the mobs from either side generally avoided one another.[46] They weren't looking to challenge the authorities or to seize and hold territory. They displayed no interest in attacking well-defended government buildings in the heart of the city. They ignored European civilians.

They were hunting for victims. For days the steady drumbeat of threats from the Congress and League leaders had put Hindus and Muslims on jaw-clenching edge. Looking around them now, Calcuttans could see that their choice was to kill or be killed. As the bodies piled up, they only felt more vulnerable, not less.

Ordinary citizens joined the ranks of the goonda mobs, which bloomed in all corners of the city. They went about their work with an almost casual murderousness. One horrified Briton recounted how his butcher had sliced up his order before calmly striding across the street and using the same knife to slit the throat of a Hindu passerby.[47] A European professor at Calcutta University entered her office to find the severed head of her servant placed carefully on her desk.[48] Muslims descended on a Hindu dairy colony and slaughtered all of its inhabitants, down to the last herdsman and calf. Sikhs, a tiny minority in Calcutta who controlled much of the transport industry, roared around town in taxis and armored jeeps, slashing away at Muslims with fearsome broadswords.

The bloodletting raged unchecked throughout Saturday, then Sunday. The units that Lieutenant-General Bucher had finally deployed struggled against the hit-and-run tactics of the mobs. Whenever troops managed to concentrate their firepower enough to subdue one neighborhood, trouble broke out in another. The gangs put spotters on rooftops to alert them with flags and flashing signal lights as patrols drew near; rioters would scatter into alleys, only to coalesce again once the danger had passed. A flood of emergency calls overwhelmed the authorities: some were legitimate, others were false alarms meant to draw troops and police away from intended targets.[49]

Whole swathes of the city became no-go zones. Makeshift barricades sprung up dividing faith from faith, neighborhood from neighborhood. Unlike the highly professional army, the local police quickly took

sides.[50] On Saturday, Burrows helplessly watched a mob beat to death three men with bamboo staves as his police escort stood by. Only a shot fired into the air by a British sergeant broke up the melee.[51]

After his speech on the Maidan, Suhrawardy had spent several hours at the police control room, clamoring for help to be sent to Muslim neighborhoods. His blatant partiality infuriated the British. On Sunday afternoon, Bucher bundled the premier into his sedan and drove around the city with an armed escort. Suhrawardy leaned forward in his seat, sleepless and agitated, and repeatedly pressed the driver to halt. "He pointed at Hindu after Hindu, accusing them of lying in wait for peaceful Muslims," Bucher later recorded. At one point the army commander asked Suhrawardy why Calcutta's Muslims and Hindus could not live as brothers like those serving in the military had for decades. "General," the premier said darkly, "that Hindu-Muslim unity will not exist very much longer, of that I can assure you."[52]

Local Hindu politicians issued equally strident complaints about bloodthirsty Muslims, Bucher reported. Shockingly, as the unrest entered its third day, not a single national Congress or League figure deigned to visit the city. Jinnah and Nehru chose to remain at their perches in Bombay and Delhi, and to use the news of the riots as ammunition in their ongoing blame game. Jinnah coldly described the tragedy — which in the end would claim more Muslim than Hindu victims — as "what treatment the Muslims should expect from the Hindu majority if they exist as a minority in undivided India."[53] Nehru told reporters dismissively that "such events as have taken place in Calcutta, deplorable as they are, do not make any major difference to the course of events."[54] Naturally, their followers expressed themselves with less restraint.

Bucher called in reinforcements. By Monday some 45,000 British, Indian, and Gurkha troops had at last begun to regain control over the streets.[55] But the chaos had upended Calcutta like a cyclone. Phillips Talbot and other Delhi-based foreign correspondents had finally managed to get into the city the night before. What they saw as they drove in from the airport stunned the veteran reporters, who after the war were scarcely unaccustomed to bloodshed:

We drove through deserted streets in which nothing moved.... Occasionally the sweeping headlights... picked up the bare walls of a corner shop, obviously stripped clean. Finally someone, seeing what we had all been sensing, muttered, "There's one." Visible momentarily in the beam of the headlights, avoided by a slight swerve, the body was again swallowed up in the darkness. "Four on this side," someone else said. In a moment we were in the thick of them, weaving to miss the ghoulish forms which flashed into view and as quickly merged into the night behind us....

In street after street ... tenements and business buildings were burned out, and their unconsumed innards strewn over the pavements. Smashed furniture cluttered the roads, along with concrete blocks, brick, glass, iron rods.... Fountains gushed from broken water mains. Burnt-out automobiles stood across traffic lanes. A pall of smoke hung over many blocks, and buzzards sailed in great, leisurely circles.[56]

The sight reminded *Life* photographer Margaret Bourke-White, who was riding in the same van, of Auschwitz. "At the end of three dreadful days, corpses bestrewed the town," *Statesman* editor Ian Stephens later wrote. "On plots of waste ground, you could see mounds of decomposing, liquefying bodies, heaped as high as the second floors of the nearby houses because of lack of space elsewhere."[57] To visit the police morgue, Stephens had to use a respirator: rotting cadavers were stacked to the ceiling.

No one knows the final death toll in what would become known as the Great Calcutta Killing. Many bodies were washed down the Hooghly or consumed in fires. The generally accepted estimate is that five thousand Calcuttans were killed, while another ten to fifteen thousand had their bones broken, limbs hacked off, or bodies charred.[58] It was by far the worst communal massacre in the annals of British rule in India.

Whom should history blame? Ever since those bloody days, the idea that Suhrawardy and Calcutta's Leaguers had laid plans to attack Hindu homes and businesses on 16 August has been central to the Indian narrative of Partition. Direct Action Day marks the moment when the political battle between Hindus and Muslims — until then waged around

negotiating tables and in debate halls — turned violent. The question of who launched the first blow is thus freighted with immense meaning: the guilty party is, by extension, held to be responsible for the hundreds of thousands of deaths to come. According to this version of the story, the League hoped both to intimidate Calcutta's Hindus and to convince the British that the two communities could not possibly live together in a united India.[59]

But Hindus — three-quarters of Calcutta's population — had also prepared for trouble that day. Early that first morning, as he ran to the top floor of his apartment building and huddled on the roof with his family, Nanda Lal could see Hindu gangs armed with staves and clubs confronting the intruders in the alleys below. Soon, "clawing, surging mobs" were tearing into one another amid cries of "Jai Hind!" (Hail, India!) and "Pakistan Zindabad!"[60]

Ultimately, it is not possible to assign blame entirely to one side or the other. What exploded so suddenly in Calcutta in August 1946 were the pent-up fears of communities convinced that they faced imminent subjugation by the other. *Riot* no longer sufficed as a description. The *Statesman* grasped for a better label: "It needs a word found in mediaeval history," the paper wrote, "a *fury*."[61]

Something had fundamentally broken in Calcutta. For the city's millions, the only bonds that still mattered now those of one's own community. "Dazed, suspicious survivors showed none of the camaraderie . . . which tends to spring up among victims of a severe bombing," Talbot wrote. Far from it: "Their eyes revealed hatred, bitterness, distrust, and fright."[62] To a Hindu in Calcutta, every Muslim now looked like a potential killer, and vice versa.

Refugees jammed the Howrah railway station, fleeing the devastated city for villages in the interior of Bengal. Hindu families clustered around their lumpy sacks of possessions and the occasional cow, boarding westbound trains.[63] Muslims eyed them warily from the opposite platform, heading to the east of the province. Along with their few ragged belongings, the refugees would carry with them horrific tales of the slaughter. In all too many cases, they had the burns and amputated limbs to back them up.

Wavell, responsible for keeping the peace across the subcontinent,

feared that the furies released in Calcutta would quickly spread. The only way to prevent a repeat — and a complete collapse of order — was to reassure Leaguers that they would have a place and a political voice in a united India. That burden fell on Nehru and the Indian National Congress, by far the more powerful of the two parties.

In Delhi, the viceroy called Nehru and Gandhi into his dark, wood-paneled office on 27 August, begging them to work out a compromise with Jinnah before another Great Killing erupted somewhere else. Wavell hinted that in the absence of a deal, he might have to withdraw the offer to let Nehru form a government. The normally pacific Gandhi erupted at the threat. Whatever happened, he insisted, Britishers could no longer deprive Indians of the right to decide their fate for themselves. "If India wants her bloodbath," the Mahatma declared, slapping Wavell's desk for emphasis, "she shall have it!"[64]

2

Jinnah and Jawaharlal

IN EARLY SEPTEMBER 1946, Wavell invited the nationalist poetess Sarojini Naidu to Viceroy's House for dinner. Naidu was a big, bawdy, irreverent woman — a scintillating raconteur and dinner party companion, especially compared to the often dour Indian politicians. Not even Gandhi escaped her lacerating wit: she impishly called the Mahatma "Mickey Mouse" for the way his ears stuck out from his bald head.[1]

Naidu had been friends with most of the leading Indian politicians, including Gandhi and Nehru, for decades. She had known Jinnah almost since his first days as a twentysomething lawyer in Bombay, when he had struggled to find clients and supposedly had had to hustle games of billiards on the side to pay the rent.[2] Naidu was the one who had joked that she needed "a fur coat" to be friends with the Muslim leader.

Reluctantly, Wavell had sworn in Nehru's interim administration on 2 September without the League's participation. Naidu did not envy the viceroy the task of bringing Jinnah and Nehru to a meeting of minds. As she explained over dinner, Jinnah's wariness of the Congress leaders went back thirty years. It was an operatic history. "Mrs. N. spoke of Jinnah rather as of Lucifer," Wavell recorded in his journal that night, "a fallen angel, one who had once promised to be a great leader of Indian freedom, but who had cast himself out of the Congress heaven."[3]

Indeed, at the beginning of his political career, Jinnah, not Jawaharlal,

had looked like India's man of destiny. Unlike Nehru, the Muslim leader had come from humble beginnings. His father ran a struggling trading business in Karachi. When Jinnah studied at the Inns of Court in London in the late 1890s, he survived for three years on what the charmed young Nehru later spent in one.[4] His difficult early years as a lawyer in Bombay instilled in Jinnah a lifelong penuriousness. Years later, after his bank accounts had fattened with rupees, friends would ask him why he still totted up the servants' salaries and expenditures every day. "This is hard-earned money!" he'd exclaim. "This is hard-earned money!"[5]

Jinnah had a cold, relentless courtroom style that earned him enemies but also victories; by 1916 he had become a force at the Bombay Bar. At the beginning of the twentieth century, politics on the subcontinent was a matter for gentlemen — successful lawyers, doctors, and wealthy industrialists — who gathered under the auspices of the Indian National Congress, established in 1885, to debate how to move the country gradually toward self-government within the British Empire. Jinnah fit right in with this crowd. If anything, his Savile Row suits were better tailored, his pants more sharply creased, his two-toned shoes even shinier than those of more established figures. Within the Congress, he quickly became known as a man to watch.

Jinnah's relative youth set him apart — he had not yet turned forty — as did his rapier intellect. But his religion is what made him truly unusual among the well-heeled Congress grandees. Ten years earlier, he had been one of only 44 Muslims among 1,500 delegates at the party's annual session. At the time, most prominent Muslims had no interest in kicking out the British. By sheer force of numbers, Hindus would dominate any democratic India. Only under British rule, these Muslim leaders believed, would their interests be safeguarded.[6] With British encouragement, a group of noblemen and large landowners had formed the Muslim League in 1906 specifically to act as a counterbalance to the Congress.

Like other Congressmen, Jinnah believed the British were deliberately stoking Muslim anxieties in order to justify the continuation of the Raj. "I say to my Musalman friends: Fear not!" Jinnah thundered in one speech. He called the specter of Hindu domination "a bogey, which is put before you by your enemies to frighten you, to scare you away

from cooperation and unity, which are essential for the establishment of self-government."[7] In 1916, while still a member of the Congress, Jinnah accepted an invitation to lead the Muslim League. He hoped to broker an alliance between the two parties that the British would be unable to ignore.

Jinnah knew the frictions between the subcontinent's two great communities had deep roots, of course. Several of the Muslim conquerors who had dominated India before the British had brutalized their defeated Hindu foes, massacring thousands and demolishing their flower-strewn temples. That history often got mixed up with contemporary economic tensions — where Hindu peasants continued to struggle under oppressive Muslim landlords, for instance. But the animosities cut both ways. Muslims bristled at the fact that their Hindu neighbors refused to share food with them or water from the same vessels, for fear of ritual pollution. The Hindu moneylenders who proliferated across India held all too many poorer Muslims in financial bondage.

In many parts of India, Muslim and Hindu families lived together amicably, even attending each other's weddings and festivals. Even then, however, bloody riots periodically broke out when religious sensibilities were offended. Muslims attacked Hindu devotees when they marched past mosques during Muslim prayer-time noisily ringing bells and chanting. Hindus assaulted Muslims when they slaughtered the cows held sacred in Hinduism. Muslims caricatured Hindus as *banias,* or merchants — haggling tricksters who were not to be trusted. Hindus stereotyped Muslims as violent and brutal.

In the summer of 1916, Jinnah himself ran up against one of the most stubborn communal prejudices. His good friend Sir Dinshaw Petit had invited him to escape Bombay's suffocating heat and spend several weeks in cool Darjeeling, high in the eastern Himalayas. Petit was a Parsi, one of India's small but hyper-successful community of Zoroastrians, and heir to a textile fortune. More importantly, he had a sixteen-year-old daughter — a sinuous beauty named Rattanbai, or "Ruttie." Jinnah would have been hard-pressed to ignore her presence. She wore gossamer-thin saris that clung to her body and had a ready, flirtatious laugh. One prim memsahib described her as "a complete minx."[8]

Like many Indians, Jinnah had been married young to someone of his

parents' choosing, a fourteen-year-old Gujarati village girl named Emi-
bai. A year later she had died while he was away studying in London. He
told friends that he hadn't kissed a woman since then (although, hearing
that particular tale, the irrepressible Sarojini Naidu trilled, "Liar, liar,
liar!").[9] Jinnah left no record of what transpired between him and Rut-
tie amid the emerald tea plantations of Darjeeling, but clearly a romance
blossomed. In July Ruttie penned a breathless letter to her friend Pad-
maja, Naidu's sixteen-year-old daughter. "I am no Philistine who would
think the outpour of fine emotions akin to madness," she wrote. "If it
really is madness, why can't all of us be mad!"[10] She was in love.

When they returned to Bombay at the end of the summer, Jinnah
asked Petit how he felt about intermarriage. The Parsi didn't realize what
his Muslim friend was angling at. A capital idea, Petit declared — just
the thing to help break down the foolish barriers that divided Indians
from one another. Jinnah's next question horrified him, though. The
nearly forty-year-old Muslim marrying *his* teenage daughter? The idea
was "absurd."[11] Petit not only refused but took out a restraining order
against Jinnah to prevent the couple from seeing one another.[12]

Jinnah was not to be discouraged, however, either personally or polit-
ically. He and Ruttie continued to correspond secretly. Like many of the
youths in her circle, she was enthralled by the romance of the nationalist
movement, and that winter she eagerly followed the news coming out of
the graceful Mughal city of Lucknow, capital of the United Provinces,
where Jinnah had helped arrange for the League and the Congress to
hold their annual sessions simultaneously. For the first time the two par-
ties agreed on a common set of demands to make of the British — what
became known as the Lucknow Pact. Jinnah won for Muslims a guar-
anteed percentage of seats in any future legislature, among other safe-
guards that would ensure they would not be perpetually outvoted by
the Hindu majority.[13] By coincidence, the lead negotiator for the Con-
gress was another successful lawyer, a Kashmiri Hindu who had been
involved in nationalist politics for years — Nehru's father, Motilal.[14]

The Lucknow Pact raised Jinnah's political stock sky-high. The next
year, Sarojini Naidu published a glowing, almost treacly tribute to him
entitled "Ambassador of Unity"; he seemed a shoo-in to become presi-
dent of the Congress one day. In November 1917, Secretary of State for

India Sir Edwin Montagu met with Jinnah on a visit to Bombay. "It is, of course, an outrage that such a man should have no chance of running the affairs of his own country," the impressed Briton noted in his diary that night.[15] A few months later, soon after Ruttie had turned eighteen, she and Jinnah scandalized Bombay's Parsi community by eloping. They quickly became one of the city's most glamorous couples, cruising down Marine Drive in Jinnah's convertible at sunset each night, her hair loose in the wind.

Then Jinnah threw it all away. Just as his political career was reaching its zenith, the spotlight in India shifted to another Gujarati lawyer, born just 30 miles from Jinnah's ancestral village. In 1915, forty-five-year-old Mohandas Gandhi had returned to India from South Africa, where he had lived for the past two decades. Having given up his English suits for a simple white *dhoti*, and his barrister's wig for an enormous turban, he looked more like a farmer than a revolutionary. He was wiry like Jinnah and much smaller in stature. Too nervous to stammer out arguments in court, he hadn't been much of a lawyer. Yet some inner vitality coursed through him, illuminating his mischievous eyes and expanding a taut chest. He had the intensity of a sage.

In South Africa, Gandhi had established a pair of ashrams in which to conduct what he called his "experiments with truth"—everything from fad diets and "nature cures" to attempts to break down Hinduism's caste barriers. He and his acolytes lived lives of utopian simplicity: they swore off drink and sex, prayed regularly, grew and cooked their own vegetarian food, cleaned their own toilets. Outside the ashram, Gandhi's efforts to organize South Africa's Indian immigrant community made him a celebrity. Instead of meekly submitting to laws that were unjust, or challenging the more powerful government by force of arms, he taught local Indians to resist peacefully—to court jail willingly for the sake of their principles.

Gandhi dubbed his strategy *satyagraha*—literally, "insistence on truth"—and it proved devastatingly effective. South African officials had no idea how to handle the "wild and disconcerting commotion" caused by thousands of Indians marching in protest and offering themselves up for arrest. The prisons swelled with Indian inmates, and journalists from around the world flocked to interview the charismatic

Gandhi. It was all "very trying," admitted future South African premier Gen. Jan Christiaan Smuts.[16]

When Gandhi now proposed replicating his methods in India, Jinnah balked. The Muslim did not challenge the principle behind satyagraha — the idea that Indians should peacefully refuse to cooperate with their British masters. "I say I am fully convinced of non-cooperation," he declared at a contentious Congress meeting in September 1920. But Jinnah did not believe that the Indian masses were educated or disciplined enough to ensure their protests remained nonviolent. He thought the Congress leaders needed to prepare their followers first. "Will you not give me time for this?" he asked the crowd at the meeting, plaintively.[17]

Not all of Jinnah's motivations were so high-minded, of course. He was unquestionably a snob: later, when tens of thousands of Muslims turned out at rallies to see him, he would recoil from shaking hands with his own supporters.[18] He also found Gandhi's appeal to the largely Hindu masses dangerously sectarian. At his evening prayer meetings, the Mahatma would frame his political arguments using parables from Hindu fables; he described his vision for an independent India as a "Ram Rajya"—a mythical state of ideal government under the god Ram. All the chanting and praying that accompanied Gandhi's sermons seemed to Jinnah like theatrics.[19]

What historians rarely acknowledge, though, is that Jinnah worried less about Hindus than about the danger of inflaming religious passions among *Muslims*. At the time, mullahs across the subcontinent were threatening to launch a jihad if the British, who had defeated the Ottomans in World War I, deposed the Turkish Sultan — the caliph, or leader, of the world's Sunni Muslims. Led by a pair of fiery brothers, Mohammad and Shaukat Ali, this "Khilafat" movement had attracted an unsavory mob of supporters. The acerbic Bengali writer Nirad C. Chaudhuri remembers Khilafat volunteers as "recruited from the lowest Muslim riffraff... brandishing their whips at people."[20]

Jinnah had no sympathy for these rough-edged Muslims nor for their fanatic cause. He feared that their rage would inevitably turn from the British to Hindus. Gandhi, on the other hand, threw his support behind the Khilafat movement; in turn, Muslim votes gave him the slight majority he needed to launch his satyagraha movement.[21] Years later,

Gandhi recalled Jinnah telling him that he had "ruined politics in India by dragging up a lot of unwholesome elements in Indian life and giving them political prominence, that it was a crime to mix up politics and religion the way he had done."[22]

Nowadays most Indian accounts put Jinnah's opposition to Gandhi down to jealousy. At a follow-up Congress meeting in December 1920, Jinnah drew jeers by referring to "Mister" Gandhi in his speech, rather than the more respectful "Mahatma." In fact, although he slipped once or twice more, Jinnah did switch to using "Mahatma." What he absolutely refused to do was refer to Khilafat leader Mohammad Ali as "Maulana," a term reserved for distinguished Islamic scholars. Jinnah was not about to encourage what he saw as religious demagoguery. "If you will not allow me the liberty to . . . speak of a man in the language which I think is right, I say you are denying me the liberty which you are asking for," he vainly protested.[23] The crowd's howls chased him off the stage.

That humiliating scene marked the beginning of a long slide into irrelevance for Jinnah as a national political figure. Sadly, his concerns appeared to be borne out less than a year later, when Khilafat protesters in the southern Malabar region turned on their Hindu neighbors and massacred hundreds of them. Yet by that time, Gandhi, now the undisputed leader of the Congress, had irreversibly transformed the nationalist movement. A new crowd now dominated party meetings — middle-class and lower-middle-class men and women, clad in saris and kurtas and sitting on the ground cross-legged rather than in chairs. Jinnah still got upset when his bearer laid out the wrong cufflinks for him.[24] He no longer fit in.

Jinnah did not disappear from the political scene, but as Gandhi's Congress grew larger and larger, the League leader was pushed further and further to the margins. He became what he had never wanted to be — a purely Muslim politician, reduced to petitioning for concessions for his community. By the end of the 1920s, the League had begun to break up into factions, and Jinnah's influence had become negligible.[25] Now his former Congress comrades dismissed him as not even the most important among several Muslim leaders. They suspected that Jinnah could not "deliver the goods" — the widespread support of Indian Muslims.[26]

This was not the illustrious nationalist hero with whom the impressionable Ruttie had fallen in love. After giving birth to a daughter, Dina, in August 1919, Jinnah's young wife had plunged into a half-baked mysticism, taking up crystals and séances. She may have begun using drugs like opium to combat a painful intestinal ailment.[27] The differences in the couple's ages and temperaments became too obvious to ignore. "She drove me mad," Jinnah told one friend. "She was a child and I should never have married her."[28] In early 1928, Ruttie moved into a suite at Bombay's Taj Mahal Hotel, leaving Jinnah home with eight-year-old Dina.[29] That spring, visiting Paris with her mother, Ruttie fell into an unexplained coma and almost died.

Jinnah, traveling in Ireland with a friend, immediately rushed to the French capital and arranged for a new doctor for her. While she recovered, their relationship did not. Jinnah returned to India at the end of the year alone, now abandoned not just by his followers but by his wife. Two months later, on 19 February 1929, Ruttie fell unconscious in her room at the Taj Mahal Hotel. She died the next day, on her twenty-ninth birthday.

Most accounts say only that the circumstances of Ruttie's demise were "mysterious." But her daughter, Dina, put it more bluntly: "My mother committed suicide," she told Jinnah's first biographer.[30] The embarrassed author left that nugget out of his hagiography, and it's never been acknowledged elsewhere. Still, even at the time, rumors about the death were rife. One of Nehru's sisters wrote that she had "reason to believe that [Ruttie had] planned" her own demise.[31]

On the night of Ruttie's funeral, Jinnah sat with a mutual friend, Kanji Dwarkadas, who had seen her just before she died. "Never have I found a man so sad and bitter. He screamed his heart out," Dwarkadas recalled. "Something I saw had snapped in him. The death of his wife was not just a sad event, nor just something to be grieved over, but he took it, this act of God, as a failure and a personal defeat in his life." Jinnah never wanted to be reminded of his private tragedy, which had become so humiliatingly public. He packed away Ruttie's jades and silks and volumes of Oscar Wilde in boxes and rarely mentioned her again.[32]

There was nothing left for Jinnah in India. In its two decades of existence, the Muslim League had accumulated fewer than two thousand

members, most of whom did not pay their dues.[33] Creditors tried to seize what little furniture remained at League headquarters to sell at auction. Parts of the factionalized party did not even recognize Jinnah's leadership.

In 1931, Jinnah moved to London with Dina and his sister Fatima. He took up cases before the Privy Council and bought a rambling Victorian mansion overlooking Hampstead Heath. He refused to answer questions about when — or if — he would return to India. "I seem," he told an Indian journalist over lunch at Simpson's, with startling candor, "to have reached a dead end."[34]

The crowds were beyond belief. When Jawaharlal looked out from the rickety stages he climbed day after day, he saw a seething, sweaty, excited mass of humanity. Tens, sometimes hundreds of thousands of people stretched to the horizon. As he crisscrossed India — by train, car, bullock cart, horse, camel, elephant, bicycle, paddleboat, canoe — thousands more Indians lined the roadsides, their hands clasped in respectful greeting, hoping for a glimpse of the forty-seven-year-old Congress president.[35]

Nehru shouted himself hoarse over static-filled loudspeakers. At times the crowds' "madness entered my veins," he wrote to a friend, and he would leap into the heaving mass to get closer to his admirers.[36] Over the course of three months of electioneering at the end of 1936 and beginning of 1937, Nehru estimated that more than 10 million Indians turned out to see him at rallies and along the roadsides. He shook so many hands that his palms swelled.

Much was at stake in the February 1937 elections. For the first time, Indians would take control of the legislatures and ministries that governed the eleven provinces of British India. But that hardly explained the outpouring of affection that greeted Nehru wherever he went; most people in the crowds did not meet the qualifications to vote. "Why does this happen? I can't make out and all my vanity does not help me to understand," he wrote, genuinely amazed.[37]

Jawaharlal's rise had been as vertiginous as Jinnah's fall. Twenty years before, when the League leader was negotiating his triumphant Lucknow Pact with Nehru's father, the son had been little more, in his own

words, than a conceited "prig."[38] He had returned from England in 1912, overeducated and aimless, disdainful of the "immoderately moderate" nationalist politics of the time yet with no alternative to propose.[39] He worked dully in his father's law offices and took the cases sent his way. Motilal found him a shy, pretty Kashmiri girl named Kamala to marry. They wed when she turned sixteen (he was twenty-five) and moved into a wing of Nehru's childhood home. A year later they, too, had a daughter: Indira.

When he met Gandhi on the sidelines of the 1916 Lucknow conference, Nehru found the ascetic older man to be "very distant and different and unpolitical." Much of the Mahatma's philosophizing looked to the resolutely secular Cambridge man — as it had to Jinnah — like cant. Yet as a child, Nehru had fallen in love with Lafcadio Hearn's tales of adventure and imagined himself, sword in hand, leading his countrymen to freedom against the British.[40] Gandhi's satyagraha offered him exactly what he had been craving — action. It was a way to *fight* the British, albeit without weapons or bloodshed.

Nehru had thrown himself into the cause. For Gandhi the independence struggle was at least as much moral as political: he wanted Indians to make themselves worthy of freedom, to develop self-reliance before assuming self-government. Nehru became a true believer. He gave up his lawyer's suits for kurtas made of homespun cotton. He replaced the rich roasts and claret at Anand Bhavan with plain flatbread and lentils. He even got himself a *charkha,* a wooden spinning wheel, and heeded Gandhi's call for every Indian to spin yarn at least an hour each day to break the dependence on British-made cloth.

A shy speaker at first, Nehru found his voice organizing peasants in the countryside around Allahabad, tromping from village to muddy village trailed by policemen, agents from the Criminal Investigation Department, and, on one occasion, a most unhappy deputy collector from Lucknow wearing patent leather pumps. The young rebel was arrested for organizing picketing, for seditious statements, and for defying official orders. He went to jail frequently and willingly: at times he seemed to enjoy himself in confinement more than outside prison walls. "Jail has indeed become a heaven for us," he declared at one early trial, in a statement that became a call to arms for many young activists. "To serve

India in the battle of freedom is honour enough. . . . But to suffer for the dear country! What greater good fortune could befall an Indian?"[41] In his jail diaries, he would record how many feet of yarn he had spun each day; in 1922, he sent home 10,576 yards of fine homespun cloth.[42] "[We] lived in a kind of intoxication," Nehru later wrote.[43] He was convinced he and his comrades were not only breaking India's shackles but changing the world.

As Jinnah's profile shrank during the 1920s, Nehru's grew, both inside and outside of India. Kamala was a sickly bride, suffering from tuberculosis, and he spent months with her in Europe going from sanatorium to sanatorium. On those trips he developed ties to leftists and revolutionaries from other parts of the world, and integrated India's struggle into the broader wave of nationalist movements then sweeping parts of Asia and the Middle East. His international profile added to his glamour at home. By the end of the decade, Nehru had already served as Congress president once, at age forty. Newspapers showered him with flowery honorifics. When he came down to breakfast, Kamala and his youngest sister, Krishna (nicknamed "Betty" as a child by her English governess), would bow deeply and ask "how the Jewel of India had slept, or if the Embodiment of Sacrifice would like some bacon and eggs."[44]

Nehru's wife, like Jinnah's, died young. In February 1936, after months of fruitless treatment, Kamala passed away in a Lausanne sanatorium from tuberculosis. Theirs had been an affectionate and respectful marriage but not a passionate one. Nehru's letters home from jail were dutiful and banal — laundry lists of queries about relatives, requests for new books, admonitions for Kamala to take care of her health. Her death seemed to elevate their relationship, at least in the eyes of others. Nehru returned from Europe to an outpouring of sympathy. Thousands of condolence letters flooded in; newspapers ran paeans to Kamala as a virtuous, selfless helpmeet to the nationalist cause. Bazaar vendors sold a diptych with photos of her and Jawaharlal side by side, captioned "The Ideal Couple."[45]

Before the end of the year, Nehru appears to have plunged into a far steamier affair with none other than Ruttie's young friend Padmaja Naidu, Sarojini's buxom daughter. They had known each other for years. His letters to "Bebee," a decade his junior, had always been far

more flirtatious than those to Kamala. Now Nehru openly admitted to the sultry Padmaja, "I am afraid I do not feel paternally inclined towards you."[46] From the campaign trail he sent her pining letters: "My dear, how you fill my mind! When I ought to be thinking of something else your image creeps in unawares through some window and upsets the train of my thought."[47] On a visit to Agra her image "got rather mixed up with the moonlight and the Taj," he sighed.[48] He signed one missive, "My love to you, *carissima*."[49]

Flush with passion, adored by millions, Nehru could barely deign to notice Jinnah, who had returned to India to lead the League's campaign in the crucial 1937 elections. Since 1909 the British had allowed Muslims to vote only for candidates for certain reserved Muslim seats. Jinnah publicly suggested that after the elections, he would be open to throwing the League's Muslim support behind his old comrades in the Congress. Nehru mocked the idea. "I thank Mr. Jinnah for the offer," he told reporters in November 1936, but "so far as our fight for freedom is concerned, it is going to be carried on by the Indian National Congress and the Indian National Congress alone."[50] Indians of all faiths faced a simple choice in the elections, Nehru declared: either cast their votes for the Congress Party or resign themselves to continued servitude to the British.[51]

Jinnah tried to protest. There was a third player in India, he insisted — the League. But the results supported Nehru. Congress swept the elections, taking control of eight of eleven provinces. The League polled less than 5 percent of the Muslim vote nationwide. Two or three winning League candidates did flirt with the idea of supporting Congress administrations in exchange for provincial cabinet posts. But Nehru laid down stiff terms: if any Leaguers wanted a share of power, he said, they would have to join the Congress and obey its high command rather than Jinnah.[52]

Ironically, Congress had done even worse than the League among Muslim voters, most of whom had cast their ballots for smaller, regional parties.[53] Yet that did not faze Nehru. He directed party leaders to deploy Congress's vast resources in an attempt to win over the Muslim masses. To Jinnah, his younger rival seemed intent on becoming India's "ambassador of unity" himself.

Jinnah was now sixty years old, graying and sickly. Unlike Nehru — whose affair with Padmaja would hardly have been a secret in certain circles — he was a lonely man. His pinched sister Fatima was his only real companion. In November 1938, his nineteen-year-old daughter Dina defied him and married a Parsi boy against his wishes.[54] From this moment onward a new bitterness entered the League leader's voice whenever Nehru's name came up. "What can I say to the busybody President of the Congress . . . [who] must poke his nose into everything except minding his own business?" Jinnah seethed to one journalist.[55] Nehru had become more than a political opponent: he had usurped all the power, glory, and romance that had once seemed Jinnah's by right.

Jinnah could easily give up and return to London. Or he could fight back. His genius was to link his own frustrations to those of his community. After the elections, Muslims, too, shared Jinnah's sense of dismay and powerlessness. In the Congress provinces, a whole new breed of official began stalking the halls of government — men in rough, rumpled homespun dhotis and white caps styled like the one Gandhi wore. The vast majority of the newcomers were Hindu, and they now controlled the schools and police. British officials, once omnipotent, had to take orders from them. Ministers often favored other Hindus for jobs, licenses, and patronage. Educated, urban Muslims — the professionals and petty clerks who would become the backbone of a rejuvenated Muslim League — could see that their prospects looked bleak in any Congress-ruled India.

Jinnah played on those fears deftly. Muslims complained of petty indignities, many of them relating to their children's education. In places pupils were required to salute Mahatma Gandhi's picture each morning or to sing the Congress anthem, "Bande Mataram," which many Muslims found objectionable for its likening of India to a Hindu goddess. Teachers in government schools allegedly favored Hindi over Urdu.[56] Jinnah began loudly decrying these "atrocities." He launched a newspaper, *Dawn*, whose editorials dispensed with any pretense to objectivity or moderation. The paper ran a thirty-two-part series on the supposed "holocaust" being perpetrated by Congress entitled "It Shall Never Happen Again." Across India, "tragedy followed tragedy and blood flowed instead of the milk of human kindness," the paper fulminated. "Terror

stalked the countryside and rendered the helpless, outnumbered few despairing and desperate."[57]

Where Jinnah had once criticized Gandhi for exploiting religion, he now started holding forth on the "magic power" of the Muslim community.[58] In by-elections, League flyers assured Muslim voters that God and the Prophet favored the party's candidates. "Jinnah seems to have gone to pieces," Nehru wrote in exasperation to Padmaja.[59] In public, the League president exchanged his suits for the knee-length *sherwani* and leggings of a Mughal nobleman. He persuaded the local Muslim powerbrokers who had dominated elections in the provinces of Bengal and the Punjab to throw their weight behind him nationally. Within a year of losing 95 percent of the Muslim vote, Jinnah began describing the Muslim League as the "sole representative" of India's Muslims.

Nehru refused to take any of this seriously. "Am I to insult my intelligence by talking baby-talk of an age gone by?" he wrote to a Muslim colleague who had switched allegiance from Congress to the League.[60] Nehru remained convinced that the supposed "Hindu-Muslim divide" was nothing but a nuisance, that both communities would soon realize they were being exploited equally by the British and Indian upper classes. After an abortive public exchange of letters with Jinnah — which the League leader concluded by sighing, "It is really difficult for me to make you understand the position any further" — Nehru gave up.[61]

Jawaharlal had become Jinnah's most useful foil, and he would play a critical role in the demand for Pakistan. The global cataclysm that would make so many things possible, even as it destroyed so much, had begun. War between Japan and China broke out in the summer of 1937. Germany seized Austria on 12 March 1938. By mid-1939, Europe, Asia, and Africa were aflame. For years now Nehru, like his leftist friends in Europe, had been warning of the looming Fascist threat. Yet when the viceroy — Wavell's predecessor, the ponderous and inflexible Victor Hope, 2nd Marquess of Linlithgow — declared on 3 September 1939 that India had joined the fight against Hitler, the only Indian he involved in the decision was the "very slow, old *moulvi*," or Muslim scholar, who translated the announcement into Urdu just minutes before it was broadcast on All-India Radio.[62] Only afterward did Linlithgow call in Indian political leaders to solicit their support for the war effort. Nehru was outraged.

Most of the Congress leaders, including Gandhi, thought it was unseemly to haggle for concessions while the British were battling for their lives. But Nehru was the party's foreign policy "expert," and his official response to Linlithgow's plea ran to several thousand words. Its rhetoric was soaring. "The crisis that has overtaken Europe," Nehru wrote, "is not of Europe only but of humanity and will not pass like other crises and wars, leaving the essential structure of the present-day world intact."[63] At the same time, Indians could hardly be expected to lay down their lives for an empire that promised to keep them in chains. Nehru first wanted a declaration that India would be freed after the war and allowed to write its own constitution. In the meantime, he wanted Indian politicians to be brought into a war council under the viceroy, so that Indians themselves would take part in leading the war effort. Gandhi hailed the manifesto's author as an "artist."[64]

To Jinnah, Nehru's resolution looked more like blackmail. The British had beaten back all of Gandhi's great satyagraha campaigns over the past twenty years. But as one rattled viceroy famously said, it had been a close-run thing: "Gandhi's was the most colossal experiment in the world's history, and it came within an inch of succeeding."[65] Britain could not risk another nationwide rebellion now: "American opinion of our policy in India is already sufficiently critical," the War Cabinet in London warned. "What it would be if a non-cooperation movement led, as it did last time, to the arrest and detention without trial of as many as 25,000 persons . . . is easy to imagine."[66]

Nehru was making a play for independence, Jinnah feared. The League leader knew that if the British granted his rival's demands, Congress would inevitably dominate any interim government, as well as any constitution-writing body set up after the war. The League — and Jinnah himself — would again be shut out of power.

The idea of breaking off a separate Muslim homeland had been floating around League circles for some time. While in exile in England, Jinnah had met the thirty-five-year-old Cambridge student Chaudhry Rahmat Ali, who had invented an acronym for this erstwhile nation. The first letter, "P," stood for his own province of Punjab; "A" for the rough tribal areas bordering Afghanistan; "K" for the lush, mountainous kingdom of Kashmir; "S" for the arid coastal province of Sind; and

"TAN" for the great wasteland of Baluchistan: PAKSTAN. (The "I" was added later to make the name more mellifluous.)

At the time Jinnah had been skeptical. "He seemed to regard Rahmat Ali's concept ... as some sort of Walt Disney dreamland, if not a Wellsian nightmare," a friend said.[67] But now, as a classified British intelligence report indicated, Jinnah was looking for a way "to show the League as the full-blooded ally of Great Britain against her two enemies, the Nazis and the Congress." When he met the viceroy in mid-March 1940, Jinnah essentially offered Pakistan to the British as a permanent foothold in the subcontinent — "a Muslim area run by Muslims in collaboration with Great Britain."[68] Importantly, staunch Pakistan would encompass the vulnerable Northwest Frontier, where the Nazis and their then-allies the Russians were most likely to invade.

Two weeks later at a meeting in Lahore, the League set the creation of Pakistan — defined as "geographically contiguous ... areas in which the Muslims are numerically in a majority as in the North Western and Eastern Zones of India"— as its official goal.[69] By adding vast, Muslim-majority Bengal, Pakistan would gain the wealth brought in by the great port and manufacturing hub of Calcutta, though this eastern wing would be cut off from the rest of the country by the crown of northern India. Privately Jinnah reassured skeptical colleagues that Partition was only a bargaining chip: the British could not hand over power to Nehru as long as Hindus and Muslims did not even agree on whether they were one nation or two.[70]

More than a few Muslim figures nevertheless wondered whether the League leader was wise to set their community against other Indians. The Aga Khan, the fabulously wealthy leader of the Ismaili sect and a one-time ally of Jinnah's, worried about the bad blood that Muslim obstructionism was stirring up. "The bitter enmity now raised by the League and its leaders," he warned in a letter to a friend, "will have to be paid for a hundred percent."[71]

The gracious Deccan Queen passenger train normally covered the 150 miles between Bombay and the hill town of Poona in three hours. Bombay's industrialists and socialites made the trip often, winding through the thickly forested flanks of the Western Ghats to escape the soggy heat

along the coast. In racing season, their villas glittered with festival lights and resounded to the clink of champagne flutes.

In early November 1942, Nehru's sister Betty boarded the familiar train on a grimmer mission — to visit her husband, Raja, at Poona's Yeravada Prison. The trip took her ten hours. Heavily armed soldiers repeatedly halted the train at checkpoints, and in spots passengers had to wait while the tracks were cleared of debris. "All along the line we saw dead cattle, overturned railway carriages, and the wreckage of war," Betty later recalled.[72]

This was not the work of the Nazis, sweeping down through the subcontinent like the Aryan invaders after whom they modeled themselves. Nor had the Japanese wreaked upon India the same devastation Southeast Asia had suffered after Pearl Harbor. In British eyes, the field marshal responsible for this mayhem was none other than Betty's older brother, Jawaharlal.

The early years of the war had been especially trying for Nehru. Across the globe the Allies were battling desperately against Fascist hordes. Yet throughout it all he had sat on the sidelines, watching in disgust as colonial officials played tennis and put on black tie for dinner, while one by one their Asian territories fell to the enemy. Japan seized Hong Kong in December 1941. The Imperial Army would drive the British out of Malaya in January, and then conquer Singapore two weeks later. The Dutch East Indies fell in March, Burma in May.

Nehru blamed Jinnah as much as the British for perpetuating this state of affairs. Shortly after the League passed its 1940 Pakistan resolution, Winston Churchill had come to power in London. The blustery Tory diehard had begun his career in India as a Kiplingesque subaltern, subduing the Pathan tribes along the Northwest Frontier. His mental picture of the subcontinent had not changed much since then; as far as he was concerned, the empire had reigned over India for centuries, and it would do so for several more. The Atlantic Charter he signed with his American counterpart, Franklin Delano Roosevelt, which listed the restoration of "self-government" as one of the Allied war aims, did not, he imagined, apply to Britain's colonies.[73]

As Jinnah had intended, the Pakistan demand gave the prime minister an excuse to stall any further concessions to the Congress. In Au-

gust 1940, Churchill authorized the viceroy to declare that the British "could not contemplate" handing over power to any "government the authority of which was directly denied by large and powerful elements in India's national life."[74] Nehru raged that Jinnah had won a "veto" over political progress.

By the middle of 1942, with the Japanese on India's eastern borders, Nehru's frustration was peaking. "I have the strongest feeling . . . that the British mean to hang on here and we shall never get rid of them if we do not strike now," he told the leftist American writer Edgar Snow in Wardha at the end of May.[75]

Snow had traveled to the Mahatma's ashram to interview Gandhi and Nehru, but also to deliver a message. The journalist had met with Roosevelt before leaving the States, and the president had told him to "ask Nehru to write me a letter and tell me exactly what he wants me to do for India."[76] The United States had developed a keen interest in the subcontinent since entering the war against Japan. The American planes resupplying Chiang Kai-shek's beleaguered forces in China flew out of air bases in eastern India. If the Japanese overran the country, the vital Middle East would be squeezed in an Axis pincer movement. At this critical moment, Roosevelt did not want Indians sitting out the war.

The Mahatma, on the other hand, had decided that the time had come to launch another satyagraha, an "all-out" struggle that would not end until the British had "quit India," bag and baggage.[77] Nehru was torn, fearing that a widespread disobedience movement might open the door to Japanese invasion. He spent weeks in a state of "pitiable perplexity," according to the government's Intelligence Bureau.[78] But by the middle of June, two weeks after Snow's visit, he was "reported to have given in to Gandhi," Linlithgow cabled to London.[79] According to one of his Congress colleagues, Nehru hoped that if nothing else, the Mahatma's threat might encourage Roosevelt to intervene more forcefully.[80] If anyone could force Churchill to bend, Nehru was betting, the powerful Americans could.

It was a bad bet. "The political crisis in India had matured a year too early for the United States," Undersecretary of State Sumner Welles later reflected.[81] Roosevelt had clashed with Churchill over India before — once even prompting a drunken threat from the Briton to resign.

"Take India if that is what you want! Take it, by all means!" Churchill spluttered to an American diplomat in Washington, red-faced and nearly incoherent. "But I warn you that if I open the door a crack there will be the greatest bloodbath in all history."[82] Roosevelt, who had just begun negotiating the Normandy invasion with his British allies, could not risk an outright break with London now.[83]

The British, not the Americans, delivered the reply to Gandhi's "Quit India" resolution, which the Congress approved on 9 August. That night police swept in after midnight and arrested the Mahatma and the rest of the Congress leadership. Unprepared, they had left their followers no instructions. Riots broke out spontaneously in several cities. Within a week, the violence had spread and become more organized—and bloodier. Across wide stretches of northern India, crudely armed peasants killed and drove out police and government officials from several districts. Saboteurs blocked or blew up rail lines to prevent the movement of troops and supplies. The army struggled for weeks, sometimes months, to regain control over the monsoon-soaked countryside in the United Provinces, Bihar, and Bengal.

Many Britons—even liberal ones—believed they were facing a well-planned, traitorous attempt by the Congress to overthrow the Raj. When authorities responded with brutal force—using tactics that one British governor later admitted "dragged out in the cold light of [day], nobody could defend"—many simply looked away.[84] British troops opened fire on demonstrators repeatedly. In the Midnapore district of Bengal, police were accused of gang-raping seventy-three women to terrorize the rebels. Prisoners were forced to lie naked on blocks of ice until they passed out.[85] The viceroy authorized the strafing of villagers from the air.

Churchill saw no reason to treat the Congress as anything but war criminals, even though no plot to overthrow the Raj was ever discovered. Nehru and the rest of the party's high command—along with thousands of their followers—were locked up for the rest of the war.

Nehru's failed gamble left the political field wide open for Jinnah. Until this point, Linlithgow had held the League leader at a wary remove, finding him useful in some cases, troublesome in others. Now, as one of the viceroy's aides told Edgar Snow, Jinnah was "sitting on the

finest velvet in the land."[86] The British were convinced that they needed to maintain the goodwill of Indian Muslims, given their high representation in the army, not to mention the importance of Britain's Muslim allies in the Middle East. Linlithgow did not fret about the danger of inflating Jinnah's stature: "He represents a minority, and a minority that can only effectively hold its own with our assistance," the viceroy breezily reminded London.[87]

In province after province, British governors began ousting Congress-friendly ministries and replacing them with what they saw as more malleable Leaguers. By the middle of 1943, the party and its allies controlled all of the provinces that Jinnah had envisioned as part of "Pakistan," from Sind in the west to Assam in the east. The extent of Jinnah's personal authority over these territories is questionable: regional Muslim leaders paid lip service to the League, as long as Jinnah did not meddle too much in their affairs.[88] But that didn't stop him from boasting of his sway. Almost 99 percent of the subcontinent's 100 million Muslims were behind him, Jinnah confidently declared at the League's annual session in Delhi in April 1943, "leaving aside some who are traitors, cranks, supermen or lunatics."[89]

A few years earlier, a Muslim newspaper editor had given Jinnah a new honorific to compete with the Mahatma's: Quaid-i-Azam, or "Great Leader." Jinnah now made a conscious effort to live up to the title. He staged a grand entrance to the Delhi meeting, parading 5 miles through the capital enthroned on the back of an open truck, his hand raised in a half-salute like Il Duce. Nehru and Gandhi were no longer the only ones who could draw a crowd. "On that day it was difficult to believe that the entire population of Delhi was not only Muslim but Muslim Leaguers," one excited observer recalled.[90] Supporters were packed tightly along Jinnah's route, and from balconies above women flung rose petals down at the Quaid. Fierce men in crisp, gray uniforms — members of the party's private militia, the Muslim League National Guards — surrounded Jinnah with drawn swords. At the next League session, held in his seaside hometown of Karachi in December 1943, the Quaid arrived on a carriage decorated to resemble a sailing ship, drawn by thirty-one caparisoned camels.[91]

While no doubt gratifying to his bruised ego, all this pageantry had

a hard-nosed political purpose as well. Jinnah could not be sure that Nehru and the other Congress leaders would remain behind bars. Jinnah needed to establish himself and the League as an equal force as rapidly as possible. His most powerful weapon was Pakistan. "He ... preaches Pakistan with an intensity not unlike Hitler's advocacy of national socialism," reads a February 1943 report by the Office of Strategic Services (OSS), the forerunner of the Central Intelligence Agency.[92] "As far as Muslim India is concerned, we have forged our own charter and that is Pakistan," Jinnah repeatedly declared. "We are not going to budge an inch from the position we have taken. Nothing will make us swerve from our goal."[93]

Jinnah batted aside all attempts to get him to sketch out his vision in more detail. Pakistan's magic was as a fantasy — "a kind of Muslim Never-Never Land, a fairy tale Utopia," the OSS called it.[94] If no one could say what it was, everyone could see what they wanted in it. Landlords envisioned rich fields being added to their holdings. Farmers imagined a life free of Hindu moneylenders. Bureaucrats saw themselves ascending to senior posts. Mullahs pictured a society lived according to the Koran.

An American diplomat who met with League leaders in the Punjab capital of Lahore reported that they did not seem to have the foggiest idea of what an independent Muslim nation would entail: their demand was "clearly emotional rather than rational."[95] That was the point. At bottom, Jinnah was promising his followers the same vague but powerfully attractive thing as Nehru — a future in which they controlled their own destiny. As an airy vision, Pakistan would prove to be dramatically effective: the League grew from 112,078 members in 1941 to an estimated 2 million in 1944.[96] Jinnah's personal stature swelled along with the party's membership rolls.

Watching all this from his prison cell, Nehru grew more and more outraged. He and the other Congress leaders — except for Gandhi, who was confined in one of the Aga Khan's palaces in Poona — spent the war imprisoned in the imposing fort at Ahmednagar, 160 miles west of Bombay. The barracks had been converted into makeshift cells, separated by 7-foot-high wooden partitions. The rooms lacked ventilation, electric lights, or fans. Windows had been bricked up. "Very cheerless

and uncomfortable-looking," Nehru judged in one of his first diary entries from the prison.[97]

This spell in prison was his longest yet — 1,040 days, almost a full three years — and in many ways, the most frustrating. Outside the walls of Ahmednagar, a new world was being born; inside, Nehru had to content himself with tending a prison-yard garden, his pebble collection, and a stray cat he nicknamed Chando. Banalities and day-to-day details pepper his diary:

11 January 1943	Felt unwell
30 January 1943	Sowed carnation seeds in box. New canvas shoes
12 April 1943	New canvas shoes
13 April 1943	Rain — rain — continuous rain! The monsoon
5 May 1944	The cat tragedy! Poor Chando hit inadvertently over head by cook — concussion of the brain. Hovering between life and death
14 May 1944	Cat Chando died in hospital
20 June 1944	New canvas shoes[98]

The journals also betray a mounting sense of anger at Jinnah. In Nehru's mind, the Quaid had replaced the British as the figure most responsible for India's continued thralldom. Jinnah's Pakistan was "mad and foolish and fantastic and criminal and . . . a huge barrier to all progress," Nehru fumed. He found Jinnah's speech at the Delhi League meeting, which had lasted for three hours, "blatant, vulgar, offensive, egoistical, vague. . . . What a man! And what a misfortune for India and for the Muslims that he should have so much influence!" The Quaid's rising profile Nehru attributed purely to "opportunism raised to the nth degree, pomposity and filthy language, abuse . . . a capacity for what is considered 'clever' politics, vulgarity . . . total incomprehension of the events & forces that are shaping the world, &c, &c."[99]

Much worse was that Jinnah had, to Nehru's mind, transformed the once-glorious freedom struggle into a squalid sectarian feud between Hindus and Muslims. "What a lot Jinnah & his Muslim League have to answer for!" Nehru wrote in September 1943. "They have lowered

the whole tone of our public life, embittered it, increased mutual dislikes and hatreds, and made us contemptible before the outside world." By the end of 1943, almost four full years before Partition, Nehru was already tempted to give the Quaid his Pakistan. Allowing Jinnah to run his own little country might at least "keep [him] far away and [prevent] his muddled and arrogant head from interfering continually in India's progress."[100] Like the irksome "Hindu-Muslim divide," Nehru just wanted his rival to go away.

The Quaid drummed his long, bony fingers on the table and watched the hands on the clock tick toward nine. A black telephone sat on the desk before him like a silent reproach. The clock hands kept moving, as did the Quaid's fingers. The phone did not ring.

Jinnah called for his secretary and furiously dictated a note, addressed to the premier of the mighty Punjab province, Sir Malik Khizar Hayat Khan Tiwana. Khizar was a slim, forty-four-year-old landowner, given to wearing enormous white turbans crowned by a single peacock feather; his family had roots in the Punjab going back to the fifteenth century. Like the leaders of the other "Pakistan" provinces, he supported the Quaid and the Muslim League in theory. But the Punjab was a special case. Although Muslims formed a slight majority of the population, they could not have governed the province without the cooperation of its powerful Hindu and Sikh communities. Factions representing all three groups ruled together in a so-called Unionist coalition, with Khizar at its head.

To maintain harmony, the Unionists focused on practical matters — taxes, grain prices, pensions — and avoided the political arguments that divided Hindus and Muslims elsewhere in the country. Khizar did not spend much time talking about Pakistan, which his Muslim predecessor as premier had privately mocked as "Jinnistan."[101]

Despite his newfound clout, Jinnah remained paranoid about any challengers to his authority. Already Leaguers elsewhere were murmuring about how the Punjab's Muslims were flouting the Quaid's authority. Jinnah spent the last week of April 1944 in the Punjab capital, Lahore, arguing with Khizar over his divided loyalties and demanding that he pledge unconditional fealty to the League. Khizar had ignored Jinnah's

27 April deadline for a response; when the Quaid's note arrived later that evening, Khizar refused to accept it. Jinnah tried to deliver it twice more, even sending the letter back to Khizar's bungalow in the hands of two top aides.[102] After midnight, the League leader called in a rage. "You are heading for disaster," he told Khizar before slamming down the receiver. "I wish you Godspeed."[103]

Much more was at stake in the Punjab than Jinnah's slighted pride. Without the province, Pakistan would be a shell. A vast network of British-designed canals had transformed the Punjab's scrub desert into some of the most fertile land on the subcontinent. Its recruiting grounds were the mainstay of the Indian Army: of the more than 2.5 million Indians who served during World War II, nearly a million were Punjabis.[104] In the Rawalpindi district, one out of every two adult males took up arms for the empire.[105] Sind, Baluchistan, and the Northwest Frontier — the other three provinces slated for the western half of Pakistan — together boasted only about 8 million people. The Punjab housed more than 28 million.[106]

Jinnah's Congress rivals appreciated the Punjab's importance as well as he did. When they were released after the fall of Hitler, Nehru and his compatriots quickly took stock of the changed political landscape. Jinnah could no longer be dismissed as a nonentity. If they wanted to prevent Pakistan, they would have to expose its inherent flaws.

In September 1945, with a new Labour government in power in London talking about granting India her freedom, Nehru laid out the official Congress position on Pakistan. No Muslim areas would be *forced* to remain part of India if they were determined to secede. Congress leaders could not "think of compelling people in any territorial unit to remain in the Indian Union against their declared and established will."[107]

At the same time, however, Nehru seized on a demographic reality that had always undermined Jinnah's case for Pakistan. In the Punjab and Bengal — by far the biggest and richest of the Pakistan provinces — non-Muslims nearly equaled Muslims in numbers. Muslims were a clear majority only in the western half of the Punjab and the eastern half of Bengal, which did not include Calcutta. The Quaid, Nehru argued, could hardly expect to include the predominantly non-Muslim halves of either province in his Pakistan if they did not wish to join.

Such a truncated Pakistan, Jinnah believed, would hardly be viable economically; he dismissed it as "a shadow and a husk, a maimed, mutilated and moth-eaten" state.[108] And that's just what Nehru wanted it to be — an unattractive prospect that might lead Muslims back to the idea of a united India. Some Congress members urged Nehru to sit down with Jinnah and work out a more amicable compromise. "Never!" Nehru snapped at a tempestuous party meeting in Bombay. "We shall face the Muslim League and fight it."[109]

He would get his chance. The British insisted that Indians first sort out their competing claims democratically before negotiating independence. Elections were called for the provincial legislatures and Central Assembly in India during the winter months of 1945–1946.

The Punjab's British governor, Sir Bertrand Glancy, feared that League electioneers would deliberately inflame passions in his province: "The uninformed Muslim will be told that the question he is called on to answer at the polls is — 'Are you a true believer or an infidel and a traitor?'"[110] Indeed, one Punjabi mullah warned that any Muslims who did not vote for the League and Pakistan would be "fuel for the fires of Hell."[111]

League volunteers in the Punjab were told to parade the Koran and hold rallies in mosques and shrines, even to lead prayers "like Holy Warriors."[112] Many Sufi saints, or pirs, issued fatwas saying that the "Muslim League is the only Islamic community and . . . all the rest are Kafirs [unbelievers]."[113] Their followers listened. In some districts, the League won three-quarters of the Muslim vote.

Even the whiskey-drinking, chain-smoking Jinnah emerged as a messianic figure. Near the end of the campaign, a League worker named Habib proudly described to Jinnah's secretary how Islam had become inseparable from the idea of Pakistan in the minds of Punjabi villagers. "They think that the League wants to establish a Muslim State," Habib wrote, "and about Quaid-i-Azam they think that he is some big *moulvi* who has a long beard and is very religious." At one village, an old man proudly claimed he had resisted pressure to support the Unionists because he knew "if he voted against the League his *eiman* [faith] would be in danger."[114]

Across the province, fired-up League supporters began asking "when

jihad would be declared," and warning the Punjab's Hindus and Sikhs that "Pakistan would soon be a reality, that the only laws that would prevail in a short time would be the Muslim laws of the Shariat, and [that] non-Muslims would have to bring their complaints to the mosques for settlement."[115] Yet the vote was close. While the League emerged as the largest single party, it fell just short of a majority in the Punjab legislature — and unsurprisingly could find no Hindu or Sikh allies to help form a government. In Lahore, Khizar survived as the head of a shrunken and fragile Unionist coalition.

Publicly Jinnah touted the "knockout blow" that his party had delivered to Nehru's Congress. The League had thoroughly dominated the Muslim vote nationally, winning all but one of the Muslim seats in the Central Assembly and taking control of Sind and giant Bengal. Still, the Quaid knew it wasn't enough. At the end of March 1946, he met with Lt.-Gen. Sir Arthur Smith, the deputy commander in chief of the Indian Army, to discuss Pakistan's defense needs. Tensions were rising around the postwar world. That same month, Churchill first warned of an "iron curtain" descending across Europe. Newspapers ran alarmist maps with great swooping arrows indicating a possible Red Army thrust toward Tehran.

Smith was categorical in his opinion. Unless Pakistan included *all* of the Punjab and Bengal — especially Calcutta, which accounted for 85 percent of India's engineering capacity and half of its sea trade — Jinnah's state was unlikely to survive.[116] Even with those areas, Smith did not believe Pakistan could defend itself against a Soviet invasion alone. If he was right, he concluded in a confidential analysis written at Jinnah's request, "the case for Pakistan falls to the ground."[117]

At this moment, barely a year before independence, Jinnah essentially gave up the demand for Pakistan — a fact not stressed in Pakistani textbooks. In the spring of 1946, Clement Attlee's British government proposed a complex compromise. India would remain a sovereign whole but with a weak central government controlling only defense, foreign affairs, and communications like the telegraph and rails. Individual provinces would hold the vast majority of powers.

At the same time, the populations of Sind, Punjab, Baluchistan, and the Northwest Frontier Province (NWFP), and in the northeast

those of Bengal and Assam, would get to vote on whether they wanted to band together and create semiautonomous administrations overseeing their two regions. Jinnah would get a sort of "Pakistan Lite." India — and most importantly for British defense planners, the Indian Army — would remain united. So would the Punjab and Bengal.

The only alternative, the British insisted, was the truncated, half-sized, dangerously vulnerable Pakistan Jinnah had already considered and rejected. Emotions were still running high after the hard-fought elections, and the Quaid had not prepared his followers for compromise. But he knew he had to take the deal. One British official who met with Jinnah found him "nervous and edgy, less in command of himself than I had seen him before. . . . For the first time he was fearful of meeting the Muslim League [leadership]."[118] At a raucous, closed-door session in Delhi on 5 June, speaker after speaker rose to challenge Jinnah and ask how they could possibly accept an ersatz Pakistan given all that the Quaid had promised them.

This was just a "first step," Jinnah protested. Once the Pakistan regional groups were established in the northwest and northeast, nothing would stop them from seceding later. He compared the fragile plan to a ship. "We can work on the two decks, provincial and group," he urged, "and blow up the topmast" at any time.[119]

He won the vote, but at a cost. Given the extensive network of Congress spies, some version of the Quaid's remarks most likely filtered back to Nehru. Like Jinnah, he was being pressed by supporters not to accept the British compromise. Congress Socialists — a rising faction within the party — had taken Nehru's bombastic speeches literally. They had expected to win a strong state unfettered by ties to the empire, and certainly not hobbled by Jinnah's shadow Pakistan. Nehru tried to defend his own reluctant acceptance of the British plan. "When India is free, India will do just what it likes," he insisted at a Congress meeting in Bombay on 7 July. *We are not bound by a single thing.*"[120] He repeated his faux pas at a press conference a few days later.

Jinnah immediately cried foul. Perhaps he should have ignored Nehru's logorrhea, which another Congress leader attributed to "emotional insanity."[121] But the Quaid's leadership had always been based partly on

bluff, partly on his image as an inveterate defender of Muslim rights. He could not afford to have that reputation challenged so publicly.

On 26 July, Jinnah called reporters to his stately Malabar Hill mansion. Nearing his seventh decade, he remained a legendarily natty dresser. Margaret Bourke-White remembered him wearing a perfectly tailored gray suit. His tie and socks matched his silver hair.[122]

Jinnah spoke in a curiously hushed smoker's rasp. Nehru and the Congress Party were not the only ones who could credibly threaten a rebellion, the Quaid told the assembled journalists. Muslims, too, could take their cause to the streets. "Why do you expect me alone to sit with folded hands? I also am going to make trouble," he declared.[123] The next day, in a hall lined with green bunting and beneath a heroic, enlarged portrait of himself, Jinnah told the League leadership that he was rejecting the British compromise and calling for "direct action" to win a fully sovereign Pakistan. The campaign would kick off three weeks later, on 16 August. This time the Muslim dignitaries roared in approval — one "with such vehemence," an observer recalled, "that his dentures parted from his gums and found a resting place in the palm of his right hand."[124]

3

▼·▼·▼·▼

Madhouse

A S HIS PLANE CIRCLED over the airport in Peshawar,
capital of the Northwest Frontier Province, Nehru could see
a churning mob lining the edges of the runway. The protest-
ers were waving spears and steel-tipped lances, as well as black Muslim
League flags. Bullets whistled past as the aircraft came in for a landing.
Nehru had to sneak into town using side roads to avoid the scrum. It
was an ignoble entrance for India's de facto prime minister.[1]

Exactly two months had passed since the Great Calcutta Killing.
Until this point, Nehru had rarely if ever met with an Indian crowd
that was not delirious in its love for him. The Islamic warriors of the
NWFP — the forebears of the Taliban — proved a rude shock. On his
five-day October visit to the tribal areas along the border with Afghani-
stan, the Congressman met with hostility nearly everywhere he went. At
his first tribal *jirga,* four hundred long-bearded elders stood up from the
hard, rocky ground and stalked off before Nehru had a chance to speak.
At the second, he tried to explain that he had come to the frontier with
"love" in his heart. "We will talk to Mr. Jinnah if we want to discuss In-
dian politics," a Wazir tribesman snarled back.[2]

Just days before, the League had at last agreed to join Nehru's interim
government. The marriage was forced and uneasy. Wavell had had to ex-
pend a great deal of energy nudging the two sides together. "It is weary

work negotiating with these people," the viceroy wrote in his journal. "It takes weeks or months to make any progress on a point which ordinary reasonable men would settle in an hour or so."[3] Among other things, Jinnah had demanded an equal stature to Nehru's in the cabinet, an even split of the most powerful portfolios, and a veto over future cabinet appointments. The Congressmen had rejected all his conditions. The League finally joined the government anyway to prevent their rivals from cementing their grip on the levers of power. The move was blatantly cynical. Jinnah nominated mostly nonentities for cabinet posts, still unwilling to serve under Nehru himself.

When they met to finalize the arrangements, Wavell had pleaded with the Quaid to approach the new coalition in a friendlier spirit. The whole point was to set aside the larger acrimony over Pakistan and concentrate — as the Unionists in the Punjab had for years — on more prosaic matters of administration. Wavell specifically urged Jinnah, in the interests of harmony, not to do anything to disrupt Nehru's frontier trip. Jinnah had worded his reply carefully: "No instructions to stage demonstrations have been issued in this connection to our organization."[4]

This was legalistic quibbling. As Nehru quickly discovered, Jinnah's reassurances were meaningless. Descending from the Khyber Pass, the bloodstained gate to the subcontinent, Nehru's convoy passed through a narrow defile. Tribesmen lined the dun-colored hills on either side. One turbaned fighter picked up a heavy stone and hurled it, smashing a car window. Another emulated him, and another. "The breaking of glass seems to send people mad," NWFP governor Sir Olaf Caroe later wrote to Wavell. Nehru's Khyber Rifles escort had to open fire to drive off the attackers.[5]

The next day, Nehru visited the Rifles headquarters at Malakand Fort, high up in the pine-forested Hindu Kush. As his convoy exited the massive gates of the fort, two dented buses suddenly rumbled to life ahead of them and blocked the road. Bearded tribesmen poured out of the vehicles. They quickly surrounded Nehru's car, shattering its windows with rocks. One of Nehru's companions grabbed a revolver from a guard and screamed at the mob to back off. Sepoys raced out of the fort to help.[6]

Nehru suffered only a few bruises and nicks. But the photos of his battered car in *Life* magazine the following week made clear just how lucky he had been. The mob could easily have lynched him.

Furthermore, he was convinced the tribesmen's anger had not been spontaneous. "There can be no doubt that all these demonstrations were League-organised," Caroe later admitted to the viceroy.[7] During the weeks of limbo after the Calcutta Killing, young radicals in the League had begun pushing Jinnah to employ rougher tactics in the fight against the Congress. British intelligence reports claimed that in early September, at a secret meeting of party leaders called to discuss the plan for direct action, there had been "loose talk" of buying arms from Muslim princes around the subcontinent. Some League firebrands had even argued for establishing covert terror squads — as Jewish fighters were then doing in Palestine — to carry out bombings and sabotage across the country.[8]

Even if party leaders stopped short of sanctioning violence, such talk was dangerous. One of the League's young hotheads — the pir of Manki Sharif, a volatile twenty-three-year-old frontier mullah — had preceded Nehru into the tribal areas. "There are secret attempts to bring you also under Hindu domination," he had warned the already suspicious Pathans.[9] The tribesmen were an excitable and easily roused audience. Nehru had walked into a trap.

Obviously, Nehru archly told Wavell upon his return to Delhi on 22 October, the experience had not "produced any feeling of assurance in me about the future conduct of the Muslim League."[10] A week earlier, just before he left for the tribal areas, Nehru had received sketchy reports from the heavily Muslim eastern reaches of Bengal. Gangs of local Muslims there had allegedly gone on a rampage against the area's tiny Hindu minority. Thousands, perhaps tens of thousands, of refugees were fleeing the roving mobs. Now, bruised and bandaged after his frontier tour, Nehru had no doubt the Bengal disturbances, too, were being directed by the League.

To his eyes, Jinnah's party looked to be pursuing a double policy, trying to sabotage the same government they had just joined in Delhi by spreading chaos out in the provinces. His new colleagues in the cabinet were openly boasting about their plans to undermine Nehru. They had

only taken up their posts "to get a foothold to fight for our cherished goal of Pakistan," one of them declared.[11] Rather than bringing the two sides together, Wavell's jury-rigged coalition was only driving them further apart.

The day Nehru flew back to Delhi, Lt.-Gen. Roy Bucher stood on the bow of an ancient paddle steamer as it nosed into the river port of Chandpur in eastern Bengal. Here in the world's greatest riverine delta, the mighty Ganges and Brahmaputra meet and roll down to the sea together. In the predawn gloom, Bucher noticed something strange: their waters refused to mingle. Off the port side he could see the Brahmaputra running clear. The Ganges flowed to starboard, brown and muddy. It was as if nature herself wished to send an ill omen.

Despite the hour, chaos engulfed the docks. Bucher — the officer who had quelled the Calcutta riots — watched as a raggedly dressed crowd scrabbled for position. By their dress they appeared to be Hindus, mostly men, skinny and sun-dark. They had a hunted look. They struggled over one another to clamber onto the boat as Bucher and his aide-de-camp disembarked.

A harried steamer agent told Bucher that in the last week, more than thirty thousand Hindu refugees had swelled the population of Chandpur, a transshipment point for the rice and jute grown across the Bengal delta.[12] Many were trying to flee to the safety of Calcutta. Strangely, the agent added, in recent days, hundreds of other Hindus had arrived *from* Calcutta. The newcomers were clad in a bizarre collection of uniforms — jungle green, khaki, "even pink," he said.[13] Several were army soldiers on leave. These "aid workers" were headed where Bucher was: further east, to the district of Noakhali.

The tales of slaughter and rape that had reached Nehru in Delhi had emerged from this lush, remote area. Noakhali was hard to reach even in the dry winter months, when farmers worked their tiny plots of land. Now, at the tail end of the monsoon season, a glassy sheet of rainwater submerged the entire delta. Peasants got around by hand-poled skiffs, or by walking along the raised earthen bunds that divided their fields. Logs and rough-cut bamboo poles served as bridges.[14]

The only thing that traveled freely in this landscape was rumor. The

initial "eyewitness" accounts of violence had been hysterical. On 15 October, a local member of the Hindu Mahasabha, the country's largest sectarian Hindu party, had returned to Calcutta from Noakhali. "Thousands of [Hindu] women have been carried away," he told reporters. "At least 10,000 have been subjected to forcible conversion, and atrocities of an indescribable nature have been perpetrated on many of them."[15] A day later a telegram from Chandpur warned that a bloodthirsty mob was marching on the town. If air force planes did not arrive urgently to strafe the marauders, the sender warned, Chandpur's Hindus would be finished.[16]

Nehru had taken such reports seriously. "The accounts we have received and are receiving from hour to hour are incredible, and yet there can be little doubt that they are largely true," he wrote to Wavell on 15 October, angrily demanding that the viceroy—who remained constitutionally responsible for law and order in India—take action.[17] Back in August, just days after the Calcutta riots had burned themselves out, Bengal's roguish League premier H. S. Suhrawardy had seemed to threaten exactly this sort of pogrom. Once Muslims decided to avenge their dead, "there [would] not be a single Hindu left alive in eastern Bengal," he had said ominously.[18]

Congress leaders, including Nehru, would put nothing past Suhrawardy and his henchmen. The man leading the Noakhali death squads, Ghulam Sarwar, was a local League strongman. His goondas were reportedly forcing Hindus to wear caps emblazoned with pro-Pakistan slogans, to show that they had "converted" to Islam.[19] Muslims made up 80 percent of the dirt-poor population in eastern Bengal, and in many cases resented the richer Hindu minority who lived among them. The idea that the majority could be manipulated to rise up against their envied neighbors seemed entirely plausible.

Yet by recklessly fanning outrage over the attacks around the country, Nehru's Congress colleagues only made matters worse. They inflated scraps of rumor into evidence—widely believed but unfounded—of a rural holocaust. The leader of the Congress chapter in Bengal insisted that at least five thousand defenseless Hindus had been slaughtered in the first six days of unrest.[20]

J. B. Kripalani, who had replaced Nehru as the Congress Party presi-

dent, issued even more inflammatory estimates. After flying over No-
akhali, he judged the chaos to be worse than the devastating 1943 fam-
ine in Bengal, which had claimed an estimated 3 million victims. When
asked what proof he had for such comparisons, Kripalani dodged the
question, saying that if all the Hindus forcibly converted, and all the
women raped had instead been killed, that would have been a "lesser
tragedy" than surrendering meekly. In any case, he added dismissively,
the government's much lower casualty figures obviously could not be
trusted.[21]

To be sure, violence was widespread: Bucher estimated that per-
haps two thousand homes and shops had been burned and around two
hundred Hindus had been killed across Noakhali and the neighboring
district of Tipperah. But by the time he arrived, his troops had largely
regained control of the district. Rather than a mass uprising, he found
that a few hundred thugs had conducted the bulk of the raids. Their
ringleader, Ghulam Sarwar, was arrested that afternoon.

No more than two forced marriages were ever authenticated, al-
though shame probably prevented most rapes from being reported.[22]
Many of those Hindus who had supposedly been "converted" had sim-
ply been forced to repeat the *kalma,* the Muslim statement of faith.
(Others had been made to eat beef or had slabs of the forbidden meat
thrown into their homes.) Most quickly went back to worshipping their
many-armed gods again.

At this point, the bigger problem seemed to be the flood of Hindu
"volunteers" that the steamer agent had reported to Bucher. They were
spreading into villages unaffected by the violence, terrifying local Hin-
dus with tales of Muslim killers lurking in the groves of coconut and
betel nut trees. Thousands were fleeing unnecessarily, the men often
leaving wives and children behind. "Many of the refugees," Bucher's aide
judged, "appeared much more like well-fed citizens of Calcutta than
people who had left everything in order to save their lives."[23]

Yet the conviction that a conflagration had engulfed eastern Bengal
persisted, and persists to this day in most Indian histories. Where the
numbers did not support that picture, Congress leaders like Kripalani
resorted to moral arithmetic. One Bengali Congressman cast the battle
against the League as a Manichean conflict, not unlike the way twenty-

first-century Western leaders would describe the struggle against Islamic jihadism:

> Dark forces — reactionary, counter-revolutionary and anti-social in nature — have been systematically organised ... under the Muslim League Ministry [in Bengal] and these dark forces have now declared a sort of total war on civilised ways of living and all that civilisation connotes. The Congress is the spearhead of civilisation and progress in India and it has no hesitation in taking up this challenge. After all, life is stronger than death and civilisation is mightier than barbarism. Life in Bengal will survive this shock and civilisation will withstand this onslaught.[24]

In some ways Gandhi contributed more than anyone to this line of argument. The seventy-seven-year-old Mahatma seemed to take the Bengal violence personally. The journalist Phillips Talbot, who met with Gandhi at this time, sensed "a feeling of frustration, if not of failure" in him.[25] He had always imagined that in his beloved villages, humble Muslims and Hindus lived and would always live together peacefully, as brothers. Now the very peasants whom he had championed as the "real" India appeared to have turned into brutal murderers. Clearly ahimsa — his creed of nonviolence — had not penetrated more than skin-deep.

For the previous several weeks, the Mahatma had been living in Delhi to help in the coalition talks with the League. While in the capital he preferred to stay in a hut in a sweepers' colony, home to Hindu Untouchables, the lowest of the low. (Of course, his "hut" had been whitewashed and outfitted with electricity and a phone: "If only that little man knew what it costs us to keep him in poverty," Sarojini Naidu cackled.)[26] At his evening prayer meetings, devotees pressed Gandhi to rush to Bengal to save Noakhali's Hindus from "genocide."

The Mahatma implored Hindus not to seek revenge. But he did not challenge the idea that League Muslims had embarked on a full-fledged pogrom in eastern Bengal. Instead, he instructed Bengal's Hindus to "die fearlessly" at the hands of their neighbors, without fighting back, to shame Muslims by their moral example. (Gandhi had offered the same advice to Jews facing the Nazi sword during World War II.) "There will

be no tears but only joy if tomorrow I get the news that all three of you [have been] killed," he assured a trio of Bengali followers who were headed to the region on a mercy mission.[27]

Gandhi fixated in particular on the most incendiary allegations coming out of Noakhali — the vastly overhyped stories about rapes and abductions of Hindu women. Although he surrounded himself with female devotees and argued strongly for equality between the sexes, the Mahatma remained a late Victorian in his obsession with feminine virtue. Sex was forbidden in his ashrams, both in South Africa and India; he himself had taken a vow of celibacy at the age of thirty-seven, after fathering four sons, in the belief that "one who conserves his vital fluid acquires unfailing power."[28] To Gandhi, the ideal Indian woman was cast in the mold of Sita, the god Ram's blameless wife, who first walked on hot coals then meekly went into exile when her chastity had been questioned.

Gandhi urged the Hindu women of Noakhali to remember "the incomparable power of Sita."[29] He wanted them to commit suicide rather than submit to their Muslim ravishers: they should "learn how to die before a hair of their head could be injured." Perhaps they could "suffocate themselves or . . . bite their tongues to end their lives," he advised. Told that such methods were impracticable, the Mahatma suggested the next day that they drink poison instead. "His was not an idle idea. He meant all he had said," reads Gandhi's own transcript of his comments.[30] Such talk kept emotions running high among Hindus.

Jinnah's comments did equally little to staunch the violence. He did not condemn the bloodshed for a full two weeks after the first raids were reported. When Wavell pressed him to speak out, the Quaid changed the subject to "Gandhi's 'continuing outpouring of poison,'" the viceroy recorded.[31] When Jinnah finally did issue a statement, he did not admit any League responsibility for the Noakhali attacks. "It takes two to quarrel," he churlishly reminded the Congress leaders, "and it is up to the leaders of both communities to put an end in the name of humanity to what is happening."[32]

Nehru was in no mood for a lecture. He had judiciously remained silent about Noakhali while away touring the frontier. As soon as he returned, though, his frustrations mounted quickly. The addition of the

Leaguers virtually paralyzed the government. Nehru's new Muslim colleagues refused to acknowledge his authority, or to attend the teatime conclaves he had taken to holding in his office, where Congress ministers tried to make policy decisions without the viceroy in the room. Deep within the bureaucracy, bitter sectarian camps had begun to form. "There is clear evidence that many Muslim clerks are ready, and even anxious, to hand over confidential documents to League officials," the Intelligence Bureau warned.[33]

Matters came to a head when Wavell suggested shifting the Home portfolio — which controlled the police and intelligence agencies — from the Congress to the League in order to balance out their responsibilities. After the disturbances in the NWFP and Noakhali, the idea of putting Jinnah's men in charge of internal security seemed like rank hypocrisy to Nehru. The Congress high command plunged into hours of crisis talks, threatening to pull out of the government altogether if Wavell did not back down. (He did.) On 30 October, Nehru took to his bed, stressed and exhausted from the Delhi infighting.

Nehru was certainly not about to let Jinnah off the hook for Noakhali. Even if not every charge could be substantiated, the League seemed to be quite obviously intent on driving a wedge between Hindus and Muslims. "What has happened in other parts of India and more so in Eastern Bengal has been so ghastly that it is even sufficient to wake up the dead," Nehru told reporters in Calcutta on 2 November. He had flown to the Bengal capital with a joint delegation of League and Congress ministers, ostensibly to show solidarity and call for calm. But he wanted the journalists to know he saw through Jinnah's game: "I am not dead," Nehru assured them. "I am very much alive."[34]

In the latter half of October, just as the uproar over Noakhali was peaking, police in the United Provinces noted a disturbing trend: the Hindu Mahasabha and other orthodox Hindu parties, which previously "had very little following or political influence," were coming "out into the open, and . . . rallying Hindus all over the country to fight Islam."[35] Tales of Hindu women being violated by Muslims were a powerful recruiting tool.

Before the war, far-right Hindus had established a pseudo-militant organization — the Rashtriya Swayam Sevak Sangh (commonly abbreviated to RSSS at the time) — that took inspiration from Hitler's Brown Shirts. They had mostly been a sideshow, parading around in khaki shorts and issuing Fascist salutes. During wartime, the British had banned any such "private armies" from wearing uniforms or drilling openly. Those regulations had expired in September 1946. Now, Noakhali propelled thousands of volunteers into the RSSS ranks. In the United Provinces alone, membership in the militia grew to 25,000 by December 1946.[36] Instead of hopping around doing mass calisthenics, Hindu cadres began training secretly in the use of swords, rifles, and crude bombs.

The United Provinces police noted one other unsettling trend in their report: a "disturbing departure for the east"— toward Bihar and Bengal —"of batches of volunteers belonging to the various communal organizations." If the spread of such militias was not halted, the report warned, "communal anarchy" threatened.[37]

Nehru's Congress could technically disclaim any responsibility for these Hindu vigilante groups. The party's own "volunteers" really were unarmed: they were used mostly for relief work and keeping order at political meetings. But after Noakhali, the line dividing the nationalists from the Hindu supremacists grew fuzzier, especially among the lower ranks of both organizations. In the autumn of 1946, "Congress party opinion began to express itself in anti-Moslem (rather than anti-League) terms," *New York Times* reporter George Jones recalled in a memoir, "partly, no doubt, because a number of militant Hindus found it politically expedient to ... join the Congress party bandwagon." In their foaming outrage over the Noakhali attacks, Jones continued, "it became rather difficult to differentiate between the frankly communal response" of Congress and the Mahasabha.[38]

The line between the two groups virtually disappeared in Bihar, where a Congress ministry held power. Hindus outnumbered Muslims seven to one in the predominantly rural province, which had witnessed some of the bloodiest fighting during the 1942 Quit India riots. Several districts had successfully resisted government control for months. Now, at the end of October 1946, the province was again seething. Many Bi-

hari Hindus had worked in Calcutta and brought home graphic tales of the killings there. Scattered stabbings of Muslims were being reported in the capital, Patna, and other towns.

Without consulting party leaders in Delhi, the Bihar Congress ministry decided to designate 25 October as "Noakhali Day." All around the province, mass rallies were staged to commemorate the "martyrs" of eastern Bengal. Speaker after speaker — including local politicians from both the Congress and the Mahasabha — accused Muslims of seeking to exterminate or drive out the Hindu population of Noakhali. Through hissing loudspeakers they cried for vengeance. Crowds took up the ugly chant "Blood for blood!"[39] The next day, more stabbings were reported, and Muslim shops in the capital were set aflame. On 31 October, the attacks worsened dramatically, with forty Muslims killed at a train station south of the capital.

At first Bihar officials tried to downplay the violence. After their one-day lightning visit to Calcutta, Nehru and the other cabinet ministers stopped off in Patna on 3 November to survey the situation. Authorities assured the delegation that the trouble was localized, spontaneous, and "certainly not organised." They estimated the death toll at no more than 300 people, in a province with nearly 30 million inhabitants.[40] Troops had been called out, although outside of the cities, the army's jeeps were having trouble slogging through the muddy landscape.

The next day, however, just before Nehru was due to return to Delhi, air patrols reported that Hindu mobs up to five thousand strong were roaming the Bihar countryside. Peasant armies had gathered across the monsoon-flooded fields, carrying axes, spears, and torches. They were embarked on exactly the sort of pogrom they imagined had taken place in Noakhali.

Compared to the free-for-all in Calcutta, this was a one-sided fight. Whole villages of defenseless Bihari Muslims were wiped out, corpses spread over half a mile or more. Mosques were desecrated and burned to ashes. Mobs laid siege to some Muslim hamlets for days at a time, and even attacked the police and military when they tried to escort terrified refugees to safety. The killers — simple Hindu farmers — were methodical. Months later, one investigator found a few bloodstained planks nailed together amid the ruins of a Muslim village; it had been used as a

butcher block to maim and behead victims, including children.[41] Independent estimates would eventually put the death toll at close to seven thousand Muslims.

Nehru was appalled. He put off his return to Delhi and threw himself into the effort to quell the violence. He raced from town to town, berating the crowds of Hindus who came out to see him. Why were they chanting useless slogans like "Jai Hind!" and "Mahatma Gandhi Ki Jai!" (Long Live Mahatma Gandhi!), he demanded to know, urging them instead to protect their Muslim neighbors. If any of them wanted to join the mobs, he declared, they would "have to murder Jawaharlal first and then, by trampling over his corpse . . . satisfy [their] lust for blood."[42] He threatened to have the police gun them down and the air force bomb them if they did not desist.

Nehru urged Bucher — who had also arrived in Bihar — to use all necessary force to put down the mobs. It was no easy task. At one Muslim village, a platoon of Madrassi soldiers had to open fire to fend off several thousand frenzied Hindus. When he heard that one hundred of the attackers had been killed by the fusillade, Nehru wrote to Padmaja Naidu, "Would you believe it? I was greatly relieved to hear it!"[43]

During these few days, Bucher developed a lasting respect for Nehru's courage. Flying over the unsettled countryside together, they came across mobs that had grown to fifteen thousand people or more. Bucher tossed teargas canisters out of the plane, to little effect. "Time and again, Jawaharlal said, 'Try to land,'" Bucher recalled years later. "Sometimes we did and, regardless of danger, [he] would jump out of the aircraft and rush towards any mobs in the vicinity."[44] Another companion described to the *New York Times*'s George Jones watching Nehru accost the defiant ringleader of one posse and wrestle him to the ground, choking him nearly into unconsciousness.[45]

Not even Nehru could stem the mobs' bloodlust, however. The mood of the crowds that came out to see him became uglier. Some shouted "Go back!" and even "Jawaharlal Murdabad!" (Death to Jawaharlal!).[46] He did not care. Before he had arrived in Bihar, Nehru had dismissed the League's claims that a massacre was underway in the province. Now he wrote privately to his Congress colleagues in Delhi, "The real picture that I now find is quite as bad, and something even worse than anything

that they had suggested. . . . There has been a definite attempt on the part of Hindu mobs to exterminate the Muslims. They have killed, indiscriminately, men, women and children en masse."[47]

In a letter to Padmaja Naidu, he described the Hindu attacks as "the extreme of brutality and inhumanity."[48] Calcutta had shown that fear could drive Hindus and Muslims to take up arms against one another. Bihar revealed a darker truth: where one community held an overwhelming majority, the killing quickly gained an unstoppable momentum. In a letter to the secretary of state for India, marked SECRET, a shocked Wavell admitted that the riots were "on the scale of numbers and degree of brutality, far beyond anything that I think has yet happened in India since British rule began."[49]

Yet if he felt sick at the Biharis' behavior, Nehru would not accept the Congress's responsibility for it. He could "only explain all this by saying that a madness had seized the people," he wrote to his colleagues in Delhi.[50] Nehru felt certain that some outside force must have perverted the villagers' essentially peaceful natures. He praised the Bihar ministry fulsomely for taking firm action to suppress the violence.

Ultimately, and astonishingly, Nehru decided that the culprit was the "unpatriotic and highly objectionable attitude of the Muslim League."[51] Hindu peasants must have been upset that Muslims — many of whom were landlords in Bihar — were blocking independence with the demand for Pakistan, and hence posing a "barrier to their social and economic hopes." By the time the situation quieted and Nehru returned to Delhi, he was praising the "simple, peaceful and likable peasantry of Bihar," who although they had done "something dreadful," at least had desisted when told to do so.[52]

This kind of sophistry incensed Jinnah and other Leaguers. They sent their own "fact-finding missions" into Bihar to interview refugees and came up with a much higher death toll of thirty thousand. Even if that number was exaggerated, the mountains of Muslim corpses in Bihar clearly dwarfed the few hundred Hindu dead in Noakhali.

Congress leaders, including Nehru, nevertheless continued to lump the two episodes together, as though one balanced out the other. (Some Congressmen unhelpfully pointed out that while the death toll may have been higher in Bihar, more rapes were alleged in Noakhali.)[53]

Muslims deeply resented the fact that Gandhi had traveled to eastern Bengal at the beginning of November — when the violence there had ebbed — instead of to Bihar, which was then still out of control. The Mahatma argued that he could influence the Hindus of Bihar from afar, using moral persuasion. Bihari Muslims were not reassured.

To add insult to injury, the instigators of the Bihar riots appeared to roam free. Just days later, in early November, Hindus in the Meerut district of the United Provinces turned on the Muslims among them, massacring hundreds in the town of Garhmukteshwar. According to some reports, the RSSS had held rallies nearby to incite the killers.[54]

Friends noticed a change in Jinnah after the Bihar riots. His anger and self-righteousness no longer seemed put on for negotiating purposes. One Briton who met the Quaid a few weeks later said he did not "ever remember seeing [Jinnah] before in a worse mood, from the point of view of reaching agreement with anyone over anything."[55] Any shred of trust the Quaid once had in Congress had disintegrated. "They are fooling the world," he complained to Wavell on 19 November.[56] For all of Gandhi's and Nehru's talk of nonviolence, how could Muslims believe any promises the Congress leaders might make about protecting them and their rights?

The League's toughs now had Jinnah's ear. Before the war, sword-wielding National Guards who surrounded the Quaid at public meetings had numbered less than two thousand nationwide. In October 1946, Jinnah appointed two new deputy commanders for the Guards.[57] The man made responsible for the "Pakistan" areas was a shadowy figure named Khurshid Anwar, a Pathan from the Northwest Frontier Province. Described as "a complete adventurer," Anwar had reportedly served as a railway guard during the war.[58] According to one story, he had been dismissed for misappropriating mess funds; another claimed he had amassed a fortune from black marketeering.[59]

Whatever the truth, Anwar's main task was to expand the ranks of the Guards and to reorganize them as a proper armed militia — with uniforms, badges of rank, daily parades, and training in everything from the wooden batons known as *lathis* to swords and spears. "Some reports state that instruction is being given in the art of knife and acid throwing, and in the use of fire-arms," a British intelligence brief added.

Bihar provided a tremendous boost to the League's recruiting, just as Noakhali had for Hindu militants. By the end of 1946, the Guards' ranks had grown from 1,500 to over 60,000 often fanatic members. At one meeting, an impressed British informant noted, "about 40 out of 100 applicants who signed enlistment forms *with their own blood* were accepted."[60]

The Guards deployed in force in Bihar, taking over the relief camps set up by the provincial government for Muslim refugees and demanding that all aid be funneled through them. They lost no opportunity to flaunt the suffering of Muslims. Visiting one camp, Bihar's British governor found only a single League aid worker: "a youth whose activities seemed to be confined to drafting manifestoes of a political nature." This boy quickly rallied the refugees. They staged a demonstration for the governor's benefit and were "ghoulish enough to dig up the bones and skulls of buried victims and strew them in my path," he noted with a shudder.[61]

Now, each side had its uniformed fanatics. And each side had political leaders who fanned the flames with their rhetoric. League propagandists visited Muslim communities across northern India with photographs from Bihar of unburied skeletons and mutilated refugees, and with the charred pages of Korans they claimed had been burned by Hindu mobs.

If they had been given no oxygen, the furies released by Calcutta might possibly have flickered out in distant Noakhali. Instead they now raced westward. In early December, tribesmen in the Hazara region of the NWFP descended on Sikh villages and slaughtered nearly two dozen of their inhabitants, prompting thousands of others to flee the area. If the trouble spread next door to the powder-keg Punjab, officials feared, it would be nearly impossible to stop. At the end of November, Jinnah's old foe Khizar banned all demonstrations in his province — whether by Hindus, Sikhs, or Muslims.

Such measures were too little, too late, Wavell knew. League officials in the Punjab had already begun stockpiling weapons and steel helmets, and recruiting Muslim university students for "underground and secret work."[62] By December the Guards' ranks in the province had grown to nearly 23,000.[63] Since August, the viceroy had been pressing Attlee's cabinet to approve his "breakdown plan," which envisioned that

the British would concentrate their forces just on the most contentious provinces in northern India while turning over the rest of the subcontinent to the Congress. He saw no other way to maintain order. The plan, he wrote, "might, from its nature, be called 'Operation Ebb-Tide'"— a scheme to withdraw gracefully from an untenable position.[64] Some wits in the Army allegedly gave the idea a more expressive name: Operation Madhouse.[65]

The roar of the York's four engines made conversation nearly impossible. That suited its passengers just fine. Once the No Smoking light went off, Jinnah, sitting in the first row of the viceroy's plane, lit up a State Express 555 cigarette and buried his hawklike nose in a new screed about Pakistan entitled *A Nation Betrayed.*[66] Nehru was seated directly behind him, dressed in a suit and tie instead of his normal kurta; a recent back injury furrowed his brow in pain. To distract himself, he plowed through two novels on the long flight to Malta — Rosamond Lehmann's *The Ballad and the Source* and one of Sinclair Lewis's last works, *Cass Timberlane,* the story of a doomed marriage between a fortysomething man of means and a beauty half his age. If the book reminded Nehru of Jinnah and Ruttie's tragic romance, he did not let on. On Malta, where the York landed on three engines and could not go any further, the two rivals muttered only a couple of sentences to one another:

JINNAH: Well, what have you been doing all day?
NEHRU: Partly reading, partly sleeping, partly walking.

Eventually another plane was found to finish the journey to London, where Prime Minister Attlee had invited the Indian leaders for last-ditch peace talks in early December. Wavell's hopes for the interim government had clearly failed. After less than six weeks of working together, relations between the Congress and the League were more acrimonious than ever. "Feelings of bitterness and animosity in Delhi are reaching a pitch possibly never experienced before," the capital's chief commissioner reported on 21 November.[67] Talk of civil war was growing louder.

The political stalemate in its largest colony now threatened Britain's larger strategic interests. Wavell's increasingly apocalyptic cables were

warning of chaos and a humiliating, potentially bloody withdrawal for British troops and civilians. Some of Attlee's ministers wanted to hand power to Nehru and the Congress immediately and leave. Others, including Foreign Minister Ernest Bevin, thought any hint that Britain had been driven out of India would destroy its credibility as a great power.[68] The prime minister himself failed to understand why Indian politicians, after clamoring so long for freedom, refused to take it when offered.

It was a fair question. If civil war really was looming, none of the Indian leaders appeared especially eager to prevent it. A couple weeks earlier, the viceroy's private secretary, George Abell, had had dinner with Liaquat Ali Khan, Jinnah's longtime deputy, and had gotten "the very clear impression from what Liaquat said that the League could not afford to let the communal feeling in the country die down." Abell and other British officials generally found Liaquat, a jovial, fifty-year-old landowner, to be less confrontational than Jinnah. But the fighting supported the League's contention that Hindus and Muslims could not live together. It was further "proof of their case for Pakistan."[69]

Nehru's own deputy, Vallabhbhai Patel — a tough, seventy-one-year-old Gujarati lawyer whom Gandhi had nicknamed "Sardar," or "Chief" — was convinced that Muslims would only respond to strength. Patel was the real power in the Congress Party — the man who controlled the flow of cash from Hindu industrialists and who doled out rewards, and punishment, to local cadres. A widower like the rest of the top Indian leaders, he had reputedly learned of his wife's death while arguing a murder case in court — and had continued with his cross-examination. His eyes were heavy-lidded, almost sleepy; his lips full and feminine. In his homespun robes he was often compared to a Roman senator.

Patel was a ruthless, unsentimental pragmatist and sympathetic — unlike Nehru — to the Mahasabha and the khaki-clad cadres of the RSSS. After Bihar, he noted with satisfaction, he detected among Leaguers "some realisation that violence is a game at which both parties can play." Patel believed that Jinnah recognized the weakness of the Muslim position and was "on the verge of settling" for something less than Pakistan.[70]

The Sardar thought he knew the real reason Jinnah had agreed to travel to London — "to solicit Churchill's help."[71] After the 1942 Quit India uprising, the Tory leader had developed a fixation about the treacherousness of Hindus — "a beastly people with a beastly religion," he averred — and the steadfastness of Muslims. He was a fan of the 1944 book *Verdict on India* by Beverley Nichols, a toxic rant against Hindus and Congress: "I agree with the book and also with its conclusion — Pakistan," Churchill had written to his wife, Clementine, after finishing the tome.[72] The sight of a Nehru government ruling in Delhi had infuriated the Tory leader no less than Jinnah, and the rising death toll across India — now into five figures — seemed to confirm all of Churchill's dire predictions of what would come from Britain giving up the Jewel in the Crown.

After a humiliating defeat in the 1945 British elections, Churchill had spent some time licking his wounds, painting landscapes at Lake Como and inveighing against Communism while touring the United States. Now he was ready to reenter the political fray, and was looking for a stick with which to poke his Labour rivals. When they finally arrived in London, Wavell accompanied Jinnah and Liaquat to dinner with several senior Conservative politicians. One of Churchill's lieutenants leaned over and cheerfully confided to the viceroy that "Winston was anxious to make [India] a party issue."[73]

At the dinner, Jinnah spun out an argument he knew would appeal to his audience: Britain should not leave India now. "His theme song," one of the attendees noted, "is what he calls the deliberate butchery of Muslims by Hindus in Bihar."[74] The British had a moral obligation to stay on and hold the ring between the warring communities until tensions had genuinely eased, Jinnah argued. Otherwise such massacres would only be repeated. A full-scale civil war would invite Soviet intervention.

Jinnah kept hammering at this theme during his entire stay in London. Opinions of his motivations varied. Some observers thought he was hoping to buy time so that the League could build up its armed capabilities. Others sensed an exhaustion in the nearly seventy-year-old Quaid. "He himself admitted to me: he really thinks that if he holds out, Churchill's line will prevail, and we [will] take over India long enough to see him — J — out," a young official who had served in India,

Maj. John McLaughlin "Billy" Short, wrote after spending time with the League leader in London.[75]

The official talks focused on the "Pakistan Lite" compromise put forward the previous spring, and the question of how to form the Pakistan "groups" in the northwest and northeast. The Congress argued that each province should get a single vote on whether it wished to join up; that would allow Assam and the Northwest Frontier Province, both then ruled by Congress ministries, to opt out. Jinnah and the League thought that the votes should go by population, so the wishes of citizens in bigger provinces like the Punjab and Bengal would receive due weight.

Over two days of talks, Attlee sided with Jinnah's interpretation. The whole point of the plan was to create enough of a semblance of Pakistan to convince Muslims to abandon the claim to their own state; all five provinces and Baluchistan had to be included. Nehru immediately left London in a huff. "Compulsion destroys cooperation," he declared angrily to Attlee in their last meeting.[76] With all the transit delays, Nehru had spent more time getting to England — sixty hours — than he had in negotiations. (Somehow he did manage to find time to sit for the sculptor Jacob Epstein, who was carving his bust, three times in four days.) The quick collapse of the talks reminded Wavell of a couplet from Browning:

> Now, enough of your chicane of prudent pauses,
> Sage provisos, sub-intents and saving clauses!

The viceroy recalled, too, how the poem began: "Let them fight it out, friend! Things have gone too far."[77]

Jinnah himself did not seem terribly interested in his diplomatic victory. As Nehru winged his way back to the subcontinent, the Quaid drove down to Chartwell, Churchill's country estate. "I greatly valued our talk the other day," the Tory leader wrote to Jinnah afterward.[78] The two men clearly agreed that Attlee's government was too hastily rushing to withdraw — "scuttling," in Churchill's cutting phrase — from India.

Churchill suggested they keep their discussions secret. "It would per-

haps be wiser for us not to be associated publicly at this juncture," he wrote.[79] The two leaders established a covert channel of communication in order to keep in touch, with code names and alternate addresses. Churchill would sign his secret missives "GILLIATT," he informed the Quaid, using his secretary Elizabeth's last name. (The choice was about as sneaky as the moniker that Churchill, a former First Lord of the Admiralty, had used during wartime: "Former Naval Person.") On 12 December, the Tory leader rose in Parliament and thunderingly denounced Labour's plans to abandon the Raj: "In handing over the Government of India to these so-called political classes, we are handing over to men of straw of whom in a few years no trace will remain," he declared. "Many have defended Britain against her foes; none can defend her against herself. But at least let us not add — by shameful flight, by a premature hurried scuttle — at least let us not add to the pangs of sorrow so many of us feel, the taint and smear of shame."[80] Delighted, Jinnah and Liaquat stayed on in England for another fortnight, giving speeches to build support for their cause.

If they wanted to have any chance at presiding over a free and united India, the onus was once again on the Congress to compromise. As soon as Nehru returned to Delhi, the American chargé d'affaires, George Merrell, cornered him. Throughout 1946 the United States had been trying to prevent a civil war from breaking out in China between Chiang Kaishek's Nationalists and Mao Zedong's Communists. Washington feared a Hindu-Muslim conflict in India would "cause widespread chaos similar [to] China which would last for many years and . . . have worldwide repercussions."[81] By comparison, the feelings of the few million citizens of Assam and the NWFP were trivial.

Merrell's argument struck home. By the end of December, Nehru had more or less agreed that Congress should reverse itself. He wrote out a new resolution, grudgingly accepting the British position on how to establish the Pakistan "groups."

A decision this important needed Gandhi's imprimatur, though. The Mahatma still had not returned from distant Noakhali. He had vowed to live as a mendicant in eastern Bengal, sheltering under the roofs of Hindus and Muslims alike, until Noakhali's Hindus felt safe enough to return home and live at peace with their neighbors. If he could restore

harmony to Noakhali, Gandhi believed, the moral force of the example would quiet the turmoil spreading elsewhere in India. His admirers have mythologized this "last crusade" as a valiant, single-handed effort to heal the subcontinent's gaping wounds. Their accounts describe the Mahatma like Jesus — a lonely figure striding barefoot from village to village, along paths strewn with shards of glass and piles of human feces by those whose hearts remained full of hate.

At the time, though, just as many observers thought Gandhi had gone "dotty," as journalist Phillips Talbot noted.[82] The Mahatma truly believed that "some grave defect in me somewhere" was to blame for the homicidal passions surging through India's communities.[83] Around this time, he began his most controversial "experiment," an attempt to purify himself as a means of cleansing the nation's soul. Each night, in whichever hut he happened to find himself, he would bed down, naked, with his eighteen-year-old grandniece Manu to reconfirm his vow of celibacy. "We both may be killed by the Muslims," he told her, "and must put our purity to the ultimate test."[84] Even the ever-loyal Nehru was "greatly troubled" by the practice, he wrote to Gandhi.[85]

Nehru spent two days at the end of December conferring with Gandhi in a Noakhali hut. The Mahatma approved Nehru's resolution but edited it to emphasize one fundamental point: whatever was ultimately decided, it "must not involve any compulsion of a province."[86] Although he signed off on the language, Nehru privately dismissed the clause as nothing more than "a pious wish."[87] A relieved Washington hoped that the Congress acceptance, while muddled, would be good enough to revive the British compromise.

Jinnah, however, had been emboldened by Churchill's support. Through private channels, Tory leaders assured the League leader that they would support the establishment of a full and fully self-governing Pakistan if it remained part of the British Empire — as a dominion that pledged loyalty to the king, like Canada or Australia.[88] The Quaid was "very pleased at the results" of his trip to London, one friend noted.[89] There seemed little reason not to keep holding out.

Gandhi's obfuscating revisions to the Congress resolution gave Jinnah all the excuse he needed. The barnstorming in London had exhausted the League leader; he spent most of January 1947 in the village of Malir

outside Karachi, resting and undergoing a Gandhi-style "nature cure." At the end of the month, he roused himself from bed and summoned the League leadership to Karachi. They formally rejected the Congress resolution as insufficient and insincere. The stalemate would go on until the British and the Congress accepted reality, the Quaid declared. A united India was impossible: Pakistan — a *real* Pakistan — was the only answer.

The American diplomat George Merrell was not alone in thinking that the Congress's pettifogging represented a colossal political failure, a missed opportunity that might well have averted the genocide that would unfold six months later.[90] At this point, the spreading violence had not yet spun out of control. A political deal might have restored harmony between India's communities. But as the killings rolled westward, they were inching nearer and nearer to the province the India Office described as the "most dangerous field for communal disturbances" in all of India, the Punjab.[91] Delhi's politicians, who continued to hurl the same wordy barbs at each other as they had for years, were running out of time.

On 24 January, Khizar, the Punjab premier, had issued a new ordinance, banning both the RSSS and the Muslim League National Guards in his province. The Hindu and Muslim militias had been growing at a terrifying pace; authorities feared they would soon be too powerful to stop. A police raid that same day turned up two thousand steel helmets hidden in a storeroom at the Guards' headquarters in Lahore. Authorities arrested several of the local League leaders, who had tried to block the search.

In Delhi, Liaquat was "almost jubilant" at the news, Merrell reported.[92] Now the League, like the Congress, had its own political martyrs to tout. Even though the arrested Leaguers were released after forty-eight hours, the party gleefully launched its own civil disobedience campaign against Khizar's government. Day after day, processions of Muslims began marching through Lahore and other Punjab cities to challenge the official ban on demonstrations. The jails began to fill with Leaguers.

There was something slightly comical about Jinnah's first satyagraha.

Punjab authorities knew they didn't have enough prison cells to detain all of the Quaid's followers. So at each protest, authorities agreed to arrest only "certain named aspirants to political martyrdom," recalled Jack Morton, the senior superintendent of police in Lahore. "A great deal of orchestrated noise was then generated after which, honour having been satisfied, the crowds would be persuaded to go home."[93] Those detained would be treated to "discreet tea parties" in the police station and then eventually set free. Activists who proved more recalcitrant — including the ravishing, twenty-six-year-old Viennese wife of one senior Leaguer — were dropped off several miles outside of town and forced to walk home.

Jinnah, however, was deadly serious. He saw a chance finally to seize political control of the Punjab — not to mention to avenge his 1944 humiliation at Khizar's hands. One older Leaguer from the Punjab visited Jinnah in Malir and tried to convince him that the demonstrations were in danger of becoming violent. Jinnah "just looked straight into his eyes and asked him if he was ill," a party activist later recalled. "The answer was, he was not. [Jinnah's] next [question] was then, why [was] he not in jail with his Leaders?"[94] The Quaid ordered the man to return to Lahore immediately and get himself arrested.

Khizar's government seemed powerless to quell the disobedience movement. Local League officials easily rallied their troops from jail. Servants brought the ringleaders cooked food every day, with bulletins hidden in the handles of saucepans. Organizers gave out orders through a hole in the prison walls meant to drain rainwater. Muslim sympathizers in the telephone department passed on directives secretly to *Dawn*, which printed them in the next day's papers.[95]

The longer this circus went on, the more apprehensive the Punjab's Hindus and Sikhs grew. They resented the traffic-snarling League processions, and what the province's new governor, Sir Evan Jenkins, agreed were "intensely provocative" slogans chanted by the protesters.[96] "Even among the more liberal of [the Leaguers] the line seems to be that having established undiluted Muslim rule [in the Punjab] they will be generous to the minorities," Jenkins wrote to Wavell.[97] The sober and brilliant Jenkins, formerly the viceroy's private secretary, was an old Punjab hand. He agreed with his predecessor, Sir Bertrand Glancy, who had warned

as early as August 1945, "If Pakistan becomes an imminent reality, we shall be heading straight for bloodshed on a wide scale; non-Muslims . . . are not bluffing, they will not submit peacefully to a Government that is labelled 'Muhammadan Raj.'"[98]

In particular, Jinnah had not accounted for a minority that, until now, had been a third party to the Muslim-Hindu struggle: the Punjab's proud, aggressive Sikhs. The most prominent Sikh leader was "Master" Tara Singh, a sixty-one-year-old demagogue and head of the Akali Dal Party. (His imposing title actually referred to his time as a school principal.) Singh had the long white beard of an Old Testament prophet and a fierce, almost unhinged devotion to the cause of Sikh rights. As his *kirpan* — the small, ceremonial dagger that every Sikh male is required to wear as part of his faith — Singh now strapped on a heavy, deadly-looking sword.

On 10 February, a massive League procession marched through the center of Lahore. Demonstrators were in an ugly mood. The night before, a brick had come flying into another League protest and killed one man. The crowd's hoarse jeers had a menacing edge to them.

League leaders had ordered all shops and businesses in Lahore to close in mourning. When they reached the baroque High Court building and found it still operating, enraged protesters slammed against its gates, then pushed aside the few guards and charged in. The mob rampaged through offices and courtrooms. A group of Muslim students made it to the roof and ripped down the Union Jack, replacing it with a League flag. Police reinforcements rushed into the fray. On the churned-up lawns outside, bewigged, black-robed barristers and scruffily dressed marchers stumbled about, coughing in a haze of teargas.

After the High Court raid, the tenor of the League's demonstrations grew noticeably nastier. Protesters began targeting Hindu and Sikh policemen, beating to death one constable and injuring fifty others on a single day.[99] On 12 February, Tara Singh exhorted Sikhs to revive under his leadership the small fighting units, or *jathas,* with which their community had once conquered the Punjab.

History remained a potent force among Sikhs, who adhered to a martial faith. Many of their founding myths centered on the astoundingly nasty tortures suffered by their founding "gurus" at the hands of

Muslims. In the seventeenth century, the Mughal emperor Jehangir had supposedly ordered burning sand poured over the fifth guru. Aurangzeb had the ninth guru beheaded. The nawab of Sirhind in the Punjab is alleged to have bricked up the tenth and last Sikh guru's two youngest sons — alive.[100] When Sikhs conquered the Punjab at the end of the eighteenth century, they wreaked a savage revenge. Among Muslims "the name of Sikhashahi — the Sikh Rule — is a synonym for misgovernment and oppression . . . to this day," Sir Olaf Caroe, the NWFP governor, wrote in a scholarly text.[101]

Jinnah should have known better than to stir up this hornet's nest. As early as January 1939, a British intelligence report had predicted that the Punjab's Sikhs would pose the biggest obstacle to an independent Muslim state. "History suggests that the Sikhs to a man would fight literally to death rather than submit to Muslim domination," the report noted.[102] Since then, tens of thousands of Sikhs had trained and fought in World War II. Many had held on to their weapons and uniforms when they had demobilized. If Tara Singh wanted an army, he would not have to go far to find one.

"Pakistan Murdabad!"

KHIZAR HAD GROWN TIRED of his long battle with Jinnah. The weeks of League vitriol had transformed the Punjab's slight, unimposing premier into a devil in the eyes of many Muslims. At demonstrations, angry street protesters mocked him as a traitor to his religion. They called him a pimp and much worse. Young demonstrators amused themselves by hanging a sign with his name on a donkey and kicking the poor, bawling beast down the street ahead of them.

At a party thrown by a Muslim friend in the middle of February, the Unionist leader was introduced to his host's eight-year-old son. "Oh, you are Uncle Khizar!" the boy blurted out. "You are the one all my friends say is coming in the way of the creation of Pakistan!" The remark cast Khizar into a funk. "I could go on fighting with the Muslim League," he lamented to one of his Sikh colleagues, "but if our children feel we are the villains of the piece, let us disappear and whatever happens, happens."[1]

Khizar wasn't the only one wearied by the fight over Pakistan. On the afternoon of 20 February, British prime minister Clement Attlee rose before Parliament in London and made an electrifying announcement. Britain would end its long rule in India no later than June 1948, just over sixteen months hence. Either Nehru and Jinnah would have reconciled by then and power would devolve to "some form of central Government for British India," or individual provinces and royal kingdoms would be

freed to make their own arrangements with one another and with London. If all else failed, the British government would hand over authority "in such other way as may seem most reasonable and in the best interests of the Indian people."[2] One way or another, Attlee emphasized, the British were leaving.

Attlee had been contemplating such a deadline for two months now, ever since his London summit with the Indian leaders had failed. The stalemate on the subcontinent had become intolerable. At home, Britons were freezing amid one of the coldest winters in years, and a dire coal shortage had shuttered factories and power plants across the country. The multibillion-dollar postwar American loan had been virtually used up: Chancellor of the Exchequer Hugh Dalton warned that Britain would "be on the rocks in two years' time" if it didn't cut back drastically on its overseas commitments.[3] Simply put, the empire was broke and unsustainable. As for Nehru and Jinnah, Attlee was convinced that only a severe shock would force them out of their stubbornly held positions. On paper he may even have been right. A day later, Nehru described Attlee's statement as a "courageous document, which would have far-reaching effects." Wavell judged the Congress leader "quite impressed."[4]

But in the weeks during which the British Cabinet had debated the deadline — originally they had approved an even earlier withdrawal date of 31 March 1948 — the League's Punjab protests had irreversibly altered the landscape in India. Now Punjabi Hindus, Muslims, and Sikhs could see that whichever party controlled the province in June 1948 would quite likely decide whether or not it would join Pakistan — which, in turn, would determine whether Pakistan would be anything more than a rump state clinging to the edges of the subcontinent. What had been a struggle for local power, even a personal feud between Jinnah and Khizar, had been transformed into an all-out war of succession.

After reading Attlee's statement, a shaken Khizar called it "the work of lunatics."[5] He believed that Jinnah was operating under a dangerous delusion. Leaguers had fixated so intently on demonizing Khizar, they seemed to imagine he was the only obstacle in their way. They completely underestimated how much fear and anger their protests had

stirred up among the Punjab's minorities. That's what they really needed to confront, Khizar believed — not him.[6]

He decided to force matters. A week after Attlee's announcement, the Punjab premier released all of the detained League protesters and lifted the ban on processions. (He had previously reversed his prohibition against militias like the League's Guards.) Then, just before midnight on Sunday night, 2 March, Khizar phoned the League's local chief, Khan Iftikhar Hussain Khan Mamdot, and announced he was stepping down.

The forty-year-old Mamdot was a landowning aristocrat, the son of a former Unionist luminary. By some accounts he was not the most sophisticated politician — the "dumb wrestler" was one of his nicknames — but he was thoroughly loyal to Jinnah and a hard-liner on Pakistan.[7] As leader of the biggest party in the Punjab legislature, he should have been in line to replace Khizar. He needed only a few Hindu or Sikh votes to gain a workable majority.

Just as Khizar had predicted, though, the mere prospect of the League taking over the Punjab incensed non-Muslims. The next day, as news of the resignation spread and jubilant Leaguers filled the streets of Lahore, Congress and Akali legislators rushed to confer. They pledged formally not to join any Mamdot-led government so long as the Muslim League persisted in its demand for an independent Pakistan. Long-bearded Master Tara Singh shaded his eyes from the sun as he emerged from the legislature building. A crowd of Leaguers had gathered outside to heckle the Hindu and Sikh politicians, shouting "Quaid-i-Azam Zindabad!" and "Pakistan Zindabad!" Tara Singh whipped his kirpan out of his scabbard and waved it above his head. "Pakistan Murdabad!" he roared. Death to Pakistan![8]

Throughout the city and beyond, Hindus and Sikhs took up the cry. At a huge rally in Lahore that evening, their leaders vowed to resist Muslim domination of the Punjab by any means necessary. These were not empty threats; with nearly fifty thousand local members, the RSSS was even better established in the Punjab than the League's Guards.[9] The next morning, mobs assaulted Muslims wearing green League badges and trampled on League flags. A rowdy procession of Hindu students

overran a Lahore police outpost, killing two constables. In Amritsar, Sikhs set fire to Muslim homes and bazaars.

The Punjab tinderbox had its match. That year, Holi, the springtime festival where participants celebrate by dancing and flinging colored powder at one another, fell on 5 March. In the western Punjab city of Multan, a "local Sikh fanatic" called on his followers to celebrate the holiday "with blood" instead of paint.[10] Muslims struck first, killing close to two hundred Hindus and Sikhs in various parts of the city in less than three hours. Muslims also went on the offensive in the garrison town of Rawalpindi, home to the Indian Army's Northern Command, and in several smaller cities. In Amritsar, as Muslims retaliated for the previous day's attacks, "most of the population seem to have produced arms," Sir Evan Jenkins reported.[11] Detachments of the League's National Guards from Sind and Delhi — their movements "well-organised and arranged," according to the Intelligence Bureau — headed for the Punjab.[12]

As with the Calcutta Killing, India's national politicians appeared to underestimate the chaos they had unleashed. Jinnah, now recovered and back home at his Bombay mansion, watched the tumult in the distant Punjab with equanimity. With no coalition in sight, Jenkins had assumed control over the disturbed province himself under so-called Section 93, which allowed the British governor to override the legislature. The Quaid demanded that Jenkins install a League ministry in Lahore instead. On 5 March, as the Holi riots were raging, a pair of U.S. diplomats had tea with Jinnah and urged him to seek a compromise with Congress before the violence spread even further. The Quaid dismissed their advice. "We have made sacrifices," Jinnah curtly reminded the Americans. "We are willing to . . . die for Pakistan. Why talk of compromise when there is no basis for compromise?"[13]

In Delhi, Nehru and the rest of the Congress high command met the following day. Hindu and Sikh legislators from the Punjab besieged them, begging for help. They described the awful stillness that had settled over once-raucous Lahore. Jenkins had imposed a curfew and temporarily banned the sale of gasoline, to thwart the wave of arson attacks. Only a few bullock carts and horse-drawn tongas now trundled down the Mall, as if it were a village road. The phone lines had gone dead.

Piles of still-smoking rubble littered the streets. In Lahore's old quarter, where behind ancient stone walls houses piled atop one another in one of the most densely populated areas on earth, slapped-together barricades divided Hindu from Muslim lanes. Rumors claimed the city's water supply had been poisoned.[14]

The visitors pressed an interim solution on the Congress leaders, one that Nehru had been mulling for weeks himself. They suggested dividing the Punjab immediately, creating separate ministries for East and West Punjab. The move would effectively surrender the Muslim-dominated western districts of the province to the League. But at least this way, Jinnah would never muster the numbers he needed to seize the rest.

Nehru later admitted that "when Congress referred to the partition of the Punjab, they had not gone into the question in any great detail."[15] He and the rest of the high command never looked at a map of the province, never calculated — even roughly — where a border dividing the Punjab would run. Wavell had produced just such a map over a year earlier, one that foreshadowed the eventual border almost exactly, but he had shared it only with the India Office in London, not with any of the Indian leaders.[16]

Nehru, who had almost no experience in actual administration, could not have explained how the civil service would be divided so that each of the new Punjabs would run properly. How would budgets for education and health be split? What about Muslim officials serving in the East and Hindu officials serving in the West? Would they be allowed to switch sides? What would happen to the middle of the province, where the Sikh holy places were concentrated and all three communities had an important presence? The fates of Lahore — a Muslim city whose economy was dominated by non-Muslims — and of the hundreds of thousands of Sikhs whose lands lay in the fertile, well-irrigated "canal colonies" of the western Punjab were not discussed. The Congress leaders approved the idea on 8 March after only a day's deliberation.

The Congress resolution was more a threat than a serious proposal. Jinnah had enticed his followers with the grand vision of a Pakistan that would stretch across much of northern India. Dividing the Punjab would bring home the less-rosy reality. Congress still controlled

the Northwest Frontier Province and Assam, as well as all the "Hindu" provinces. If the British decided to hand power over to the existing provincial governments in June 1948, Muslims could not count on getting more than Sind, useless Baluchistan, and now a crippled Punjab and Bengal. "The truncated Pakistan that remains will hardly be a gift worth having," Nehru wrote to a friend in London.[17]

For the first time, the Congress resolution implicitly accepted the idea that India might be divided into two nations. But, Nehru assured Gandhi, such a weak and misbegotten Pakistan could "never succeed economically or otherwise."[18] Even if formed, it would soon have to reunite with the rest of India.

The message to the League was clear: if they wanted their full Pakistan, they would have to fight for every inch of ground. News of the resolution appeared in newspapers on Sunday morning, 9 March. Jenkins feared it "would almost certainly be treated by the Muslims as a challenge," he wrote to the viceroy that afternoon. Already attacks were spreading out of the Punjab's cities and main population centers — where troops and police could easily be concentrated — and into surrounding villages. "We will do our best to keep the trouble out of the rural areas," Jenkins concluded, without tremendous conviction. "But if we fail," he warned, "widespread massacres are inevitable."[19]

It was already too late.

In the western Punjab's villages, Muslims outnumbered Hindus and Sikhs more than four to one. Huge Muslim mobs started to form, armed with as lathis, scythes, and spears. The head of Northern Command, Lt.-Gen. Sir Frank Messervy, was throwing a coming out party for his daughter at Command House in Rawalpindi when the first reports of trouble flooded in. The next morning, he flew over nearby hamlets in a light plane. "It was a horrible sight," he recounted. The mobs had swept through the area like locusts. "You could see corpses laid out in the fields just outside a village, like rabbits after a shoot."[20]

Messervy was a lifelong Indian Army officer who had battled Rommel's forces in the Western Desert and chased the Japanese through the jungles of Burma. The Nazis had overrun his headquarters in Africa — he had escaped by disguising himself as a valet — and he had lost

two whole brigades to the Japanese at Imphal.[21] Yet even he was unsettled by the one-sidedness of the Muslim assault. As far as he could tell, the countryside massacres "seemed to be almost entirely anti-Sikh."[22]

Messervy's own intelligence officer had gone to the Rawalpindi rail station to buy a ticket; he returned ashen. While standing in line he had suddenly felt a weight against his back. A Sikh slumped against him, "stabbed in the back and dead." No one around would admit to seeing anything. The British wife of another officer said her train had been stopped at dawn before reaching the city, and she awoke to bloodcurdling shrieks and groans. Raising the blinds of her compartment, she was horrified to see Sikhs being dragged out of carriages and hacked to pieces alongside the tracks. One of the blood-spattered killers — a Muslim — had tried to calm her. "Don't be frightened, memsahib. No one will harm you," he said gently. "We've just got this job to do and then the train will go on."[23]

Unlike the initial riots in Lahore and Amritsar, these attacks were not random and spontaneous. In rural mosques, ringleaders warned Muslim villagers that huge Sikh jathas had formed and were marching on their homes. Speakers tearfully evoked the devastated streets of cities like Amritsar, which they claimed were littered with corpses of Muslims, slaughtered by Sikhs.

Some of the instigators were League Guards, others were local officials or even policemen; several were Muslim ex-soldiers inspired by the call for Pakistan.[24] They were not necessarily operating under direct orders from above: no evidence has emerged that implicates the League's top Punjab leaders like Mamdot in the slaughter, let alone Jinnah himself. Nonetheless, a terrified and isolated Sikh peasant had to assume this was what "Pakistan" meant — a thousands-strong rabble, pounding drums and howling, their forest of spear tips glinting in the torchlight.

On Sunday afternoon, as Jenkins was dictating his letter to Wavell, a crowd of hundreds of Muslims gathered on the edges of the western Punjab village of Qazian. As darkness fell they advanced to the sound of drums, setting fire to Sikh homes, shops, and a *gurdwara,* or temple. A local Sikh, Sant Singh, fired at the attackers, killing one and driving off the rest. The next day, the mob returned at twice the size. Dozens of

Sikhs who had taken shelter at the home of the Muslim village headman were hauled out, stripped of their crude weapons, and killed. Three Sikh girls were raped out in the open. The mob threw a rope around Sant Singh's neck, dragged him to a firewood stall, and hacked him to death with axes before lighting his corpse on fire.[25]

Similar scenes were repeated in village after village. Refugees fleeing eastward could see long columns of smoke rising across the flat countryside, each marking another hamlet aflame. "If communal trouble developed in the rural parts of a large number of districts," Messervy had warned Jenkins in Rawalpindi, "it would be virtually uncontrollable."[26] Troops were already spread thin, the bulk of their reserves committed to riot work in the cities and towns. As in Bihar, many villages were only accessible by dirt tracks or bridle paths. The Muslim mobs roamed unchecked day after day for almost two full weeks.

Jenkins estimated that something like four thousand Punjabis, almost all of them Sikhs and Hindus, lost their lives in that fortnight of violence.[27] The true toll of the riots went beyond the casualty count, though. The attacks seemed designed to humiliate and terrorize Sikhs, to drive them out of the western Punjab entirely. Razed homes were plowed up immediately so that their former inhabitants could not return and rebuild. A mob descended on Tara Singh's ancestral village, killing one of his uncles and making a point of burning his childhood home to the ground. Muslim goondas in Amritsar reportedly sent sacks of glass bangles to their counterparts in Lahore, to mock them for fighting like women and not killing enough Sikhs.

Despite the weight of their common history, Muslims and Sikhs were not necessarily doomed to fight. The two communities shared many similarities. Both religions emphasized the equality of all men, unlike caste-ridden Hinduism, and both worshipped according to a holy book. Both were deeply attached to their martial traditions. Each had cherished memories of its time ruling over the Punjab, yet also knew the anxiety of living as a minority in a Hindu sea.

Jinnah was not the only one who believed that Sikhs would be better off casting their lot with the League. If the Punjab remained whole, with perhaps its easternmost, Hindu-dominated tip lopped off, the province's 5 million Sikhs would form a substantial and influential minority

within Pakistan and especially within its army. On the other hand, if the province — and hence their community — were split in half as the Congress was now demanding, Sikhs would be reduced to an even smaller and less-powerful presence in both countries.

To Jinnah the logician, that prospect seemed self-evidently foolish. At the London talks in December, while he had snubbed Nehru, the League leader had "most indefatigably" wooed Sikh defense minister Baldev Singh, who had accompanied Nehru on the trip.[28] Years later, Singh recalled the Quaid flourishing a matchbox in front of him. "Even if Pakistan of this size is offered to me, I will accept it," Jinnah had declared. "But . . . if you persuade the Sikhs to join hands with the Muslim League, we will have a glorious Pakistan, the gates of which will be . . . in Delhi itself."[29]

The problem was that Jinnah never backed up his grand statements with real, concrete assurances. At one meeting with Master Tara Singh and other Akali Dal leaders, he offered to give the Sikhs a blank sheet of paper on which to list their demands, which he pledged to sign without a glance. Yet the Quaid wouldn't commit to incorporating those concessions into a future Pakistani constitution. No need to worry, he had said breezily: "My word in Pakistan will be like the word of God. No one will go back on it."[30] The Sikh leaders had been unimpressed.

Any chance of compromise was lost after the March massacres. The slaughter traumatized the proud and close-knit Sikh community: "Our mustaches have been lowered" became a common refrain.[31] Incendiary images from the riots seared themselves into Sikh minds. In the village of Thoa Khalsa, dozens of Sikh women had hurled themselves into a well to save themselves from being captured and raped by a Muslim mob — a dishonor to their minds worse than death. Months later, Attlee himself received a set of black-and-white photographs from a friend visiting the Punjab that included gruesome images from the scene.[32] In the pictures, shot from above, bloated and waterlogged bodies curl up next to one another almost tenderly. Their silk scarves, or *dupattas,* billow around them like clouds.

Sikh leaders did not wait to start planning their answer to the attacks. On 19 March, Tara Singh secretly dispatched letters to the two most powerful Sikh princes in the Punjab: Maharajah Yadavindra Singh of

Patiala and Rajah Harinder Singh of Faridkot. Independent Sikh kingdoms like theirs lay scattered across the central and eastern Punjab, running up into the foothills of the Himalayas. The biggest fielded their own British-trained armies, with mortars, armored cars, and sometimes even aircraft. Tara Singh hoped to enlist those forces in the task of revenge.

In his letter, the Akali leader proposed a byzantine scheme.[33] Rather than depend on the British or the Congress to protect their interests, Sikhs would seize the Punjab for themselves. Faridkot's battalions were to occupy the British-run districts that surrounded his territory; Patiala was to do the same further east. Tara Singh and his deputy, Giani Kartar Singh, would meanwhile raise an irregular force of blue-turbaned Akalis, many of them ex-servicemen, to seize Lahore, Amritsar, and the Sikh holy places in the central Punjab. Jinnah could have the far western reaches of the province. The rest would unite in an independent Sikhistan.

The plot sounded crazy, like some seventeenth-century intrigue — "all very reminiscent of de Boigne, Dupleix, and the rest," a British general dryly remarked, recalling the buccaneering era when the British and French schemed and fought for territory along the coasts of India.[34] The Sikhs were deadly serious, however. Muslims had "made a dead set" at their community, in Jenkins's words, and they did not plan to surrender the initiative again. Quietly Tara Singh began crisscrossing the province, visiting Patiala and Faridkot to argue the merits of his proposal personally. In Faridkot, he and Giani Kartar Singh borrowed a military jeep and bumped along from village to village, warning Sikh farmers "that the time was coming when they would have to settle with the Muslims."[35]

Separately, the Giani met with three hundred Akali cadres and exhorted them to prepare for war. He handed each a five-page pamphlet listing the supposed Sikh casualty counts from the recent riots. The entries for each village were short and lurid. "Domel: none out of the 1,500 Sikhs is alive. Women murdered in cold blood. 70 young girls forcibly converted to Islam." One Lahore newspaper ran an ad calling on Sikhs to contribute to a 5-million-rupee war chest to buy arms. Sardar Baldev Singh, the defense minister in New Delhi, was listed as treasurer.[36]

Jenkins's judgment was unsparing. Borrowing the viceroy's plane, he had spent the past two weeks racing from one hot spot to another, trying to tamp down the riots. The Indian politicians hadn't proved much help. Mamdot and the local Leaguers awaited instructions from Jinnah, who neither visited the Punjab nor expressed sympathy for Sikh victims. A procession of Delhi ministers, starting with Nehru, did arrive to survey the carnage. But the governor found most of these flyby visits worse than useless. "These [national] politicians have no contacts with anyone but their own followers and allies," he complained.[37] Often communal tensions rose after they showed up, rather than easing.

Exhausted and frazzled, the governor finally lost his temper on 20 March with Raja Ghazanfar Ali, the most pugnacious of the five League members of the interim government. Ghazanfar Ali was a Punjabi himself: Jenkins believed he should have understood better than anyone that Muslims could only rule the Punjab by consensus, not by fiat. "Non-Muslims with some justice now regarded the Muslims as little better than animals," the governor said bitterly. Yet rather than apologizing, Leaguers continued to give "the impression that the Muslims were a kind of ruling race in the Punjab and would be good enough to treat with generosity their fellow Punjabis, such as the Sikhs, when their rule was established."[38]

Jinnah may have feared that accepting anything less than untrammeled power in the Punjab would weaken his claim over other recalcitrant Pakistan provinces. (Up in the NWFP, League leaders including Guards commander Khurshid Anwar had recently helped to launch another disobedience movement against the Congress-led ministry.) Jinnah's intransigence, though, had made the Punjab literally ungovernable. "I said that the troubles of the Muslim League were due to folly and bad leadership," Jenkins recalled of his talk with Ghazanfar Ali. In the month since Attlee had announced the end of the Raj, the Quaid had "fooled away a kingdom."[39]

Attlee's 20 February statement had included one more critical piece of information: he was sacking Wavell. The gruff field marshal was exhausted and out of ideas; he hardly seemed the man to break the stalemate in India. In December, the prime minister had offered the

job instead to His Excellency Rear Admiral the Right Honorable Louis Francis Albert Victor Nicholas, Viscount Mountbatten of Burma, KCG, PC, GMSI, GMIE, GCFO, KCB, DSO — cousin to the king, great-grandson of Queen Victoria, and most recently supreme Allied commander in Southeast Asia. The announcement had been delayed in part by Wavell's reluctance to return home to receive the news in person. Britain's new proconsul — and her last — landed in India on 22 March.

Forty-six-year-old "Dickie" Mountbatten looked like the Hollywood version of a British prince. He was tall and tanned, with broad shoulders and a chest full of medals, ribbons, and honors. The war had quite literally made him a celebrity: his good friend Noël Coward had written and directed a wildly popular movie, *In Which We Serve,* based on Mountbatten's exploits as a destroyer commander. Churchill imagined him "more of a swashbuckler than I really am," Mountbatten admitted, and promoted him rapidly — first to head of Combined Operations and then to chief of the new Southeast Asia Command (SEAC), where he led more than a million troops against the Japanese Imperial Army.[40]

Mountbatten even fought the war in style, importing his barber from Trumpers, the gentlemen's shop near Piccadilly Circus, to his headquarters in the misty highlands of Ceylon. From there he zipped out to the front in his specially outfitted, four-engine Dakota, which he had had padded in white leather and equipped with plush armchairs, sofas that turned into beds, and a fully stocked cocktail cabinet.[41] Sadly, Dickie's qualities as a war fighter were less abundant: Earlier he had steered his destroyer HMS *Kelly* into a British minefield in the Tyne estuary, then lost her entirely in the Mediterranean to a flock of German dive-bombers. At Combined Operations, he ordered the disastrous commando raid on Dieppe that resulted in thousands of Allied casualties. "Endless wallawalla, but damn little fighting," the curmudgeonly American general Joseph "Vinegar Joe" Stilwell grumbled of his playboy commander.[42]

Still, Mountbatten possessed preternatural charisma — a charm and self-confidence so powerful that tremendously able men were eager to follow where he led. Troops adored him. His capacity for work was endless, and he had an able, quick mind. Even Wavell acknowledged in his

diary after learning the name of his replacement, "Dickie's personality may perhaps accomplish what I have failed to do."[43]

Mountbatten was hardly naive about the task ahead of him. "I have never supposed that the Indians could achieve their self-government without the risk of further grave communal disorders," he told Attlee at their first meeting on 10 December.[44] In the weeks between accepting the job and finally embarking from Northolt airfield outside of London, however, the viceroy-designate had concentrated largely on the question of how to forge the ideal strategic relationship between India and Britain. He asked Gen. Hastings Lionel "Pug" Ismay — Churchill's wartime chief of staff — to come out to India to fill the same role for him. Ismay had more recently been working with the British chiefs of the defense staff on imperial strategy; he argued that "from the military point of view . . . it was nearly as vital as anything could be to ensure that India remained within the Commonwealth" as a self-governing dominion like Canada or Australia, whose troops would be at London's service.[45] Mountbatten urged Attlee to add a line to his formal instructions setting that out as a primary goal.

By contrast, Mountbatten's last internal security briefing from the mandarins at the India Office was dated 4 March and barely mentioned Khizar's resignation in the Punjab. "It was, I am sure, not until we got to India that we [realized] . . . how serious the situation was and how different things were from the briefing we had in the India Office," another of Mountbatten's aides recalled many years later.[46] The threat of a Sikh uprising confronted the new viceroy immediately. At Mountbatten's very first staff meeting, he was informed of a letter from Giani Kartar Singh vowing to overthrow any League government in Lahore by force.[47]

Sikh leaders had always imagined that they enjoyed a special relationship with the British, owing to their long loyalty and feats of arms in service of the empire. They hardly troubled to hide their anxieties about Pakistan, or their plotting for revenge. The maharajah of Patiala, a tall, handsome sportsman who was a favorite among Raj officials, told the wife of one at a party that he and his fellow Sikhs knew exactly what to do if the British gave Jinnah his own country. "We won't leave a Moslem

here," Patiala said matter-of-factly. "Nor in the districts around. Every Sikh will draw his kirpan and it will be, 'Death to all Moslems.'" The prospect appeared not to depress the jovial maharajah too terribly. He ended the evening leading a conga line through the palace, "over and under the chairs and tables — great fun!" a participant recorded.[48]

On the evening of 27 March, his fourth official day in office, Mountbatten asked the top commanders of the Indian Army to dinner to discuss the deteriorating security situation. Over cognac and cigars, Lt.-Gen. Sir Reginald Savory, the army's adjutant-general, recounted a conversation he'd had with the rajah of Faridkot less than a week earlier, in which the headstrong young prince had laid out the Sikhs' plans for conquering the Punjab. At a follow-up meeting, Faridkot even dropped "strong hints that *I* should command their armies," Savory noted in his diary. Faridkot was looking to enlist other British officers as well — "1 Brig; 4 Cols; 8 Majors; plus 1 Wing Comd. and other R.A.F. officers for his air force of 5 Austers!!"[49] At the dinner, Northern Command's Messervy, too, "had a good deal to say about large-scale plots by the Sikhs," one of Mountbatten's advisers anxiously recorded.[50] There was talk of seizing the Punjab's main irrigation headworks to gain a choke hold on the rest of the province.

Mountbatten must have felt an unsettling twinge of déjà vu. When his forces reoccupied Southeast Asia after the war, they had faced a rash of desperate insurgencies not unlike the one the Sikhs were now threatening. In Vietnam and Indonesia, independence-minded nationalists had taken up arms to resist the reimposition of French and Dutch control, respectively, over their former colonies. Mountbatten's troops — many of them Indian — had been caught in the middle.

The fighting had been vicious and indefinite. "One simply could not tell friend from enemy or, more correctly, who had a rifle hidden in the nearest bush and who had not," one young British officer battling insurgents in the jungles of Sumatra lamented.[51] In the eastern Javanese port of Surabaya at the end of October 1945, some 140,000 poorly armed but fanatic guerrillas had scattered a contingent of 6,000 British and Indian SEAC troops. Mountbatten had retaliated with a massive air and ground campaign, killing possibly as many as 15,000 Indonesians.[52] In March 1947, hostilities continued to wrack both countries.

A full-scale conflict in India would be infinitely bloodier. "In the Punjab all parties are seriously preparing for civil war, and of these by far the most businesslike and serious are the Sikhs," Mountbatten wrote in the first of his fortnightly reports to his cousin King George VI.[53] Two things were immediately obvious to the new viceroy. First, he could not cede the entire Punjab to Jinnah. Second, whatever he decided, he had to decide fast. "Things are electric," Ismay wrote to his wife the morning after dinner with Savory and the other army commanders. "If we don't make up our minds on what we are going to do . . . there will be pandemonium." Of course, Ismay added laconically, "if we do, there may also be pandemonium."[54]

That evening, in the sprawling Mughal Gardens behind Viceroy's House, the Punjab's chaos seemed worlds away. Fairy lights looped through the trees. A cooling breeze rose off the fountains and rippling waterways that ran between the flower beds, which were in full springtime bloom. Mountbatten's statuesque, red-liveried bodyguard — half of them Sikhs, the other half Punjabi Muslims — lined the entrance where a strange assortment of guests had begun to arrive. They included Indians in kurtas and saris, many of whom had never set foot on the grounds of Viceroy's House before, as well as British officers in starched khaki. There were also mandarin-collared Nationalist Chinese, fiery Indonesians, redcheeked Tibetans, Burmese, Vietnamese, bookish scholars from Cairo's Al-Azhar University, even Jews and Arabs from tense Palestine.

The foreigners were delegates to the impressive-sounding Asian Relations Conference taking place that week on the grounds of the Purana Qila, a ruined Mughal fort in the center of the city. Nehru had personally spent weeks organizing the conclave, forgoing sleep to dash off late-night invitations and soothe diplomatic tensions among delegates. "For too long we of Asia have been petitioners in Western courts and chancellories. That story must now belong to the past," he declared at the opening plenary.[55] Nehru fervently believed that the nations of the East were ready to forge a new world order, with India at their head. Although the confab turned out to be mostly a talk shop, he excitedly described the week of sessions and speeches to a friend as "the beginning of a new era in Asian history."[56]

Mountbatten seemed to agree. The garden party was, according to his fawning press attaché Alan Campbell-Johnson, "a clear token of the new Viceroy's goodwill towards Nehru's most ambitious move to assert Indian status in Asian affairs."[57] Attlee had chosen Mountbatten in part because of his relatively liberal attitude toward the question of freeing Europe's colonies. In Southeast Asia, he had irritated his Dutch and French counterparts by pushing them to work with, rather than fight, local nationalists like Sukarno and Ho Chi Minh. Attlee had been particularly struck by Mountbatten's handling of Burma, where his embrace of charismatic independence leader Aung San had helped to produce an interim government and agreed timetable for the transfer of power.

Mountbatten saw Nehru much in the same light. The two men had met a year earlier, when Nehru had flown out to Singapore to address Indian soldiers and former POWs. Where some British officers had resented the recently jailed Congressman's tour, Mountbatten had treated Nehru as a leader-in-waiting, giving him an official escort and even riding together with him in an open-topped car, as throngs of enraptured Indian troops and civilians cheered from the canopied sidewalks.[58]

In Delhi their first meeting had lasted for three hours. Mountbatten found the Congress leader "most sincere"; Nehru was taken by the new viceroy's energy and decisiveness.[59] In truth, they had little to argue about. Mountbatten, too, hoped to transfer power to a strong central government that would oversee a united India. They spent much of their time discussing Jinnah, whom Nehru belittled as a "mediocre lawyer" who had achieved political success only in the last decade of his life by rejecting any and all reasonable compromise. No doubt the fact that Mountbatten seemed to accept this judgment at face value further endeared him to the Congressman.

Nehru quickly developed a rapport with the viceroy's circle as well, even his family. He spoke to them in terms that they understood, and in a polished Cambridge accent; they enthused about his statesmanship and literary sensibilities. Campbell-Johnson and other aides began attending breakfasts at Nehru's bungalow at 17 York Road. After the garden party at Viceroy's House, in fact, several staffers had trooped there to watch a traditional dance performance in a *shamiana,* or tent, set up on Nehru's lawn. Mountbatten's wife, Edwina, the svelte and

fabulously wealthy granddaughter of King Edward VII's banker, Sir Ernest Cassel, came along as well. A photograph showed the attractive vicereine seated regally during the recital, her host — the erstwhile leader of Asia — curled at her feet like a cat.[60]

This growing intimacy had to have alarmed Jinnah. The Quaid had scorned Nehru's Asian Relations Conference as "entirely a Hindu Congress show" and had tried unsuccessfully to persuade Arab Muslims not to attend.[61] Now he stewed in Bombay, ignoring an invitation from the new viceroy to meet in Delhi. Jinnah accepted only after a week had passed, and did so with ill grace — not by letter but "through the newspapers," an irritated Mountbatten complained to his staff.[62] By the time the Quaid arrived in Delhi on 5 April, Mountbatten had just concluded five days of friendly one-on-one meetings with Gandhi. The nationalist press had gushed over the bond apparently struck between the Mountbattens and the Mahatma: a photograph of the elderly Gandhi resting a hand on Edwina's porcelain shoulder as they ascended the steps to Viceroy's House was hailed as India's benediction of the viceregal couple.

Jinnah's first meeting with Mountbatten was, by contrast, disastrous. When the Quaid strode into the viceroy's freshly painted, air-cooled office, "he was in a most frigid, haughty and disdainful frame of mind," Mountbatten recorded. "After having acted for some time in a gracious tea-party hostess manner, he eventually said that he had come to tell me exactly what he was prepared to accept." When Mountbatten cut Jinnah off, saying that the purpose of this first meeting was purely to make each other's acquaintance, the League leader sulked. For the next hour he issued monosyllabic replies to Mountbatten's questions.[63] The gregarious viceroy was so put off that he changed his mind about asking the Quaid to dinner that night, unable to stomach the thought of spending another minute with him.

The one moment of levity came when the two men stepped outside with Edwina to pose for the gathered photographers. Jinnah had prepared a canned line of flattery for the vicereine: "Ah, a rose between two thorns." Unfortunately, as flashbulbs popped and reporters scribbled down his words, the Quaid realized that he had positioned himself between the glamorous British couple. Some good-natured ribbing "unfroze" Jinnah a bit after that, Mountbatten recalled later.[64]

Still, the next five days of talks proved arduous. Meeting with Jinnah for hours at a time — sometimes alone, sometimes with Ismay and other aides — Mountbatten tried every argument he could muster to undermine the Quaid's insistence on Partition. The viceroy's staff had armed him beforehand with a list of "awkward questions" to pose to Jinnah.[65] How exactly did Pakistan propose to defend itself? Mountbatten refused to consider splitting up the Indian Army before June 1948, and even after that, any Pakistan Army would depend on its larger Indian counterpart for training, equipment, even officers. How would Pakistan form a functioning bureaucracy and government from scratch, or develop a modern industrial economy? Why would Jinnah want to break up a nation that could help shape the postwar world if united, but "divided, would not even rank as a second-class Power?"[66]

Mountbatten's trump was the Punjab. The Sikh threats had convinced him that a League takeover of the province would mean immediate bloodshed. At their contentious third meeting, the viceroy told Jinnah flatly that if Muslims wanted to secede, they had to allow the non-Muslim eastern Punjab to remain with India, just as Nehru had always argued. The same principle held true in Bengal, which meant that Pakistan would almost certainly lose the economic engine of Calcutta. Jinnah would get an amputated state, one that would be beholden to its much-larger neighbor for its survival. "He would find that he had thrown away the substance for the shadow," Mountbatten suggested, when instead he could revert to the previous year's compromise plan and enjoy autonomy for Muslim areas within a federal India.[67]

Jinnah refused to back down. He "expressed himself most upset at my trying to give him a 'moth-eaten' Pakistan," Mountbatten recorded. The League leader argued that it made no sense to destroy the unity of the Punjab and Bengal, two provinces "which had national characteristics in common: common history, common ways of life; and where the Hindus have stronger feelings as Bengalis or Punjabis than they have as members of the Congress." That was true enough, Mountbatten replied, but the exact same point could be made about India as a whole. The two men went round and round. "Mr. Jinnah was a psychopathic case," Mountbatten told his staff the next morning. The Quaid "had not

been able in his presence to adduce one single feasible argument in favour of Pakistan. In fact he had offered no counter-arguments. He gave the impression that he was not listening. He was impossible to argue with."[68]

In hindsight, Mountbatten's aides would say that this was the point at which they admitted to themselves that Britain would have to concede Pakistan in some form: there was no shaking Jinnah. The League leader, however, remained very concerned that the viceroy "make his Pakistan 'viable,'" citing the example of Poland after World War I to illustrate the dangers of creating a too-weak state.[69] In fact, that's precisely the prospect Mountbatten — like Nehru — wanted to lay before Muslims. As the viceroy told a meeting of governors from the eleven British Indian provinces on 15 April, "The great problem was to reveal the limits of Pakistan so that the Muslim League could revert to a unified India with honour."[70] The more fragile the state offered now, the greater chance Leaguers would change their minds before June 1948 when Mountbatten finally departed.

Jinnah had assumed from his conversations with Churchill and other Tories that Britain would welcome Pakistan as a dominion — and would hence want it to be as strong as possible. Mountbatten poured cold water on those hopes, too. He had developed a close enough rapport with Nehru to think that he could persuade India — a far bigger prize — to remain within the Commonwealth. In their first meeting, Nehru had mused vaguely about some form of "common citizenship" that would bind Indians and Britons together. The Congressmen were "groping for a formula," Mountbatten thought, one that would allow them to feel fully independent yet still gain the benefits of the imperial connection, including, most importantly, the continued services of British officers in the Indian Army.[71] Meanwhile, he told Jinnah that Britain would not consider including Pakistan alone in the Commonwealth. The news, Mountbatten noted proudly, came as a "very rude shock" to the Quaid.[72]

Indeed, the drift of events now visibly distressed Jinnah. During an interview on 18 April, *Telegraph* correspondent Colin Reid, who had a good relationship with the League leader, found him in a "most dis-

turbed state of mind."[73] When *New York Times* bureau chief George Jones arrived at Jinnah's Aurangzeb Road mansion in Delhi the next day, he too was stunned by the Quaid's sickly appearance.[74]

A map of the subcontinent made of beaten silver hung on the wall of Jinnah's study: Pakistan, including all of the Punjab and Bengal, was marked out in green. Sitting beneath it, Jinnah answered Jones's questions uncertainly and appeared to suffer from a tic. "His conversation did not make sense," Jones flatly warned a U.S. diplomat afterward. The Quaid rambled in his answers, interrupting himself more than once. "'[I can't tell] you anything about that now,'" he said "in a distraught manner" when the reporter asked for his assessment of the ongoing talks.[75] The *Telegraph*'s Reid thought that perhaps Jinnah "was susceptible to 'squeeze'" if he could be presented with a face-saving way to back down.[76]

Mountbatten was quietly pleased. In conversation with Liaquat, he got the clear impression that Jinnah's deputies, too, were worried about where the Quaid's inflexibility was leading. The viceroy's staff advised Mountbatten that "this process should be allowed to take its course; there would be a psychological moment at which to take advantage of it."[77] He had only to wait a bit longer.

Jinnah left behind few clues as to his thinking, unlike Nehru. The Congress leader wrote lucid, eloquent letters; articles for international magazines; long aide-mémoire; carefully preserved diaries; and more than one autobiography. The *Quaid-i-Azam Mohammad Ali Jinnah Papers* — eighteen volumes (and counting) compiled by admirers in an attempt to match the voluminous collected works of Nehru and Gandhi — include only a few revealing speeches and letters. The bulk of Jinnah's correspondence is numbingly pedestrian: one typical exchange from the spring of 1945 carefully preserves for posterity the extended back-and-forth between the leader of India's 100 million Muslims and the Matheran Electric Supply Company over what he insisted was an extortionate bill of 10 rupees for replacing a lightbulb.[78]

Scholars still debate whether Jinnah's equally adamant insistence on a full Pakistan was a bluff. An influential school of thought holds that the Quaid always intended to settle for a united India, after he had

extracted as much power and autonomy as he could for himself and the five "Muslim" provinces. The League leader was perfectly rational, Liaquat told Mountbatten: he understood, or could at least be persuaded to understand, how fragile and unworkable a shrunken Pakistan would be.[79]

Yet now, with the viceroy's draft plan for partitioning India nearly finished and Ismay preparing to return to London to seek the British Cabinet's approval, Jinnah doubled down. When he next met with Mountbatten on 23 April, he reiterated the League's maximalist demands: full provinces, full sovereignty for Pakistan. To cut up the Punjab and Bengal, he warned, would "loose terrible forces." It was "suicidal."[80]

Some mix of paranoia, gamesmanship, and bravado seemed to be driving the Quaid. He claimed that Hindu generals — who along with Britons filled the top ranks of the army — were planning a coup after the British left.[81] If he agreed to a united India, Muslims would always be at the mercy of such men. (Jinnah's fears were not idle: the highest-ranking Indian officer, Brig.-Gen. K. M. "Kipper" Cariappa, had indeed begun approaching several colleagues with the idea of a military takeover.)[82] At the same time, Churchill, perhaps through their secret backchannel, had reassured Jinnah that Pakistan could count on British support and troops: "You have only to stand firm and demand your rights not to be expelled from the British Commonwealth," the Tory leader had advised. Britons "would never stand for the expulsion of loyal members of the Empire."[83] For good measure, Jinnah made a bid for American support, assuring a visiting State Department dignitary that Pakistan would usefully block "Hindu imperialism" from spreading its tentacles into the vital Middle East.[84]

The Quaid's brinkmanship hardened feelings on all sides. Nehru's deputy, Sardar Patel, was convinced that the League was delaying a settlement in order to weaken India as much as possible. In Calcutta that spring, goondas flung fuming bottles of nitric acid at one another in ongoing street battles. Up in the Northwest Frontier Province, Khurshid Anwar's rallies had led to open attacks on the tiny local communities of Hindus and Sikhs. Reports claimed that various maharajahs and Muslim nawabs were scouring the international arms market, preparing to hold out for independence after the British left.[85]

For months Patel had been seeking a way for Congress to assume control of the country sooner rather than later. One of the holdovers from Wavell's regime was a remarkable South Indian civil servant named V. P. Menon. Born in Malabar, he had dropped out of school at age fifteen after contracting typhoid. He worked in the Mysore goldfields and at a Bangalore tobacco company before landing a job as a clerk in the Home Department in Delhi.[86] Brilliant and driven, he studied law in night school and transformed himself into the foremost expert on Indian constitutional affairs and a trusted adviser to the viceroy.

Most importantly, "VP," as he was universally known, had won Patel's ear. As early as January, Menon had argued to the Sardar that the fastest way to gain power was to lop off the recalcitrant Pakistan areas and accept dominion status for the rest of India: constitutionally at least, nothing would then prevent the British from handing over control to the Congress Party almost immediately.

Nehru had always been the obstacle. The idea of acknowledging the sovereignty of the British Crown — as empty as it seems now — struck him as humiliating and intolerable. "Any attempt to remain in the Commonwealth will sweep away those who propose it," he had written to Defense Minister Baldev Singh as recently as 14 April.[87] Mountbatten's entreaties had yet to produce a change in heart.

The weeks of tension and delay, however, were taking a toll on Nehru, too. He had grown emotional in meetings — "to an alarming degree," Ismay wrote to his wife — and combustible.[88] In frustrated speeches he cursed Jinnah's intransigence: "I want that those who stand as an obstacle in our way should go their own way," Nehru told a crowd in Delhi in mid-April.[89]

Mountbatten knew, as he admitted during a 1 May staff meeting, that "if he fell foul of Congress it would be impossible to continue to run the country."[90] (He later had the lines discreetly redacted from the official minutes.) With temperatures in the capital soaring above 114 degrees in the shade, the viceroy moved to break the logjam. The next day, Ismay flew back to England with the draft plan — unchanged despite Jinnah's threats — in hand. Individual provinces would decide whether to join India or Pakistan. The two halves of the Punjab and Bengal would vote independently, so they could go their separate ways if they wished. The

following weekend, Mountbatten invited Nehru up to cool Simla, the Himalayan summer capital of the Raj, while they awaited the cabinet's sign-off. VP and a few other aides accompanied them.

While Mountbatten still hoped to bring Nehru around on the question of dominion status, the Congressman's mood was not promising. Nehru loathed the Viceregal Lodge, an alien monstrosity with monogrammed soaps and a mock-Tudor facade. At a tea party on Friday afternoon, 9 May, he made stiff small talk about the ongoing sugar shortage and the state of Burma's roads, relaxing only when the party went for a hike through the surrounding orchards.[91]

After dinner the following evening, the viceroy pulled Nehru aside. Ismay had just cabled back a revised version of the Partition plan, now approved by the British Cabinet. Mountbatten gave Nehru a copy to take back to his room to read. He would be, Dickie emphasized, the first Indian leader to see it.

The favor did not have the intended effect. This "final" version of the plan made clear that any province or kingdom could choose to join India or Pakistan — or to declare independence after the British left. Already Suhrawardy was leading a campaign for a united Bengal to break away on its own. If rulers of the larger states like Kashmir and Hyderabad followed suit, India would end up even more "moth-eaten" than Jinnah's Pakistan.

The plan as written, Nehru raged in a note he scribbled before dawn, "would invite the Balkanization of India."[92] His colleagues would never accept it. Suddenly the speed offered by VP's proposal looked vitally important. Under Menon's plan, Congress would be able to take power almost immediately. Provinces would be given a choice of joining India or Pakistan only, while states would face heavy pressure to do the same. In a phone call to Simla, Patel pressed Nehru to accept this alternate scheme. With India secured as a dominion, the Sardar knew, Mountbatten would have even less reason to tolerate Jinnah's stonewalling.

One problem remained: the Sikhs. In the Punjab, the spring crop had been harvested, and Hindus, Sikhs, and Muslims had all reached "an advanced stage of preparedness for a renewal of the conflict," according to an intelligence officer in Lahore.[93] Two different Sikh militias — later merged into one — were recruiting members in villages across the prov-

ince. More ambitious RSSS cells had begun to experiment with home-made bombs, occasionally blowing themselves up in the process.

Sikh leaders had grown deeply paranoid. Master Tara Singh refused to talk to Jinnah or any other League officials: "I shall not lick the hand besmeared with the blood of my innocent children, sisters and brothers," he wrote to Jenkins's private secretary on 13 May.[94] The Akali leader had taken to hiding his movements, convinced that Muslims were tapping his calls and looking for a chance to assassinate him. Jenkins thought the impulsive Faridkot was lamentably "enjoying the political intrigues in which he is involved."[95] The rajah's army appeared to be supplying the Akali militias with grenades and guns. The parking lot at Faridkot House in Lahore filled with mysterious station wagons bearing the state insignia; dozens of beefy men bedded down on the mansion's marble floors.[96]

Upon his return from Simla, Mountbatten made one last attempt to bring Jinnah and the Sikhs together to find a compromise that would not split the Sikh community in half. Over dinner on 14 May, the maharajah of Patiala recalled, "offers were made by Mr. Jinnah for practically everything under the sun if I would agree to his plan" for including both halves of the Punjab in Pakistan. The talks continued over tea two days later but with no result. Jinnah still refused to provide any guarantees other than his word, and as Patiala wrote to Mountbatten afterward, "any assurance of generous terms to [Sikhs] under a Muslim-dominated state does not cut much ice."[97]

Publicly, Jinnah declined to make any concessions whatsoever. "The Muslim League cannot agree to the partition of Bengal and the Punjab," he wrote to Mountbatten on 17 May after studying VP's new Partition scheme. "It cannot be justified historically, economically, geographically, politically or morally. . . . It will be sowing the seeds of future serious trouble and the results will be disastrous for the life of these two provinces and all the communities concerned."[98] The next morning, Mountbatten boarded his York on his way back to England to brief the cabinet personally on the change in plans. He had to hope the Quaid was bluffing.

Four days later, Mountbatten opened the London papers to read an interview with Jinnah. In it the League leader not only refused to accept

a truncated Pakistan. Now he demanded an 800-mile-long land corridor across the top of India to link the two halves of his new state. The story had been carefully planted to influence Tory opinion in England. As soon as Mountbatten had taken off, Jinnah had called around and offered the interview to several British correspondents in Delhi.[99] Furious, Nehru dismissed the ultimatum as "fantastic and absurd."[100]

Politicians and negotiators often proceed with bluffs, brinkmanship, and over-the-top rhetoric. But they are usually not doing so against a backdrop of life and death. The negotiations over Partition are especially painful to ponder given the body counts that had already amassed, and that now threatened to grow exponentially. In the Punjab, killings were starting to pick up again. Unknown assailants swarmed a settlement of Muslim pastoralists, firing revolvers and hurling homemade bombs. Seven were killed and twenty injured. The next morning, the parking lot at Faridkot House was empty of cars and swept clean.[101] Rumors of an impending Sikh offensive poured in. An "ungraded" intelligence report from the Punjab arrived in Delhi on 22 May, warning of planned Sikh attacks on Muslim villages, as well as on trains and telegraph lines. Sikh fighters were "being encouraged to expect something big" in about ten days, as soon as Mountbatten returned from England.[102]

Before leaving Delhi, the viceroy had ordered the 4th Indian Division to take up position in the Punjab to forestall just such an outbreak of violence. In private meetings, he had bluntly threatened Tara Singh and the other Sikh leaders: "I said I particularly wished to have tanks, armoured cars, and aircraft used so that the poorly armed insurgent armies would feel that their resistance was futile since they were being mown down without even a chance of killing any of the regular armed forces."[103] Jenkins knew better: the troops wouldn't be in position in time, and wouldn't be sufficient anyway. He had asked for at least another brigade's worth just to pacify Lahore.[104]

One thing was certain: the deal Mountbatten had taken with him to London pleased no one entirely — not Congress, who stood to lose a united India; not the League, whose Pakistan would be stripped of its most economically vibrant areas; and especially not the Sikhs, who faced what they imagined to be the dissolution of their community.

Writing to a U.S. diplomat, Ismay noted that it was commonly assumed that once Mountbatten returned and made the plan official, "a general massacre would at once ensue." A lady friend of Pug's even told him that the YWCA had decided to reschedule its next committee meeting, originally set for the first week of June. The Indian members had pointed out that "by that time the rioting and bloodshed [would] be in full swing," and they would all no doubt be confined to their homes—"if our houses still exist!"[105]

5

✦✦✦

Indian Summer

GURGAON, ONCE THE easternmost district of the Punjab, is today a suburb of Delhi — a shapeless sprawl of mirrored-glass corporate towers and condo developments stretching to a purplish, smog-choked horizon. In 1947, it was still rough country-side, populated mostly by Hindus but also by a sizable minority of hardy Muslim peasants known as Meos. At the end of March 1947, shortly after Mountbatten's arrival in India, a Meo had tried to intervene in a fight between two Hindus. The altercation somehow ended with the slaughter of ten Muslims. In the current climate, even minor confrontations escalated with terrifying speed. The two communities had proceeded to trade attacks, setting ablaze one another's crude villages, until a detachment of British soldiers showed up to enforce an uneasy peace.

Hindus broke the truce on 25 May, when a mob descended without warning on the village of Naurangpur and killed twenty Muslims. Two days later, Patrick Brendon, the British official in charge of the district, was out patrolling when "to my horror I saw first one, then a second and then a third village go up in smoke." Organized Meo mobs were retaliating, attacking Hindu villages at four points along a 50-mile front. "It was a day of wild confusion," Brendon later wrote in an unpublished memoir. He estimated that troops fired over one thousand rounds of live ammunition trying vainly to restore order.[1]

Within days, as Hindus also took up arms, a local civil war had broken

out on the capital's doorstep. Delhi politicians clamored for the army to restore order — by which they usually meant to suppress the opposite community. Yet troops could only traverse the district's rocky hills and ravines by jeep, and then only at a few miles per hour. They struggled to intercept huge mobs, largely Hindu, who roamed cross-country armed with axes, spears, muzzle-loading guns, and even homemade mortars. One young British officer with only a half-dozen men faced off against a horde of five thousand.[2]

Brendon's handling of the riots reinforced what Nehru had long believed: British officials could no longer be trusted to maintain law and order. The Briton made little secret of his League sympathies. A year earlier, after some Congress activists had been injured in protests in nearby Pataudi state, he had dismissively suggested they use their leftover election flags as bandages. (It was a "bad joke," he admitted in hindsight.) Now Brendon took steps to even the odds for the outgunned Meos. When a Muslim ex-soldier admitted that he had organized a thousand local fighters to defend Meo villages, "I quickly told him that as far as I was concerned they could have as many unlicensed weapons as they could get," Brendon later wrote. "A happy smile then came over his strained face."[3]

Even when they weren't biased, many Raj officials were burned-out and cynical, and they had no interest in refereeing a civil war. "The British civil servants neither want to deal with the present situation effectively nor are they capable of it," Nehru wrote in frustration to a friend. "They feel that they have to go anyhow pretty soon, so why should they bother. There is often also a secret satisfaction that India is going to pieces."[4] The longer men like Brendon remained in their posts, Nehru believed, the more Indians would die.

Mystery and misinformation still cloud the most pivotal decision in the Partition process — to rush forward the date of the British departure by ten months to 15 August 1947. Mountbatten is typically blamed for accelerating the handover so the British would not be held responsible for the bloodbath to come. He was legendarily heedless: "I've never met anyone more in need of front-wheel brakes," even Pug Ismay wrote.[5] Mountbatten did himself no favors by boasting in later years that he had plucked the date out of thin air at a press conference, choosing the

anniversary of the Japanese surrender simply because it sprung to mind. If that were true, hundreds of thousands of dead and millions of displaced Pakistanis and Indians would indeed have been victim to one man's whimsical diktat.

But Nehru and the Congress leaders also wanted the British out as soon as possible. Nehru had made clear he was accepting dominion status only as a means to gain power faster; the longer the transition dragged on, the greater the chances he might change his mind. Before leaving for England, Mountbatten had already begun talking about transferring power to Congress in 1947 rather than June 1948. When he returned from London on the last day of May, the viceroy cabled Sir Evan Jenkins and the other provincial governors to say that His Majesty's Government was now contemplating a handover "not later than October 1st this year."[6]

What is little understood is that the British do not seem to have intended this date to be a hard-and-fast deadline for *both* India and Pakistan. With a military and administrative structure already in place — including everything from ration cards to currency — a new Indian government could take power almost immediately, perhaps even "sometime in August," as Clement Attlee told U.S. ambassador Lewis W. Douglas in London on 2 June. On the other hand, "Pakistan being without administrative machinery, power transfer to it might be delayed until this is available."[7] Another British official estimated that this might not happen until the end of the year, "but this was just a guess — it might take longer." In the meantime, some sort of joint body or "superstructure" could be set up to oversee defense and foreign affairs for both dominions, while they gradually and amicably worked out the terms of their separation. "Thinking in this connection," Douglas reported skeptically, "has not gone very far."[8]

When Mountbatten gathered the Indian leaders around a cramped conference table at Viceroy's House on 2 June, he emphasized this point: the transfer of power did not mean an abrupt end to the British connection. Far from trying to abandon their obligations, he declared, the British "would stay at the disposal of the Indians as long as the latter wished."[9]

To the viceroy's right, Nehru looked drawn and tense. To his left, Jin-

nah sat sphinxlike, precisely attired in a pale, double-breasted suit with matching pocket square. For now Mountbatten asked only that the Indian leaders accept the plan in its entirety—and that they signal their assent in writing by that evening.

Jinnah chose this moment to grandstand. He piously insisted he could not accept on behalf of the League, which was "a democratic organisation."[10] The question would have to be put to a vote of the party's leadership, which would take a few days to organize.

This was precisely the sort of negotiating tactic that so infuriated Nehru. "During the past few years it has been our repeated experience that Mr. Jinnah does not commit himself to anything," the Congressman had written to one of Mountbatten's aides just a few days earlier. "He accepts what he gets and goes on asking for more." The Congress leaders had had enough: "We have arrived at a stage where this kind of thing will do good to nobody."[11] Without a clear-cut acceptance from the League, the Congress would reject Partition, too, and go back to demanding power over all of India.

Jinnah's caginess is puzzling. Five days earlier he had boasted to George Merrell, "I tell you we are going to have Pakistan—there is no question about it."[12] The Quaid's Malabar Hill mansion was on the market for 2 million rupees, and he was negotiating to buy a vacation houseboat (the *Mayflower*) on fabled Dal Lake in the Kashmiri capital of Srinagar.[13] (Although ruled by a Hindu maharajah, Kashmir was nearly 80 percent Muslim. Jinnah fully expected the state—the "K" in "PAKSTAN"—to join his Muslim dominion.) Privately at least, Jinnah seemed to have resigned himself to winning only a moth-eaten Pakistan.

Yet when Dickie summoned him back to Viceroy's House near midnight, the Quaid continued to equivocate. While in England, Mountbatten had taken the precaution of seeing Churchill, and had delighted him with the news that Nehru had agreed to keep India within the Commonwealth. The Tory leader had given Mountbatten a message to pass along if Jinnah proved troublesome: "This is a matter of life and death for Pakistan, if you do not accept this offer with both hands."[14] The Quaid merely shrugged. The next morning, he gave only the briefest of nods when Mountbatten told the reassembled Indian leaders that he trusted the League would ultimately approve the Partition plan.

Whatever well-meaning timetables had been imagined in London would clearly not survive the partisan furnace in Delhi. At his staff meeting the previous afternoon, Mountbatten had suggested moving up the handover date to 31 July, less than sixty days away. Horrified aides had persuaded the viceroy that "this would be impracticable, if not absurd," according to a source at the meeting.[15] Yet now Mountbatten presented the Indian leaders with a sobering, thirty-three-page paper laying out the "Administrative Consequences of Partition"— all the complex and divisive tasks involved with dismantling the century-old Raj. On his instructions, the document's preamble stated "that the work should be sufficiently advanced to allow transfer of power by August 15th."[16]

Mountbatten was pleased to see that the Indian leaders "were dumbfounded and displayed some alarm" at the tight schedule.[17] Naively, he hoped that they would be too busy over the next two and a half months to quarrel much.

Instead, Nehru "reacted very badly" after studying the paper, one of Mountbatten's aides reported, not because of the August deadline but because the plan did not involve immediately booting Jinnah's five obstructionist Leaguers out of the government.[18] At a cabinet meeting just days later, Nehru exploded when Liaquat tried to stop him from appointing an ambassador to Moscow; the Quaid's deputy claimed that Pakistan had no wish to establish an embassy in the Soviet Union. "The ensuing scene was babel, with everyone talking furiously at once," Alan Campbell-Johnson recorded in his memoir. "Nehru asserted . . . that if the Government was to be turned over to the League he would immediately resign."[19] It did not help that the envoy Nehru intended to nominate was his eldest sister, Vijaya Lakshmi Pandit, nicknamed Nan.

With goodwill between the parties, a speeded-up Partition might have worked. The most important issues — whether Pakistan would continue to use the Indian rupee, for instance — could have been dealt with over the course of several more months, if not years. But after all the tension and distrust and death of the preceding months, every decision, no matter how petty — from how many fighter jets each country would be allocated to who would get the subcontinent's single tide predictor — was fraught. Each became one more opportunity to add to the store of suspicions and resentments dividing the League from the

Congress, Muslims from non-Muslims. Mountbatten famously had wall calendars made up for Raj officials, each page announcing in bold numerals exactly how many days remained until the transfer of power. The numbers dwindled all too quickly — yet not nearly fast enough.

Would there be one India or two? Although press leaks and the lengthy negotiations had drained some suspense from the question, Indians from Calicut to Chittagong still gathered around their radio sets on the evening of 3 June to hear the verdict. At the offices of All-India Radio, employees crammed balconies and leaned out of windows as the vice-regal motorcade rolled up outside. Nehru, Jinnah, and Baldev Singh followed Mountbatten into the building, harangued by a group of saffron-robed *sadhus* — Hindu ascetics — shouting anti-Pakistan slogans.[20] The viceroy had asked each of the Indian leaders to speak to the nation after him — to convince their followers to accept Partition and move forward.

Mountbatten had begun working on his own address within weeks of arriving in India, and he delivered it smoothly and with assurance. Baldev Singh signaled Sikh assent glumly but without quibbling; he still hoped that there would be a way to draw the border to keep the Sikh community intact.

Jinnah, by contrast, was disappointing. Like many others, Ismay found his address to be "egotistical and much below the level of events."[21] The Quaid noted that "the plan does not meet in some important respects our point of view."[22] He even refused to say whether the League would accept the scheme as a final settlement or only as a compromise that could later be adjusted.

Nehru's short address was bittersweet but firm in its resolve to draw a line under the madness of the last year. There would at last be an independent India but one shorn of its northwestern and northeastern wings and tens of millions of its citizens:

> It is with no joy in my heart that I commend these proposals to you, though I have no doubt in my mind that this is the right course. . . . We stand on a watershed dividing the past from the future. Let us bury that past in so far as it is dead and forget all bitterness and recrimination.

Let there be moderation in speech and writing. . . . There has been vio-
lence — shameful, degrading and revolting violence — in various parts
of the country. This must end. We are determined to end it. We must
make it clear that political ends are not to be achieved by methods of
violence now or in the future.[23]

Almost everywhere, the news had an initial calming effect. Over the
next fortnight, provinces reported a palpable easing of tensions across
most of the subcontinent. Rather than exploding into riots, cities like
Bombay and Calcutta seemed to exhale in relief — their citizens glad
finally to have clarity and a break from the ceaseless fear of preceding
weeks. "A new feeling of hope and expectancy [is] abroad," Mountbat-
ten wrote to the king on 5 June.[24] For a moment the viceroy could allow
himself to believe that he had pulled off, as an excited Ismay put it, "a far
bigger thing than the destruction of Hitler."[25]

One province, however, remained deeply unsettled: the Punjab.
There, the Partition plan only delayed a reckoning. According to
Mountbatten's scheme, the seventeen Muslim-majority districts in the
western Punjab and twelve non-Muslim districts in the east were to vote
separately on whether to join India or Pakistan; then, a Boundary Com-
mission would determine exactly where the final border would run.
While Tara Singh and other Sikh leaders seemed willing to await the
commission's verdict, they also vowed to resist any dividing line that
did not ultimately extend India to the banks of the Chenab River in
the west, leaving only a sliver of the province to Pakistan. "I am not a
magician," Mountbatten sighed when asked at a press conference how
he planned to reconcile the Sikh and Muslim claims. "I believe that it is
the Indians who have got to find out a solution. You cannot expect the
British to solve all your problems."[26]

The militias that had been gathering in the Punjab for the past few
weeks filled the resulting political vacuum. They met little resistance.
"All governments, without exception, are stable only insofar as they
can effectively reward and punish. In the Punjab we began to lose this
power in February 1947," Governor Sir Evan Jenkins recalled many years
later. "In June 1947 when it was made clear that we were to leave on
15th August of the same year, we became politically impotent."[27] Both

Muslim and non-Muslim militants could count on sympathizers in the administration to pass them intelligence. Police and magistrates of the same religion reliably looked the other way. If arrested, fighters could be confident they would be freed after independence if not before.

Local League, Congress, and Akali politicians were strongly suspected of encouraging, if not actually paying, the militants. Newspapers funded by Hindu tycoons spewed "insidious incitement to future violence," according to the Punjab's fortnightly report for the first half of June. Editorialists assured Sikhs of the Congress's backing for their impossible demands. If the commission did not concede them, Lahore's *Tribune* exhorted, the Punjab's turbaned warriors could always fall back on a final appeal — the "appeal to cold steel."[28]

Day by day through the first half of June, the flickering war of shadows on the streets of Lahore and Amritsar began to burn brighter. There were no riots, no great, unruly mobs as there had been back in March. Instead, each night, those few foolish enough to venture outside their Hindu or Sikh or Muslim bastions simply ended up dead. Police would find limp corpses scattered about the next day, blood pooling around their bony limbs. After dark, arsonists skittered across rooftops in Lahore's walled city, flinging kerosene-soaked balls of rags and shooting flaming arrows into Hindu homes or shops. (Although a minority in the city, Hindus owned more than three-quarters of the property; they provided the most tempting targets.)

Muslims conducted the vast majority of arson attacks. Jenkins had "no doubt whatever that the Muslim League approved, and in some degree directed, the burning," he reported to Mountbatten.[29] Firefighters wearing ancient tin helmets struggled to control the blazes in temperatures that rarely dropped below 100 degrees, even at night. Lahore had only two fire engines in all, and they proved next to useless in the spiderweb of tiny lanes that ran through the walled city. Hindus and Sikhs quickly lost faith in the authorities' ability or willingness to protect them. They reinforced the metal gates and barricades blocking off their neighborhoods and began stockpiling barrels of water to put out fires. Armed spotters took up positions on rooftops.

They also looked for ways to retaliate. By the middle of June, RSSS bombmakers had finally started to master their craft. Beginning on

10 June, crude bombs began exploding in crowds of Muslims — in a mosque, a cinema, a hospital. The devices were not particularly deadly, killing only fourteen people over ten days. But they injured over a hundred, and they terrified many more. With each outrage, the terrorists appeared to be getting more skilled. Just two bomb attacks on 20 June accounted for more than a third of the casualties.[30]

The bombings enraged men like Billa Jatt — a Lahore Muslim goonda well-known to police for his brawling past. As his son recounted sixty years later to researcher Ishtiaq Ahmed, Jatt and his family had been driven out of the Hindu-dominated Shahalmi Gate neighborhood during the March riots.[31] The area had since become an RSSS stronghold. According to rumor, Hindus and Sikhs were stockpiling guns, bombs, and ammunition behind its walls.

After the latest RSSS bomb attack, a local Muslim magistrate came to Jatt with a plan to teach Shahalmi Gate's Hindus a lesson. The goonda readily agreed to help. Just after midnight on 21 June, a Saturday night, members of Jatt's gang snuck past sentries posted at the Shahalmi Gate with two *pippas,* or drums, of a flammable solution used in shoemaking. They splashed the liquid across wooden shop fronts and homes, even on the barrels of water kept to fight fires. As the big clock at Lahore's Government College struck 1:00 a.m., they lit torches. Wooden homes — dry from the monsoon-less summer — went up in a roar of flames. "Huge tongues of fire" were visible from miles away.[32] Jatt's son, who was watching next to his father, sneezed from the smell of chilies burning in local spice shops. Half a century later, the agonized screams of victims still chilled him.

A fire crew showed up, drawing water for their hoses from a nearby canal. But the Muslim magistrate who had masterminded the attack ordered the crew to turn their hoses around. "The result was that while it sounded as if the fire brigade was working full throttle, the water was flowing back into the canal," Jatt's son recalled.[33] Over 250 homes burned to the ground over the next twelve hours. Ironically, the firefighters engaged in this charade while standing next to a small Hindu temple built years earlier by Nehru's father, Motilal, whose wife had grown up in Lahore.

In Delhi, word of the fires reached Nehru just after he returned from

a dispiriting visit to a refugee camp in Hardwar in the Himalayan foot-hills. Thousands of Punjabi Hindus and Sikhs displaced by the earlier riots in Rawalpindi had pressed in on him and Gandhi, "forming a solid wall of smelling, perspiring flesh which made one gasp for breath," the Mahatma's secretary recalled.[34] Their misery weighed heavily on Nehru and blended in his mind with the piteous plight of Shahalmi Gate's resi-dents. Wild stories claimed that as Lahore's Hindus rushed out of their burning homes, they were being gunned down by the police — who were predominantly Muslim — for breaking curfew.

Nehru held Jenkins's administration responsible for failing to quell the League's arson campaign, and he felt his own powerlessness keenly. Late on Sunday night, he penned a distraught, almost inconsolable note to Mountbatten. He had tried to stop himself, "but the thought of La-hore burning away obsessed me and I could not restrain myself," Jawa-harlal explained:

> At this rate the city of Lahore will be just a heap of ashes in a few days' time. The human aspect of this is appalling to contemplate.... I do not know if it can be said that what is happening in Lahore is beyond human control. It is certainly beyond the control of those who ought to control it. I do not know who is to blame and I do not want to blame anybody for it. But the fact remains that horror succeeds horror and we cannot put a stop to it.... Are we to be passive spectators while a great city ceases to exist and hundreds of thousands of its inhabitants are reduced to becoming homeless wanderers, or else to die in their narrow lanes?[35]

The Shahalmi Gate fires raged for days. The flames "signalled a Muslim victory," writes historian Ian Talbot. "Hindus and Sikhs would henceforth live in [Lahore] on Muslim terms"— and they knew it.[36] The trickle of minorities fleeing the Punjab capital for Delhi and other cities in India became a torrent. By the beginning of July, half of La-hore's Hindu population had abandoned the city. Since non-Muslims dominated the worlds of finance and commerce, the flight of capital was even more striking: some 3 billion rupees, or $912,547,528.51 in 1947 dollars, had been transferred out of the Punjab by 8 July.[37] Hindu-con-trolled banks and insurance companies shifted their offices to Delhi.

Trains and planes to the Indian capital were reportedly filled with gold bullion, jewelry, and banknotes. Houses went on the market for a third of the price they would have commanded six months earlier.

Jenkins saw no way for police — or even army troops — to prevent every single arson attack or stabbing. Traditional intelligence networks had broken down as informants switched their loyalties from the departing British to the communal militias. In desperation, the Punjab Criminal Investigation Department (CID) set up a secret interrogation facility in an unused wing of the Lahore Mental Hospital to try and develop leads. Although Jenkins vehemently denied that police tortured suspects there, the CID officer in charge of the facility admitted to a colleague, "I have been hitting out pretty hard."[38]

In spite of that, progress was agonizingly slow. "What is needed is direct and private pressure on the party underworld and a stoppage of funds," Jenkins implored the viceroy.[39] Rapprochement, however, was no longer much of a priority for local politicians. On 23 June, with Shahalmi Gate still burning, the two halves of the Punjab legislature convened behind barbed-wire barricades and formally voted to go their separate ways.

Nehru wished he could do the same in Delhi. The long summer weeks were for him a frustrating limbo, filled with rambling committee meetings, negotiations over assets, constitutional drafts, and endless memos. After a referendum in the NWFP, the province was lost to Pakistan. Tiny Assam was partitioned, with its Muslim-majority Sylhet district added to eastern Bengal. Bengalis, like Punjabis, voted to divide their province.

Nehru was running through relays of shorthand typists every night, drawing up long-range economic plans that Liaquat, as finance minister, reliably blocked.[40] The ungodly heat — the rains were late that year — made tempers short. "Nehru is over-working himself to such a degree that he practically is not sleeping at night and is having real difficulty in controlling himself at meetings," a worried Mountbatten wrote.[41] One of the viceroy's aides thought the Congress leader might well be "heading for a nervous breakdown."[42] After the Shahalmi Gate fires, Nehru again told Mountbatten that he would quit if Jinnah's men

were not kicked out of the interim government and the Congress Party allowed a free hand in its own territory.

This was hardly Nehru's first threat to resign, nor would it be his last. With just over six weeks left before the handover, however, it may have been the most alarming. The Indian Independence Bill was still slowly wending its way through Parliament in England, where many Tories had not yet resigned themselves to losing Britain's Indian empire. The process of dividing up the Raj had barely begun. India's surveyor general recalled being asked to draw up a list of his department's assets by the end of June. On the 21st — a Saturday — he had been told to draft a plan immediately to divide everything. Two days after that, his entire staff was given twenty-four hours to decide whether they wanted to work for India or Pakistan.[43] It would not take much to drive the whole improbable process off the rails.

Mountbatten tried to reason with both Nehru and the more even-keeled Patel, to no avail. "Both agreed that all Congress leaders are firmly united in their complete refusal to be dictated to by Jinnah any longer," the viceroy cabled London. Even allowing for his typical hyperbole, Mountbatten wasn't far off when he warned, "Situation here incredibly explosive and more dangerous than any I have seen to date."[44]

The viceroy suggested a compromise. He could assign all the cabinet ministries to the Congress nominees as Nehru was demanding, but allow the Leaguers to hold on to shadow portfolios in order to watch over Pakistan's financial and other interests. Jinnah found the proposal intensely demeaning. "This was now only a matter of 40 odd days," he complained. "He would appeal to the Congress to rise to the occasion and not to put forward a proposal . . . humiliating to either side." The Quaid also feared that once in control of all ministries, the Congressmen would cheat Pakistan out of its rightful share of the Raj's assets. He insisted that the British government be asked to rule on the legality of the move. Patel sarcastically urged Jinnah "to look after his own area and to leave them to look after theirs. What was the good of going into the legal side of the question?"[45]

Jinnah certainly bore his share of blame for embittering politics on the subcontinent over the past decade. Still, as the clearly weaker party, he had every incentive now to work for a friendly, stable relationship

with the future leaders of India. The fighting in Lahore had disturbed him no less than Nehru: "I don't care whether you shoot Muslims or not, it has got to be stopped," the Quaid had told Mountbatten the day after the Shahalmi Gate blaze broke out.[46]

Yet everywhere Jinnah turned he seemed to face a wall of Congress hostility. Patel refused to let Pakistan have even one of the six printing presses that belonged to the British Raj, all of which sat in Indian territory. "No one asked Pakistan to secede," the Sardar growled when Mountbatten pressed him to show more generosity. The Congress leaders "all absolutely blew up" when Jinnah proposed inviting League representatives to Delhi in mid-July to begin writing a constitution for their new nation. Mountbatten favored the idea, which would have allowed Pakistanis and Indians to mingle together informally at evening soirees. "In no circumstances," Nehru and the others told the viceroy flatly, "would they agree to allowing the Pakistan Constituent Assembly anywhere near Delhi."[47]

It was in this mood that Jinnah approached perhaps the most critical decision of the summer: whether Pakistan would initially share a governor-general with India. The position — the constitutional link between a dominion and the British Crown — was largely ceremonial. But it was crucial to the "superstructure" that London had envisioned for the subcontinent. With a single, impartial governor-general uniting the two new dominions, the Indian Army could remain whole for the time being. Alliances and foreign policy could be coordinated. Internal disputes could be adjudicated peaceably. Nehru and the Congress had already nominated Mountbatten for the role.

Jinnah had been stalling for weeks. On 2 July, "astounded" at the Quaid's dilatoriness, Mountbatten demanded an answer.[48] By this point, Jinnah had reason to wonder about the viceroy's impartiality — or at least his willingness to stand up to Nehru's petulant threats. When he arrived at Viceroy's House that evening, the League leader adopted a sorrowful mien. Many times in his career he had had to pass over those nearest and dearest to him, he told Mountbatten. He would have to do the same now: his followers were insisting that the Quaid himself become Pakistan's first governor-general.

Mountbatten desperately wanted the glory of both ending the Raj

and leading the world's newest nations. Not surprisingly, he scoffed at the explanation. "The only adviser that Jinnah listens to is Jinnah," Mountbatten wrote in his next report to the king.[49] The next day, the viceroy spent four hours trying to shake Jinnah's resolve. "Do you re- alise what this will cost you?" Mountbatten warned. Unperturbed, the League leader acknowledged that Pakistan might lose out on tens of millions of rupees in assets in the ongoing division. "It may well cost you the whole of your assets and the future of Pakistan," Mountbatten barked before storming out of the room.[50]

Jinnah urged Mountbatten to stay on as India's governor-general at least, to provide a restraining influence over the Congress leaders. Still, the fact remained that there would henceforth be no single figure or institution uniting the new dominions. Partition would be total, and Pakistan would have to be ready to govern itself on 15 August. In the halls of Delhi ministries, those Muslim civil servants who had opted to serve in Pakistan now looked to some of their colleagues like foreign- ers and potential fifth columnists. Indeed, the second-in-command in Patel's Intelligence Bureau, a Muslim, became Pakistan's first spy chief.[51]

By the time Parliament approved the Independence Bill on 18 July, the Quaid had forfeited any sympathy he might have expected from Mountbatten. The next morning, the viceroy told Jinnah his time was up: the Congress would be given charge of all central government min- istries as Nehru had asked. Muslim League appointees could only inter- fere in matters directly affecting Pakistan.

It was a Saturday, the first day of Ramadan. When Muslim officials showed up to work on Monday, they found their former offices closed to them. Weak from fasting, they had to drag desks and chairs out onto the lawns of ministry buildings, sweating under the flat, harsh glare of the sun. Furious and embarrassed, Liaquat told Mountbatten that he had originally questioned the rush to get Pakistan established by 15 Au- gust. Now, though, he wished "to God you could get Partition through by the 1st August!"[52]

For now, Jinnah could only retaliate with symbolic gestures. He rejected the flag Mountbatten himself had designed for Pakistan, which bore the Union Jack's cross next to the crescent of Islam. He scotched the sugges-

tion that the king should continue signing "George R.I." (*Rex Impera-tor*) even after he was no longer "Emperor of India." Jinnah refused to commit to flying the traditional, deep-blue governor-general's flag over his house.[53] Tradition-obsessed, Mountbatten was "almost in despair" over the Quaid's behavior, Ismay told Jinnah on 24 July. The League leader feigned dismay. "I beg to assure the Viceroy that I am his friend and yours for now and always," he said with transparent insincerity.[54]

What Jinnah and Pakistan needed most was allies. On the same day he saw Ismay, the Quaid met with a delegation from the kingdom of Hyder-abad in southern India. The state's ruler, His Exalted Highness Nizam Sir Mir Osman Ali Khan Siddiqi Asaf Jah VII, was reputed to be the rich-est man in the world, with storehouses piled high with rubies, emeralds, and gold. He was also an ill-tempered, eccentric gnome who shuffled about his grand palace in threadbare slippers and a yellowing kurta, and reputedly used the Jacob Diamond — a 280-carat monster — as a paper-weight. Heir to a centuries-old Muslim dynasty, the nizam ruled over a state nearly the size of France through a predominantly Muslim court elite, even though 86 percent of the state's population was Hindu.

Indian territory surrounded Hyderabad on all sides. Like every one of the 565 "independent" monarchs in India, the nizam had surrendered control over defense, foreign affairs, and communications to the British. On the advice of his constitutional adviser, Sir Walter Monckton — an eminent Tory lawyer and friend of the Mountbattens — he now pro-posed to sign a treaty transferring those same powers to Nehru's govern-ment after 15 August.

The Quaid had a long history with India's colorful monarchs, whose support he had pursued in the quest for Pakistan, and some of whom he had represented in legal proceedings. Jinnah strongly urged the nizam to reconsider. If Hyderabad instead declared itself fully independent af-ter 15 August, it could "give a lead to other States."[55] Kingdoms like My-sore and Travancore — which was rich in thorium and possessed a long, strategic coastline — had more enviable resources than some members of the fledgling United Nations. Jinnah had already promised Travan-core's erudite *diwan,* or prime minister, Sir C. P. Ramaswami Aiyar, that his Hindu maharajah could count on food aid from Pakistan if the state decided to hold out against India.[56] If the Congress leaders threatened

the nizam, Jinnah promised, "he and Pakistan would come to the help of Hyderabad in every way possible. There should be no doubt on that point."[57] Jinnah's intervention worked. As of 15 August, the nizam still had not acceded to India.

If this sort of thing continued, India faced a potential nightmare. Hundreds of kingdoms were tiny, some no bigger than a farmer's fields. But together they accounted for nearly half of the landmass of British India. A few like Hyderabad were big enough to indulge fantasies of striking out on their own, with small but well-trained and well-equipped militaries. If enough chose to do so, India would be gutted internally, cut up by pockets of potentially hostile territory. Rebels and smugglers would find a plenitude of safe havens. Trade within the country would forever be vulnerable to disruption. U.S. strategists feared a return to the pre-Mughal days, when warring states pockmarked the subcontinent. Washington pressed Attlee to reject any overtures from the nizam or any other independence-minded rulers.

Although a royal himself and close to several Indian monarchs, Mountbatten had no intention of letting his playboy compatriots undermine the dominion he was about to lead. Patel, who had taken charge of India's relations with the various princes, was willing to offer them the same terms as the British, asking only for powers over defense, foreign affairs, and communications as part of their accession to India. The rulers could keep their palaces and baubles and seventeen-gun salutes — as long as they signed up before independence.

On 25 July, Mountbatten donned his "Number Tens"—his ivory-white admiral's uniform with its rows upon rows of medals — and gravely presented this offer to a packed Chamber of Princes in Delhi. His loyal hagiographer Alan Campbell-Johnson later put forward the accepted account of the proceedings, in which Mountbatten masterfully charmed the glittering assemblage. Deploying humor and his immense charisma, speaking without notes yet "never at a loss for word or phrase," Mountbatten emphasized the generosity of the Congress offer and the bright future the princes would share as part of a resurgent India. He dissolved the room in laughter, once pretending to look into a crystal ball and divining that an absent ruler wanted his prime minister

to agree to join India. "His fluency was matched only by his extraordinary frankness," Campbell-Johnson gushed. "Mountbatten can regard the whole occasion as yet another personal *tour de force*."[58]

In fact, immediately after the meeting, Campbell-Johnson huddled with V. P. Menon for four hours, scrubbing much of that "frankness" out of the official transcript of the proceedings. According to a different viceregal aide, Mountbatten had actually delivered a blistering, unprintable message to the rulers, most of whom he found "very stupid": "He threatened sanctions — such as withholding arms, ammunition, and other supplies — against States not agreeing to accede." He let "Sir C.P." in particular "have it" for making overtures to Britain and the United States, and pledged to "do everything in his power" to make life difficult for Travancore if its leaders continued to resist joining India.[59]

In the end, the government itself did not need to lift a finger to sway the rulers. Hindu industrialist Seth Dalmia had already donated 500,000 rupees to the underground Congress organization in Travancore to foment protests. After Aiyar returned home, he was stabbed in the neck with a bill-hook and nearly died.[60] Travancore signed.

While his aides were busy sanitizing the record, Mountbatten changed into evening wear and sat down to dinner with the Quaid and his sister Fatima. The conversation stumbled along awkwardly. Jinnah spent much of the meal interrupting Mountbatten and "cracking a series of very lengthy and generally unfunny jokes."[61] When the discussion turned to the states, Jinnah chided Mountbatten "not to be in such a mortal hurry" to pin down their rulers: "after all, one could not make the world as one wanted it to be in a week."[62] "In that affectionate tone which he has recently begun to use with me," as Mountbatten put it, the League leader instead urged "a period of suspense and delay," while the new dominions got established and the states adjusted themselves to a post-British reality.[63]

The two men touched only briefly on the one big state that bordered both Pakistan and India — Kashmir. The Himalayan kingdom's situation was almost exactly the reverse of Hyderabad's: a Hindu maharajah ruled over a population that was more than three-quarters Muslim. Jin-

nah swore he did not intend to pressure the state one way or the other. Whether Kashmir wanted to sign a treaty with Pakistan and use Karachi as an outlet to the sea, or preferred India and the port of Bombay, the Quaid promised not to stand in the way.

Nehru, for one, did not believe him. According to rumors reaching Delhi, Kashmir's Hindu prime minister, Pandit Ram Chandra Kak, was encouraging the maharajah to throw in his lot with Pakistan — presumably under Jinnah's baleful influence. Two days after Mountbatten's dinner with the Quaid, Nehru sent the viceroy a curt note, declaring that Kashmir had become his foremost priority. He intended to fly to Srinagar to confront the maharajah himself.

Nehru had long felt an almost mystical kinship with his ancestral land, with its spiky, snowcapped peaks and meadows aflame with wildflowers. Just as importantly, he loathed its ruler, Sir Hari Singh, who typified everything Nehru despised about the decadent, feudal princes. In 1924, Singh had gotten caught up in a sensational sex-and-blackmail scandal in Paris and had had to flee the continent, paying 150,000 pounds to hush up the matter.[64] While his state produced the finest, most delicate shawls in the world, most of his subjects lived in rags. Kashmir's timber and tourism, its walnuts and apples and saffron, earned millions of rupees — a great number of which the monarch spent at the racetrack in Bombay, as well as on his stables and extensive harem.

The maharajah had thoroughly repressed any hint of democratic opposition to his rule. Most of the leading members of the National Conference — the Congress-affiliated people's party in the state — had been in jail for the past year. Nehru had personally taken under his wing the party's populist leader, Sheikh Mohammed Abdullah, the towering son of a Muslim shawlmaker from Srinagar. Miraculous legends had grown up around Abdullah. After one of his eight arrests, the people said, when Hari Singh had tried to boil him in oil, Abdullah had casually scooped up the bubbling liquid "as you would lift up curds or cool cream." Peasants insisted that they had found leaves on trees engraved with Abdullah's nickname, "Sher-i-Kashmir"— Lion of Kashmir.[65] In July 1945, shortly after being released from prison, Nehru had spent several days trekking through the mountains with Abdullah. Village women had serenaded the men as they walked past:

You are the golden earring in our ears.
Where are you going far away from us?
The way is long and perilous,
Come back, come back to us soon.[66]

Although Muslim, Abdullah rejected the League's call for Pakistan. He spoke Nehru's language of democracy and people's rights, of land reform and industrialization; he insisted that Hindus and Muslims were one people, and India one nation. After the sheikh's latest arrest in June 1946, Nehru had rushed to his defense, only to be detained overnight himself when he tried to cross the Kashmir border.[67]

Nehru's note horrified Mountbatten. He pictured Nehru being tossed into jail again and sternly told the prime-minister-to-be that with just over two weeks to go before he assumed responsibility for 300 million Indians, this was not the time "to leave the capital on what really amounted to almost private business."[68] Patel had assumed control of negotiations with the princes precisely to avoid this sort of half-cocked outburst. He, too, remonstrated with Nehru. The Congress leader broke down in tears, saying Kashmir meant more to him at that moment than anything else, even independence. "As between visiting Kashmir when my people need me there and being Prime Minister, I prefer the former," he told Gandhi.[69] Finally, Nehru agreed to let the Mahatma go to Kashmir in his stead.

The idea of losing the state to Jinnah gnawed at Nehru, though, and he was furious at Mountbatten's intervention. "I hardly remember anything that has exasperated me quite so much as this affair," Nehru grumbled to Gandhi.[70] On 1 August, according to *Time* magazine correspondent Robert Neville, a group of ash-smeared sadhus protesting the division of the country lay down in Nehru's driveway to block his car. The Congress leader leaped out in a rage and started kicking the Hindu holy men.[71] His sister Nan quickly joined him, then his servants arrived armed with sticks. At least one of the sadhus was later hauled off to the hospital, beaten and bloody.

1 August. Mountbatten's ominous wall calendars showed fourteen days left. The switchboard at Viceroy's House lit up with an urgent call from

the Punjab. Jenkins had disturbing news to report. In the countryside around Amritsar, roving Sikh death squads had begun targeting Muslim villages. Nearly two dozen Muslims had been killed and thirty wounded in just the last forty-eight hours, while four passenger trains had been attacked. Jenkins believed a bigger offensive was planned. "There is going to be trouble with the Sikhs. When, and how bad, the Governor cannot yet say," one of his aides advised.[72]

The ranks of Sikh militants had swelled from a few thousand at the beginning of the summer to nearly twenty thousand by the end of July.[73] Many of the fighters were ex-military — well-trained and battle-tested in the deserts of North Africa and jungles of Burma. Several had switched sides during the war and fought for a Japanese-sponsored rebel force, the Indian National Army, in Southeast Asia. Bankrolled by Hindu tycoons and Sikh maharajahs — Faridkot had allegedly converted a distillery in his state into an explosives factory — they also tended to be better armed than their rivals.[74] Late that summer, British historian Michael Edwardes — then a young soldier — stumbled across nearly three hundred Akalis drilling with rifles and tommy guns in a village just a few miles from Amritsar. They eagerly put on a shooting contest for him "in which the targets were dummies of Muslim men, women and children." The fighters vowed that "there would not be a Muslim throat or a Muslim maidenhead unripped in the Punjab" when their work was done.[75]

With so many amped-up, heavily armed young men roaming about the central Punjab, clashes were virtually inevitable. Thus far the Akali jathas seemed to be freelancing: "I have the impression that they have made certain preparations, some of which are now being disclosed prematurely," Jenkins reported.[76] Years later, Master Tara Singh confirmed the governor's impression, saying that the murder of a Brahmin in the village of Nagoke had prompted the militants to retaliate on the night of 30 July. "In the fight which ensued," Singh wrote in a private letter, "the Muslims were routed and the Sikhs continued their offensive."[77]

For the past two months, a steady stream of Sikh dignitaries had begged Mountbatten and Jenkins to carve out a Sikh homeland. They wanted the borders of the Punjab redrawn, with its western edge given to Pakistan, an eastern sliver attached to India's United Provinces, and

the remainder left as home to at least 80 percent of the Sikh community, as well as most of Sikhism's holiest shrines and the rich canal lands cultivated by Sikh farmers. If the remaining Sikhs in Pakistan — less than a million of them — were exchanged with Muslims in this "Sikhistan," "then the Sikh problem is solved," Giani Kartar Singh had assured the viceroy.[78]

If their demands were not met, on the other hand, Sikhs dolefully promised to fight — "murdering officials, cutting railway lines and telegraph lines, destroying canal headworks, and so on," the Giani told Jenkins on 10 July. The Punjab governor had immediately alerted Mountbatten, warning, "This is the nearest thing to an ultimatum yet given on behalf of the Sikhs."[79] Jatha leader Mohan Singh, a former commander in the Indian National Army, had presented the Punjab governor with an even more chilling scenario the next day:

> He said that the only solution was a very substantial exchange of population. *If this did not occur, the Sikhs would be driven to facilitate it by a massacre of Muslims in the Eastern Punjab.* The Muslims had already got rid of Sikhs in the Rawalpindi Division and much land and property there could be made available to Muslims from the East Punjab. Conversely the Sikhs could get rid of Muslims in the East in the same way and invite Sikhs from the West to take their places. He did not put his case quite as crudely as this, but his general ideas were clear.[80]

The Sikhs' demands fell on deaf ears. In mid-July, some well-meaning British intermediaries, including former Punjab official Penderel Moon, had shuttled between Lahore and Delhi to promote a different option: granting autonomy to the Sikhs within Pakistan.[81] Jinnah was no longer interested. The Sikhs who would end up on his side of the border would be useful to Pakistan as "hostages," he told Pug Ismay; their presence would ensure that Muslims left behind in India were not ill-treated.[82] "As far as Jinnah was concerned," wrote Moon, now serving as revenue minister in the Muslim state of Bahawalpur, "the Sikhs could go to the devil in their own way. It was they who had demanded the partition of the Punjab. They could now take the consequences."[83] Jenkins blasted the Quaid's attitude as "perilously unsound."[84]

Nehru had hardly been more realistic. He disliked on principle

Mountbatten's suggestion of exchanging Sikh and Muslim populations before the transfer of power.[85] Instead, Nehru advised Sikhs to trust in the Boundary Commission that would set the final border. Although the line was meant simply to divide populations of Muslims and non-Muslims, he had ensured that vague "other factors"—including presumably the location of Sikh shrines and property—would also be taken into consideration.

In short, the Sikhs were useful pawns to Nehru and India, no less than to Jinnah. It was not inconceivable that in order to avoid a civil war, the Boundary Commission would grant the Sikhs' claims. Whatever extra territory they gained—including possibly the city of Lahore—would naturally accrue to India, not Pakistan.

The commission tasked with dividing the Punjab—two Muslim judges, a Hindu, and a Sikh—wrapped up their hearings in early August. They had sweltered for weeks in a shabby Lahore courtroom, as peons shuffled papers and circulated through the audience with brass stands carrying glasses of water. Lawyers for the League, the Congress, and the Sikhs had put forward elaborate cases for their communities, backed up by population statistics, maps of property ownership and irrigation canals, personal testimonies, historical texts, and legal precedents. Money may have changed hands as well: some Sikh figures gleefully claimed to have bribed the commission to accept rigged population numbers.[86]

As might have been expected, the commissioners deadlocked, each siding with his own community. That put the case in the hands of one man—Sir Cyril Radcliffe, chairman of the Boundary Commission. Radcliffe was a wealthy Inner Temple lawyer with an unfortunate schoolboy nickname ("Squit").[87] He had never been to India before. After finishing his task, he would never return. "I suspect they'd shoot me out of hand, both sides," he candidly admitted to one interviewer.[88] Radcliffe knew next to nothing about the lands he was tasked with dividing, nor did he have time to learn. He only arrived in Delhi on 8 July, with barely five weeks to finalize the border.

Radcliffe spent most of his time in a bungalow on the viceregal estate, dripping sweat onto ordnance maps and closely typed census tables. He described the brutal Indian summer as a foretaste of "the mouth

of hell."[89] (Little did he know how literal that thought would prove.) Commissioners in Lahore and Calcutta sent him daily transcripts of their hearings to study. It would have taken years to settle on a proper boundary, Radcliffe later wrote, one that took into account not just demographics but natural features, canal headworks, communications, and culture. Yet to blame his ignorance, or the radically shortened timetable, for the massacres to come is too easy.

No conceivable border could have satisfied both Sikh and Muslim demands. Mountbatten had created the mechanism of a Boundary Commission less to square that circle than, as one senior British official in London put it, "to keep the Sikhs quiet until the transfer of power."[90] After that, when the Sikhs confronted the reality of their position, they would be the problem of the new dominions; the British would be gone. Radcliffe's task was in that sense quite simple. "Jinnah, Nehru and Patel told me that they wanted a line before or on 15th August," he recalled. "So I drew them a line."[91]

Only now, after a month's work, did the interrogators at the Lahore Mental Hospital begin to produce some usable intelligence. On the morning of 5 August, Jenkins dispatched a CID officer named Capt. Gerald Savage from Lahore to Delhi to see the viceroy. After hearing his report, Mountbatten held back Patel, Jinnah, and Liaquat following a midday meeting so that Savage could brief them as well.[92] Two detainees, a Sikh and an RSSS Hindu, had separately implicated Master Tara Singh in the stockpiling and distribution of guns and explosives in the Punjab. One of the captured men claimed he had delivered railway timetables to the Sikh leader, who had indicated they were to be used to target the Pakistan Special trains that would transport Muslim government officials from Delhi to Karachi. In his presence, the Sikh leader had also mused aloud about assassinating Jinnah, possibly on Independence Day, as Pakistan's leader paraded through the streets of Karachi.

The Sardar gruffly tried to downplay the confessions as extracted under pressure. According to Jinnah, Mountbatten "leapt on Patel" immediately, saying his reaction implied "you already know about this plot."[93] The Quaid wanted Tara Singh hauled in at once. Savage warned that an arrest now might set off a full-scale Sikh uprising. Ultimately the leaders

agreed to Mountbatten's suggestion that any arrests be postponed for a week, by which point Radcliffe's border would be ready. Still unhappy, Jinnah left two days later for Karachi without fanfare. As his plane circled above Delhi one last time, the Quaid gazed down impassively. "Well, that's the end of that," he muttered.[94]

In the Punjab, reports of the spreading village massacres were provoking Muslims to retaliate with a spate of stabbings and bombings in the cities of Lahore and Amritsar. Casualty counts rose steadily, with the daily toll of killed and wounded running between fifty and one hundred. On 9 August, one hundred Hindus were reported killed by Muslims in a single village outside Amritsar, their bodies thrown into a nearby canal.[95]

Jenkins did not disagree with the decision to hold off on arresting the Sikh leaders. He followed up with Mountbatten on 9 August, after conferring with the two men slated to replace him — Sir Francis Mudie for Pakistan, a hard-drinking Brit with a particular dislike of the Congress leaders, and polished Sir Chandulal Trivedi, the former governor of Orissa, for India. There seemed little point in detaining the Sikh leaders at all, Jenkins wrote. If they were jailed in the Indian East Punjab, they would no doubt be freed after independence; if caught in the West, they would likely be killed.[96] "Their followers were in any case unlikely to be deterred by their absence!" he noted years later.[97]

What the governor really needed were more troops and reconnaissance planes to hunt down the marauding jathas. "Rural raiding in areas in which communities are inextricably mixed cannot be checked except by display and use of force on massive scale," Jenkins advised the viceroy.[98] Troops, who were much better armed and trained, easily defeated the militants in open combat. One tank unit surprised and gunned down sixty mounted Sikhs in a battle outside the village of Majitha. But these early jatha raids were scattered and unpredictable. Soldiers usually didn't arrive until well after the killers had finished their grisly work and fled.

Mountbatten and the Indian leaders believed they had prepared adequately for this contingency. As early as 11 July, Field Marshal Sir Claude "the Auk" Auchinleck, the longtime commander in chief of the Indian Army, had proposed forming a Boundary Force of mixed Sikh, Hindu,

and Muslim units to patrol the dozen or so most disputed districts of the central Punjab. The Auk had gotten his start soldiering nearly a half-century earlier as a second lieutenant in a Punjab regiment; he spoke fluent Punjabi and knew the province and its peoples intimately. He argued that a show of force by neutral units under British officers would ease fears in the border areas and prevent a panicky exodus of refugees in either direction.

In theory this body — anchored by the 4th Indian Division under Maj.-Gen. T. W. "Pete" Rees, a tough little veteran of Monte Cassino — would eventually encompass fifty thousand soldiers. Alan Campbell-Johnson claimed it would be the largest peacekeeping force ever assembled.[99] Whenever he met with Sikh leaders, Mountbatten repeated his threats from earlier in the spring: the Boundary Force would meet any violent uprising with tanks, airplanes, and artillery. It would be suicidal to resist.

The Auk's beloved Indian Army, however, was in the throes of a wrenching transition. For nearly a century, the British-run military had knitted the subcontinent together. Muslim, Hindu, and Sikh battalions had fought and bled within the same regiments, purposely thrown together so that no one community could rise up in rebellion. Now, though, those units had to be dismantled and reconstituted, with Muslim units transferring to Pakistan and non-Muslims to India. Over "many weary hours" of discussions in the spring, Ismay had tried to convince Jinnah that the task would be an infinitely harder challenge than dividing the Punjab and Bengal. "An Army was a single entity with a single brain, a single heart, a single pair of lungs, a single set of organs. A peremptory partition thereof — a surgical operation without an anesthetic — would be fatal," Ismay argued.[100] Auchinleck estimated that the division, even if possible, would require at least three years to complete. Anything less and the army would disintegrate.

In the meantime, the reorganization "would virtually immobilise the units involved" for the next six months — just when their services would no doubt most be needed to prevent bloodshed. Worse, the process itself would only intensify the communal feelings that had been growing within the ranks since the end of the war. Whether Madrassi soldiers would obey orders to fire on Hindu rioters, or Baluchis on Muslims,

was no longer a given. "I cannot state with any certainty that during this process of reconstitution, the Army will retain its cohesion or remain a reliable instrument for use to aid the civil power in the event of widespread disturbances," the Auk formally advised Mountbatten.[101] Jinnah didn't care. Unless he had an army under his command on 15 August, he refused to take power.

The Boundary Force never came close to reaching its full strength. At this point, Jenkins had only about 7,500 effective rifles at his disposal. Those soldiers had to cover twelve border districts that together housed 14.5 million people.[102] Amritsar district, currently the most disturbed, was patrolled by just one weak brigade.

Worried, Liaquat ordered that extra guards be assigned to the Pakistan Special trains, the first of which set out from Delhi on 9 August. In Faridkot state, after darkness fell, the five Sikh saboteurs loaded their gelignite charges into a jeep and set out into the starlit countryside to intercept it.

Faridkot himself was in Delhi that evening, making nervous small talk at a cocktail party at the U.S. ambassador's house. As deeply involved as he had been in Sikh plotting to this point, the young rajah must have worried about what he and the Akali leaders had unleashed. "Faridkot asked me if it would be possible for us to give him and his family asylum at the Embassy if things got very bad," the new ambassador, Henry Grady, reported to Washington.[103] In fact, the Sikh ruler was hoping to buy himself a ranch in California. The Punjab was clearly no place to be right now.

6

Off the Rails

THE EXPLODING GELIGNITE ripped seven feet of rail out of the ground and flipped the train's carriage onto its side. A screech of rending metal cut through passengers' screams. As the brakes on the Pakistan Special jammed, the next two cars overturned as well. Four more careened off the rails. The exultant Sikhs leaped from their hiding place along the canal bank.

Stumbling out of the wreckage, the train's escort guards took aim at the bombers and opened fire. The Sikhs tossed aside the last, unused slab of guncotton and let off several rounds with their revolvers to slow any pursuit. Making it back to their jeep, they roared north toward the borders of Faridkot. The troops returned to the wrecked train, relieved to discover that only one woman and her child had been killed. Another twenty passengers had been injured, two of whom died later.

Despite the limited fatalities, the bombing's shock waves reverberated throughout Jinnah's soon-to-be Pakistan. This was not some jatha raid on a nameless Punjab village: Tara Singh's men had quite deliberately struck at the heart of Pakistan's still-nascent government. Crowds bearing flags and sweets had gathered along the train's route to cheer it onward. In Bahawalpur, from which a relief train was quickly dispatched, news of the derailment "aroused a good deal of excitement and indignation," Penderel Moon recalled with some understatement.[1] Officials in Karachi, the train's destination, feared for the fate of relatives

and close friends onboard. Further Special services were suspended indefinitely, given the risk of further attacks. By September, some seven thousand Muslim officials remained stranded in Delhi — a good chunk of Jinnah's new administration.[2]

The 9 August attack came as a rude shock to the Quaid. He had made a triumphant entrance into Karachi two days earlier, and was beginning to enjoy the trappings of being a head of state. He had immediately claimed the grand marble pile that had been the British governor's house for his own, striding through the halls imperiously, designating one wing for himself and his sister, another for "only very important people, like the Shah of Persia, or the King of England."[3] Copying the army of uniformed staff at Viceroy's House in Delhi, his new servants donned armlets with the monogram "Q" for Quaid.[4]

All around him Jinnah's new capital bubbled in a state of giddy chaos. Karachi was no longer the dusty port town where he had spent his childhood. The city's population had grown from 375,000 in 1941 — two-thirds of them Hindu — to nearly 600,000.[5] The newest arrivals, the enthusiastic partisans who had come to help build Pakistan, crowded into whatever housing they could find, from the bungalows of British officials to tenements in the brothel district along Napier Road. The wife of Pakistan's first foreign secretary recalled arriving by sea to cries of "Allah-o-Akbar!" Her companion grew teary-eyed at the sight of a little navy sloop flying the Pakistan flag in the harbor. "It is very small," he sniffed, "but it is ours."[6] Streets were strung with green lights in anticipation of the independence celebrations to come in a few days.

Jinnah himself seemed to have abandoned the cheap sectarian rhetoric that had marked his decadelong struggle against Nehru and the Congress. "You are free," he told Hindus and Sikhs at the opening session of Pakistan's Constituent Assembly:

> You are free to go to your temples, you are free to go to your mosques or to any other place of worship in this State of Pakistan. You may belong to any religion or caste or creed — that has nothing to do with the business of the State.... We are starting with this fundamental principle that we are all citizens and equal citizens of one State.... Now I think we should keep that in front of us as our ideal, and you will find

that in course of time Hindus would cease to be Hindus and Muslims would cease to be Muslims, not in the religious sense, because that is the personal faith of each individual, but in the political sense as citizens of the State.[7]

The message itself wasn't new. At a press conference in Delhi a month earlier, Jinnah had berated reporters when asked if Pakistan would be an Islamic theocracy. "You are asking me a question that is absurd," he had scoffed. "For goodness sake, get out of your head [such] nonsense."[8] Now, though, the words no longer sounded calculated. The Quaid didn't need to pretend for the mullahs nor obfuscate to keep his flock united. He was describing the state he had always intended — a multifaith democracy, just as he had once championed for India itself.

Jinnah had expected to get word of Radcliffe's boundary award — and now, surely, Tara Singh's arrest as well — on 12 August. Yet Delhi was silent on both. All that the papers carried that day was an interview with Sardar Patel, who unhelpfully predicted that Pakistan's new citizens "would be disillusioned soon" with Jinnah's rump state, and that "it would not be long before they began to return."[9] The lack of news was ominous. The Karachi rumor mill claimed that Radcliffe's frontier was undergoing some "last-minute jiggery pokery" inside Viceroy's House, as one pro-Pakistan Briton put it.[10]

Jinnah's suspicions were hardly alleviated by Mountbatten, who arrived in Karachi the next day to preside over the Pakistan handover. Before a formal dinner that night, the two men argued. Jinnah disagreed with the decision not to arrest the Sikh leaders. And he grew especially hot when Mountbatten revealed that the official border between India and Pakistan would now not be announced until 16 August — the day *after* independence.[11] At birth, amazingly, the subcontinent's new nations would not know their exact shape.

The viceroy's explanation sounded dubious. He claimed that Radcliffe had only just finished his work that morning, a couple of hours before Mountbatten had left for Karachi. Unable to study the maps carefully, Mountbatten had locked them in his safe, sight unseen. Now there was no time to have them printed until after the independence holidays in both dominions.

In fact, the Punjab border had been mostly ready several days before. Mountbatten had sent a preliminary sketch map to Sir Evan Jenkins on 8 August so that he could alert officials in the affected districts, and details had promptly leaked. Jinnah had already heard, for instance — correctly, it turned out — that most of the northern Punjab's Gurdaspur district had been given to India despite having a slight Muslim majority.[12] This decision meant that Nehru would get the land access to Kashmir he would need if the kingdom were to join India.

The real reason for the delay had nothing to do with Gurdaspur, though. That early sketch map also showed the Muslim-majority Ferozepore district — where the Pakistan Special bombing had just occurred — as part of Pakistan. The northeastern part of the district, however, formed a salient that crossed the Sutlej River. The spur would cut off Amritsar to the south, leaving the city surrounded on three sides by Pakistan territory. On 9 August, Nehru had warned Mountbatten that no slivers of Pakistan should pierce the Sutlej — an important line of defense.[13] A couple of days later, the maharajah of Bikaner, one of Mountbatten's closest friends in India, sent representatives to Delhi to point out that the canal headworks in Ferozepore controlled irrigation to Bikaner, as well as to much of East Punjab. The maharajah threatened to accede to Pakistan if the territory ended up falling on Jinnah's side of the border.[14]

Mountbatten pretty clearly appears to have pressured Radcliffe to redraw the map to give Ferozepore to India. The two Englishmen had lunch together on 12 August, joined by Pug Ismay. A few hours later, Jenkins received a terse, coded phone message from Viceroy's House: "Eliminate salient."[15] That evening, a pair of the viceroy's aides visited Radcliffe and convinced him not to submit the revised awards until just before Mountbatten had lifted off for Karachi, at which point it would be too late to publish.[16]

Mountbatten had more than one reason to delay releasing the award. He feared that the Congress leaders, too, would be incensed about the border: in Bengal, a Buddhist-majority tribal hill tract near Chittagong had been given to Pakistan. If Nehru and Patel found out, Mountbatten worried, they might boycott the grand independence celebrations he had planned for 15 August. In conjunction with his reluctance to arrest

the Sikh leaders, however, the Gurdaspur and Ferozepore awards could only look to Muslims like a deliberate attempt to shrink and undermine Pakistan — a "parting kick" from the British and their Congress friends.[17]

By the end of the evening, Jinnah's mood had grown dark. At an after-dinner reception "attended by some 1,500 of the leading citizens of Pakistan, which included some very queer-looking 'jungly' men" from the tribal areas, as Mountbatten later reported to the king, the Quaid stood aloof from his guests, almost in a reverie.[18] (One attendee likened him to a "walking, talking corpse.")[19] In another part of the lawn, Mountbatten yammered on to guest after guest, gracing them with the full force of his personality. Finally the Quaid called over a young aide-de-camp and asked him to tell Mountbatten to retire so that everyone could go to bed: "He had had enough of him."[20]

There were barely twenty-four hours left until the end of the British Raj. In the heart of the Punjab, the bloodbath Gandhi had once claimed as India's right now began in earnest. At 10:40 p.m. that night, Jenkins cabled Mountbatten with a grim admission: "Lahore urban area and Amritsar district are out of control."[21]

Order had collapsed swiftly after the train bombing. The very next day, a new Hindu police commander had taken up his post in the city of Amritsar and ordered anyone who planned to serve in Pakistan after independence to turn in their weapons.[22] Muslims accounted for nearly two-thirds of the city's harried police force. Suspecting a trap, they quickly piled their families and belongings into trucks and made for Lahore. In the jatha-ridden countryside, Muslim constables took to their heels as well, abandoning isolated and vulnerable outposts. One detachment foolishly "decided to fight their way to the Lahore district," according to Amritsar's district magistrate, and fired on a military patrol while fleeing.[23] A mortar unit wiped them out.

The district of Jullundur alone would eventually lose 7,000 of its 8,500 police officers. Left defenseless, Muslim civilians followed the constables, abandoning their homes and farms and heading westward for safety. By Monday, 11 August, a motley cavalcade of furious police deserters and terrified refugees had begun rolling into Lahore.

The Hindu writer Fikr Taunsvi was having lunch with a friend in a Muslim café that day. The morning's newspapers had carried news of the bombing of the Pakistan Special train, and the talk in the restaurant was angry: "We'll tear these Sikhs to pieces!" "We'll drink the blood of these Hindus!" "We'll not let any of their children go alive!" Suddenly, chairs scraped and shutters banged as the restaurant began to close up. A loudspeaker van raced past outside, announcing that a curfew had been reimposed. That night, Taunsvi, closeted like thousands of other Lahoris in his stifling, cramped flat, "felt a hammering on my brain . . . [as if] my head was about to burst."[24] Outside the crash of gongs and rat-a-tat of drums mixed with gunshots, the screams of victims, and the crackling of flames.

With Lahore almost certain to go to Pakistan, there was no longer any need for killers to hide in the shadows. The League's National Guards came out into the open in full uniform and took over the streets that night, directing attacks against Hindus and Sikhs who had not yet abandoned the city. The police, worked up by their brethren from Amritsar, allowed the militants a free hand. Some cops even helped in the looting of Hindu houses. A mob cut down fifteen Sikhs cowering in a temple; "police almost certainly connived at, if they did not actually carry out, this massacre," their own commander reported. Nearly eighty people were stabbed overnight, almost all of them non-Muslim. "Feeling in Lahore City is now unbelievably bad," Jenkins reported the next morning.[25]

The Lahore attacks seemed intended partly as intimidation: Muslims, Jenkins noted skeptically, appeared to believe that "by reprisals they can bring the Sikhs to a less violent frame of mind." Of course the killings had precisely the opposite effect. The jathas — now with almost no police and only a few army detachments to oppose them — began their own open slaughter in the fields around Amritsar. On 12 August, one Sikh raid wiped out an entire village of two hundred Muslims.[26] Lahore's Muslims were quick to respond: a reporter driving around the city before dawn the next morning counted at least 153 corpses on the streets.[27] And so it continued. When Mountbatten flew over the central Punjab on his way back to Delhi on 14 August, he could see dark, angry trails of smoke curling skyward.

Those clouds cast a shadow over what should have been Nehru's moment of triumph. In these last couple of weeks before independence, he had struck many friendly observers as worn-out and dispirited. "He is deeply disappointed in the division and, I think, has a feeling of frustration," the American ambassador, Henry Grady, reported confidentially to Washington. "I am not sure he knows where he is going."[28] On the evening of 14 August, just hours before he was to herald the end of the British Raj with one of the most moving and memorable speeches of the twentieth century, Nehru received a call at home from a friend in Lahore. The caller tearfully described the inferno the city had become, the animal-like fear that had seized its Hindu and Sikh citizens. Bodies littered the alleyways. Gurdwaras were aflame; in one, nearly two dozen Sikhs burned to death that night. Men with daggers prowled the train station, hunting Hindus and Sikhs who were trying to flee. When he put down the phone, Jawaharlal's eyes, too, were wet with tears.[29]

Once again, Nehru rose to the occasion. His speech at midnight fully captured the grandeur of the moment, which marked the beginning of Asia's modern resurgence. "Long years ago we made a tryst with destiny," he famously declared, "and now the time comes when we shall redeem our pledge, not wholly or in full measure, but very substantially. At the stroke of the midnight hour, when the world sleeps, India will awake to life and freedom. A moment comes, which comes but rarely in history, when we step out from the old to the new, when an age ends, and when the soul of a nation, long suppressed, finds utterance."[30]

In a message written for the next day's newspapers, Nehru added two lines that appeared intended to reassure the terrified minorities in Lahore: "We think also of our brothers and sisters who have been cut off from us by political boundaries and who unhappily cannot share at present in the freedom that has come. They are of us and will remain of us, whatever may happen," he vowed.[31]

All summer long Nehru had blamed lax or vindictive British administrators for allowing Lahore to burn. Once in control of the country, he and Patel had constantly repeated, Congress would restore peace within days. Outside of the central Punjab, on their first day as free people, Indians seemed to vindicate their leaders' confidence. In city after city, province after province, Hindus and Muslims happily celebrated inde-

pendence together. Gandhi had chosen to spend the day in Calcutta, where the Muslim minority feared a massacre in retaliation for the killings a year earlier. His presence appeared to produce a miraculous change of heart, as Hindus and Muslims crossed into each other's neighborhoods for the first time in months, exchanging sweets and hugs. In scenes reminiscent of Andrew Jackson's inauguration, a joyous mob overran Government House, lying on the beds, stealing dishes and portraits as souvenirs. The departing British governor and his wife had to sneak out the back.[32] In Bombay, Hindu and Muslim mill workers cavorted through the streets in jammed trucks and climbed atop tramcars, whooping excitedly.

After months of debilitating fear, Indians appeared to have rediscovered their better selves — exactly as Nehru had long predicted they would. Standing on a balcony as the new Indian tricolor was raised above the National Assembly building, he beamed happily while the masses below roared. By that afternoon, the crowds leading down the hill to the India Gate, where the flag was to be raised at dusk, had grown to a suffocating half-million people — most of them there to see "Raja Jawaharlal," as one villager put it.[33] Nehru and the other VIPs on the platform were stranded in a sea of shouting, clapping, cheering Indians; Mountbatten, trying to wend his way down Raisina Hill toward them by horse-drawn carriage, could barely make out the red turbans of his mounted bodyguard above the churning mass. The only look of unhappiness to cross Nehru's face that day came when one of the bodyguards' horses fell in the crush. His expression lifted with relief when the horse regained its footing and pranced forward with the others.[34]

As it had during the Bihar riots, the prospect of action galvanized Nehru. The next morning, Sir Claude Auchinleck — who continued to oversee the Boundary Force — briefed the Indian leaders on how independence had been celebrated in the Punjab. Muslims had attacked several eastbound trains full of Hindu and Sikh refugees, hacking passengers to death. A mob had burned down the gurdwara of the sixth Sikh guru on Lahore's Temple Road. Boundary Force commander Pete Rees had raced immediately to Amritsar, hoping to preempt any Sikh retaliation. He was too late. By then, dozens of Muslim women had

been stripped naked and paraded through the city streets; several had been raped and killed before the others were given shelter in Amritsar's Golden Temple, the holiest site in Sikhism. Even Tara Singh, Rees claimed, had wept when he learned of the outrage.[35]

Nehru sounded more determined and focused than he had in weeks. There could be no two views about the task at hand, he declared: "This must be put down and suppressed."[36] India was responsible for protecting Muslims on its side of the border and would do so. His government's first challenge, Nehru told a huge crowd from the ramparts of the Red Fort in Old Delhi, would be to "ruthlessly suppress" all sectarian killings.[37]

Nehru convinced Liaquat — Pakistan's first prime minister, who had flown in from Karachi to receive the official boundary award that day — to come with him to the Punjab. In the city of Ambala, in the new Indian province of East Punjab, they met with the two new governors, Sir Francis Mudie and Sir Chandulal Trivedi, as well as several of their ministers and top Sikh leaders. Nehru took charge immediately. First he sat the Sikhs down privately and laid into them.[38] Tara Singh did not deny that Sikh leaders had for weeks been "openly inciting their followers to violence and had approved of most of what they had done up-to-date," Nehru later reported to Mountbatten. Still, Singh acknowledged that matters "now had gone too far."[39] The Akali leader promised Nehru that he would travel through Amritsar and the surrounding countryside with Giani Kartar Singh to call off the jathas.

Mudie, the West Punjab governor, believed that the first order of business should have been to evacuate minorities from Amritsar and Lahore as quickly as possible — to reduce the possibility of friction. Nehru thought this a counsel of despair. He wanted to discourage the idea that Hindus and Muslims could not live together, and as in Bihar, he was convinced of his ability to make his countrymen see reason. Against Mudie's objections, he toured Lahore the next day with Liaquat and chastised local Muslim leaders. Later, the two prime ministers did the same with Sikhs in Amritsar.

Remarkably, within a few days, shops began to reopen in the Punjab's two principal cities. His tour had "produced good results," Nehru wrote

confidently to Gandhi on 22 August, one week after the independence celebrations.[40] The killings in Amritsar and Lahore appeared to have slowed.

The few hours that Nehru and Liaquat had spent on the ground, however, probably had little to do with the improvement. More importantly, Auchinleck had dispatched two more infantry brigades and one mixed squadron of armored troops to the Punjab. Concentrated in relatively compact urban areas, they were able to shunt aside the biased police and overwhelm any potential opposition. At the same time, minorities in the two cities ignored Nehru's advice and abandoned their homes as quickly as they could, choking the 35 miles of road between Lahore and Amritsar with their cars, trucks, and horse- and bullock-carts. By 19 August, only a couple thousand Sikhs remained in Lahore. The real lesson of these first battles in the Punjab's civil war was a bleak one: the killings stopped when there was no one left to kill.

"Sounds like a loose rail there," murmured D. G. Harington-Hawes. On 18 August, the Briton was crammed into a train engine with the driver and a Hindu soldier as they crossed a canal bridge in the Ferozepore district.[41] They had left the other cars of the Calcutta-Lahore Mail behind at the previous station while they tried to discover why no signals were coming from the posts ahead. It turned out that someone had removed two joints from the rails on the bridge; a pickaxe lay nearby. In this part of Ferozepore, the countryside was mostly flat and open, but at intervals, great clumps of a coarse, reedlike grass grew as much as 10 feet high. Harington-Hawes saw three Sikhs dodging through the grass about 200 yards away. He fired his revolver once in their direction.

Returning to the rest of the train, the men decided to reattach the passenger cars and proceed before the line was sabotaged further. Although they didn't realize it at the time, most of the Hindu and Sikh passengers had mysteriously disembarked. When the train reached the canal bridge again, the wooden ties were charred — the Sikhs had tried to set the bridge on fire — and an entire rail had been removed. The three men were able to reattach the rail, and the train hurtled forward. But a mile before the next station, the driver suddenly slammed on the

brakes and shouted, "My God, the track's gone!" Harington-Hawes remembered thinking, "Now we're for it," and "with squealing brakes, escaping steam, and a roaring and a crashing, the heavy locomotive plunged off the track ... dragging the tender and the first three coaches after it."

At the spot where they had derailed, the grass grew high and close to the tracks. Harington-Hawes could see the outlines of a large body of Sikhs hiding there, and more rushing to join them. It was dusk; knowing that the train carried a small escort, the fighters seemed content to wait for nightfall before attacking. Soon there were hundreds of them. From the reeds came a chilling, triumphant cry: "Wah Guruji ki fateh!" (Victory to the Guru!).

A day earlier, All-India Radio had broadcast the details of Radcliffe's boundary award. In that morning's papers, maps showed Punjabis precisely how their province would be sliced up. The details of the border should not have come as a great surprise, other than the transfer of parts of Gurdaspur and Ferozepore to India. But Sikhs now had to abandon any hope of a more generous allotment from the Boundary Commission or a last-minute intervention by Mountbatten. It was official: Jinnah's Pakistan had split their community in two.

That year, the end of Ramadan and the holiest day in the Muslim calendar, Eid, fell on 18 August. For Muslims living in the eastern Punjab, that was also the day when "the whole countryside seemed to have gone up ... as if on a prearranged signal," as Harington-Hawes later wrote. Not just in Ferozepore but in the districts of Hoshiarpur, Gurdaspur, and Jullundur — all in the now-Indian half of the Punjab — large, well-armed jathas swept down on Muslim villages and swarmed into Muslim neighborhoods in cities to begin methodically massacring their inhabitants. The Sikhs were merciless and single-minded; some cried "Rawalpindi" as they struck to invoke the March slaughter. This was revenge.

When Boundary Force brigadier R. C. B. Bristow visited the city of Jullundur the next morning, the streets were deserted, except for the armed Sikhs who had poured in overnight. Corpses filled Muslim homes. The police had vanished. Sikhs used long poles with burning rags at the tips to set fire to buildings where other Muslims still cowered.

A Muslim magistrate later told Bristow that at the end of the first day's assault in Hoshiarpur city, "blood was pouring from the upper storeys into the streets below."[42]

The Sikh war bands appeared to be "working under some centralised control," General Rees reported, with orders delivered by messengers on foot, on horseback, and in jeeps.[43] They employed "sound and enterprising tactics"— almost military in their precision.[44] After surrounding a Muslim village, the Sikhs would often attack in waves. A vanguard would hurl grenades over the walls while others set fire to the thatch huts and swordsmen hacked down those trying to flee.[45] Rees himself interrupted an attack that more closely resembled a War College exercise than a riot. A distinguished-looking Sikh stood by his car beside the road, "with a little staff round him, and two messengers with bicycles." In the fields, his men had torched a Muslim village. As victims ran screaming from the flames, the jatha commander kept an eye out for stragglers and calmly repositioned his fighters to intercept them.[46]

Hardcore militants traveled in groups as small as a couple dozen and as large as five hundred men. Where they appeared, they would rally Sikh villagers to join in their assaults, often swelling the size of mobs into the thousands. In some cases, Boundary Force troops tolerated attacks. In Jullundur, Bristow came across a tank unit manned by Hindus from the Jat peasant caste firing harmlessly in the air above a gang of Sikh marauders. When he demanded to know why they were shooting high, the Jat officer told him innocently that their guns had been set for anti-aircraft fire and couldn't be lowered. "The Jat soldiers were not unfriendly, but conveyed by their demeanor that the Raj had ended, and the conflict should be left to them to settle in their own way," Bristow recalled.[47]

This was not "civil war" as it is normally imagined, with Hindu and Muslim peasants suddenly and inexplicably picking up whatever sharp implements happened to be closest to hand and slashing away at one another. (In fact, Hindus hardly seem to have participated in these initial attacks.) Instead, the Sikhs appeared to have launched the concerted assault jatha leader Mohan Singh had predicted over the summer — an ethnic-cleansing campaign to denude India's half of the Punjab of its

Muslims. Years later, Faridkot's constitutional adviser Ajit Singh Sarhadi admitted there was at least some design behind the jathas' rampages. "The main effort of . . . the Akali High Command was to somehow get the East Punjab vacated from the Muslims, who [w]ould be made to migrate to Pakistan," he wrote. The maharajah, he added, had done "a great service" by helping to arm the Sikh war bands.[48]

The Pakistan government would eventually produce a series of pamphlets with titles like *The Sikh Plan* that claimed to prove a conspiracy lay behind the attacks. The case for this is circumstantial at best, and it ignores the fact that mobs — smaller and less organized, admittedly — had also sprung up on Pakistan's side of the border. Many British accounts are biased by stereotypes of the Sikhs as a turbulent, hot-tempered community — a people who had, as Jenkins put it, "not lost the nuisance value which they have possessed through the centuries."[49] And of course, even if some Sikhs did have a "plan," their many leaders were too divided and inconstant to coalesce behind a single strategy.

What seems incontrovertible is that of all the Punjab's militias, the Sikhs were the best organized, best trained, and best armed. As the BBC's Robert Stimson put it after touring the Punjab extensively in August, they "were therefore more effective and behaved worse."[50] Sikhs had clearly been "the aggressors," Nehru declared without hesitation in his 22 August letter to Gandhi, estimating that twice as many Muslims had been killed in East Punjab to that point as Hindus and Sikhs in the West. When he wrote to the Mahatma again three days later, Nehru said he believed that some Akali leaders were hoping to provoke a war between India and Pakistan, so they could launch an invasion to recapture the western half of the Punjab.[51]

The patchwork of Sikh kingdoms laid across the eastern Punjab gave the jathas another deadly advantage. Boundary Force troops could not legally pursue guerrillas across the borders of states like Faridkot and Patiala; gangs would lurk there until the troops had moved on, then reemerge to seek out targets. Muslims who lived within the states met a grim fate: thousands were killed or driven out over the ensuing weeks, often with the help, or at least the acquiescence, of royal troops.[52] Faridkot later claimed that "when he had told Patel that all Muslims had

been evacuated from his state, Patel expressed satisfaction."[53] A British report indicated that guillotines had been employed in the massacres there.[54]

Civil administration in the Indian half of the Punjab collapsed almost immediately. Over the summer, Hindu and Sikh officials had put off leaving Lahore as long as they could, hoping that the Punjab capital might be assigned to India. They had barely had time to get established in East Punjab. Trivedi's ministers found themselves without offices, secretariats, or communications. For a while provincial ministries were scattered across four different cities. As late as mid-October, Trivedi could not even place a direct call to Delhi — all the phone and telegraph lines in the Punjab were routed through Lahore, now part of Pakistan.[55] "They ... are living on rumours," one of Mountbatten's stunned aides reported after visiting the governor and his ministers.[56]

Orders from the top were routinely ignored at the local level. In both East and West Punjab, party hacks had been promoted to positions that were often beyond their experience and capabilities. Partisan officials displayed, as one Sikh deputy commissioner lamented of his new brethren, "almost a tendency to extol the misdeeds of miscreants and justify the ill luck that had befallen the [victims]."[57]

To outsiders, it looked as though the jathas had been given the run of East Punjab. About a week after independence, Penderel Moon traveled through the province on his way back to Bahawalpur from a short break in Simla:

> So far as I could make out, the villages of the Eastern Punjab were just being allowed to run amuck as they pleased. From the Grand Trunk Road, particularly on the stretch from Ambala to Ludhiana, murderous-looking gangs of Sikhs, armed with guns and spears, could be seen prowling about or standing under the trees, often within fifty yards of the road itself. Military patrols in jeeps and trucks were passing up and down the road, yet taking not the slightest notice of these gangs, as though they were natural and normal features of the countryside.[58]

Whether due to a conspiracy or not, the eastern Punjab did indeed begin to empty of minorities. After an attack, or often out of fear of one, whole villages of Muslims decided that they could no longer live in

India. They took to the roads in a panic, bringing only their livestock and what few ragged possessions they could carry, sometimes even leaving behind the little food they possessed. They were "cowed and tired and miserable," observed I. L. Potter, an American employee of Caltex India — and terribly vulnerable.[59]

This flood of refugees, more than anything else, sent the Punjab spinning out of control. The Boundary Force was already too thinly spread to handle the metastasizing jatha raids; now the roads became fertile hunting grounds, too. Traveling across the Indian East Punjab on 25 August, Potter witnessed several horrible, flailing ambushes unfold: Sikhs charged out of the tall grasses lining the road, slashing away furiously with spears and swords as terrified peasants scattered pell-mell across the fields to try and escape. Young women were trussed up and hauled off to be raped. Boundary Force troops tried to organize escorts for the caravans and collected refugees in small, guarded keeps before transporting them en masse to Pakistan. But during these frenzied melees, the soldiers could hardly tell attacker from victim, and more often than not, killed equal numbers of both.

Unending waves of refugees washed over the East Punjab. They left grim reminders of their passage — trees stripped of bark, which they peeled off in great chunks to use as fuel; dead and dying bullocks, cattle, and sheep; and thousands upon thousands of corpses lying alongside the road or buried shallowly.[60] Vultures feasted so extravagantly that they could no longer fly.

Once the migrants crossed the border, their stories and their scars spread hate like an oil slick. "Corpse trains" rolled into Lahore station dripping blood, their carriages filled with hacked-off limbs, women without breasts or noses, disemboweled children. Provocateurs made sure that even those who did not witness these atrocities heard about them in graphic, often exaggerated detail. Muslim villagers who had initially pledged to protect their Sikh and Hindu neighbors in Pakistan now took up crude arms and joined the ranks of the mobs.

The spiraling chaos threatened to paralyze Pakistan's economy. Rail drivers and engineers refused to work unless their families were given military guards, which meant some thirteen thousand rail wagons lay idle on both sides of the border. Coal, cloth, and gasoline — all im-

ported from India — began running short. All that seemed to be coming from across the border were hollow-eyed refugees. Within ten days, over 150,000 migrants had flooded into Lahore. Within a month, more than ten times that number had arrived.[61]

Pakistanis berated their government for not forcing a halt to the massacres. A furious crowd of Muslim refugees stoned Mamdot's house in Lahore. Within a week of his inauguration, Jinnah himself was the target of an assassination attempt when five masked men, most likely dispossessed Muslims from the Punjab, broke into the grounds of Government House in Karachi.[62]

On Sunday, 24 August, the Quaid took to the airwaves to address his wobbly nation. His suspicions about Tara Singh and the Sikhs had, it seemed, been confirmed. His address was aggrieved and one-sided. He gravely condemned "the orgies of violence in Eastern Punjab, [which] have taken such a heavy toll of Muslim lives and inflicted indescribable tragedies."[63] *Dawn* had probably captured his feelings in an editorial a couple days earlier, when the paper claimed, "It was well-known that all the violence, crime and arson had been in East Punjab only."[64] Ignoring the not inconsiderable number of attacks on Hindus and Sikhs that had already taken place in West Punjab, Jinnah simply cautioned his new citizens: "It is of the utmost importance that Pakistan should be kept absolutely free from disorder, because the outbreak of lawlessness at this initial stage is bound to shake its newly laid foundations."[65]

The Quaid's paranoia had returned in full force. There were dark elements at work, he told his people, "enemies who do not wish well to Pakistan and would not like it to grow strong and powerful. In fact, they would like to see it destroyed at its very inception."[66] In the prevailing atmosphere, Jinnah's bitter tone would have undercut any good his words might otherwise have done. Already, Penderel Moon noted, "to kill a Sikh had become almost a duty; to kill a Hindu was hardly a crime." The day after the Quaid's address, a battalion of Bahawalpur state troops watched impassively as Muslims in the town of Bahawalnagar went on a rampage. A trainload of mutilated Punjab refugees had pulled in that night, enraging locals. The next morning's casualty fig-

ures made it clear just how diligent the soldiers had been in restoring order: 409 Hindus had been killed in the mayhem — and 1 Muslim.[67]

At dawn on 26 August, Brig.-Gen. K. S. "Timmy" Thimayya, one of Rees's two Indian deputy commanders, drove up to the town of Sheikhupura, about 25 miles northwest of Lahore. The shrine of Nankana Sahib, birthplace of the founder of the Sikh religion, lay nearby, and the town had a sizable minority of Sikhs and Hindus. Thimayya could hear the rattle of machine-gun fire from 4 miles away.

The town's main street was "strewn with hundreds of bodies." Smoke hung over the city from dozens of burning buildings. Thimayya entered a small gurdwara to find the corpses of three gutted children, a woman "wordlessly screaming," and a jam-packed crowd of survivors "crazed with fear."[68] The British poet and BBC reporter Louis MacNeice later visited 80 badly injured Sikhs and Hindus in the local hospital, attended to by a single doctor with no equipment. Another 1,500 victims were crammed into a local schoolhouse, their white clothes stained rust-brown with blood, flies buzzing around the stumps where their hands had once been. "But hardly any [were] moaning," MacNeice wrote in his diary, "just abstracted, even smiling in a horrible unreal way."[69] The first police officer Thimayya found — a Briton — told him the town had had "a spot of trouble" but that everything was under control now.[70]

A couple of days earlier, a jeep full of Baluchi soldiers had roared through Sheikhupura. "Are you people asleep?" they had berated the Muslim locals. "Don't you know what has happened to your brethren in East Punjab? Join us and we will avenge the wrong done to our co-religionists."[71] That night mobs had torched several Hindu and Sikh neighborhoods.

The next day, according to multiple reports, terrified minorities either headed for the train station or gathered in the compound of a Sikh-owned rice mill for protection. Baluchi soldiers surrounded the mill and ordered the refugees to throw out their weapons, then all their gold and silver. What happened next is unclear: a Muslim soldier may have tried to drag off a young Sikh girl, or one of the jumpy refugees may have shot at the surrounding troops. The Baluchis opened up with their

mounted machine guns. The fusillade "caused blood to flow like water," one survivor told researcher Ishtiaq Ahmed.[72] Hundreds, perhaps more, were gunned down.

Thimayya and other commanders had long feared this scenario, with members of the armed forces joining the slaughter. On both sides of the Punjab border, Sikh, Hindu, and Muslim soldiers had been growing increasingly restive when asked to subdue rioters from their own communities. On 23 August, a clash between Baluchis and Dogras — Hindu troops originally from the Jammu region of Kashmir — had left ten dead and twenty wounded.[73] The Boundary Force had been established to prevent exactly these sorts of clashes between heavily armed, professional soldiers. If discipline collapsed outright and troops began taking sides, death tolls would skyrocket.

When he received the first reports of the Sheikhupura massacre, Nehru had just returned from a muddy, three-day tour through East Punjab. He now understood that his initial optimism had been premature. "This Punjab business becomes bigger and bigger the more one sees it," he wrote to Mountbatten.[74] The roadside speeches he had delivered to Punjabi peasants seemed to be having no impact. Police and petty officials — his own government — were openly encouraging mob rule. Foreign correspondents were painting his India, the ostensible light of Asia, as a land of unchecked savagery: The Sikhs "are clearing eastern Punjab of Muslims, butchering hundreds daily, forcing thousands to flee westward, burning Muslim villages and homesteads," wrote Ian Morrison in the London *Times,* claiming the violence had been "organised from the highest levels of Sikh leadership."[75]

On 27 August, Nehru shared his frustrations with Mountbatten in a rambling note — for no reason, he said, other than to "unburden my mind a little." He felt "peculiarly helpless," he wrote, powerless to stem the wave of murderousness sweeping the Punjab. Indeed, Nehru had begun to doubt whether he was the right man to lead India through this crisis: "And even if I don't doubt it myself, other people certainly will."[76]

After Sheikhupura, a new narrative started to form in Nehru's mind. While to this point the worst violence had taken place in East Punjab, Indian diplomats now started to send back hysterical reports from Paki-

stan. "50 THOUSAND HINDUS AND SIKHS ARE DAILY BUTCH-
ERED BY THE MILITARY AND POLICE HERE. NO HIGH COM-
MISSIONER CAN SAVE THEM. ALL HINDUS AND SIKHS IN WEST
PUNJAB WILL BE FINISHED," Sampuran Singh, India's deputy high
commissioner in Lahore, cabled Delhi on 27 August.[77] Rumors reached
Nehru that huge Muslim gangs were blocking Hindus and Sikhs from
escaping to India, trapping their refugee convoys at river crossings and
massacring thousands.

Nehru knew such casualty figures were likely "incredible" and "ex-
aggerated," he admitted to Mountbatten. Still, he was all too ready to
believe that Pakistan was deliberately downplaying the bloodshed on its
side of the border. The West Punjab government had imposed a virtual
news blackout, censoring all articles about the riots before publication.
According to Hugh Stephenson, a British diplomat stationed in Lahore,
it wasn't until 26 September that Pakistan authorities finally adopted
"a policy of telling the truth about casualties."[78] Even privately, Mudie
maintained "a stony silence," his counterpart Trivedi complained, refus-
ing to reciprocate or even respond to the daily situation reports sent to
him from the East Punjab.[79] Indian newspapers talked of a Soviet-style
"curtain" falling across the new border.

When he faced reporters on 28 August, Nehru claimed — against
all existing evidence — that matters in East Punjab were in fact now
"more under control" than in West Punjab, where thousands were be-
ing slaughtered. He seemed more concerned with chastising correspon-
dents for sensationalizing the extent of the chaos on India's side of the
border. Independent India was in no mood to be lectured by "virtuous"
outsiders, he said peevishly, warning Western journalists against writing
stories that might "embitter relations" in the future.[80]

Nehru simultaneously sent a cable to V. K. Krishna Menon, a long-
time friend and Labour activist whom he had appointed as India's high
commissioner in London. Nehru wanted him to remind the London
press who exactly had launched the cycle of violence between Hindus
and Muslims. The bloodbath, Nehru claimed, represented the "first
fruit of Pakistan and ideology of hatred and violence which Muslim
League has spread for years past."[81] If Jinnah had never launched his

insane demand for Pakistan, if the League had not pushed its "ceaseless campaign of hatred and violence" since the spring, Nehru suggested, the Punjab massacres would not have happened at all.[82]

In less than two weeks, the facade of amity maintained by the two dominions had quite plainly cracked. Jinnah flew up to Lahore to take charge of the refugee crisis personally. On 29 August, he and Nehru met at Government House, along with other top Indian and Pakistani leaders. It was the last time the two rivals would ever sit down together in the same room.

Like the politicians, the soldiers of the Boundary Force no longer trusted one another, Pete Rees reported grimly at the meeting. The horrors they were witnessing daily had drained any sympathy they might have had for the opposite community. Punjabi troops feared for the fate of wives and daughters left at home. Rees's own position as Boundary Force commander had "become impossible. He would be unable to guarantee the reliability and general impartiality of the troops under his command beyond the middle of September."[83] Auchinleck recommended that the force be disbanded by 1 September and its troops reassigned directly to the Indian and Pakistani armies. Nehru and Jinnah readily agreed.

The two sides made a show of cooperativeness. They decided that soldiers would be allowed to cross the border to guard and escort refugees from their own communities. They made plans to air-drop leaflets imploring Punjabis to come to their senses. Before independence, Mountbatten had arranged for a Joint Defence Council led by himself and attended by the prime ministers and defense ministers of the two countries to meet monthly to head off any wider conflict.

But essentially, the governments of India and Pakistan would now be responsible solely for their own territories and people. They would trust only their own troops, under their own (still British) commanders in chief. Auchinleck's Supreme Command would concern itself solely with dividing up men, weapons, and equipment between the two armies. Liaquat even told Nehru that there was no point any longer in the two prime ministers touring both Punjabs together, as they had planned to do over the next few days. The two men got into a "heated

altercation" on the sidelines of the meeting, with Mountbatten "coming in hot and strong" on Nehru's side until Liaquat reluctantly relented.[84]

Although he still resisted the idea of making an exchange of populations official policy, Nehru's rhetoric also subtly changed. Now he talked about Hindus being trapped on the other side of the border, in need of rescue by India. A 31 August visit to Sheikhupura left Nehru "sick with horror," his nostrils filled with the lingering, coppery smell of blood and charred flesh.[85] Along the road he was stunned to find an old acquaintance marching in a refugee column, "once a prosperous man but he had now only a shirt on."[86]

Nehru urged his friend not to give up hope. India would send help — "a thousand motor trucks, trains and aeroplanes would be employed to evacuate those who felt themselves in danger."[87] Perhaps these should have been Pakistan's citizens, but they were now India's people.

Even Gandhi seemed impotent in the face of the Punjab's furies. For two weeks, the peace that had settled over Calcutta after his arrival had blissfully persisted. The Mahatma had struck upon a particularly cinematic gesture to reinforce his message of communal harmony: he had agreed to live in the city, in a rundown villa owned by a Muslim woman on the edge of a Hindu slum, as long as the infamous ex-premier H. S. Suhrawardy stayed there with him. The pomaded Suhrawardy had agreed; he was at loose ends after Jinnah had chosen a rival to serve as governor of the new province of East Bengal. The erstwhile butcher of Calcutta and Gandhi had driven around town together in Suhrawardy's convertible and shared the stage at gargantuan prayer meetings, preaching unity. Tens of thousands of Hindus and Muslims mingled in the audiences, a sight that would have been well-nigh unthinkable anytime in the past year.

At the end of August, though, tales of the Sheikhupura massacre circulated throughout Calcutta — spread in part by Shyama Prasad Mukherjee, a Bengali and the one Hindu Mahasabha member of Nehru's cabinet.[88] Late on the night of 31 August, a crash of glass woke Gandhi. A Hindu mob had brought a wounded boy to the house where the Mahatma was staying. Scattered street fights had broken out that day;

the boy claimed to have been stabbed by a Muslim in the bazaar. The crowd demanded vengeance.

Gandhi tried fruitlessly to remonstrate with them. Another brick came whizzing past the Mahatma's head, hitting a Muslim friend beside him. Police had to fire teargas to disperse the crowd. The next day, Hindu mobs, soaked by torrential monsoon rains, brought out their swords and Sten submachine guns and went after Muslims all over the city. Nearly three hundred people were injured and at least fifty killed.

Gandhi was distraught. "What was regarded as a miracle has proved a short-lived, nine-day wonder," he wrote to Sardar Patel the next day.[89] The Mahatma had been pressing Nehru to allow him to "rush to the Punjab . . . and if necessary break myself in the attempt to stop the warring elements."[90] Now, though, he could hardly face Punjabis and ask them to live together again if he could not keep the peace in Calcutta. That evening, Gandhi announced that he would not leave the city, and would not eat or drink again until its citizens regained their sanity. Many Calcuttans doubted he would live to see that day.

The idea that Churchill's prophecy might come true, and that independent India might collapse into anarchy, no longer seemed unthinkable. To this point, the crisis had hammered Jinnah's dominion harder than Nehru's. Less than 5 percent of India's population lived in East Punjab, whereas West Punjab represented the biggest, richest, most vital region in Pakistan's western wing. But trouble in India now began to spread well beyond the border areas. Hundreds of thousands of Hindu and Sikh refugees from Pakistan had made their way to Delhi, the United Provinces, and points further east and south. They brought little with them except for their hate, and they found — in the 40 million Muslims who still lived in India — an all-too-rich environment of targets.

Indeed, India's size and variety made the country even more unstable than Pakistan in some ways. The RSSS had tens of thousands of well-drilled cadres distributed throughout the country, particularly in the United Provinces, next door to the Punjab. Big cities like Calcutta and Bombay — where riots also broke out on 1 September for the first time since independence — remained full of armed goondas. Refugee camps were time bombs: one, located 700 yards outside the military academy

at Dehra Dun in the United Provinces, housed ten thousand Hindus and Sikhs from West Punjab, but also included "military deserters, bandits, criminals, and thugs of all sorts," according to the academy's commandant.[91] The camp's inmates boasted an arsenal that ranged from kirpans and country-made bombs to light machine guns.

Nehru and Patel had little control over the princely states, which had yet to integrate themselves with the rest of the country except on paper. The Meo war that had begun in the late spring just outside Delhi had spread across their borders. According to persistent reports, state troops in the small kingdoms of Alwar and Bharatpur were now systematically massacring or driving out their Meo populations. The maharajah of Bharatpur's own brother was later accused of leading some of the death squads, shotgun in hand.[92] A Briton traveling through Alwar by rail in early September was horrified to find a barely alive Muslim girl atop a pile of corpses on a train platform. When he tried to give her some water, a bearded Hindu brushed him aside, saying, "'Don't do that, sahib!' He then produced a bottle of petrol, forced some of it into the girl's mouth and set her alight."[93]

Filled as it was with unhinged refugees, Delhi itself had become almost a far eastern extremity of the Punjab. (Jinnah had an advantage over India's leaders in this way: his capital lay hundreds of miles from the Punjab's mayhem.) Knots of Hindu and Sikh refugees gathered each morning outside Sardar Patel's bungalow, filling his ears with "tales of woe and atrocities," he wrote to Nehru on 2 September.[94] Some demanded to know why Muslims — who made up around half the city's population before Partition — were allowed to live unmolested in the Indian capital, even to work for the government, after the horrors their coreligionists had perpetrated in the Punjab.[95] RSSS leaflets appeared on the streets of Delhi, urging Hindus and Sikhs to prepare "to attack all Muslims they could see, and to terrorise the city."[96]

Sketchy intelligence reports were warning of the opposite as well: a brewing Muslim uprising in the capital. An accidental explosion at the home of a Muslim science student was thought to have been caused by a bomb he was making. Most of the city's ammunition dealers were Muslim, as were most of its blacksmiths.[97] The latter had supposedly converted their workshops to churn out bombs, mortars, and bullets. Mus-

lim agitators were reported to have collected country-made guns and other weapons in their homes, as well as wireless transmitters provided by sympathizers in the army. Patel had been worried enough about the threat to issue licenses to several new Hindu arms dealers in Delhi. He had "been giving arms liberally to non-Muslim applicants" for self-defense, he reassured a Congress colleague.[98]

By this point, the tough Sardar seemed "very pessimistic in regard to the situation in the country," reported Zahid Hussain, a former civil servant and finance minister in Hyderabad who had been named Pakistan's first ambassador to India.[99] India's army was too thinly spread to cope with widespread disturbances. With the dissolution of the Boundary Force, commanders had to bring up troops from Madras province to reinforce the Punjab. Another sixteen battalions that were ultimately destined for India remained stationed on the Northwest Frontier to watch over the tribes.[100] They now faced the ugly prospect of having to fight their way out. Twice in quick succession, Pathan raiders had swooped down on trains transporting troops to India, riddling the carriages with bullets.[101] On the evening of 2 September, before flying to Lahore to meet with Nehru and several Pakistani leaders, Patel lamented to Gen. Sir Rob Lockhart, India's new commander in chief, that "anarchy looked like [it was] spreading throughout India and . . . he was powerless to stop it."[102]

Another fear now crept into Nehru and Patel's most private discussions. Less than two months earlier, assassins had gunned down Burma's prime-minister-in-waiting, Aung San, and several members of his cabinet in Rangoon. A low-ranking British Army officer would later be implicated in the plot. There was open talk in Delhi of the "Rangoon precedent"— the possibility that the British-led military might stage a coup and overthrow the two-week-old Indian government.[103]

The Indians already distrusted Auchinleck, whose aide-de-camp was a strongly pro-Pakistan Muslim. The Auk had had many run-ins with the Congress leaders over the summer regarding the share of troops and weapons that should have been allotted to Pakistan. He had accused Sikh defense minister Baldev Singh of an "insane desire to do down Pakistan at all costs" by crippling its fledgling military.[104] Although

commanders like Lockhart now worked for the Indian government, they remained personally loyal to Auchinleck. Indeed, later that same night, Lockhart asked Reginald Savory, with whom he shared a bungalow, "Do you think there is any chance of the Auk taking over complete control and running the show on his own?"[105] (That kind of talk was sure to make it back to Patel, who had spies planted inside Auchinleck's Supreme Command.)[106] Although Nehru had asked for them to be withdrawn as soon as possible, thousands of British troops remained in the country, including a battalion just 40 miles away in Meerut.

On the sidelines of the meeting in Lahore on 3 September, Nehru quietly admitted to Pete Rees that he and his government "were beginning to doubt the loyalty of the Indian Army to the present Congress Government, and that if the situation in the Army continued to develop along the anti-Congress lines which they claim it is developing toward them that they (Nehru and Company) could foresee the fall of their Government and anarchy in India."[107] Nehru insisted that all the new brigadiers stationed along the border with Pakistan had to be Indian, not British.[108]

That evening, Nehru returned with Patel to a capital on edge. For the past several nights, Sikh gangs had attacked trains coming into the city. One band of killers had boarded a train that Ismay's daughter Sarah was riding down from Simla.[109] Barely 20 miles from Delhi, they had pulled the brake cord, then swarmed the third-class compartment, dragging out Muslims and chopping them to death on the platform with axes and sharpened hoes. Bazaar rumors claimed that a wholesale massacre of the capital's Muslims was about to begin. From Delhi, residents could see smoke from villages burning only 3 miles away.[110]

The next morning, a small bomb went off in a Hindu neighborhood of Old Delhi. The explosion acted like a starter's pistol. A wave of bombings, stabbings, shootings, and arson attacks swept across the city. Nehru told his cabinet that he feared the Punjab's troubles were about to spread to the rest of the country and lead to "complete chaos."[111]

The Indian government looked to be teetering very close to the kind of breakdown that would invite army intervention. Patel's aide V. P. Menon knew there was one figure India's British commanders would

unquestionably respect and obey: Dickie Mountbatten, the former Supremo. He had gone up to Simla after the independence celebrations for a much-needed rest. Apparently without informing Nehru or the Sardar, Menon called him that night and asked him to rush back to Delhi immediately. As Mountbatten wrote later to the king, Menon "felt that the matter was one of life or death for India."[112]

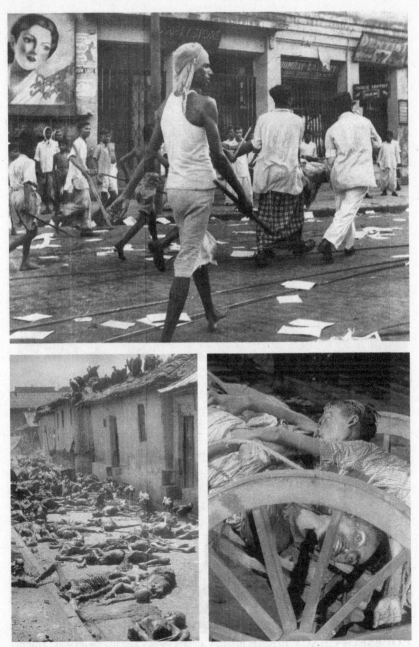

"A FURY": Mobs ravaged Calcutta for four days in August 1946, leaving at least five thousand dead.

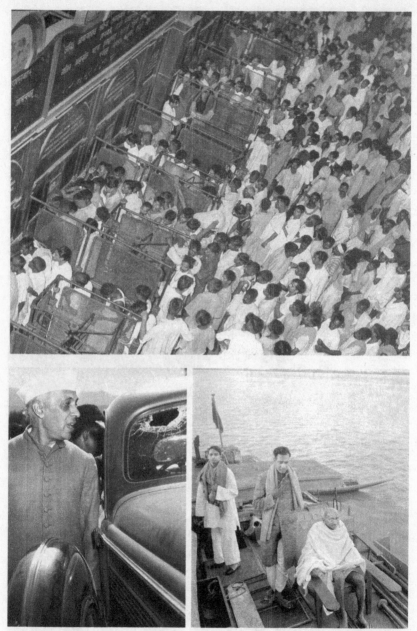

COURSE OF CHAOS: Refugees fleeing Calcutta spread hate like an oil slick; Frontier tribesmen stoned Nehru's car; Gandhi exaggerated the carnage in the watery Noakhali district.

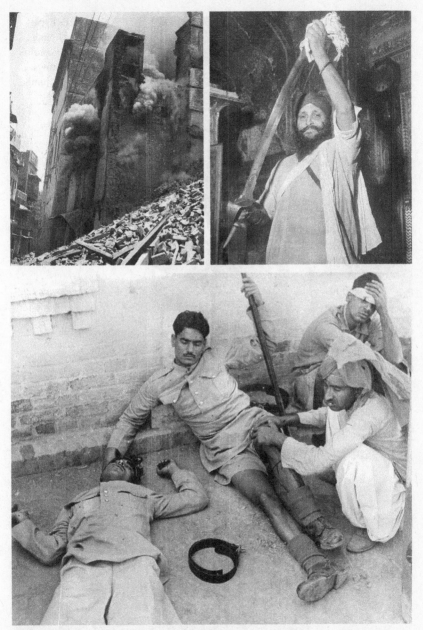

MARCH MADNESS: Arsonists reduced parts of Lahore's Old City to rubble; Sikhs vowed revenge after the Rawalpindi massacres; League demonstrators attacked non-Muslim police.

ICE AND FIRE: Even old friends found Jinnah's personality frigid; Gandhi's evening prayer meetings seemed like mumbo-jumbo to many Muslims.

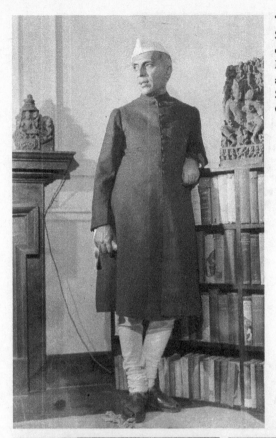

"WE ARE LITTLE MEN":
Suave Nehru had legions
of admirers abroad; Dickie
Mountbatten looked like
a Hollywood prince; gruff
Sardar Patel served as
Congress enforcer.

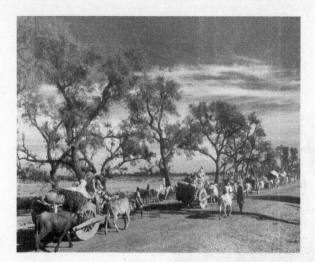

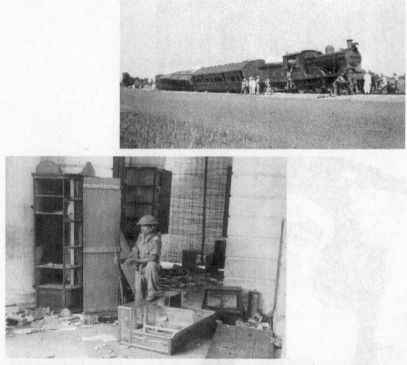

EXODUS: Sikh convoys were orderly and armed; train attacks peaked in September 1947; troops struggled to pacify Delhi.

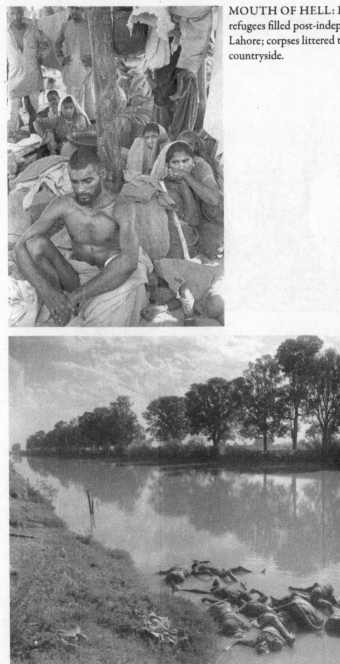

MOUTH OF HELL: Bereft Muslim refugees filled post-independence Lahore; corpses littered the Punjab countryside.

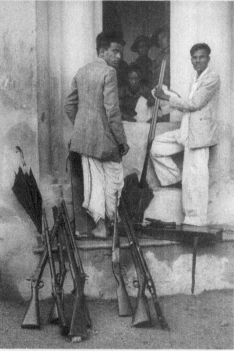

KINGDOMS IN CRISIS: The Wāli of Swat contributed money and men to the Kashmir jihad; Sidney Cotton's airlift flooded Hyderabad with small arms.

7

·▿·▿·▿·▿·

"Stop This Madness"

Throughout august, as the Punjab descended into mayhem, lights had continued to blaze from New Delhi's ivory-white Imperial Hotel. On weekends, diners packed the tables in the Grill Room overlooking the lawns, while Indian socialites dripping with gold and jewels filled the dance floor well past midnight. To many of the capital's well-to-do, the bloodshed felt unreal. The Indian women in particular seemed to be "on heat," one British journalist noted hungrily. "The aphrodisiac was independence."[1]

No band played on Saturday, 6 September, however. A curfew had emptied the dining room. Anyone standing on the hotel's veranda would have been bathed in a different light — a rose-colored glow that filled the horizon to the north. The Muslim neighborhoods of Old Delhi were on fire.

Despite the curfew, along the broad, manicured avenues of the capital, small groups of Sikhs and khaki-clad RSSS cadres had been roving about openly armed for several days running.[2] Some appeared to have been marking out the rooms in government dormitories occupied by Muslim clerks and peons, as well as the houses and bungalows where Muslims lived or worked as servants. A British diplomat later reported seeing a truck full of Sikhs pull up outside the home of the local chairman of British airline BOAC, whose planes were helping to ferry Paki-

stan officials from Delhi to Karachi. "That's the place," one of the Sikhs confirmed, carefully noting down the address.[3]

Sword-wielding gangs now began working their way from target to target, dragging out and killing Muslims. The next morning, the furies erupted into plain view. Mobs took to the streets all over the city. One descended on the military airfield at Palam, from which the BOAC charters were taking off; another blocked the runways at the civilian Willingdon Airport as airline employees fled in terror.[4] Muslims caught out in the open were stabbed and gutted, including five who were killed in front of New Delhi's cathedral while worshippers celebrated Sunday Mass. Looters broke into Muslim shops in Connaught Place, the colonnaded arcade at the heart of the city. By ten o'clock that night, Delhi hospitals were reporting three times as many Muslim as non-Muslim casualties.[5]

Rushing to Connaught Place, Nehru was appalled to see a contingent of police standing by idly as Hindu and Sikh rioters carried off ladies' handbags, cosmetics, and wool scarves from Muslim shops; the looters even ransacked bottles of fountain-pen ink.[6] The prime minister grabbed a lathi from one indifferent policeman and flailed away at the crowd himself. Nehru would learn later that Delhi police had picked up rumors that "two well-known Akali extremists from Amritsar" had been organizing Punjab refugees into killing squads in the capital.[7] Supposedly the Sikh fighters were to mark themselves out by wearing white topknots, while Hindus donned the khaki shorts favored by the RSSS. Plot or no, Delhi's police appeared more than content to let the rioters go about their business unmolested.[8]

Although they later tried to play down the extent of the chaos, India's leaders clearly lost control of their own capital for a time. Ministries sat empty because clerks and officials were too afraid to come to work. Buses, taxis, and tongas — usually driven by Muslims — stopped plying the roads. The phones went dead.[9] Within forty-eight hours, hospital mortuaries had filled to capacity; dozens of bodies lay unclaimed on the streets for days. With food shipments rotting in abandoned trains, ration shops closed up. At one point, the city had only two days' stock of wheat in reserve.[10] "This is more hectic than at any time of the war," Pug Ismay wrote to his wife on Monday — a potent statement from a man

who had lived through the Blitz. He advised her to cancel her plans to come out and see him: "There is a possibility — and most keen a possibility — that orderly Government may collapse."[11]

The riots in Delhi arguably posed a greater threat to the new dominion than the Punjab massacres. Mountbatten, who had rushed back from Simla, quickly organized the Indian ministers into an Emergency Committee that met daily and issued a blizzard of orders and decrees. "If we go down in Delhi, we are finished," he warned.[12] To many foreign observers, India's weeks-old government looked dangerously out of its depth. Western embassies had to become makeshift refugee camps as Muslim servants and their families all crowded into the grounds for safety.[13] Watchful Sikhs lurked outside the gates, demanding that the asylum seekers be turned out. Inside, diplomats subsisted on tinned salmon and crackers, and asked the British about supplying troops for protection. The requests pained Nehru, who remained acutely sensitive to international opinion. The picture being drawn abroad was apocalyptic: one wire report ludicrously tried to claim that 500,000 Delhiites — half of the city's population — were involved in running street battles.[14]

Initially none of the Indian leaders had any doubt that Sikhs had spearheaded the attacks. Over 200,000 refugees from what was now Pakistan had squeezed into Delhi since the summer, and plenty of them thirsted for revenge. Patel called in Delhi's Sikh leaders and threatened to toss their followers into concentration camps if the violence did not cease.[15] He also gave the army a "free hand" to go after Sikh troublemakers.[16] Commanders ordered their troops to shoot rioters on sight. Although the military could not admit openly to targeting any particular community, Mountbatten joked grimly, "The object would have been achieved if in 48 hours' time the local graves and concentration camps were occupied more fully by men with long beards than those without."[17]

Very quickly, however, Patel's assessment of the threat changed. The problem was not just the Sikhs. Some Delhi Muslims had indeed, as he had feared, been stockpiling firearms. They fought back against the police as well as the roving gangs; among reported gunshot victims on Sunday, non-Muslims actually outnumbered Muslims forty-five to

twenty.[18] All day long on Monday, staccato bursts of rifle and Sten-gun fire echoed through the predominantly Muslim neighborhood of Sabzi Mandi in Old Delhi. Officials later claimed that troops had come under heavy fire from residents, and that huge caches of arms and ammunition had been stashed in Muslim homes.[19]

Quite a few Delhiites seemed to believe that the city's Muslims posed as great a threat as the death squads, if not greater. In addition to the Punjab refugees, thousands of Muslim Meo villagers had also fled for safety to the capital. The raging battles in Gurgaon and nearby states in recent weeks had contributed to the Meos' warlike reputation. Among some Hindus and Sikhs, an idea took hold that Akali fighters had just barely saved the capital from a planned Muslim rebellion.

Patel had police lay out the weapons they had seized from Muslim homes for cabinet ministers to examine. According to Education Minister Maulana Azad, himself a Muslim, the arsenal consisted mostly of "dozens of rusty kitchen knives, pocket knives, iron spikes from fences of old houses, some cast iron pipes." Mountbatten picked up one or two of the blades and said dryly that their owners "seemed to have a wonderful idea of military tactics if they thought the city of Delhi could be captured with them." The Sardar refused to brook any criticism of Delhi's police. When Nehru lamented at a meeting of top Congressmen that he felt "humiliated" by the slaughter and "helpless" to defend the city's Muslims, Patel flared up.[20] He insisted that outside of a few isolated incidents, security forces were doing everything possible to safeguard all of Delhi's citizens.

Azad recalled that "Jawaharlal remained speechless for some moments." Gandhi, who had arrived in the capital on 9 September, sat cross-legged between Nehru and Patel. The Mahatma had ended his fast after seventy-three hours, once Hindu, Sikh, and Muslim leaders in Calcutta had sworn they would maintain harmony among their communities; now he hoped to pacify Delhi, too. Nehru "turned to Gandhiji in despair. He said that if these were Sardar Patel's views, he had no comments to make."[21]

In recent weeks, as they struggled to cope with India's postindependence crisis, a worrying rift had opened up between the prime minister and his deputy. Their differences were both practical and ideological.

Patel saw little point to Nehru's endless goodwill tours with Pakistani leaders. As far as the Sardar was concerned, the only way to restore stability to the Punjab was to transfer minorities from one side of the border to the other as quickly as possible. While the principle that Hindus and Muslims should be able to live together remained central to Nehru's vision for his new nation, Patel was less sentimental. He did not trust that all of India's Muslims, many of whom had so recently supported Jinnah, had switched loyalties.[22] If they did not think of themselves as Indians, he believed, then they belonged in Pakistan.

Patel was more in sync with the popular mood than Nehru. During the riots, officials trying to rescue Delhi's Muslims often found the public less than eager to help. Owners of private cars and trucks removed key parts so that the authorities couldn't requisition the vehicles. Volunteer drivers pretended to get lost or develop engine trouble when asked to deliver aid to Muslim areas. Eventually the government enlisted idealistic students to ride along and watch over them.[23] Even four days into the rioting, the American military attaché witnessed army troops standing by as Muslim women and children were clubbed to death at Delhi's railway station.[24]

Nehru would almost certainly have lost an open fight with Patel. Horrified by the casualty reports, the prime minister tried to ban Sikhs from wearing kirpans across the city. Patel pushed back, saying the decree discriminated against the Sikh faith. "Murder is not to be justified in the name of religion," Nehru protested. Yet after a "violent disagreement" between the two men, the Sardar triumphed. Sikhs regained the right to carry their daggers after a forty-eight-hour pause.[25]

Nehru seemed to believe that he had a better chance of quelling the unrest single-handedly than by working through his own administration. He went "on the prowl whenever he could escape from the [cabinet] table, and took appalling personal risks," Ismay recalled in a memoir.[26] As he had during the Bihar riots, Nehru angrily faced down mobs himself, rushing from trouble spot to trouble spot. At night he drove around the city, unable to rest — once even picking up a terrified Muslim couple and bringing them to his own home for safety. A veritable tent city filled with Muslim refugees sprouted on the lawns of his York Road bungalow.[27]

One night, a Muslim friend named Badruddin Tyabji showed up at Nehru's door to alert him to an especially troubled area — the Minto Bridge, which Muslims fleeing their Old Delhi neighborhoods had to cross to reach the safety of refugee camps in New Delhi. Each night, Tyabji said, gangs of Sikhs and Hindus lurked nearby and sprung on the defenseless Muslims as they trudged past. Nehru immediately bolted from his seat and dashed upstairs. He returned a few minutes later holding a dusty, ungainly revolver. The gun had once belonged to his father, Motilal, and hadn't been fired in years. He had a plan, he told Tyabji. They would don soiled and torn kurtas and drive up to the Minto Bridge themselves that night. Disguised as refugees, they would cross the bridge, and when the thugs tried to waylay them, "we would shoot them down!" The stunned Tyabji was able to persuade the leader of the world's second-biggest nation "only with great difficulty" that "some less hazardous and more effective method for putting an end to this kind of crime should not be too difficult to devise."[28] Mountbatten feared Nehru's impulsiveness would get him killed, and assigned soldiers to watch over him.

Nehru's individual heroics evoked great admiration in men like Ismay and Mountbatten (not to mention Edwina, who worked closely with Nehru to organize relief for the swelling ranks of refugees).[29] But they did little for Delhi's Muslims. After the initial wave of attacks, thousands had fled their homes. Authorities almost immediately started evacuating the rest, claiming that they could not guarantee the safety of Muslims who remained where they were. The evacuees were dumped in guarded sites by the truckload — places that it would be generous to describe as refugee camps. Within a week, over fifty thousand Muslims were crammed into the Purana Qila, where Nehru had held his grandiose Asian Relations Conference less than six months before.[30] They huddled pitifully on the muddy ground with no lights, no latrines, and hardly any water or food. The Pakistan government flew in shipments of cooked rice and chapatis all the way from Lahore to feed them.[31]

Ismay melodramatically compared the scene at the Purana Qila to "Belsen — without the gas chambers."[32] Dignified Muslim professors and lawyers were squashed next to cooks and mechanics, longtime Gandhians next to stranded, would-be Pakistan bureaucrats. The

wounded and sick moaned without medical attention; babies were born in the open. Armed Sikhs patrolled the one choked entrance, taking down the license plate numbers of Europeans driving in to deliver food and supplies to their friends and former servants.[33]

With the help of Gurkha and South Indian troops — who were less vulnerable to the sectarian passions roiling their northern counterparts — authorities managed to regain control of the capital within a week. Volunteers began to clean up the streets, and ration shops reopened. Nehru asked the governors of other Indian provinces to take in tens of thousands of Punjab refugees, to get them out of Delhi. He told reporters that a thousand victims had died in the rioting, though that estimate was generally considered "ridiculous," according to U.S. ambassador Henry Grady.[34] Grady figured the true toll to be at least five times higher; others said twenty times.[35]

Many observers believed that the instigators of the riots had not been defeated; they had only moved on. On Friday, 12 September, Akali gangs rampaged through the picture-book town of Simla, breaking into the Grand Hotel and slaughtering a Muslim family in front of one of Nehru's cousins.[36] Even more dangerously, the bond of trust between Delhi's Muslims and their government had been broken. When Gandhi visited the Purana Qila to promise that food was on its way, refugees angrily shouted that they preferred to eat chapatis from Lahore than anything provided by Nehru's administration.[37]

Many if not most of Delhi's Muslims now believed that they had no future in India's capital. "The atmosphere in Delhi today is such that a Muslim appears in public only at the risk of his life, and there is no assurance that either police or Indian Army troops will interfere if he is attacked," a U.S. diplomat wrote in mid-September.[38] By the end of the month, the cabinet minister in charge of refugees estimated that 90 percent of the Purana Qila's miserable inmates wanted nothing more than a speedy removal to Pakistan.[39]

When Jinnah gathered his ministers on Tuesday, 9 September, to address the burgeoning crisis in Delhi, one key figure was missing. Zahid Hussain, Pakistan's high commissioner, was supposed to have flown in from the Indian capital to brief the cabinet personally. He never showed

up. In the previous forty-eight hours, Hussain's cables from Delhi had grown increasingly alarming.[40] Hundreds of Muslim refugees had carpeted the grounds of his house, he reported, and the embassy's food supplies were running out. Hussain described the Indian government as either intent on eliminating the capital's Muslim population or indifferent to its fate. Army troops were openly gunning down innocent Muslims. Tens of thousands of Sikh and Hindu villagers from the surrounding countryside were supposedly mobilizing to "fall upon Delhi to give a final blow." In one of his last cables, Hussain had warned, "The entire Muslim population of India is facing total extermination."[41]

When he heard that the Pakistani ambassador was on his way to see Jinnah, Mountbatten sent an aide to the airport to yank the hysterical envoy off the plane. "Had he gone to Karachi in such a frame of mind the picture painted to the Governor-General of Pakistan would have sent Mr. Jinnah through the roof," Ismay explained to the British ambassador in Delhi. In fact, when Hussain didn't show up, the Pakistanis initially feared that he, too, had been killed.[42]

Jinnah was ready to believe the worst. *Dawn's* coverage of the Delhi riots had been incendiary: CITY FALLS TO THE FURY OF ARMED SIKH HORDES SPREADING MURDER, LOOT AND ARSON, read one typical headline.[43] With evacuation flights disrupted, the thousands of Pakistan government bureaucrats and their families still in Delhi were trapped. Two nights earlier, four hundred furious civil servants had burst onto the grounds of Government House while the Quaid was throwing a pool party for the emir of Kuwait. They shouted down Liaquat — whose mood was one of "black depression," according to one observer — and demanded that Jinnah somehow get their families out of Delhi. The next day, riots broke out in Karachi, too, as Muslims stabbed fourteen Hindus and killed eight others.[44]

A conviction was taking hold that India, in Liaquat's phrase, had launched an "undeclared war" to destabilize the weaker Pakistan.[45] The Indian leaders seemed unwilling to transfer Pakistan government servants to Karachi or to protect them in their Delhi homes. Cargo trains full of equipment and supplies meant for Pakistan were being derailed and torched in the Punjab. At least some members of the Indian Cabinet appeared to be winking at the Sikhs' murderous activities. "It is ob-

vious that their orders are not carried out," one of Hussain's cables said of the Indian leaders, "or at least different members of the government are following conflicting policies."[46] Pakistan's communications minister, Sardar Abdur Rab Nishtar, had been in Delhi when the riots had first broken out. His firsthand report would not have put any of his colleagues' minds at ease.[47]

For two and a half hours, the cabinet debated how to respond. Jinnah thought Pakistan needed to enlist outside help. He had a letter to Clement Attlee drafted — under Liaquat's signature rather than his own, to maintain constitutional propriety — charging that "the Government of India are apparently unwilling or powerless to restore order":

> Delhi has been the scene of carnage on a large scale.... While stern and ruthless action is called for, speeches and appeals to reason are being made instead without any effect on those who are determined to achieve their object of destroying the Muslims.... It is clear that the India Dominion as a member of the British Commonwealth has failed in the primary duty of protecting the life, property and honour of one section of its citizens — the Muslims who are marked out for death and destruction.

The letter asked that the Commonwealth "immediately consider effective ways and means of saving gravest situation in India which presents a serious threat not only to the peace of this great subcontinent but to that of the whole world."[48] Although vaguely phrased, the implication was clear: Pakistan wanted India condemned by the Commonwealth, if not kicked out entirely. Soon thereafter, noting that Pakistan's stability was "of world concern" given its strategic location, Jinnah dispatched an envoy to Washington to try to secure a $2 billion loan from the Americans — the first of many such requests Pakistan would make over the ensuing decades.[49]

The cabinet also considered one other matter, which at the time seemed slight by comparison: a request by the princely kingdom of Junagadh to become part of Pakistan.[50] Most of Jinnah's ministers had probably never heard of the tiny state, which lay on the Kathiawar Peninsula, where both he and Gandhi had roots. Like many of its neighbors, the kingdom was a crazy jigsaw: obscure vassal states ruled patches

of land within its boundaries, and some parts of Junagadh territory lay in other states. India surrounded Junagadh on three sides; its only link to Pakistan was by sea, through the port of Veraval, which was not even navigable during the monsoon months.

The state's Muslim nawab was a vaguely ridiculous character, obsessed with dogs. His eight hundred canines supposedly each had their own apartment, complete with attendant and phone. A three-day "wedding" between two favorites cost the state exchequer 300,000 rupees.[51] The "bride" was borne to the Durbar Hall on a silver palanquin, while 250 mutts attired in brocade and accompanied by a military band greeted the gold-bedecked "groom" at the train station.[52] Certainly the nawab seemed to care more for his pets' well-being than that of his roughly 800,000 citizens, more than 80 percent of whom were Hindu.

Before he left Delhi over the summer, Jinnah had made overtures to a whole slew of Hindu-majority kingdoms. Some, like Indore and Bhopal, whose Muslim ruler was an old friend, were completely enclosed by Indian territory and never had a chance of acceding to Pakistan. Others, like the Rajput states of Jaisalmer and Jodhpur, at least lay near the Pakistan border. Jinnah offered the maharajah of Jodhpur his own blank sheet of paper on which to write his terms for accession. But swift work by V. P. Menon and some arm-twisting by Mountbatten had persuaded the hot-tempered young prince that his best interests lay with not provoking India.[53] Among them Mountbatten, Patel, and Menon had bagged virtually all the states that lay within India's borders before 15 August.

During his charm campaign, Jinnah had also met with Junagadh's newly appointed prime minister, Shah Nawaz Bhutto (father of Zulfikar Ali Bhutto and grandfather of Benazir Bhutto, both future Pakistani prime ministers). The Quaid had reassured Bhutto that Junagadh need not fear Indian threats. "Veraval is not far from Karachi," Jinnah had declared (rather extravagantly for a man without much of a navy). "Pakistan [would] not allow Junagadh to be stormed and tyrannised."[54] His pitch worked: on 15 August, Junagadh had offered to accede to Pakistan rather than India.[55]

In recent days, Bhutto had written to remind Jinnah of his promises.

Although Nehru and Patel were distracted by more pressing matters, local Indian officials in Kathiawar were threatening to attack Junagadh "from both inside and outside" if the nawab did not reverse himself, Bhutto warned.[56] He needed to know if Pakistan planned to ratify the state's accession and come to its defense, or not.

Jinnah had no special interest in this particular speck of Gujarati coastline. According to Mountbatten, he later "freely admitted that there was no sense in having Junagadh in the Dominion of Pakistan and said that he had been most averse [to] accepting the State's accession." But the Indian threats now made the state useful. If India decided to invade Junagadh to try and thwart its accession, Pakistan would have an even better case to present to the world "as the small innocent nation and the victim of the aggressive designs of its large bullying neighbour," as Mountbatten later put it.[57] The cabinet voted to make the state part of Pakistan.

Jinnah must have known that both decisions would enrage India. He no longer cared. Pug Ismay arrived in Karachi two days later, dispatched by Mountbatten to give the Quaid a more evenhanded account of the troubles in Delhi. Jinnah "couldn't have been a more charming host. He pressed me over and over again to regard his house as my home, and to come for as long as I liked and as often as I liked, bringing you with me," Ismay wrote to his wife in England.[58] But in eleven hours of talks spread over three days, the Pakistani leader did not mention either the letter to Attlee or Junagadh's accession.[59]

For his part, Ismay did not try to deny that petty officials may have encouraged rioters in Delhi and East Punjab — as they had on the Pakistani side of the border, too — or even that leaders as powerful as Patel had displayed less sympathy for Muslims than for Hindus and Sikhs. Instead, the chief of staff built his case on Nehru. "Could anyone who knew Pandit Nehru doubt his humanitarian principles or his courage?" Ismay asked Jinnah, using Nehru's Kashmiri honorific.[60] "I had, with my own eyes," Ismay noted, "seen [him] charge into a rioting Hindu mob and slap the faces of the ringleaders. He seemed to have no thought whatsoever for his personal safety."[61] The storm that had swept over Delhi would have disrupted any government in the world, let alone one

that was only a few weeks old, Ismay insisted. At least Pakistanis could trust that India's leader did not mean any harm to them or India's own Muslims.

This was not an argument calculated to win Jinnah's confidence. If nothing else, Muslims knew where they stood with a strongman like Patel. Nehru was almost worse — a dreamer incapable of forceful, effective action. By now the Quaid was convinced that the Punjab cataclysm had been planned for months. Although intelligence had fingered Sikh leaders over the summer, they had been allowed to walk free. India, with her vast resources and powerful military, could even now have suppressed the Sikhs if only Nehru had the necessary "will and guts."[62] Instead, he could not even guarantee the safety of Muslims in his own capital.

Ismay returned to Delhi profoundly depressed. In a secret codicil to his report, meant for Mountbatten's eyes only, he warned that Jinnah had begun speaking in dangerously warlike tones. In the very first hour of their talks, the Quaid had struck Ismay "as a man who had given up all hope of further cooperation with the Government of India." All that had happened in the month since independence just "went to prove that they were determined to strangle Pakistan at birth," Jinnah had told Ismay grimly. "There is nothing for it but to fight it out."[63]

As a discouraged Ismay flew back to Delhi on 14 September, Nehru was racing the other way, to attend an emergency summit with Liaquat in the Punjab. Jinnah was not the only one talking about a war.

Most accounts of the Partition riots tend to focus on the eruption of violence in mid-August, leaving the impression that the chaos steadily tailed off thereafter. In reality, the massacres grew wider and more intense for weeks. By mid-September, they were approaching their peak. The exodus from both halves of the broken province had assumed biblical proportions. An estimated 1.75 million Muslims had crossed into Pakistan from East Punjab, while a roughly equivalent number of Hindus and Sikhs had emigrated to India.[64] Millions more were on the move. Organized refugee convoys — called *kafilas* — now stretched for 50 miles or more. The tramping of hundreds of thousands of cows, buffalo, and blistered human feet churned up the Punjab's dirt roads. When these great masses of humanity paused for the night, *Life* maga-

zine photographer Margaret Bourke-White wrote, the flicker of thousands of campfires "rose into the dust-filled air until it seemed as if a pillar of fire hung over them."[65]

One kafila, filled with more than a quarter-million Muslim refugees from East Punjab, had recently begun the long, dangerous march to Lahore. The most direct route would bring them through the Sikh bastion of Amritsar. The city had been emptied of its Muslim population and was now filled with tens of thousands of vengeful Hindu and Sikh refugees from West Punjab. They refused to let the column pass. Crowds chanted "No Muslims out!" and swore that not a single Muslim would cross the border alive.[66]

Master Tara Singh could not — or would not — control his followers. Any remorse he might have felt at the start of the massacres had dissipated as refugees recounted the horrors they had suffered on Pakistan's side of the border. Meeting with "Timmy" Thimayya, who had been promoted to major-general and was now in charge of Indian troops in East Punjab, Singh said he saw only one way to resolve the worsening conflict: war between India and Pakistan.[67]

The army did not relish the challenge of reining in the Sikhs. The jathas had grown bigger, bolder, and more organized. They vastly outnumbered the kafila escorts: already, in one assault, a ten-thousand-strong jatha had attacked a detachment of sixty soldiers, wounding their Sikh officer four times.[68] Commanders feared their Sikh soldiers would begin to desert if they had to keep fighting their brethren.

Across the table from Liaquat in Lahore, Nehru was forced to admit his government's impotence. He could not open Amritsar's gates. The best alternative Thimayya could propose was to bulldoze a new road around the city for Muslim convoys to use.[69] The project would take several days. In the meantime, the refugees — who suffered repeated attacks on their journey, and were refused food and water in the villages they passed — would have to wait.

Tara Singh's idea of carving out a powerful Sikhistan in the Punjab sounded less crazy now. In the Sikh states, ongoing pogroms were denuding villages of Muslims. Kafilas that ran the gauntlet of Sikh kingdoms made fat, all-too-easy targets for royal troops. One Indian Army officer sent to investigate conditions in Patiala met a Sikh ex-soldier who

had served in his unit during the war. He asked how the man was faring. "Fine," the former sepoy said with satisfaction. "We are getting the most excellent *shikar* [hunting]. If we don't kill 700 Muslims a day we think it is a poor bag."[70] Nehru himself told Pug Ismay that "he did not doubt that [the maharajah] of Patiala wished to get complete supremacy of Sikhistan" and had killed or expelled his kingdom's Muslim population as a first step.[71]

To a disturbing extent, Sikh militants seemed to be dictating events in territory controlled by Nehru's government, too. Visiting Pakistani officials claimed that "a complete Sikh raj" had taken over East Punjab; some of their Indian counterparts complained of having to take orders from an underground Akali high command rather than the Indian government.[72] Trivedi, the provincial governor, appeared to have little sway over his Sikh ministers. In early September, he had pressed Home Minister Swaran Singh to take more forceful action against the jathas. For almost two weeks, Singh had not even deigned to respond, and when he did, he casually dismissed the massive raids as "sporadic and local outbursts of violence."[73] The urbane Trivedi finally lost his temper, blasting Singh's police for taking part in rampant looting and slaughter. "I would not be sorry if the Army shot them [all], including their officers," the governor raged.[74]

Suspicions were further inflamed by a sudden Sikh migration out of the verdant canal colonies of Montgomery and Lyallpur, which were now part of Pakistan. In early September, Akali leaders had ordered their followers to evacuate the canal lands en masse, even though they had not yet been targeted by mobs. Unlike the wretched Muslim kafilas—which "straggled sorrowfully along the road like a lot of tired ants," in Ismay's words—the Sikhs' loaded bullock carts rolled out with "march discipline ... worthy of the British Army at its best."[75] Armed and mounted scouts guarded the convoys' flanks, while white-bearded former soldiers carrying shotguns and wearing their World War I medals led the way. The Sikhs looked like they were leaving with "their tails up," said one British official.[76] In his letter to Attlee, Jinnah described this "controlled exodus" as "part of the Sikh plan" to consolidate their community on lands that had been wiped clean of Muslims.[77]

These Sikhs were abandoning large plots of some of the most fertile

land in the subcontinent, and they were not likely to be satisfied with the small, hardscrabble farms that awaited them in East Punjab. Worries now grew that once their ranks had been collected, Sikhs would launch an insurgency across the Punjab border to reclaim the whole province. In mid-September, Patel dispatched eight hundred rifles to Faridkot and told the prince he might soon be called upon to defend "territory other than that within the boundaries of his own State."[78] There was open talk of a Sikh invasion of Lahore. "THIS MAY SOUND ALARMIST," West Punjab governor Mudie wrote to Jinnah, the passage marked out in boldface type, "BUT IF ANYONE SIX MONTHS AGO HAD PREDICTED WHAT THE SIKHS HAVE ACCOMPLISHED IN THE LAST TWO MONTHS, HE WOULD HAVE BEEN LAUGHED TO SCORN. WE CAN AFFORD TO TAKE NO RISKS."[79] Pakistan's army was already stretched to the limit: by the middle of September, General Messervy, now Pakistan's commander in chief, had "not a single battalion in reserve."[80]

On 19 September, Tara Singh swore to Nehru that he had not the slightest ambition of creating a Sikhistan.[81] Yet the very next day, the Akali leader told an Amritsar newspaper that Sikhs could never tolerate "the surrender of the canal colonies we built with our endless endeavour." He called for all Sikhs along the border to be armed by the Indian government. "A state of war exists between India and Pakistan today," he said matter-of-factly. "I wish India realised that it would be far better to fight it out with the aggressor openly . . . so that millions of more lives may [not] be lost in vain."[82]

If Nehru wouldn't start that war, the Akalis appeared intent on doing so. As part of the effort to evacuate Muslims who wanted to leave Delhi, India had resumed the Pakistan Special services for government officials. The trains carried armed escorts, followed undeclared routes, and kept their timings secret. Yet the jathas seemed to have no trouble tracking them, even broadcasting news of their arrival over loudspeakers at Amritsar's station.[83]

While the image of the "corpse train" arriving full of dead and mutilated bodies remains perhaps the most enduring icon of Partition, most passenger services had actually been halted after the initial attacks. The worst massacres only came to pass now. Over the weekend of 20–21 Sep-

tember, four of the Pakistan Specials rolled across the border and into Lahore one after the other, their floors slick with blood. Some had been attacked multiple times. One train's escort had driven off a jatha only after forty-five minutes of ferocious, hand-to-hand fighting. Another had lost several hundred passengers, including sixty-two children under the age of eight.[84]

On 22 September, after a refugee train coming the other way arrived in Amritsar with dead and wounded, the Akali fighters went berserk. A mob estimated at ten thousand people swarmed a Pakistan-bound train full of Meo refugees, firing automatic rifles, tossing bombs, and slashing away with swords.[85] Only 200 horribly wounded passengers survived; at least 1,500 people were killed, including the British commander of the train's escort. Bourke-White arrived at the scene soon afterward. All along the platform, she later wrote, blue-turbaned Sikhs sat cross-legged, their curved kirpans across their knees, patiently waiting for the next arriving Special.[86]

Pakistan had few means of retaliating. Mudie suggested to Jinnah that if India could not bring the Sikhs to heel, Pakistan should make use of its "hostages." A convoy of 400,000 Sikhs from Lyallpur was now approaching the Balloki Headworks, which bridged the Ravi River. On 23 September, Mudie informed Thimayya that he was closing off the headworks until the Indians could guarantee the safety of Muslim refugees coming the other way. "This is said to have made a considerable impression on him," Mudie advised the Quaid.[87]

Thick jungle lined the road leading to the canal crossing. It was perfect cover for ambushes. The Lyallpur convoy had been on the road for nearly two weeks now, and if not allowed to pass, India's deputy high commissioner Sampuran Singh wrote to Nehru, the refugees would "suffer untold privation, disease and misery."[88] Pakistani authorities had a different worry: "Situation in which vast and well-armed Sikh convoys might try to fight their way out is electric," Sir Laurence Grafftey-Smith, Britain's ambassador to Pakistan, urgently cabled London. "Government are rushing troops into West Punjab."[89] That day, the rains finally broke, drenching the already miserable refugees on both sides of the border. The Punjab's rivers swelled, ready to burst their banks.

• • •

Meanwhile, a different kind of civil war was unfolding on Delhi's swank York Road. Tensions between Nehru and Patel had continued to build over the past fortnight, pitting their respective camps against one another in the cabinet. By now the rift "had reached dangerous proportions," according to Railways Minister John Matthai.[90] Foreign embassies reported almost daily rumors that the Sardar was maneuvering to oust the prime minister and take over the government.[91]

The partnership between the two Congress leaders had always been an awkward one, held together primarily by their mutual loyalty to the Mahatma. Patel found Nehru to be weak, too tortured and impulsive to grip and wield power effectively. Nehru, who felt like a "misfit" amid the jostling factions within the Congress, mistrusted Patel's greater hold over the party machine.[92] If Gandhi hadn't personally intervened a year earlier, in fact, Congress cadres would have made the Sardar their president — and likely India's first prime minister.

For years Patel had devotedly followed the Mahatma and his principles, with more conviction than Nehru even. Yet since the outbreak of rioting in Delhi, the Sardar "had gone completely communal," Mountbatten said.[93] The fact that so many of Delhi's Muslims now wanted to move to Pakistan only confirmed Patel's suspicions about them. Better to expel them as quickly as possible, to eliminate both a provocation to the Punjabi refugees in Delhi and, he imagined, a security threat. At one point, Patel even suggested sending a battalion of troops into the Purana Qila to search for the weapons he believed Muslims had stockpiled there.[94]

Nehru, on the other hand, found the idea of losing Delhi's Muslim population — the source of so much of the capital's greatest art, architecture, music, and poetry — tragic and abhorrent. Internally, he had been arguing that the nearly 200,000 Muslims trapped in the city's squalid refugee camps needed to be reassured and returned to their homes, not shipped off to Pakistan. The government had a choice, he wrote in a memo to the cabinet: to pursue policies that would "lead to the progressive elimination of the Muslim population from India," or to "consolidate, make secure and absorb as full citizens" those same Muslims.[95] Nehru fully realized that he was "out of tune" with prevailing sentiment. But he was convinced, as he wrote to a fellow Congressman,

that if its leaders adopted the former course, India would be "doomed as a nation."[96]

Even as the Sikhs remained bottled up at Balloki Head, Nehru began going out every day to remonstrate with Hindu and Sikh crowds in Delhi. He warned them that they were emulating the "evil ways of the Muslim League." To continue to do so would be to admit that the League had been "victorious in the battle against virtue."[97] Nehru now painted the unrest in Delhi as a plot that had been organized by Akali and RSSS cells—"fascists," he called them, no different than Jinnah's thugs or Hitler's. Privately, he pressed Patel to round up these "terrorists" and their sympathizers in the police and administration.[98]

The Sardar was open in his disdain for Nehru's theatrics. "I regret our leader has followed his lofty ideas into the skies and has no contact left with the earth or reality," Patel scoffed to Mountbatten, who found the comments deeply disturbing.[99] According to Matthai, Gandhi swore that "he would be finished with [Patel] forever" if his longtime acolyte moved against Nehru.[100] Still, U.S. ambassador Henry Grady reported to Washington that if the Sardar were to attempt a cabinet coup, he would "undoubtedly succeed."[101]

Matters came to a head on 29 September. Dickie Mountbatten was upstairs in his chambers at the renamed Government House, dressing for dinner, when V. P. Menon burst in, shouting, "The worst has happened!"[102] Patel was threatening to resign and bring down the government.

What had spurred Patel's ultimatum was neither the crisis in the Punjab nor the fate of Delhi's Muslims but, in Pug Ismay's apt description, "two ridiculous little principalities in Kathiawar, with a total annual revenue about large enough to keep a sparrow."[103] Barbariawad and Mangrol were obscure, insignificant feudal states, tucked away somewhere inside Junagadh territory. Even Indian Army commanders had trouble locating them on a map. After the rest of the state had joined Pakistan, Menon had enticed their rulers to break away and accede to India instead. On 22 September, the nawab's troops had put an end to this brief rebellion by marching into Barbariawad and forcing the sheikh of Mangrol to rescind his accession. Menon and Patel were convinced these

flyspecks were part of India. In Jinnah's eyes, however, they belonged to Pakistan.

Arriving at Government House after an urgent summons from Mountbatten, Patel adopted a belligerent stance. He wanted to send Indian troops to retake Barbariawad and Mangrol, "to show that the Dominion of India was not afraid of Pakistan or their machinations and did not intend to be bluffed by Mr. Jinnah." Mountbatten argued that this was precisely what Jinnah wanted: Pakistan would be able to condemn India in the court of international opinion as a bully and aggressor. "The country that had lost its national position need not bother about her international position," Patel retorted.[104]

A day earlier, the cabinet had held a four-hour meeting on a Sunday to consider its military options. All of India's service chiefs — General Lockhart and the heads of the Royal Indian Air Force and Navy — were British, as were their counterparts in Pakistan. Rather than an actionable war plan, they handed the Indian leaders a letter refusing to take part in any such operation. An invasion of tiny Barbariawad would be a declaration of war against Pakistan, the commanders argued. With most of its troops tied up with internal security duties, India could ill afford to wage such a conflict. More importantly, British generals could not "be the instrument of planning or conveying orders to others" if the operation in question would pit British officers in the Indian and Pakistani armies against one another.[105] As supreme commander, Auchinleck had issued top secret orders that in the event of a conflict, British officers on both sides would have to stand down immediately. The chiefs' insubordination enraged Patel. He vowed to quit within twenty-four hours if Nehru didn't back him against the brass.

Patel had taken Junagadh's accession to Pakistan personally. A proud Gujarati, he loathed the thought that India should lose any part of his home region. As states minister, he had also issued firm pledges to defend the other Kathiawar kingdoms. If Delhi now allowed a pocket of Pakistan — one that might soon be filled with Jinnah's troops — to exist on their borders, they would never feel safe. The Sardar had been absolutely "vitriolic against Pakistan" when Attlee revealed Jinnah's appeal to the Commonwealth on 21 September, Mountbatten recorded.[106]

The journalist Durga Das, who was close to Patel, claimed that he had "ordered ordnance factories to work 24 hours a day to produce arms and ammunition" to meet the threat from across the border.[107]

A deeper worry obsessed Patel as well, as V. P. Menon explained to a U.S. diplomat in Delhi. Spreading out a map of the subcontinent, Menon pointed meaningfully at the southeastern corner of Junagadh, then at the western tip of Hyderabad, to show how little distance separated them.[108] Legally, there was nothing to stop the nizam of Hyderabad from acceding to Pakistan just as Junagadh had. A beachhead on the coast of Gujarat would provide Karachi with an immensely useful sea and air link to Hyderabad. Indeed, a young British pilot who spent a month ferrying Muslim refugees and supplies for Pakistan told the U.S. consul in Calcutta that "Pakistan's interest in Junagadh was wholly as a base between Karachi and Hyderabad, especially for military planes."[109]

In hindsight such fears sound paranoid. But by late September, Patel's spies were reporting ominous changes in the nizam's court. For weeks, Sir Walter Monckton, Hyderabad's constitutional adviser, had been working diligently to persuade the nizam to return to the idea of a treaty with India, one that did not involve the word "accession." But members of the leading Muslim party in the state, the Majlis-e-Ittehad-ul-Muslimeen, or Council for the Unity of Muslims, had visited Jinnah in Karachi at the beginning of the month. After they returned home, the nizam's position had hardened, and he wrote to Attlee and the British king to argue for Hyderabad's independence.[110] In August, the head of Hyderabad's military, Maj.-Gen. Syed Ahmed "Peter" El-Edroos, had traveled to London looking to buy weapons on the open market.[111] Indian intelligence reports claimed that he had discussed 3 million pounds' worth of orders with Czech arms factories.[112]

The mercurial nizam also suggested that Monckton's services were no longer required. "I cannot put my finger on the influences which have moved him," a bewildered Monckton wrote to Mountbatten on 24 September, "but it is plain that they must be Pakistan influences at the root."[113]

Patel and Menon would accept any risk to prevent Jinnah from destabilizing a huge swathe of southern India. Menon unsuccessfully tried,

on his own authority, to order two Indian Navy sloops to deploy off the Gujarat coast. Rear-Adm. J. T. S. Hall, head of the Royal Indian Navy, had pushed back. As General Savory recorded in his diary, "Hall pointed out that the essence of a threat was the determination to carry it out if need be, and asked V.P.M. if he realised this. V.P.M.: 'YES.' Hall: 'That means war.' V.P.M.: 'Why not?'!!"[114]

Nehru took a less alarmed view of Junagadh's accession, but he, too, had found the chiefs' letter "extraordinary ... an announcement that they should not carry out the Government's policy in case they did not agree with it."[115] More to the point, he could not afford a showdown with Patel. That night, with Mountbatten mediating, the Indian leaders struck a temporary compromise. The brass would withdraw their letter, since it was indeed unconstitutional. The military would load troops and tanks onto landing craft and send them up the coastline from Bombay. But the Indian forces would only deploy in nearby Kathiawar states that had acceded to India, rather than in Junagadh itself. They would make no move to enter Barbariawad or Mangrol.[116]

Nehru had always argued that the people, not their monarchs, should decide the fate of the princely states. He thought India could easily undermine Junagadh's nawab through a ginned-up "internal" uprising, without any need for outside troops. Menon had already cobbled together a gimcrack "provisional government of Junagadh" from a group of Kathiawaris living in Bombay, led by one of the Mahatma's nephews, Samaldas Gandhi. Earlier that day, they had rolled into the nearby administrative center of Rajkot on a special, beflagged train. It was "pointed out that funds, arms and volunteers were not likely to be lacking to help a rising in Junagadh," Mountbatten recorded.[117] Support could always be funneled through the Congress Party in Bombay — just as Mountbatten had threatened over the summer.

Samaldas Gandhi's "provisional government" struck its first blow the very next day. Rebels scaled the walls of a palace in Rajkot owned by the nawab of Junagadh and claimed the property for India.[118] A couple dozen of the nawab's mystified servants were taken into custody. An Indian flag soon flew from the rooftop.

If Delhi believed its moves were restrained, they did not look that

way across the border. Messervy sent a frantic message to Auchinleck's Supreme Command on 1 October, complaining that the Royal Indian Navy ships steaming toward Kathiawar had been stripped of their British officers and packed with ammunition, as if preparing for an attack. Reports claimed that a squadron of Royal Indian Air Force fighters had deployed in nearby Nawanagar state. "CONSIDER THESE STEPS HIGHLY PROVOCATIVE. . . . I URGENTLY REQUEST YOUR INTERVENTION TO STOP THIS MADNESS," Messervy cabled.[119] A Pakistani sloop, the *Godavari,* had intended to dock at Junagadh but was now held off to avoid an incident at sea, "particularly as Captain is inclined to be impetuous," British ambassador Grafftey-Smith informed London.[120]

Jinnah's mood had only grown more bleak since Ismay's visit earlier in the month. Attlee had offered no encouragement to Pakistan's hopes of getting the Commonwealth involved in the dispute. In the meantime, even as the massacres continued in the Punjab, Patel was shipping out trainloads of Muslim refugees daily, not just from East Punjab but from Delhi, the United Provinces, and surrounding princely states. The Sardar seemed intent on swamping Pakistan's fragile economy with a wave of destitute migrants.[121]

With their rhetoric, Indian leaders also appeared to be encouraging Hindus and Sikhs to leave places like Karachi, where Jinnah claimed they were perfectly safe. A devastating exodus was already well underway: Pakistan was rapidly losing its bankers, merchants, moneylenders, shopkeepers, clerks, and sweepers. Karachi banks, bereft of their Hindu managers and clerks, could now mostly handle only cash transactions.[122] Cotton — a key export — was piling up in warehouses because all but ten of the brokers at the Karachi Cotton Exchange had fled.[123] "Every effort is being made to put difficulties in our way by our enemies in order to paralyse or cripple our State and bring about its collapse," Jinnah wrote to Attlee on 1 October, pleading again for intervention.[124]

Ismay returned to Karachi on 3 October on his way home to England to brief the cabinet and the chiefs of staff personally on the deteriorating situation on the subcontinent. He described for Jinnah Nehru's impassioned appeals for India to protect its Muslim minority, and pointed out

that the prime minister was risking his life every time he went before one of the restless, hostile crowds in the Indian capital. The Quaid — who probably didn't appreciate Nehru's repeated comparisons of the League to the Nazis — was not impressed. "He said that Nehru himself was a figurehead, vain, loquacious, unbalanced, unpractical, and that the real and almost absolute power lay with Patel," Ismay recorded.[125] (Pug later admitted that to some extent, "he believed Mr. Jinnah to be right.")[126] India was "determined on the destruction of Pakistan," Jinnah insisted to Ismay.[127]

Britain was now actively worried about the prospect of war between the dominions. Military planners in London had begun laying out scenarios for a conflict.[128] Grafftey-Smith and the British ambassador to India, Sir Terence Shone, started making plans to evacuate British and American civilians from the conflict zone.

The same day he saw Ismay, Jinnah met with Sir Archibald Carter, the permanent undersecretary at the Commonwealth Relations Office, who was visiting Karachi. They talked money. India had not yet agreed to a fair distribution of the former Raj's reserves; Pakistan had barely enough funds in its exchequer to keep the government running for two months. Carter had spoken to Jinnah's Finance Ministry officials about the possibility of Britain extending to Pakistan a 100-million-pound loan to cover the dominion's short-term spending gap.[129]

The Quaid, Carter reported, "seemed not the least interested" in this immediate shortfall. Jinnah wanted to discuss long-term military assistance — both money and tanks, rifles, and aircraft — from Britain. He had asked Ismay to relay the same request to London. When it came to the tools to defend itself against India, Jinnah indicated, Pakistan wanted "as much as the U.K. could afford."[130]

Ironically, it was now, in late September, that the fever of hate finally started to recede in the Punjab. Days of whipping monsoon rains had flooded much of the province, widening the Beas River from half a mile to 10 miles across. Racing waters washed away makeshift refugee camps and whole sections of kafilas. Refugees clung to the tops of trees and begged for help as their livestock and few pathetic belongings tumbled

along below. Near Jullundur, one army officer witnessed Sikh villagers going to the aid of the stranded Muslims; when asked why, they said the floods were an act of God — all were victims.[131] Perhaps more importantly, the mobs could get around no better than their prey in the drenched landscape. Forced to pause in their depredations for several days, they seemed to lose some of their bloodlust.

Patel visited the Punjab himself on 30 September and delivered a blunt message to Sikh leaders to call off their fighters. The unrest in the Punjab was threatening the stability and unity of India, and the government could ill afford the distraction. "Evil cannot be met by evil," he told the gathered Akalis and Sikh princes. He advised them to conserve their energies. "When the right time and the right cause come, you can use your sword to your heart's content. Now you have to sheathe your sword so that you can raise the moral tone of the people."[132]

The next day, Liaquat arrived in Delhi for a meeting of the Joint Defence Council. Mountbatten prevailed upon him to release the Sikh convoy blocked at the Balloki Headworks, so as not to undercut whatever good Patel's speech had done. The Pakistani prime minister agreed reluctantly, on the condition that Muslim convoys be kept moving in the other direction, too. This at least was progress. If the riots had been their only concern, the two dominions might now have started to take steps toward real cooperation.

There remained the question of how to defuse the Junagadh crisis, though. Liaquat bristled when Mountbatten informed him that India planned to land troops and tanks on the borders of the state. The Pakistani complained that the move savored of "pressure and the intent to commit a hostile act."[133] Nehru interrupted to insist that India's disciplined troops would not be the ones to fire the first shot in Kathiawar.

Then, as Mountbatten had been pushing him to do, Nehru suggested a way out: he pledged that India would accept the results of any free and fair plebiscite or referendum of Junagadh's citizens, asking them which dominion they preferred to join. Mountbatten immediately pointed out that, as a statement of policy, Nehru's offer would apply to any other state whose accession remained in doubt. A vote would obviously go India's way in huge Hyderabad; both there and in Junagadh, Hindus outnumbered Muslims four to one. But there remained a last kingdom

that had not yet allied itself with either dominion, one whose monarch also ruled over a population that adhered to a different faith. "Nehru nodded his head sadly; Liaquat Ali's eyes sparkled," Mountbatten wrote afterward, describing the scene for the king. "And there is no doubt that the same thought was in each of their minds: 'Kashmir!'"[134]

8

✦✦✦✦

Ad Hoc Jihad

A FAIRYLAND RINGED by Himalayan peaks and dotted with
startlingly clear rivers and lakes, Kashmir seems too idyllic to
be the source of decades of tensions, skirmishes, and militancy.
Yet with the passage of time, memories of the unimaginable slaughter in
the Punjab would fade into the subcontinent's collective subconscious.
Delhi's Muslims would depart en masse for Pakistan; the Indian capital
is today in many ways a Punjabi city, its culture remade by the hundreds
of thousands of Hindu and Sikh refugees who took their place. In most
current histories, neither Junagadh nor Hyderabad rates more than a
few pages.

The wound that keeps the paranoia and hatreds of 1947 fresh for
both Pakistanis and Indians is Kashmir. The state has been the cause
of two outright wars between their nations since 1947, and remains the
likeliest spur to another. Without Kashmir, a border might separate the
South Asian rivals today, rather than a violent, unbridgeable chasm.

Jinnah had last visited Srinagar, the garden-filled playground of the
Mughals, in the summer of 1944. K. H. Khurshid was then an eager,
twenty-year-old local stringer for the Orient Press, the only Muslim-
owned news agency in India. Each morning, Khurshid would climb
into a small rowboat and glide across glassy, mist-covered Dal Lake to
the *Queen Elizabeth,* the flat-bottomed houseboat where the Quaid
spent several weeks relaxing.[1] The young man faithfully delivered what

Jinnah called "the gup"— the day's gossip — and tried vainly to extract a newsworthy quote from the League leader. Jinnah, impressed by Khurshid's persistence, hired him.

Now, at the beginning of October 1947, Khurshid quietly returned to Srinagar on a mission. In recent weeks, Maharajah Hari Singh had been sending out disturbing signals. He had replaced his former, pro-Pakistan diwan with one who was known to have close ties to the Congress leaders. He had refused Jinnah permission to visit the state, even for vacation. Most worrying, on 29 September, the king had without warning released his bête noire — Nehru's protégé, Sheikh Abdullah — from prison. Jinnah needed to know what was happening inside the palace in Srinagar.

The news wasn't good. "The position appears to be that the Maharaja is dead set against Kashmir's accession to Pakistan," Khurshid wrote to Jinnah from Srinagar on 12 October. "He is reported to have said that even though his body be cut into 700 pieces, he would not accede to Pakistan."[2]

Radcliffe's award of Gurdaspur to India had made it possible for Kashmir to join either dominion. Pakistan still had the plainer case to make, and by many measures, the stronger. Kashmir's population was more than three-quarters Muslim, a figure that rose above 90 percent in the legendary Vale. For five centuries, the lush Kashmir Valley, bursting with cherry orchards and saffron fields, had been ruled by Islamic Mughal emperors; Hari Singh's Dogra ancestors had administered only the Jammu region until 1846, when the British had sold them the rest of the kingdom for 7.5 million rupees as a reward for their loyalty in the Anglo-Sikh Wars.[3] Almost all of Kashmir's economic life flowed up and down the rivers and roads leading into what was now Pakistan territory.

On the other hand, if Kashmiris had been asked their opinion in October 1947, they might well have preferred to join India. The one-sided population statistics were somewhat misleading. It's true that ethnically and culturally, Muslims in the southwestern Poonch region were almost indistinguishable from their compatriots across the border in West Punjab. But Jammu, the Dogra heartland, was nearly half Hindu. Other parts of the state, like snowy Ladakh on the Chinese border, contained many Buddhists. Even the majority who lived in the Vale were not or-

thodox Muslims: they practiced a softer, more easygoing form of Islam greatly influenced by Sufism.

Most critically, Sheikh Abdullah's pro-India National Conference was the only real organized political force in the state. The rival, pro-Pakistan Muslim Conference was "essentially defunct," Khurshid admitted; most of its leaders were in jail.[4] A free and fair election would quite likely have put Nehru's ally into power. Certainly India, which remained home to tens of millions of Muslims even after the creation of Pakistan, could make a plausible case for the state's accession.

Khurshid's conclusion was blunt. "In the light of the above," he continued in his report to Jinnah, "I am personally of the opinion, Sir, that Pakistan must think in terms of fighting . . . as far as Kashmir is concerned." Khurshid suggested a strategy similar to the one India was pursuing in Junagadh: a proxy war. "All that Pakistan has to be ready for in such an eventuality is to supply arms and foodstuffs to the tribes within and without the State who are already sharpening their weapons," he claimed. He even had a commander in mind — the man Jinnah had earlier entrusted with reorganizing the League's paramilitary. "I may say, Sir, that Major Khurshid Anwar (of Muslim [League] National Guards) is already in Rawalpindi and he can very well be trusted with the work of liaison." Anwar just needed orders to move.[5]

What Khurshid didn't know was that the Guards commander had already received his orders. For the past month, while attention had focused on the drama unfolding in the Punjab, Delhi, and Junagadh, a struggle over the future of Kashmir had quietly begun.

Back in early August, when he had met with Gandhi in Srinagar, Maharajah Hari Singh had still believed vaguely that Kashmir could remain independent, maintaining relations with both neighboring dominions like some Himalayan Switzerland. Inside the palace, though, his wife appears to have been pushing him to seek Indian protection. Then in early September, shipments of gasoline, sugar, and other vital goods that usually arrived via the western Punjab had mysteriously started to dry up. The king feared that Jinnah was deliberately turning the screws on him.

At the maharani's urging, Hari Singh had hired as his new diwan a

Punjabi judge named Mehr Chand Mahajan, who was close to India's new leaders. (Mahajan had argued the Congress case before Radcliffe's Punjab Boundary Commission.) On 19 September, the diwan flew to Delhi to confer with Patel and Nehru. Kashmir, he told them, wanted to accede to India.

The Sardar seized on Mahajan's offer. Less than a week earlier, Patel had told Defense Minister Baldev Singh that he wouldn't complain overmuch if Hari Singh chose Pakistan over India.[6] But Jinnah's power grab in Junagadh had changed Patel's thinking. He immediately set about bolstering Kashmir's defenses. The only "road" connecting the state to India was a barely usable jeep track that led north from Gurdaspur across numerous bridgeless tributaries of the Ravi River, up and over the 9,000-foot Banihal Pass — closed by snow several months of the year — and into Srinagar. Patel ordered crews to improve this pitted track. He arranged to send wireless equipment so that the short runway at Srinagar could be used through the winter, and to fly in loads of gasoline to make up for the shortfall from Pakistan.[7] He told Baldev Singh to collect weapons for the maharajah's army out of Indian stores.[8]

Nehru wanted his ancestral land to join India even more desperately than Patel did. But he still did not trust Hari Singh, and he had no interest in propping up the unloved Dogra monarchy. If Kashmir really wanted to accede, Nehru wrote to Mahajan after their meeting, the king should first release Sheikh Abdullah and take steps to establish a popular government under his leadership.[9] Only if offered by their own chosen representatives would any accession look legitimate to the Kashmiri people. This was not a matter of religion or ethnicity — it was about power and democratic principle. Reluctant to surrender any of his authority, Hari Singh balked at Nehru's demands.

The delay would be enough to seal Kashmir's fate. For across the border in Pakistan, a parallel set of machinations were also taking place. A few weeks earlier, in the Poonch region, Hari Singh's troops had put down a series of protests in favor of joining Pakistan. Poonchis were proud and tough; like the Sikhs, they had served in large numbers during World War II. They deeply resented the maharajah's rule, not to mention the raft of new taxes that his administration had imposed after the war. There were taxes on cows and buffalo, sheep and goats, win-

dows and hearths. There were taxes on imports and exports, extra wives, and even widows.[10]

Kashmir authorities estimated that at most twenty protesters had been killed in the unrest. Still, at the end of August, Poonchis had inundated Jinnah with telegrams urging him to back their petty rebellion.[11] "Atrocious military oppression in Poonch," one read. "Public being looted and shooted at random. Kindly intervene."[12] Preoccupied with the Punjab riots, the Quaid had not heeded the request.

Taking matters into his own hands, a Poonchi named Sardar Mohammad Ibrahim Khan crossed the border into Pakistan in mid-September. A thirty-four-year-old London-educated barrister, Ibrahim was looking for weapons and Pakistani volunteers to help launch a full-scale uprising against the maharajah. In Rawalpindi, he met with Col. Akbar Khan, the director of weapons and stores for the Pakistan Army. In a memoir, Khan recalled that he put together a plan to divert four thousand rifles meant for the Punjab police to Ibrahim's guerrillas, and shared the draft with a West Punjab minister.

A few days later, sometime in the third week of September, Khan was summoned to a meeting at Government House in Lahore. Among those he claimed were present were Liaquat himself; Pakistan's finance minister, Ghulam Mohammad; Guards commander Khurshid Anwar; and several provincial ministers and civil servants. "The conference lacked the businesslike precision that we are used to in the Army," Khan — the only serving soldier in the group — noted diplomatically. "But it was to some extent compensated by the enthusiastic willingness" of the would-be conspirators.[13]

At the time, Tara Singh's Sikhs were still blockading Amritsar, and trainloads of dead Muslim children were rolling into Lahore. Liaquat allegedly jumped at the chance to strike back at India in Kashmir, even offering to try and procure some Bren light machine guns for the would-be rebels from American war dumps in Italy. (When they finally showed up these "Bren guns" turned out to be Italian-made Stens, with a range of only 200 yards.)[14] No operational details were discussed at the meeting, and, Khan added, "in the atmosphere of cheerfulness and confidence that prevailed, it did not seem right for me to strike too serious a note by drawing attention to even such elementary matters as the need

for ammunition."[15] But very soon thereafter, the Kashmir state forces began noticing armed irregulars coming across the border from West Punjab, launching hit-and-run raids in Poonch.

Pakistan's unofficial support for the attacks was hardly a secret, and it marked the first use of the armed proxies that Pakistan's leaders would employ throughout the country's history. NWFP governor Sir George Cunningham, who had replaced Caroe after independence, noted in his diary on 6 October that Pakistani officials were "wink[ing] at very dangerous activities on the Kashmir border, allowing small parties of Muslims to infiltrate into Kashmir from this side."[16] The rebels quickly announced the formation of a "Provisional Republican Government" in Muzaffarabad, the first sizable town after crossing the Jhelum River into Kashmir, and decreed that henceforth, "no citizen or any other officer or subject of the state shall obey any order issued by Hari Singh or any of his relatives, friends, or any other person acting under his instructions."[17]

The insurgents claimed that they had taken up arms to defend Kashmir's Muslims against Dogra oppression. At the end of September, reports of Muslim villages being burned in Kashmir proliferated. Jathas from Patiala state and Hindu RSSS extremists had supposedly crossed the border and were massacring Muslims. The maharajah's Dogra soldiers were accused of joining in. On 30 September, the British chiefs of the Kashmir Army and police both quit, saying that the queen's brother was issuing orders to their men behind their backs.[18] Hari Singh insisted that his forces were merely defending themselves against raiders from across the border in Pakistan. Mahajan and Liaquat began an acrimonious correspondence, trading accusations about who had first attacked whom.

Given the paucity of unbiased accounts, the question — while endlessly debated over the next six decades — is impossible to answer. What's important is that the confused and often hysterical reports coming out of Kashmir made leaders in both Delhi and Karachi intensely paranoid. The wildest rumors were easily believed. On 9 October, Patel received an intelligence report from a "fairly reliable source" who claimed that Pakistan had deployed over thirty thousand armed Pathans along the border with Kashmir. "It had been given out that they had been sent

out for 'defensive' and not 'offensive' purposes," the source noted, adding that local officials had been told to provide them with as many guns as they could spare.[19] Nehru had received similar reports earlier, and had warned Patel that the Pathan tribesmen meant to infiltrate Kashmir quietly and seize power once snows blocked the road to India.[20]

On the other side of the border, Jinnah, too, saw shadows everywhere. The release of Sheikh Abdullah at the end of September—clearly a sop to Nehru, although the maharajah remained reluctant to share power—seemed to foretell Kashmir's imminent accession to India. A Pakistani military intelligence assessment concluded that if Pakistan did not act, India would seize the state as soon as the new road to Srinagar was completed.[21]

Around this time—on or about 10 October—Pakistan's defense secretary, Iskander Mirza, tried to brief the Quaid on the brewing insurgency in Kashmir. Liaquat and the others had approved a second offensive as well, north of Poonch, under Khurshid Anwar's command. Anwar had indeed begun to rally and arm a *lashkar*, or levy, of Pathan tribal fighters from the NWFP to help unseat the maharajah.[22]

Jinnah interrupted before learning more details of what would in effect be an invasion, by Pakistani citizens, of a sovereign state. "Don't tell me anything about it," he said, while making no move to stop the operation. "My conscience must be clear."[23]

A few hundred miles west of the Kashmir border lay another past and future trouble spot. The Pathan tribes that straddled the badlands of the Afghan frontier—birthplace of the Taliban—loomed large in the imagination of British India. Since the late nineteenth century, thousands of troops, including a young Winston Churchill on one of his first overseas adventures, had been deployed to keep them in check. The British exerted what little political control they had through payoffs to tribal chieftains, or *maliks*. Periodically, the subsidies proved insufficient incentive, and rifle-toting swarms of fighters would descend on Peshawar and other settled towns in the Northwest Frontier Province in search of loot. More rarely—but most dangerously—a rabble-rousing preacher would rise up and call on the devoutly Islamic tribesmen to defend their faith against the infidel British.

During earlier terms as NWFP governor between 1937 and 1946, Sir George Cunningham had been renowned for his sway over these notoriously difficult figures. Among the dog-eared manila folders that contain Cunningham's official papers is one dating back to the early years of World War II marked "Secret — In H.E.'s [His Excellency's] personal custody." It details a series of bribes authorized by the British governor to mullahs all along the frontier. In exchange, the clerics agreed to preach not against the Raj but against her enemies — first the godless Soviets and their then-allies the Nazis, later the brutal Japanese, and, after 1942, the rebellious Congress. In effect, Cunningham had bought himself a pro-British jihad. Even he had been surprised at the results. "In some areas," the governor marveled in one note, "religious Talibs [students] were encouraged to go into the Army — a thing which, I believe, was unknown before."[24]

Now Cunningham was quick to recognize the signs of a new holy war developing. On 13 October, the governor noted in his diary that tribes in the Hazara region were rallying "for Jehad against Kashmir." Preachers were inciting the volatile tribesmen to defend their fellow Muslims across the border: "They have been collecting rifles, and have made a definite plan of campaign."[25] Two days later, Cunningham learned the name of the man behind the covert operation. "A Punjabi called Khurshid Anwar, something in the Muslim National Guard, is on the Hazara border organising what they call a three-pronged drive on Kashmir," he wrote.[26]

A frontier lashkar was a fierce, uncontrollable thing. Whether driven by burning religiosity or visions of loot, the tribesmen were not likely to be satisfied with the kind of pinprick, cross-border raids on Kashmiri police stations that had taken place so far in Poonch. Some of those involved in the alleged plot would later claim that Anwar had been warned not to stir up especially unpredictable tribes like the Wazirs and Mahsuds.[27] But on the other hand, he had clearly been picked for his frontier ties, having earlier helped to organize the League's "direct action" disobedience campaign in the NWFP.

Everyone involved in the plot also knew that the tribes were in a war-like mood. Since August, tribal maliks had been begging Jinnah to be allowed to go kill Sikhs in the Punjab. "I think I would only have to hold

up my little finger to get a lashkar of 40,000 or 50,000," Cunningham had written in his diary on 22 September.[28] Now the tribesmen were hearing tales of Hari Singh's troops setting fire to Muslim villages along the Kashmir border, driving refugees into Pakistan. Kashmir, wrote the Peshawar-based British diplomat C. B. Duke, "has always been regarded by the lean and hungry tribesmen of the North West Frontier as a land flowing with milk and honey, and if to the temptation of loot is added the merit of assisting the oppressed Muslims the attraction will be well nigh irresistible."[29]

Far from trying to head off the budding invasion, Cunningham noted in his diary, his own provincial officials appeared to be lending a hand. They had "sanctioned quite a lot of petrol and flour" to be dispatched from the capital, Peshawar.[30] Trucks belonging to the paramilitary Frontier Scouts were transporting fighters from the tribal areas to the Kashmir border, 300 miles away. Police were guarding gasoline pumps in Bannu, on the edge of untamed Waziristan, and Peshawar to ensure that enough fuel was available. In Abbottabad, barely 30 miles from the border, the deputy commissioner was distributing "large quantities of grain . . . as rations for the tribal expeditionary forces." "It was also at Abbottabad that the Civil Surgeon informed one of his official patients that he would be unable to attend to him for some time as he was off to Kashmir to establish advanced dressing stations," C. B. Duke later reported.[31]

Only two Pakistan officials — both Britons — appear to have made any minimal attempt to halt the invasion. On Friday evening, 17 October, Cunningham called in his chief minister, Khan Abdul Qayyum Khan, and "faced [him] with everything I knew about Kashmir," asking point-blank "whether he was in it." A Kashmir-born barrister with a wide, friendly face, Qayyum was an opportunist above all. He had belonged to the Congress until the 1945–1946 elections, when he had seen the writing on the wall and switched sides. Now Qayyum played innocent, saying that while he personally believed it would be a "very good thing if Kashmir could be filled up with armed Muslims to the greatest possible extent," officially civil servants and the police should of course "give no support or sympathy to the movement, and prevent any kind of mass movement towards Kashmir."[32]

Unpersuaded of his chief minister's sincerity, Cunningham phoned Gen. Sir Frank Messervy, now Pakistan's commander in chief, on Saturday.[33] Messervy — not coincidentally, he later suspected — had just been ordered to return to England to beg for more arms for Pakistan's army. He had heard some of the same reports as Cunningham, and agreed to take up the matter with Liaquat the following day before flying to London.

Liaquat was bedridden when he met Messervy on Sunday, having suffered a massive coronary thrombosis earlier in the week. From his sickbed, he reassured the British general that there had been no change in Pakistan's policy of noninterference toward Kashmir. The prime minister was similarly unperturbed when Cunningham rang up on Monday, 20 October, to report that over a thousand tribesmen had left that morning for the Kashmir border. Liaquat said he saw no need to say anything publicly about the matter, nor for the government to try and intercept the fighters.[34]

By this point, Pakistani officials had had at least a week to put a stop to Anwar's jihad. Jinnah later argued that there would have been no way to hold back the tribesmen other than to have the army shoot them. "The result," Cunningham wrote to Mountbatten several months later, "would *without a particle of doubt* have been such an outburst of popular feeling in the Province that not one of our Hindus and Sikhs (I suppose 120,000 of them) would have been left alive."[35] The fact that no one bothered to alert Hari Singh to the storm headed his way, however, suggests that Pakistan's leaders were at the very least curious to see what the lashkar could accomplish. On 20 October, Jinnah drafted an uncharacteristically silky note — which, of course, he later released to the press — inviting the Kashmir diwan, M. C. Mahajan, to come to Karachi for a friendly visit.[36] The letter would be Jinnah's alibi, proof that he had gone out of his way to seek a peaceful rapprochement.

Khurshid Anwar led his column of fighters across the rushing, mineral-blue Jhelum River before first light on Wednesday, 22 October. When Cunningham had the news relayed to Liaquat's secretary, the aide asked only two questions: "How many men have we there?" and "Are they getting supplies all right?" The next day, Liaquat himself went on the radio to reaffirm Pakistan's neutral stance toward Kashmir.

He made no mention of the lashkar, whose assault had not yet been reported. "This was a pleasant little bit of comedy to start the day with!" Cunningham recorded.[37]

Over the next twenty-four hours, a motley cavalcade of vehicles rumbled into Hari Singh's kingdom — jeeps, station wagons, military trucks, and ranks of dented, smoke-belching buses flying green-and-white Pakistan flags. Cunningham thought the lashkar probably numbered some two thousand frontier tribesmen, another two thousand from the Hazara district bordering Kashmir, and "many thousands" of gunmen from West Punjab.[38] Other estimates vary widely. A British businessman, Wilfrid Russell, bumped into the convoy on the Grand Trunk Road near the village of Hassan Abdal. A uniformed Pakistani policeman was calmly directing the stream of vehicles eastward. Russell's driver strolled over and asked the officer where the column was headed. "Kashmir, sahib," the driver reported, grinning, when he returned to the car.[39]

The rebel fighters displayed little organization and even less discipline. Each petty mob of guerrillas boasted its own "commander." They were fearsome in appearance, though, with matted beards and rough turbans tied loosely around their heads — and they were remorseless in their advance. Within a day, the lashkar had secured Muzaffarabad and pressed on toward the capital. "We shot whoever we saw," an Afridi fighter told the British journalist Andrew Whitehead, many decades later. "We didn't know how many were killed. We forced Hindus to run for their lives."[40]

The maharajah's army crumbled quickly. Many Muslim soldiers switched sides. The rest, battling amid the narrow, rocky gorges of the Jhelum Valley, could not slow the world's best mountain fighters. At Uri, "the tribesmen covered the last three miles to the town in one hour of non-stop gunfire, which rolled away then came tumbling back from 10,000 ft. snow-capped peaks," wrote *Daily Express* reporter Sydney Smith, who witnessed the attack. Through field glasses Smith watched "mobs of black-turbaned and blanketed figures rushing through [the] bazaar street," seizing the loot they had been promised in lieu of pay.[41] After they had stripped Uri's shops bare, the tribesmen resumed shooting up the town, massacring what remained of its Hindu and Sikh population. Before them, the road to Srinagar filled with terrified refugees.

Smith was the only journalist on the scene. Remarkably, no word of the invasion emerged from Kashmir for an entire day, then two. When correspondents in Lahore tried to wire out reports of the fighting on Friday, 24 October, Pakistani officials blocked or delayed the cables.[42]

Desperate for help, Hari Singh dispatched an envoy to Delhi that day. He carried two letters. One begged for arms and Indian Army troops to help repel the onrushing invaders. In the other, the king formally offered to accede to India on whatever terms were being afforded to the nizam of Hyderabad.[43]

Nehru received the missives on Friday evening, just before hosting a reception for the Siamese foreign minister. That same night in Srinagar, the maharajah decided to go ahead with his annual durbar banquet, a lavish celebration during which his noblemen reaffirmed their loyalty to the throne one by one.[44] Chandeliers blazed in the grand Durbar Hall — which had its own generator — and musicians entertained the richly attired guests. When they emerged near midnight, though, the courtiers found Srinagar's streets cast into a blackness so deep, the city seemed buried under a shroud. Jackals howled. The tribesmen had seized the power station that provided electricity to the capital. They were only 35 miles away.

Rumors had unnerved Srinagar for weeks now. Around 12 October, the Californian author and adventurer Nicol Smith — a spy for the OSS during the war — had received a cryptic visitor at the houseboat he was renting on Dal Lake. Lt.-Col. R. C. F. Schomberg was a fellow writer-explorer — author of *Between the Oxus and the Indus* — and, according to Smith, an "English Intelligence Officer." (He was also the friend who had sent Clement Attlee photographs of the Sikh dead from the March Rawalpindi riots.) The British spy "told me to get out of Srinagar as quickly as possible," Smith later recounted. Schomberg was himself leaving immediately for Karachi, where he said he planned to meet with Jinnah. Asked why he was so insistent that Smith also flee, "he said he had no particular reason, but felt that it would be wise to go."[45] In the following days, Smith heard of Pakistani infiltrators floating across the Jhelum on logs under cover of darkness, among other wild tales.

The American was nevertheless taken aback on Friday night when

Srinagar's lights blinked out. Daylight revealed scenes of panic. The capital's Hindus and Sikhs feared a massacre at the hands of the tribesmen, who numbered anywhere from 2,000 to 26,000 depending on whom one asked. Tonga drivers were charging an extortionate 200 rupees to transport refugees by road to Jammu. The Muslims who leased out the luxurious Dal Lake houseboats set up a tidy business selling or renting the little cook boats attached to them. "Now immensely popular as a means of escape," Smith noted, the small craft could be poled upstream faster than heavier boats, and could hide in narrow tributary canals and streams.[46] Some of those who weren't able to flee donned European clothes in hopes of disguising themselves. Police vanished from the streets.

In Delhi, Nehru convened an urgent meeting of the cabinet's Defence Committee on Saturday morning to consider India's response to the invasion. Ministers quickly agreed on the first of Hari Singh's two requests: military aid.[47] As a matter of fact, Patel had approved the dispatch of arms to the maharajah's forces weeks earlier; the Sardar was furious to learn only now that the weapons still lay scattered in army depots around the country — held up, he was convinced, by pro-Pakistan officers in Auchinleck's Supreme Command. Patel ordered that the guns be shipped to Srinagar immediately, flown in by civilian airliners if necessary. Nehru was ready to send Indian soldiers, too.

Not everyone agreed. Menon argued against dispatching troops unless Kashmir acceded to India first. If the state's legal status remained in limbo, Pakistan could just as easily send its own forces across the border to "help" local Muslims in their supposed uprising. And tactically, Jinnah faced a much easier task. Srinagar lay only 150 miles from Abbottabad, down a fairly good road now mostly controlled by tribesmen. India, by contrast, would have to airlift all of its troops and supplies to the small airport in Srinagar — whose runway could fall to the invaders at any moment.

Typically, Patel didn't see the point in fussing over a slip of paper. Kashmir, an independent state, had been invaded and had asked for help. Nothing legally prevented India from responding. Nehru, for his part, still had the same concerns as before: if India accepted an offer of accession from the maharajah — even conditionally, premised on a later

referendum, as Mountbatten suggested — its motivations would be suspect among ordinary Kashmiris. "There was bound to be propaganda to the effect that the accession was not temporary and tempers might be inflamed," Nehru said.[48] The committee decided to table the decision for the time being and to dispatch V. P. Menon to Srinagar that evening to assess the situation.

Menon returned to Delhi the next morning and drove straight from the airport to Nehru's York Road bungalow. Sardar Patel was already there. "It could be said that the Maharajah had gone to pieces completely — if not gone off his head," Menon reported.[49] The palace in Srinagar had been in an uproar when he arrived the previous evening: doors flung open, clothes and possessions strewn everywhere. Menon had found Hari Singh rushing into and out of rooms, packing up his pearls and rubies, vowing to join his troops on the front lines.[50] At two o'clock in the morning, the king had leaped into his car and, with his Bombay jeweler Victor Rosenthal by his side, led a speeding convoy 200 miles south to his winter capital in Jammu.[51]

Menon had brought M. C. Mahajan back to Delhi with him to negotiate on the king's behalf. "Give us the military force we need," the diwan begged Nehru. "Take the accession and give whatever power you desire to [Abdullah's] party." This was India's last chance: "The Army must fly to save Srinagar this evening or else I will go . . . and negotiate terms with Mr. Jinnah."[52]

Nehru's temper blazed at the threat. Patel quickly intervened, murmuring soothingly, "Of course, Mahajan, you are not going to Pakistan." Then, an aide walked in and handed Nehru a note. "Sheikh Sahib also says the same thing," Nehru announced after reading it, according to Mahajan's memoir.[53] Abdullah had arrived in Delhi the previous afternoon and had eavesdropped on the argument from an adjoining room.

The sheikh's approval settled the issue. Later that morning, ministers approved the deployment of Indian troops. General Lockhart laid out all of the difficulties involved with the complicated airlift, and asked Nehru whether he believed the mission was worth the risk. "The future of Kashmir is vital to India's very existence," Nehru told the army chief.[54] On short notice, the air force could muster only four Dakotas to ferry troops. Patel rounded up another half-dozen civilian airliners. Soldiers

had to rip out the cushioned passenger seats to make room for their ammunition and equipment.

The cabinet also instructed Menon to draft a formal accession agreement for Hari Singh to sign, as well as a rider pledging to put Sheikh Abdullah in charge of an interim government. Menon finished both documents a little after 3:30 p.m. and raced back to the Palam airport — but missed his flight. It is a sign of just how fraught Kashmir remains that for decades, India tried to obscure the simple fact of Menon's tardiness. Indian historical accounts commonly assert that he made it up to Kashmir and secured the maharajah's signature that same day — *before* Indian troops flew to Srinagar.

In fact, at least two British officials attested to the fact that he did not. Trudging back from the airport, Menon met at five o'clock on Sunday evening with Alexander Symon, the No. 2 at the British embassy. Menon spoke vaguely about his delayed mission, saying only that India was prepared to stop the tribesmen's advance "at all costs."[55] He caught the first flight out the next morning. Another embassy official — Maj. William Cranston, a military attaché on his way to Srinagar to organize the evacuation of British citizens — was on the same flight, and witnessed Menon and Mahajan disembark at Jammu at 8:35 a.m. on Monday.[56] By the time Cranston landed in Srinagar forty minutes later, four Royal Indian Air Force Dakotas sat on the tarmac. Heavily armed Sikh troops guarded the airfield.

Menon himself later admitted to Phillips Talbot that "soldiers were being flown toward Kashmir before the Maharajah's accession reached Delhi."[57] The legal implications of the delay are disputable at best. Hari Singh had asked for Indian help, accession or no; the troops did not technically need to wait for Menon to complete his mission. On the other hand, some Pakistan partisans argue that the king, by abandoning his Srinagar palace, had already lost any right to rule and to summon outside aid.

The delay did have one crucial repercussion, however. Nehru had agreed to alert Liaquat to the Indian intervention. Without a signed accession in hand, though, Nehru stalled. He did not cable the Pakistani prime minister until eight o'clock on Monday morning, he later admitted to Pug Ismay, by which point "the military operation was a

fait accompli."[58] The Indian government made no public announcement of the operation until Menon returned to Delhi that evening with the signed papers in hand.[59] Given the still-snarled communications in Lahore, it is not clear when exactly Liaquat received Nehru's message.

By dinnertime on Monday, Jinnah still didn't know about the Indian airlift.[60] He had flown into Lahore the night before on a previously scheduled trip and had reason to be pleased with the way events were unfolding. The tribesmen had reached the outskirts of Srinagar. Hari Singh's administration had quite visibly crumbled.

Jinnah's efforts appeared to have borne fruit in Hyderabad, too. Sir Walter Monckton had persisted in his efforts to reach an accommodation with India, and had nearly persuaded the nizam to sign a one-year "standstill agreement" freezing relations in place in order to allow time for more talks. Then, just before he left Karachi, Jinnah again met with envoys from the Ittehad-ul-Muslimeen. The party's leader, Qasim Razvi, was a birdlike demagogue with blazing eyes and a wispy, Rasputin-style beard; he was given to statements like "We Muslims rule, because we are more fit to rule!"[61] A large portrait of Jinnah hung in his office.

Whatever Jinnah told the Ittehad representatives — and he later insisted he had done little more than make small talk — at 3:00 a.m. on Monday morning, a mob of twenty thousand Ittehad supporters suddenly surrounded the villa where Monckton was staying in the Hyderabad capital, to prevent him from flying to Delhi with the signed agreement.[62] By Monday night, the nizam had reversed himself and accepted Razvi's advice to appoint a new, Ittehad-led negotiating team.

Perhaps Jinnah really believed he might end up dominating the two biggest, richest kingdoms on the subcontinent, thus improving Pakistan's chances of survival immensely. At Government House in Lahore, he and his host, Sir Francis Mudie, were settling into armchairs after dinner with a pair of stiff whiskeys when Mudie's military secretary rushed in. He had heard the news on the radio: India had sent troops to Srinagar and seized the airport. Nehru had Kashmir.

The report sent Jinnah into a fury. The Indians must have been scheming with Hari Singh all along, he thought: how else could they have gotten their troops into position so quickly? Mudie, who loathed Nehru nearly as much as Jinnah did, seems to have had several more

whiskeys that night. He and the Quaid ran through Pakistan's options. Close to midnight, Mudie had his military secretary ring up Command House in Rawalpindi, where Lt.-Gen. Douglas Gracey was filling in as commander in chief while Messervy was away in England.[63] Jinnah had ordered two Pakistani brigades rushed into Kashmir, one to capture Srinagar and the other to cut off the road to India, to prevent Delhi from sending reinforcements. The troops were to deploy immediately. The Quaid wanted to go to war.

Late that night, Sir George Cunningham received an urgent call from Jinnah, summoning him to Lahore. The NWFP governor flew down first thing the next morning. By the time he arrived, he noted in his diary, the halls of Government House were "buzzing with Generals, including Gracey, and a real flap."[64]

As Cunningham quickly discovered, the acting army commander had defied Jinnah's orders the night before — invoking Auchinleck's instructions to avoid any conflict that might pit British officers against one another. Gracey had insisted that the Auk be consulted. An obviously drunk Mudie had grabbed the phone from his military secretary and shouted abuse down the line, demanding to know "why the hell Gracey was not carrying out Mr. Jinnah's orders. What had it got to do with the Supreme Commander?"[65] Gracey had stood firm.

Auchinleck had flown to Lahore that morning, too. Jinnah was now closeted with the two British commanders, who were desperately trying to persuade the Quaid to rescind his orders. If he did not, and all British officers quit, Auchinleck warned, the Pakistan Army would fall apart. Although "not at all convinced" of this last claim, Jinnah reluctantly backed down.[66]

At best the decision only temporarily staved off a war. "Situation remains explosive and highly dangerous," Auchinleck cabled to the chiefs of staff in London. Jinnah was "very angry and disturbed."[67] Around noon, the Quaid met secretly at Liaquat's bedside with just the two British governors, Mudie and Cunningham. The Quaid was at his most self-righteous, Cunningham recalled: "When talking even in a small intimate conference like this, Jinnah talks as if he were making a speech at the Bar." He called Hari Singh's accession "fraudulent and impossible

to accept." ("I couldn't quite follow his reasoning here," Cunningham admitted.)[68] Both Liaquat and the Quaid said they feared the response in the wider Islamic world if they stood by and did nothing as Muslims were butchered by Sikh and Dogra troops in Kashmir.

In Delhi that morning, Nehru was leading a meeting of the cabinet's Defence Committee. The Indian ministers were also in a belligerent mood. They quickly approved the dispatch of an entire brigade group to Srinagar by air. Patel commandeered nearly three dozen more civilian airliners to help fly in the reinforcements.[69]

In the middle of the meeting, an aide called Mountbatten away: Auchinleck was on the line from Lahore. The Auk wanted to get the Indian and Pakistani leaders together in a room before matters spun further out of control, and he told Mountbatten that Jinnah had consented to meet in Lahore the next day. Mountbatten immediately sent for Nehru, who, "after some thought," agreed to make the trip.[70]

News of a summit "seemed to have cleared the air somewhat tonight," *New York Times* journalist Robert Trumbull reported from Delhi.[71] When word of Nehru's acceptance reached Lahore, Cunningham recorded, the conversation around Liaquat's bedside turned from Pakistan's military options to Jinnah's negotiating stance.[72] The Quaid agreed that he would demand an immediate plebiscite in Kashmir, administered jointly by the Indian and Pakistani militaries. Nehru had already pledged that India would abide by the results of any popular vote. The gap between the two dominions seemed bridgeable.

That evening, however, when the full Indian Cabinet met, Nehru's colleagues rounded on him angrily, Patel in particular. "For the Prime Minister to go crawling to Mr. Jinnah when we were the stronger side and in the right would never be forgiven by the people of India," the Sardar told Mountbatten later.[73]

If Jinnah believed India had conspired to win Kashmir for itself, many Indians thought the same of Pakistan. Rumors that the Quaid had been dangling potential real estate and construction contracts in the kingdom as bait for a massive American loan were so widespread that the U.S. embassy wondered whether the Soviets had planted them.[74] (There was just enough truth to the claim to make it dangerous. Jinnah had repeatedly emphasized Pakistan's strategic location when pitching for

money abroad, and Gilgit — in the far northwest of Kashmir — nearly touched the Soviet Union.)

Hard-liners saw no reason why India should parley with Jinnah now that his supposed plot had been exposed. Nehru, torn between his promise to Mountbatten and his colleagues' adamant opposition, took to his bed that night "looking very seedy and sorry for himself," Mountbatten later wrote.[75] The Briton had to send a message to Lahore calling off the conference.

Jinnah felt suckered, as he had so many times before in dealing with the capricious Nehru. When Cunningham saw the Quaid at ten o'clock the next morning, Jinnah "was very angry with Mountbatten and Nehru, and said that this was just a plot to delay things while more Indian troops were flown into Kashmir. . . . He said he felt his hands were now free, legally as well as morally, to take any line he liked about Kashmir."[76] In other words, if India was not going to play straight, why should Pakistan?

For the next six decades, a succession of Pakistani leaders would invoke that question to justify all manner of covert operations, from the country's nuclear program to its sponsorship of the Taliban. Legitimate doubts exist about the Muslim League's role in the Calcutta Killing, the Punjab bloodbath, even Khurshid Anwar's lashkar. Jinnah's conscience may well have been "clear." From this moment on, however, there is no question that the Quaid personally approved the funding and sponsorship of a proxy war in Kashmir.

That afternoon, Jinnah and the two British governors gathered around Liaquat's bedside again. They decided to maintain a force of at least five thousand tribesmen in the Kashmir Valley, sending up drafts to relieve tired fighters.[77] The West Punjab authorities would supply arms and ammunition; Cunningham would provide 100,000 rounds from village stocks. The tribesmen would be paid in cash when they came back from the front. A few serving army officers would be enlisted in the effort, including Col. Akbar Khan, one of the original conspirators, though they would technically be put on leave. Otherwise, the regular military would stay clear of the fight: the point was not to start a war with India but rather to gain Pakistan some leverage in negotiations.

The official line would be that the tribes could not be called off un-

less they were convinced that Kashmir's Muslims would get to choose freely whether or not to join Pakistan. "We must avoid suggesting that we can influence [the tribesmen] by Government pressure," Cunningham noted.[78] At the same time, a committee of civilian officials led by the district commissioner of Rawalpindi would oversee recruiting, supplies, and the dispatch of reinforcements.

Pakistan's backing for the jihad quickly became apparent to impartial observers. "Whatever Jinnah and others may say the fullest assistance is in fact being given to the tribesmen," British diplomat Hugh Stephenson reported a few weeks later. According to an Englishman sympathetic to the effort, "officers were going up in mufti to the front and Abbottabad had all the appearance of a base Headquarters."[79] C. B. Duke visited Abbottabad at the end of November and found that "the tribesmen were conspicuous with their rifles over their shoulders, girt with bandoliers and looking thoroughly piratical." To keep them focused on fighting India instead of robbing their fellow Pakistanis, officials had housed them in a former Government Stud Farm, 3 miles outside of town. From there a steady stream of trucks departed for the border at night to avoid Indian fighter planes. The sympathetic Englishman "described the idea of there being any opposition to their passage as laughable."[80]

Top Pakistan Army officials knew generally of the scope of operations. When Messervy returned from England, he wrote to Mountbatten many years later, Liaquat had come up to visit Rawalpindi. Messervy walked over to the prime minister's bungalow one night and "saw a bearded figure rush out of the room where Liaquat was and disappear round the corner of the house. I said to Liaquat, 'That was Akbar, wasn't it?' He hesitated and said, 'Yes.'" The prime minister admitted that several Pakistani officers had been given leave and sent to Kashmir to impose some order on the tribal offensive. "I agreed to this," Messervy admitted, "and in fact I expect that the number of officers seconded to the tribal forces was increased."[81]

Jinnah's covert support for the tribesmen destroyed any hope of a quick resolution to the crisis. It prompted wild reports in Delhi, including that the lashkar was being supplied with trucks and heavy weapons, "even flame-throwers."[82] Nehru had agreed to a compromise suggested by Mountbatten — that the two men fly to Lahore for a

1 November meeting of the Joint Defence Council so that they could discuss Kashmir with Jinnah on the sidelines. But the day before they were to travel, the Quaid released a statement decrying Kashmir's accession to India as "based on fraud and violence."[83] Even Ismay, normally sympathetic, agreed this was a direct slap in the face. When he and Mountbatten left for Lahore the next morning, Nehru did not accompany them.

Jinnah greeted the two Englishmen coldly — he not only refused to meet them at the airport but declined to rise from his chair when they entered the room. The trio spent three and a half hours together, engaged in "the most arduous and concentrated conversation."[84] Jinnah, Ismay wrote, "was at his most obstinate and on his highest horse."[85] He condemned the Indian intervention as "the end of a long intrigue," and claimed that Congress figures were backing a campaign by Hari Singh to cleanse Jammu of Muslims. The accession "would never be accepted by Pakistan," the Quaid declared. He said he could not come to Delhi for talks, that he was "too busy" in Lahore now that Liaquat was laid up. Instead, he suggested the two governors-general fly up to Kashmir and order both sides to withdraw, then organize a plebiscite themselves. "He said that the two of us could settle this in one day," Mountbatten recorded.[86]

When Ismay stepped out of the room, Mountbatten lacerated the Quaid for his uncompromising attitude. Jinnah was unmoved. "Mr. Jinnah became extremely pessimistic and said it was quite clear that the Dominion of India was out to throttle and choke the Dominion of Pakistan at birth, and that if they continued with their oppression there would be nothing for it but to face the consequences," Mountbatten recorded. "However depressing the trouble might be he was not afraid of them; for the situation was so bad that there was little that could happen which would make it worse."[87] On that point at least, Jinnah could not have been more wrong.

India's apparent coup exhilarated Nehru. "If we had vacillated and delayed even by a day, Srinagar might have been a smoking ruin," he wrote to his sister Nan on 28 October. "We got there in the nick of time." He

praised the lightning-fast deployment of Indian troops as "a very fine piece of work."[88]

In fact, Srinagar's fate remained far more uncertain than Nehru seemed to realize. That very afternoon, the Sikh colonel commanding the Indian contingent, Dewan Ranjit Rai, was shot in the head and killed by a Pathan marksman. Rai had led 140 men to the town of Baramulla, at the mouth of the Kashmir Valley, to intercept the raiders. Indian newspapers compared them to the Spartans at Thermopylae. In a furious battle on the 28th, the tribesmen blew the Indians off the ridge where they had taken up position, using 3-inch mortars and machine guns. The Sikh troops hastily buried their commander by the side of the road and retreated, and the lashkar continued to advance on Srinagar.

In these first few days, chaos prevailed at the Kashmiri capital's tiny airport. Planes trying to land from India had to dodge crates of ammunition and supplies along the edges of the runway — not to mention dozens of cars abandoned by fleeing refugees.[89] Tempests and Spitfires crowded the tarmac after strafing missions, lacking the crews, equipment, or bullets to reload.

As troops piled out of the big Dakotas, they were immediately bundled into civilian trucks and rushed to the front, now less than 20 miles away. Headquarters officers struggled to organize Srinagar's defenses, ripping old maps off the walls of Nedou's Hotel and the Srinagar Club to plan out deployments.[90] Communications were so bad that one Sikh officer had to drop orders to his unit from a low-flying plane. To the south, Indian engineers frantically tried to slap together a pontoon bridge over the Ravi in order to open the land route to Srinagar to heavy vehicles.

After Jinnah approved support for the lashkar on 29 October, Akbar Khan had dashed to Rawalpindi to scrounge up more ammunition, then headed into Kashmir himself on a reconnaissance mission. He came across a surge of tribal reinforcements as he raced to the front: "The lorries were full to the brim, carrying forty, fifty and some as many as seventy. Men were packed inside, lying on the roofs, sitting on the engines and hanging on to the mudguards. They were men of all ages from graybeards to teenagers. Few were well-dressed — many had torn clothes, and some were even without shoes." One decrepit station

wagon with no roof, no headlights, and "doubtful brakes" carried the headquarters staff of the Swat Army.[91] The fighters were armed with an assortment of British, French, German, and locally made rifles; some carried only daggers.

Indian fighter planes had forced the tribesmen to scatter off the main road leading to Srinagar. But the swelling ranks of the lashkar still outnumbered the Indian forces. Indeed, now that they had dispersed into smaller, more mobile units, the insurgents were almost more dangerous than before. Some of the tribesmen adopted Kashmiri garb and pretended to be refugees in order to sneak up on Indian positions. Probing attacks drew nearer and nearer to the airfield. When a new Sikh officer flew into Srinagar to replace the fallen Rai, he ordered his pilot to do a low pass first, to make sure that the Indians still controlled the landing strip.[92]

On 30 October, Khan joined a band of Mohmand tribesmen as they sniped at an Indian position just a few miles from the center of Srinagar itself. He was convinced that the capital, defended with flimsy barbed wire, could easily be overrun. Khan quickly returned to Pakistan to beg for a few armored cars to lead the assault. A fellow army officer volunteered to drive a squadron into Kashmir in mufti, with or without permission.[93]

The tribesmen nearly broke through on their own. On 3 November, around seven hundred of them massed and attacked an Indian patrol less than 5 miles from the Srinagar airfield, pinning the troops down with mortar fire. Outnumbered six to one, the Indians suffered fifteen killed including an officer and another twenty-six wounded.[94] Khurshid Anwar later claimed that he and twenty of his men closed to within a mile of the airport before they were driven off.

The next morning, Sardar Patel and Defense Minister Baldev Singh flew into Srinagar to take stock of the situation. They held an emergency conference on the tarmac with Brig.-Gen. L. P. "Bogey" Sen, the local commanding officer. Sen flatly declared that without more men, he could lose the city.[95] When the Sardar returned to Delhi, he was "despondent."[96]

India quickly redoubled its commitment to the fight. The cabinet or-

dered the dispatch of another two battalions of troops by air. A squadron of armored cars and a battery of field artillery set off along the just-completed road from Pathankot in East Punjab to Srinagar.

In his 28 October letter to his sister, Nehru had claimed loftily that he would "not mind if Kashmir [became] more or less independent," though, he added, "it would have been a cruel blow if it had become just an exploited part of Pakistan."[97] Now, however, he demanded that Indian commanders go on the offensive: he wanted Baramulla retaken "at every cost and every consequence"— and within three days.[98] He found it "absurd" that troops could not distinguish between tribesmen and locals, he wrote to Sheikh Abdullah after Patel's visit. Reinforcements were on the way, but Nehru decried the prevailing "spirit of not taking action till more troops come."[99]

Before dawn on 6 November, the tribesmen made one more attempt to break into Srinagar. Colonel Khan's plea for reinforcements had been unsuccessful: his superiors had vetoed the idea of sending in an armored-car squadron for fear of provoking an outright war with India. Years later, the Pakistani officer was still resentful. "India herself was intervening," he wrote in his memoir. "She was already calling us aggressors and she had squarely accused us of bringing the tribesmen in across 200 miles of Pakistan — would a couple of armored cars make that accusation any worse? . . . What difference would another incident make? More shouting, more complaining, more cursing — that is all."[100] After several hours of fighting on the western outskirts of the city, the outgunned guerrillas had to break off and retreat.

By now India's own armored cars had arrived by road from the Punjab, and some three thousand Indian troops had stiffened Srinagar's defenses. Early on 7 November, the Indian forces surrounded the tribesmen, who had regrouped near the village of Shalateng just outside the capital, and attacked from multiple directions as well as from the air. "I gave the word GO," Sen claimed in a boastful memoir, "and hell broke loose. . . . There was complete confusion in the enemy positions. . . . Trying to escape the fire that was hitting them from three sides, and seeing the bayonet charge descending on them, [the raiders] rushed in all directions and, crashing into one another, turned and fled west-

wards."[101] Indian accounts claimed the guerrillas left nearly 500 dead on the battlefield and another 150 more on the road as they staggered back toward Baramulla.

The battered station wagons and wheezing buses that had carried the flag-waving jihadists into Kashmir now turned tail and trundled back toward Pakistan. "The only impression they left behind was that the tactics of some were 'hit and run,' of some 'see and run' and of some just 'run,'" Khan wrote disgustedly.[102] Heeding Nehru's orders, the Indian forces pressed forward against the collapsing resistance. By 8 November, they had reoccupied Baramulla — just barely making Nehru's deadline.

Pakistani newspapers continued to publish fantastical accounts of the raiders' glorious victories. "The Liberation Forces' three-pronged advance on Srinagar continued unabated in spite of strong opposition," *Dawn* reported the day after the Shalateng rout.[103] Jinnah surely knew better. For him, yet another humiliating defeat at Nehru's hands loomed.

His health could not stand the strain. The seventy-year-old Jinnah's yellowed lungs now showed unmistakable signs of tuberculosis. On doctor's orders, he would spend the next month bedridden. At one of his last public appearances — a visit to a Lahore refugee camp on 6 November — he looked so cadaverous that a local official pleaded to transfuse his own "healthy blood" into the ailing Quaid.[104] His role in the Partition drama had not ended yet. But from this point on, whether he or his followers recognized it, the Quaid's days were numbered.

9

Himalayan Quagmire

FOUR DAYS AFTER Baramulla fell, Nehru paid a visit to the once-cheerful riverside town. Scenes of devastation greeted him. "It looked as if an earthquake had shaken it," Colonel Khan, who had passed through a week earlier, recalled in his memoir. "Shops were empty, doors and windows were gone — brick, stone and paper littered the ground."[1] When the lashkar reached the town, some of the uneducated tribesmen seemed to believe that they had arrived at Srinagar, or even Amritsar, the Sikh stronghold.[2] They lingered for two days, burning and killing. They looted everything they could find, even prying loose the bracelets on women's wrists and the earrings from their ears.

In one of the most famous incidents, a party of Mahsud tribesmen from South Waziristan overran the town's Catholic mission and killed a British couple as well as two others, and gravely wounded the mother superior. "These men came from all directions, climbing over the compound wall," one of the survivors, a child at the time, told the journalist Andrew Whitehead. The fierce, unkempt fighters were armed with rifles, huge daggers, and axes, which they used to hack apart the chapel's altar and statues of saints. "They smashed everything in sight. . . . Any adult person they just stabbed or shot, and there were screams and cries."[3]

The tribesmen more than likely raped some of the surviving nuns, who had been locked into a dormitory along with the mission's medi-

cal patients and several terrified townspeople. During the rampage, the invaders seemed not to distinguish among Christians, Hindus, or even Muslims. A Muslim shopkeeper caught passing information to Indian forces was crucified in the town square as an example to others.[4] Reports of the lashkar's brutality so appalled officials in Pakistan that they sent in more responsible tribal figures to restore order.[5] It is impossible to calculate an accurate death toll, but according to Indian troops, barely a thousand of the town's normal population of fourteen thousand remained after the tribesmen had finally been driven off.

You are the golden earring in our ears. . . . To Nehru, who had not visited Kashmir since his July 1945 hiking trip with Sheikh Abdullah, all of the ugliness and brutality of the past three months seemed concentrated in these "great, wild, black beasts," as one of the mission priests described them.[6] They had descended upon the pristine Kashmir Valley crying "Allah-o-Akbar!" and seeking to impose medieval rule by the sword. Kashmiris had now gotten "a taste of what Pakistan means," Nehru bitterly informed a crowd in Baramulla on 12 November.[7]

By contrast, the apparently happy picture that greeted him in Srinagar thrilled Nehru. With the collapse of the maharajah's administration, Sheikh Abdullah's National Conference had quickly organized a people's militia made up of Muslims, Hindus, and Sikhs to maintain order in the city and guard critical bridges and intersections. The volunteers wore red armbands and bright smiles, and had restored calm within twenty-four hours. Schoolchildren ran through the streets yelling pro-Abdullah slogans.[8]

Such scenes reassured Nehru that he had not been wrong about the glorious unity of the Indian peoples after all. The savage Punjab massacres had shaken his faith. But now he thanked a huge, enthusiastic audience in the Kashmiri capital for reaffirming it: "You have not only saved Kashmir, you have also restored the prestige of India, your mother country," he declared. The harmony displayed by Srinagar's communities had "brought hope to my disappointed heart. Kashmir has set an example to the whole of India."[9]

Too often Nehru's undeniable obsession with Kashmir is written off as sentimentalism. Although he had never lived in his ancestral homeland, the Indian prime minister clearly felt invigorated there as he did

nowhere else on the subcontinent. He contributed to this impression with comments like the ones he made to Edwina Mountbatten in June 1948, when his letters to the former vicereine had become as frilly and romantic as those he had written to Padmaja Naidu a decade earlier: "Kashmir affects me in a peculiar way; it is a kind of mild intoxication — like music sometimes or the company of a beloved person."[10]

Yet the fact that Indians remain ferociously defensive about Kashmir a half-century after Nehru's death makes clear that the issue represents more than one man's obsession. As Nehru retorted when Lieutenant-General Bucher suggested that "the romanticism of mountain and snow" too greatly influenced him in Kashmir, "This is something much more than romanticism for a mountain. There are plenty of mountains in India."[11]

Much as Afghanistan would serve for the United States many decades later, Kashmir became the stage for a morality play. At stake was a particular *idea* of India. If the people of a predominantly Muslim kingdom chose willingly to join a predominantly Hindu nation, Jawaharlal would disprove not just Jinnah's hateful ideology — a "poisonous plant," Nehru had called it in his 28 October letter to his sister — but also Sardar Patel's suspicion that India's Muslims were disloyal. "Through Kashmir," Gandhi declared at one of his prayer meetings while Dakotas filled with Indian troops roared overhead, "that poison might be removed from us."[12] This was Nehru's own holy war.

Both Mountbatten and Pug Ismay feared that the Indian leaders were getting carried away by their initial victories over the tribesmen. "They have won a small battle, and they think that they have won a war! Such is the intoxication of a slight military success," Ismay, who knew something about winning wars, wrote in his diary.[13] Triumphant headlines declared that Srinagar had been saved. Indian brigadiers gloated over the headlong retreat of the "groggy and disorganised" tribesmen.[14]

Even before Nehru traveled up to Kashmir, Mountbatten had warned him against mission creep. Snows would soon block the Banihal Pass — along the only road link to India — and also hamper flights into Srinagar. To pursue the tribesmen much beyond Baramulla would threaten the precarious Indian supply lines. Mountbatten argued especially strongly against trying to occupy the Poonch region, where insurgents had bottled up several detachments of the maharajah's army. The

front there would run parallel to the Indians' line of communication; the enemy could slice through it at any point.[15] If Indian forces tried to do more than hold the Vale and Jammu, Ismay predicted, they would almost certainly "get a bloody nose."[16]

Yet all across the subcontinent, dominos suddenly seemed to be falling in India's favor. A couple of days before Nehru's trip, Indian troops had marched unopposed into pesky Junagadh. Quite unnoticed amid the rapid-fire events in Kashmir, Delhi had been fomenting its own little lashkar on the Kathiawar Peninsula. A local Indian official confirmed on 22 October — the same day the tribesmen crossed into Kashmir — that he had distributed one hundred rifles as instructed to the "gentleman who came [to] Delhi."[17] Presumably the guns were meant for Samaldas Gandhi's provisional government. Within a week, Gandhi's militia had seized sixteen villages that belonged to Junagadh but were separated from the state proper.[18] On 1 November, India had quietly moved forces into the disputed principalities of Barbariawad and Mangrol.

Feeling the noose tightening, Junagadh's nawab had fled to Karachi, bringing with him his wives, his dogs, and most of the contents of the state treasury. By 7 November, his diwan, Shah Nawaz Bhutto, could see that no aid would be forthcoming from beleaguered Pakistan, so he secretly sent his chief of police to discuss a deal with Samaldas Gandhi. The next day, Bhutto cabled Delhi saying he would rather hand over power to the Indian government directly than to Gandhi's unruly rebels. Sardar Patel accepted with alacrity. If Mountbatten and Ismay hadn't raised objections, the Indians might not even have informed Pakistan before marching their troops across the Junagadh border. "I reminded [the Indian leaders] of Hitler's technique and told them that the world would think they were copying it" if they did not explain their actions, Ismay later recorded.[19] Patel mocked the Englishmen as "sissies" for being so conscientious.[20]

Even the mighty kingdom of Hyderabad was beginning to sound more humble. After the mob attack on Sir Walter Monckton's house, the nizam had dispatched a new negotiating team to Delhi to demand changes to the nearly completed standstill agreement. Ittehad leader Qasim Razvi had assured the nizam that the Indians would buckle,

given how preoccupied they were with Kashmir. Instead, the negotiators had returned empty-handed, while the Indians crowed about their victory in Srinagar.

Hyderabad's eccentric monarch rapidly rediscovered the virtues of compromise. He penned a series of repentant notes to Monckton, who had decided to return to England; the nizam begged him to stop off in Pakistan and convince Jinnah to rein in Razvi — that "rascal!" — before the Ittehad leader pushed Delhi too far.[21] "The Hindus are watching the situation with open eyes and are bent on making mischief in case a handle is given to them," the nizam warned darkly.[22] By the end of November, he had signed the very same standstill agreement he had rejected a month earlier.

As for Kashmir, Nehru returned from his visit there determined to press the fight to its finish. Although he continued to pledge that India would abide by a plebiscite, he now insisted that every single "raider" had to be expelled before any vote was held. The demand was especially open-ended because by "raider," Nehru meant anyone taking up arms against the interim administration Abdullah had established in Srinagar. Privately, Nehru had begun to doubt the feasibility of holding a vote, particularly with winter approaching. If fighting continued for several months, he wrote to Abdullah, prospects for a plebiscite would "automatically fade out."[23] The National Conference leader was even more explicit. Visiting Baramulla, he told reporters that after what Kashmiris there and elsewhere had suffered, they "might not even bother" about a referendum.[24]

Cabling London, British ambassador Sir Terence Shone described the Indian leaders as deliriously "cock-a-hoop," confident that they had "practically settled the business on their own."[25] Indian troops quickly pushed forward another 25 miles past Baramulla, retaking the town of Uri and reconnoitering the road that led all the way to the Pakistan border.

A bomb splinter had crippled Khurshid Anwar, leaving Akbar Khan in charge of the lashkar. To mask his identity, he had given himself an impressive-sounding nom de guerre — "General Tariq," after an eighth-century Muslim invader who had sailed from North Africa to Spain and then ordered his boats burned in order to eliminate any thought

of retreat. In reality, though, Khan's forces had dwindled to around a thousand tribesmen who could do little more than take potshots at the Indians from the hills.[26] The guerrillas blew up small bridges across the winding Jhelum River to slow the Indian advance.

Pakistan was in an awkward place when it came to support for the lashkar. Government decision-making had more or less frozen the moment the Quaid had taken to his sickbed in Lahore. "Any file sent by me to the Private Secretary is either not shown him at all ... or else comes back with the remark that he cannot attend to it until he returns here," Jinnah's military secretary in Karachi noted in his diary. "Even the Ministers are devastated as they can get no decisions on anything."[27] "General Tariq" could not expect to drum up any additional forces or weapons.

Still recovering himself, Liaquat floated the idea of asking the fledgling United Nations to consider the question of all three disputed states — Kashmir, Hyderabad, and Junagadh. The Indians ignored him. On 18 November, with Mountbatten away in England for the wedding of his nephew Philip to Princess Elizabeth, Ismay spent two hours with Nehru, trying to convince him merely to sit down with his Pakistani counterpart. "Nehru made it clear that whereas a meeting was desirable in principle there was no real hurry," Sir Terence Shone reported to London. "In fact, the impression left on Ismay was that Nehru thought things were going so well in Kashmir that the longer the discussion with Liaquat was deferred the stronger would be India's own position."[28]

Nehru brushed aside Ismay's warning that by expanding military operations in Kashmir, India might overreach. He breezily promised to reconvene the cabinet's Defence Committee again soon. "There was," he noted, "an important paper on the organisation of cadet corps which required early consideration."[29]

Nehru should have known better than to be so cavalier. That very day, an envoy he had sent to Jammu had filed a disturbing report. RSSS cadres were infiltrating the Kashmiri province, with the help of elements in the Indian Army. "Almost every official is secretly in sympathy with them and would probably turn a blind eye on their entry," wrote Kanwar Sir Dalip Singh, a former High Court judge from Lahore. The Indian

military had launched a massive operation to ship equipment and stores to Jammu to last troops through the winter, and the Hindu extremists were hitching rides on army trucks headed north. "They are prepared to work," Singh noted. "Their boys have been lengthening the air strip. This kind of thing naturally makes them popular."[30]

The influx of militants added a dangerous destabilizing factor to the conflict. Rumors persisted that the maharajah was using them not just as manual laborers, but as shock troops to rid Jammu of its Muslims. Although Hindus made up only around 40 percent of the province's population, in eastern areas and the capital they outnumbered Muslims three to one. In addition to the incoming RSSS fighters, thousands of revenge-minded Hindu and Sikh refugees from West Punjab had taken up temporary residence in Jammu. The maharajah of Patiala had sent a battalion of Sikh troops to reinforce Hari Singh's Dogra army.

British embassy reports talk of Muslims in Jammu being frightfully "oppressed" by these various forces but provide few details. As in the Punjab, the scale of any carnage is impossible to pinpoint with accuracy. Pakistani accounts claim that 300,000 of Jammu's 500,000 Muslims fled across the border into West Punjab, and the rest must have been killed. With some justification, Nehru responded that such crude calculations "did not hold water."[31] Yet a confidential estimate provided to the American embassy by a former and still well-connected British intelligence operative remains indisputably grim. Sikhs and Hindus, he said, "undertook a wholesale massacre of the local Muslims [in Jammu], and it is stated that up to 20,000 were killed at the end of October. This matter is . . . being kept strictly secret."[32]

Nehru did not deny the most egregious attacks. On 5 and 6 November, with all eyes on the defense of Srinagar, Dogra troops in Jammu city had piled five thousand Muslim men, women, and children onto buses and told them they were being escorted to Pakistan. Instead of heading for the border, though, the soldiers had driven deeper into Kashmir, then forced the civilians out of the vehicles. As the disoriented Muslims huddled in a clearing, Hindu and Sikhs — most likely Akali and RSSS extremists — rose out of the underbrush and laid into them with rifles and kirpans. A couple hundred Muslims escaped into the fields.[33] The rest were either raped or killed outright.

On 21 November, Nehru raised the subject of the massacre in his reply to Dalip Singh. He had been "shocked" by reports of the killings, Nehru wrote, in particular evidence that there had been a "great deal of trickery and very probably connivance" by Hari Singh's troops in the massacre. He demanded an inquiry, lamenting the incident as a "black stain" on India.[34] Indian commanders were given strict instructions to ensure that no Kashmiri Muslims were harmed in areas where their troops were deployed.

If Nehru thought India could distance itself from such outrages, he was mistaken. Indian soldiers posted in Srinagar had already shot and killed National Conference volunteers, mistaking them for tribesmen as they approached a checkpoint on the edges of the city. The more troops India sent, and the longer they stayed, the greater the chance they too would be accused of committing atrocities.

Widening the war only increased that risk. Muslims in the Poonch region genuinely supported accession to Pakistan. Any fighting there would be against locals, not just Pakistani irregulars. Before leaving for England, Mountbatten had reluctantly agreed to send Indian relief columns to the region, to try and free three trapped garrisons of Kashmir state troops. The Indians rescued two; the third was overrun. But India unwisely decided to leave units behind to hold the towns of Poonch and Mirpur, which were full of non-Muslim refugees.

The precariousness of the Indian positions quickly became apparent. The detachments were virtually surrounded by hostile forces. One of the relief columns had to fight a rearguard action just to make its way back to its base in the town of Uri.[35] Distracted, the Indians let up on their drive westward toward the Pakistan border, which lifted pressure on the remnants of the lashkar.

Yet when the Defence Committee met again on 24 November, Nehru adamantly refused to withdraw from Poonch. "The Prime Minister replied that we could not be strong everywhere," the minutes read, "but we must be firmly established in such places ... from where we could attack and take the initiative." The stakes, in Nehru's mind, could not have been higher: "In his opinion any reverse in that theatre would have most serious psychological repercussions in the whole of India."[36]

India's expanding goals began to worry Nehru's military command-

ers. As anti-Soviet mujahedin would prove in the 1980s and the Taliban in the 2000s, insurgents could fight on indefinitely if they had safe havens across the border in Pakistan to which they could retreat. Lieutenant-General Bucher, now No. 2 in the Indian Army, grimly advised the Indian leaders that the task of asserting authority over every corner of Kashmir would require six to eight divisions of troops and two to three years, with all of India on a war footing.[37] Otherwise, Pakistan could sustain a guerrilla war indefinitely.

Many British observers thought the solution was to partition the kingdom. The heavily Muslim areas that bordered West Punjab, as well as Gilgit in the frigid north of Kashmir, were eager to join Jinnah's dominion. Eastern Jammu and Buddhist Ladakh would no doubt prefer India. The problem was the Kashmir Valley, where the bulk of the population lived. When Abdullah suggested that the region be separated administratively from Jammu, where the king continued to rule, Nehru resisted vehemently. Like many others, he considered the Vale to be Kashmir itself and would not risk losing it. Even to suggest the possibility of splitting the two regions, he wrote, was "dangerous."[38] In Lahore, Mudie similarly failed to impress the logic of partition on the ailing Quaid: "Jinnah was disgusted with the Award of the Punjab Boundary Commission and he said, 'I will not have more Boundary Commissions now.'"[39]

Diplomacy offered the only other chance of avoiding a quagmire. When the two sides finally met at the end of November, a month after the lashkar's invasion, they nearly reached a breakthrough. By that point, Sardar Patel was assured and "in good heart" about the situation in the subcontinent, Mountbatten reported upon his return from London.[40] Hyderabad had at last approved the yearlong standstill agreement, one that would, in theory, prevent Jinnah from interfering in the state's affairs. Junagadh was now firmly in the Indian fold, and the raiders appeared to be on the run in Kashmir.

At lunch on 24 November, Patel assured Ismay, "India had no desire to strangle Pakistan. Indeed, it was in their interests that Pakistan should be prosperous and peaceful."[41] A few days earlier, Liaquat had told British diplomat Paul Grey that "he would seek every means of settlement" with India, even though "his extremists were pushing him the

other way."[42] At least the deputy leaders of both dominions seemed to recognize that pouring resources into an unending conflict in Kashmir served neither of their nations.

On 26 November, Liaquat came to Delhi for the first Joint Defence Council meeting in India since early October. The Pakistani prime minister was haggard and still weak; during meetings he sat in an arm-chair with a rug warming his knees. The two sides made good progress on nearly every administrative issue remaining from the Partition, in-cluding the one most critical to cash-starved Pakistan: how to divide the Raj's sterling balances and international debt. Pakistan got a larger share of the reserves than it had expected — 550 million rupees, or nearly $2 billion in today's dollars — and in turn accepted responsibility for more of the debt.

During the talks, Liaquat and Nehru met five different times and began to sketch out a deal on Kashmir, too. In broad strokes, Paki-stan would work to pull out all the tribesmen, while India drew down its forces to a token presence. The two sides would agree to have the United Nations design and supervise a plebiscite.

Mountbatten thought that both Nehru and Liaquat were happy with the outlines of the deal. "Things have been 'happening' here," Ismay told British high commissioner Sir Terence Shone.[43] That night, Mountbat-ten was ecstatic. He said that when Patel had agreed to give Pakistan the 550 million rupees, the Sardar had remarked, "That ought to show Pakistan that India was not out to throttle her."[44] Everyone seemed to agree it had been a good day.

Patel, however, had a clear idea of what he expected to buy with that money. As Shone later learned, Patel had vowed to rescind the offer unless Pakistan agreed to a final deal on Kashmir. He "said something to the effect that India had to show her strength," the British ambassa-dor reported.[45] At a cocktail party at the American embassy, the Sardar pulled out a box containing two small bottles of pills. It had been taken off a "raider" in Kashmir, he told Shone sarcastically. It was a kit for sterilizing water — standard issue for Pakistani soldiers.

No one hoped for a rapprochement between India and Pakistan more than Pug Ismay. The chief of staff prided himself on his impartiality, on

which point, "I could not yield an inch," he had written to Mountbatten several weeks earlier.[46] Unlike the former viceroy, whose loyalty to Nehru had only deepened through India's first months of crisis, Ismay had refused to become a partisan of one dominion or the other. In his note he announced that it was time for him to return to England before his position was further compromised.

Now it looked like he might be leaving on a high note. At a farewell party for Ismay on 30 November, Nehru's private secretary suggested that "the corner had been turned" in relations between the dominions, though he added a major caveat: "There was always the spectre of Mr. Jinnah in the background."[47]

As a matter of fact, the Quaid appears to have been displeased with the draft agreements Liaquat brought back from Delhi. In Jinnah's papers is a note also dated 30 November 1947 sternly reminding Pakistani ministers, "No commitments should be made without my approval of terms of settlement. Mr. Liaquat has agreed and promised to abide by this understanding."[48] If his genial lieutenant was ready to compromise with Nehru, clearly the Quaid was not.

Jinnah had chosen an inopportune moment to rise from his sickbed. The next day, he finally returned to Karachi, a month after falling ill. His military secretary, Col. E. St. J. Birnie, was shocked at the Quaid's appearance: "He left here five weeks ago, looking 60 years of age. Now he looks well over 80."[49] Jinnah continued to insist that he was suffering only from "mental strain" and exhaustion, yet at a garden party at Government House a fortnight later, he was still "so ill that his aides declined to permit anyone to shake hands with him or to converse with him," the American chargé d'affaires, Charles W. Lewis, reported.[50] Margaret Bourke-White, who had come to Karachi to photograph the Quaid, could not erase the image of his "unsteady step, listless eyes, the white-knuckled, nervously clenched hands."[51]

Illness and the isolation of the past few weeks had inflamed Jinnah's already bitter paranoia. Repeated assassination attempts did not help: during the last one, assailants had almost managed to break through his security cordon, killing one guard and seriously injuring another before being apprehended.[52] The atmosphere at Government House, never welcoming, had grown to be "frigidly megalomaniacal," according to

the British ambassador.[53] Ministers and servants alike were terrified of crossing the Quaid. He dined with his shrewish sister Fatima, coldly and formally, while his aides scrounged for what scraps they could find in the kitchen.

In private, Jinnah was "apoplectic" about the leaders in Delhi, according to BBC correspondent Robert Stimson. In an off-the-record conversation, Jinnah raged that Mountbatten had virtually "become a Hindu." His wife, Edwina, had been spending a suspicious amount of time with Nehru. She "now [walked] about 'with folded hands,'" Jinnah said mockingly. "He fully expected to see her wearing a caste mark in the center of her forehead."[54] All Hindus, Jinnah informed his Hindu friend M. S. M. Sharma, a Karachi newspaper editor, were like Kashmir's treacherous Hari Singh: not one could be trusted.

The very mention of Kashmir would set off a tirade, Sharma recalled. "Damn it, it is a fraud!" Jinnah would burst out, sometimes to no one in particular.[55] He refused to accept that India had any role to play in the state or that a plebiscite was even necessary. He regretted having let Auchinleck talk him out of sending Pakistani troops to Srinagar immediately. Again off the record, Jinnah was blunt with the BBC's Stimson:

> Kashmir is historically, geographically and economically a part of Pakistan and it is unthinkable and it will be unnatural and artificial to contemplate that it can accede to Hindustan. It is obvious that 95% of the Musalmans will never agree to it, and if by some manoeuvre and machinations and by suppression and oppression of the people some sort of an artificial verdict is obtained in favour of Hindustan, there will be no peace in Kashmir and so long as Kashmir does not join the Pakistan Dominion there will be no peace between the two Dominions and it will continue to be a menace not only to both the sister Dominions but to the world situation.[56]

Around this time, Pakistan appears to have made the decision to escalate the Kashmir jihad. At the beginning of December, Akbar Khan returned from the front in western Kashmir to Rawalpindi, again seeking more men and weapons. In his memoir, he claims to have met with Liaquat at Command House. Messervy, listening from an adjoining room, sent in a note to the two men: "You will not have to do it with

sticks alone any longer, I am going to help."[57] Less than a week earlier in Delhi, Messervy had sworn to Mountbatten that he had not been asked for, nor had he provided, any help to the tribesmen.[58] According to Khan, the British commander in chief now agreed to supply a million rounds of ammunition and another dozen serving officers to lead the insurgency.

There is no way to verify Khan's account, but in his own memoir, the brigadier leading Indian forces in that sector, "Bogey" Sen, recalled that "during the first week of December, the tactics employed by the enemy underwent a radical change. The battle formations adopted made it obvious that the enemy . . . [now] included a percentage of either regular or irregular troops."[59] Rebels cut the road lifelines to Poonch city, where Indian troops guarded a population of 45,000 mostly Hindus and Sikhs. The soldiers had only enough food to last for five days; the city's residents, for fourteen days. Indian commanders began to consider the disastrous prospect of having to evacuate their men under fire, using the town's barely serviceable airstrip.[60]

Liaquat seems to have thrown himself back into the cause, his ardor presumably rekindled by the Quaid. Just before his meeting with Khan, the Pakistani prime minister had visited the rebel staging areas in Pakistan's Sialkot district. According to a top Pakistani civil servant, Liaquat had returned "in a state of excitement and emotion which he could not remember having seen him in before."[61] Sardar Ibrahim's Azad Kashmir (Free Kashmir) insurgents had categorically rejected the proposed settlement Liaquat and Nehru had worked out in Delhi, saying they would rather fight on than leave Abdullah in power until a plebiscite. They also filled the prime minister's ears with sensational accounts of Sikhs butchering every Muslim male in Jammu, and of camps where hundreds of naked Muslim girls were being held and raped repeatedly. After the horrors he had seen in the Punjab, Liaquat did not doubt the stories. He allegedly gave a speech encouraging more tribesmen to flock to the front, vowing that Pakistan would never surrender Kashmir.

Coming just days after he had left Delhi talking of peace, Liaquat's reported call to arms enraged Nehru. The Indian prime minister had been hearing his own stories from Kashmir of abducted Hindu women being auctioned off for 150 rupees apiece, and of thousands of "tribes-

men"— half of whom were Pakistani soldiers, he was convinced — massing along the border.[62] The loss of Akhnur — a town just 6 miles from the maharajah's palace in Jammu — and the plight of the trapped battalion in Poonch raised emotions in Delhi to dangerous levels.

Indian ministers clamored for an all-out offensive. Nehru himself told his military commanders that "he was not prepared to tolerate the present state of affairs in Kashmir to continue." He rejected any prospect of retreating from Poonch. He even backed a shocking suggestion from Patel and Baldev Singh that the air force carpet bomb a 10-mile-wide cordon sanitaire up and down Kashmir's border with Pakistan. "The Prime Minister stated that according to Mr. Liaquat Ali Khan all the Muslims of this territory had evacuated to Pakistan and we knew that the Hindus and Sikhs had either been killed or had fled to Jammu," read the minutes of the 3 December Defence Committee meeting. "Therefore, any destruction of life would be that of the insurgents who had moved in."[63] Only Mountbatten questioned this ludicrous assumption.

In a letter to Hari Singh written on 1 December, Nehru had entertained the idea of eventually cutting off Poonch and giving the region to Pakistan.[64] Now his position had hardened. On 6 December, he made a flying visit to Jammu and told an audience that India would not be satisfied until every insurgent had been driven from the state. "We will clear Kashmir completely of the raiders," he promised. "We do not believe in leaving things half-done. We will send more troops . . . and fight till we succeed."[65] He refused to discuss anything else with Pakistan's leaders until they "exercised their influence to stop this state of frightfulness."[66]

A follow-up meeting between him and Liaquat in Lahore two days later was, not surprisingly, a disaster. The two men spent five straight hours arguing before finally breaking for dinner. The transcript of the meeting is raw with anger. Liaquat accused Sheikh Abdullah's followers of launching a witch hunt against the pro-Pakistan members of the Muslim Conference, even of abducting and raping party leader Ghulam Abbas's wife and daughters.[67] (Nehru later discovered that at least one young female relative of Abbas had indeed been carried off to Amritsar.)[68] Pakistan refused to call off the "raiders" unless India agreed to

replace Abdullah's government with an impartial administration before any plebiscite.

Hearing Abdullah criticized always made Nehru's temperature rise. He praised the interim administration in Srinagar for uniting the city's population and maintaining order; to remove Abdullah now was unthinkable. At one point, Nehru burst out operatically that he would rather "throw up his Prime Ministership and take the sword himself, and lead the men of India against the invasion."[69]

Discussions resumed after dinner and ran until midnight. Nehru remained stubborn, at least once repeating his threat to join the front lines himself. Mountbatten had to exert heavy pressure just to get him to agree to an announcement of the separate agreement over the Raj's financial reserves, which had been reached previously in Delhi. The meeting ended with Nehru saying no more than that he would consider referring the dispute to the United Nations, as both Mountbatten and Liaquat were urging. The talks had been draining, Nehru wrote to Abdullah a few days after returning to Delhi, and had ended in a "complete deadlock."[70]

In the hills surrounding Uri, snow had begun to fall. The town sat at a strategically critical juncture — along the road from the border crossing at Domel, where the tribesmen had first entered Kashmir, to Srinagar; a separate spur led south to the town of Poonch. While Indian forces firmly controlled Uri itself, insurgents lurked on the ridges above. On 11 December, a fusillade of machine-gun fire rained down from a high position near the village of Bhatgiran, halting all traffic into town.

Before dawn two days later, several companies of the 1st Sikh Battalion — the unit that had led the airlift into Srinagar — crept up the frozen hillside to clear out the enemy position. They found the ridge quiet, apparently deserted. Officers ordered them back to town. Scrambling back down the hillside, the battalion stumbled into an ambush.[71] Gunfire ripped through their ranks from three sides; blood spattered the crystal-white ground. By the time the Indians fought their way out, battling hand to hand in places, they had taken more than 120 casualties, half of them killed in action. The battalion lost more men in those few

hours than they had in the seven weeks since they had landed in Kashmir.

The battle exposed the terrible vulnerability of India's forces in Kashmir. Although better armed and trained than the insurgents, Indian troops remained outnumbered and exposed, at the distant endpoints of long lines of communication. The onset of winter meant fewer supplies could make their way through; Kashmiri laborers had to dig out the road over the Banihal Pass almost daily to keep it clear of snow. The troops at Uri and elsewhere lacked proper cold-weather gear: they had to buy locally made *poshteens* — knee-length leather coats with fur lining — and quilted "Gilgit boots" and share them among sentries while on duty.[72]

Meanwhile, Pakistan's support for the raiders seemed unstinting. As many as four thousand insurgents were now thought to surround Uri. British intelligence reports show that Pakistan made multiple secret attempts in December to procure arms abroad: 60,000 rifles and submachine guns and 8 million rounds of ammunition from British companies; another 10,000 guns, 200,000 hand grenades, and 30 million rounds from the United States; and trucks, radar equipment, and other weaponry from Italy and Belgium.[73] Some of this materiel appears to have been intended for Hyderabad, from which Pakistan was seeking a massive loan. But the balance was presumably meant for Pakistani irregulars — a "home guard" had been proposed to patrol the border with India — and the fighters in Kashmir. The dominant role the army had assumed in Pakistan is clear from the country's first budget. Despite the huge burden of caring for and resettling several million Muslim refugees from India, 70 percent of government spending was earmarked for the military.[74]

In Delhi, Sardar Patel was not the only one wondering why India should replenish Pakistan's coffers by handing over the 550 million rupees that represented its share of the former Raj's reserves. At a cabinet meeting, he categorically refused to transfer any money that Jinnah could use to help kill Indian soldiers in Kashmir — "not a pie [penny]," he swore.[75]

Liaquat might well have wondered what he and others had unleashed in Kashmir. After unofficially promoting the campaign there as a "holy

war," Pakistan could hardly back down now. Yet its government was running on little more than fumes; only 20 million rupees were left in its accounts.[76] The jihad, Sir George Cunningham told a British diplomat, "had hopelessly undermined all discipline and mutual confidence in the services," as junior officials were encouraged to abuse their authority, siphon off equipment, mislead their superiors — anything that could be justified as support for the shadow war.[77] Cunningham himself had seriously considered resigning three times in the past month. Jinnah's doctors were reportedly giving the Quaid only six months to live.[78] If he died, Liaquat would be saddled with a government that was broke and edging closer to disintegration.

On Sunday, 21 December, the Pakistani prime minister returned to Delhi for another Joint Defence Council meeting "in a very chastened mood," Mountbatten recorded. "He obviously was frightened at the situation, which appeared to me to be getting out of his control."[79] Although the financial agreement between the two countries had been reached nearly a month earlier, no money had yet changed hands. Liaquat now feared that India might repudiate the pact altogether.

When Nehru arrived at Government House at ten o'clock that night, Mountbatten urgently pulled him aside. The governor-general, Nehru wrote afterward, was "greatly worked up" and repeatedly pressed him on "national and personal grounds" to show flexibility when he met with Liaquat.[80] The Pakistani prime minister had to cool his heels for an hour while Mountbatten made his case.

Nehru's position remained unbending. He suggested only that India would ask the United Nations to compel Pakistan to cease its support for the raiders. No mention was made of a plebiscite. Yet by the time they parted shortly after midnight, Liaquat had "hardly raised any difficulties" and, indeed, urged that their two nations "put an end to conflict and misunderstanding." The Pakistani prime minister seemed to Nehru "eager and anxious" to strike a deal.[81]

The moment slipped away. At the conference the next day, Liaquat was furious to learn that the Indians were still not going to pay the money they owed until the Kashmir issue was settled. When Nehru tried to hand him a draft letter formally accusing Pakistan of aiding the insurgents, the normally easygoing Liaquat slapped it aside. "At one

moment, indeed, he seemed near tears," Mountbatten recorded. "He was unable to accept the position whereby he was put under financial pressure over the Kashmir settlement. . . . The cash balances did not all belong to India. The due share was the legal right of Pakistan. It should be handed over right away."[82] Nehru was unmoved.

With the politicians deadlocked, zealots once again seized control of the narrative. The Indians had stationed a small garrison — only two companies — in the town of Jhangar in Jammu province, hoping to advance from there to relieve the battalion in Poonch. On the night of 23 December, an estimated six thousand guerrillas attacked the isolated detachment, outnumbering the Indians thirty to one. The troops were overrun; a relief column sent out to help had to turn back after losing four armored cars. The next day, along with news of the defeat, reports reached Delhi that an unbelievable thirteen thousand insurgents were massing to attack Uri. If the town fell, the road to Srinagar would once again lie nearly defenseless.

A school of thought had begun to develop among Indian leaders that Jinnah's real aim was to tie down Indian forces in Kashmir and stir up trouble in Hyderabad so that Pakistani troops could then attack unimpeded across the Punjab border. Nehru had warned Liaquat that India could no longer tolerate the bases allegedly being provided to insurgents in Pakistan. With safe havens, Nehru had noted a few days earlier, the tribesmen could continue fighting "for months and months and years." The drain on India's resources was immense. "The burden on Pakistan is relatively little."[83] Six decades later, the United States would issue the same lament about Pakistan's support for the Taliban.

India had committed more than a division's worth of troops to Kashmir, and yet the conflict looked virtually stalemated. Only one course seemed effective to Nehru now: "to strike at these concentrations and lines of communications *in Pakistan territory*."[84]

On Christmas Day, Nehru summoned Major-General Thimayya to an unannounced meeting in Delhi. Lieutenant-General Bucher was there as well, but the commander in chief, General Lockhart, who was departing at the beginning of the year, was not. Nehru did not tell Mountbatten about the conference either — one of the rare secrets he kept from the former viceroy.

If Uri fell to the tribesmen, Nehru wanted Indian forces to cross into Pakistan's half of the Punjab to "obliterate" the insurgents' "bases and nerve centres." At the meeting it was decided not only to dispatch more regular troops to Kashmir but to raise a force of irregulars to bolster defenses in East Punjab, in case Pakistan tried to retaliate by sending tribesmen into India itself.[85]

This was a dangerous game to play, then as today, as Indian leaders threaten to respond to Pakistan-linked terrorist attacks with "limited strikes" across the border. While Nehru met with his generals, Mountbatten was writing the Indian prime minister a long, emotional letter, begging him to call in United Nations observers who would "stop the fighting." Even a targeted cross-border strike, Mountbatten warned, would "mean war between India and Pakistan"—one that would not likely "be confined to the Subcontinent, or finished off quickly in favour of India without further complication." Each time Nehru had recently suggested such an attack, Mountbatten had "been more and more appalled."[86]

Nehru's response the next day did not mention the plans that were being laid to strike into Pakistan. But he made clear he was done compromising with Jinnah. "I am convinced that the whole of this business has been very carefully planned on an extensive scale and that high authority in Pakistan has encouraged this," he wrote. Any conciliatory gestures from India now would be misinterpreted as weakness: "Peace will only come if we have the strength to resist invasion and to make it clear that it will not pay. That is the only way Pakistan seems to understand. . . . Vast numbers of the enemy are entering Kashmir at many points. . . . There are large concentrations near the West Punjab border also, where the cry is 'March to Delhi.' There is imminent danger of an invasion of India proper. Can we afford to sit and look on? We would deserve to be sacked immediately."[87]

Although he acknowledged Mountbatten's arguments about the consequences of war, Nehru thought the alternative — an India supine before her rival — worse. "We have taken enough risks already" in an effort to avoid conflict, he declared in his letter. "We dare not take any more."[88]

The next night, Sir Terence Shone was startled awake by two visitors,

aides of Mountbatten's. They had brought a copy of his letter to Nehru, as well as Nehru's chilling reply. Mountbatten wanted both forwarded to Attlee, along with a personal plea for the British prime minister to fly out to the subcontinent immediately. "The previous drift in affairs has given way to an avalanche," Mountbatten warned.[89]

Although not as obviously as in Pakistan, the fighting had begun to eat away at India, too. The rift between Patel and Nehru had ripped open once again. Nehru had begun to assume more control over the Kashmir campaign — usurping authority that the Sardar, as states minister, rightfully believed to be his. On 23 December, the night of the Jhangar attack, the two men had exchanged angry notes. Patel complained that Nehru had diverted money and trucks to Abdullah's forces in Srinagar without informing him, and threatened to resign if the prime minister continued to interfere. "I can't work like this," Patel told Nehru the next day.[90]

Even as India geared up for a possible war with Pakistan, the tensions between the two Indian leaders began to spread through the bureaucracy. Guns allocated for Abdullah's militia disappeared on their way to Srinagar — allegedly diverted to RSSS fighters in Jammu. Nehru was particularly incensed at intelligence that suggested Hindu militants were conducting propaganda against Abdullah and in favor of the dissolute Hari Singh.[91] When challenged, Patel simply brushed off the reports as rumors.

Attlee declined to hop on a plane for the subcontinent. Instead, he chastised Nehru by letter, warning, "I am gravely disturbed by your assumption that India would be within her rights in international law if she were to move forces into Pakistan in self-defence. I doubt whether this is in fact correct juridically and I am positive that it would be fatal from every other point of view."[92]

Meanwhile, sympathetic British officials quickly alerted Pakistan to India's military buildup.[93] By 30 December, Indian reconnaissance showed that the concentrations of thousands of guerrillas who had been poised to attack Uri had mysteriously vanished.[94] Whether the tribesmen had been called off, had gone to ground because of the weather, or had never been there in the first place almost didn't matter. That same

day, Liaquat finally responded to Nehru's earlier letter complaining of Pakistani support for the raiders. In a long screed of his own, Liaquat accused India of attempted genocide in the Punjab and of trying to destroy Pakistan as a viable state.[95] Ignoring the particulars, Nehru filed India's formal complaint to the United Nations on New Year's Day. That, as Mountbatten had hoped, at least temporarily slowed the march to war. The Security Council postponed discussion of India's complaint until mid-January.

The longer the conflict dragged on, though, the more jingoistic the atmosphere within India became. "Kashmir is increasingly regarded as a matter of prestige," Phillips Talbot wrote in a letter home. "Indians' nerves are raw. Every issue tends to produce a crisis. An oversensitive nationalistic spirit is visible."[96]

Relations between Muslims and non-Muslims in India remained bitter — and were made worse by tensions with Pakistan. Hundreds of thousands of Hindu and Sikh refugees still crowded into Delhi. They had taken over the homes of Muslims who had fled to Pakistan, and even of some who had stayed, kicking their inhabitants out onto the streets. RSSS sympathies flourished: one estimate, surely exaggerated, put the militants' numbers in the United Provinces at 4 million.[97]

Patel hardly bothered to disguise his own admiration for the Hindu nationalists. In a speech in Lucknow on 6 January, he obliquely criticized those — like Nehru — who talked of crushing the RSSS by force. "The *danda*" — the stick — "is meant for thieves and dacoits," the Sardar declared, whereas RSSS cadres were only "patriots who love their country."[98]

The ugly mood dismayed Gandhi. Since the Delhi riots had rendered his more humble accommodations unsafe, he had taken up residence at the luxurious compound of one of his richest supporters, industrialist G. D. Birla. Muslim petitioners came to the Mahatma's prayer meetings on the lawn outside Birla House virtually every evening, begging for relief from Hindu and Sikh attacks. The growing split between his acolytes added to Gandhi's pain. The Sardar's speeches were growing "vicious," according to Mountbatten. In Lucknow, Patel had a blunt warning for Indian Muslims who had not yet condemned Pakistan's jihad in Kashmir: "I want to tell you very clearly that you cannot ride two

horses. You select one horse, whichever you like better."[99] He did not specify what would happen to those who chose wrong.

The 12th of January 1948 was a Monday — Gandhi's day of silence. At his prayer meeting that evening, a devotee read out a statement from the Mahatma. "Just contemplate the rot that has set in in beloved India," the remarks read.[100] Gandhi could look on passively no longer. He had decided to fast until "heart friendship" returned to Hindus, Muslims, and Sikhs in Delhi, or until his own heart gave out. Although he had seen both Nehru and Patel that afternoon, he had given them no hint of his plans lest they try to stop him.

The news angered the Sardar, who understandably believed that the fast was directed at him. The next day, he was "very bitter and resentful," Mountbatten recorded, and felt Gandhi was "putting him in an impossible position."[101] Gandhi himself denied any such intention. But, encouraged by Mountbatten, the Mahatma did press Patel and the Indian Cabinet to stop blocking the funds owed to Pakistan. On the morning of 14 January, rapidly weakening, Gandhi summoned Nehru and Patel to his bedside. Tears ran down the Mahatma's face as he pleaded with them. For India to try and starve her sister dominion into submission was, Gandhi declared, using a word Mountbatten had chosen to prick his conscience, "dishonorable." The money should be paid immediately.

Patel responded with "extremely bitter words," he later admitted. At a cabinet meeting later that day, he, too, shed tears as the others decided to heed Gandhi's request. "This is my last [cabinet] meeting," Patel vowed.[102] The next day, he left for a tour of the Kathiawar states in his native Gujarat.

Before leaving, he drafted an emotional letter to Gandhi. "The sight of your anguish yesterday has made me disconsolate," Patel wrote.

It has set me furiously thinking. The burden of work has become so heavy that I feel crushed under it. Jawaharlal is even more burdened than I. His heart is heavy with grief. Maybe I have deteriorated with age and am no good any more as a comrade to stand by him and lighten his burden. . . . It will perhaps be good for me and the country if you now let me go. I can only act in my way. And if thereby I become bur-

densome to my lifelong colleagues and a source of distress to you, and still I stick to office, it would mean that I allowed the lust for power to blind my eyes.[103]

By now Gandhi weighed only 107 pounds. He was too nauseous even to drink water. He spent most of the day curled in a fetal position in an enclosed porch at Birla House, swaddled in white khadi from head to toe like an infant. A long line of well-wishers, both Indians and foreigners, filed past to catch a glimpse of him, touching their hands in respect and weeping as they passed.[104] Nehru visited daily, tired and strained. Congress Party figures struggled to commit leaders of Delhi's various communities to a pledge promising to defend the rights of minorities to live and worship in the capital.

Even from his cot, Gandhi could hear the shriek of the furies that still roiled India. Small crowds of Hindus and Sikhs, many of them Punjab refugees, had gathered outside the gates of Birla House to wave black banners and denounce the Mahatma as a traitor for supporting Pakistan. "Let Gandhi die!" some chanted. Leaving the Mahatma's side one evening, Nehru stopped his car and charged the demonstrators. "How dare you say those words?" he shouted angrily. "Come and kill me first!"[105] No doubt some in the crowd would have gladly obliged.

10
⩊⩊⩊⩊

The Last Battle

ANDHI'S FAST WOULD LAST three more days. After his
doctors warned that the Mahatma's kidneys were failing — and
the patient himself suggested that those who wished to save
his life might want to "hurry up"— Indians at last bestirred themselves
to action.[1] Across the country, Hindus and Muslims once again linked
hands in "peace brigades" and marched together to affirm their brother-
hood. Shops and universities closed in sympathy. Messages of support
poured in from Pakistan. In Delhi, Hindu and Sikh refugees promised
to welcome Muslims back to their former homes and mosques. On
18 January, Gandhi took a sip of orange juice — his first sustenance in
nearly 122 hours.[2]

Newspapers around the world hailed the moment as a victory for tol-
erance and goodwill over hate. Yet in the interim, something twisted
and ugly had taken root — India's own "poisonous plant." Just two days
later, an emaciated Gandhi limped out to the dais overlooking the Birla
House lawns and led a prayer meeting for the first time since embarking
on his fast. As he concluded a disquisition on the "barbaric" practice of
lynching in the United States, a slab of guncotton exploded in a corner
of the courtyard, rattling the windows of the British High Commission
across the street.[3] No one was hurt, and in a barely audible voice, Gan-
dhi tried to dismiss the ruckus as a military exercise taking place nearby.
In fact, seven Hindu radicals had infiltrated the meeting. They meant

to launch a gun-and-grenade assault after the explosion but hesitated at the critical moment. Plainclothes police nabbed the bomber; the other would-be assassins fled.

To Hindu and Sikh extremists, the only concrete result of Gandhi's fast seemed to be that Pakistan was now 550 million rupees richer. The money had not bought peace in Kashmir, nor even a more conciliatory attitude from Jinnah. Quite the contrary: at the United Nations in New York, world powers seemed to be taking Pakistan's side in the dispute. The country's suave foreign minister, Sir Mohammad Zafarullah Khan, harangued the Security Council with a five-and-a-half-hour oration, tracing what he called a sinister pattern in Indian behavior — from the slaughter of Muslims in the Punjab and Delhi to the invasion of Junagadh to the intrigue with the maharajah of Kashmir. All added up, he argued, to a concerted, conscious attempt to grind Muslims and Pakistan into submission.

British diplomats in particular sympathized with Zafarullah's plea that Pakistan could not persuade the tribesmen to withdraw from Kashmir until they were assured that the state's Muslims would get to decide their own fate. Commonwealth Relations Minister Philip Noel-Baker, who had flown in from London to head up the U.K. delegation, flatly told U.S. officials that "Kashmir would probably go to Pakistan under a free plebiscite, except for those Hindu-majority districts in the extreme south."[4] He supported Pakistan's demand that Sheikh Abdullah be replaced by a neutral administrator pending a vote, and that Pakistani troops jointly guarantee security in the state along with the Indians. Both suggestions were intolerable to Nehru.

On every front, India appeared to be losing ground to its rival. A report in the *Hindustan Times* revealed that Hyderabad had secretly extended a massive loan of 200 million rupees to Jinnah's dominion, in the form of securities issued by the former Raj. If Pakistan chose to sell those stocks suddenly, Jinnah could plunge India's financial markets into turmoil. The newspaper condemned the nizam's move as a "hostile act" — one that if not reversed quickly, "would prove to the world that Hyderabad was nothing more than a pocket of Pakistan inside the Indian Union."[5]

Hindu militants talked openly of assassinating Gandhi and Nehru,

reviving fears of a right-wing coup. Anonymous posters and pamphlets incited readers "to murder Mahatma Gandhi, to cut him to pieces and throw his flesh to dogs and crows."[6] At a speech in Amritsar on 29 January, Nehru blasted the RSSS as "traitors" bent on overthrowing the government.[7] Police arrested a young man in the audience hiding three grenades under his clothes.

Perhaps the Mahatma could sense that his fast had not softened all Indian hearts. On 30 January, he met with the photographer Margaret Bourke-White at Birla House. Gandhi spun cotton on his wooden charkha as they spoke, and joked that the American was taking too long to finish her intended book on India. Near the end of their conversation, though, as they discussed conditions in the postwar world, Gandhi's words grew "toneless and low," Bourke-White recalled. "The world is not at peace," he murmured almost in a whisper. "It is still more dreadful."[8]

Later that afternoon, Sardar Patel came to see Gandhi. Nehru's deputy still wanted to be "released" from the government; he claimed at least four other ministers wanted to join him.[9] The depressing conversation made Gandhi late for his five o'clock prayer meeting. His arms resting on his grandnieces Manu and Abha — "my walking sticks," he called them — the unhappy Mahatma hurried toward the dais. A blaze of midwinter marigolds and nasturtiums, lit by the setting sun, spilled over the flower beds along his path.

The young man who bumped into Manu, knocking the Mahatma's rosary and prayer book from her grasp, had his hands folded in respectful greeting.[10] With one of them, he reached into his safari jacket, pulled out a Beretta pistol, and pumped two bullets into Gandhi's chest and one into his abdomen. The Mahatma died on the spot. His killer was one of the earlier conspirators — Nathuram Godse, the fanatic editor of a Hindu nationalist newspaper in Poona — who had returned alone to finish the botched job.

Word of the shooting unleashed a torrent of grief, something close to national hysteria. "Mahatma Gandhi is assassinated," "Mahatma Gandhi is assassinated," "Mahatma Gandhi is assassinated," an announcer on All-India Radio shrilly repeated.[11] In Calcutta, newspapers quickly

produced one-page editions — called "telegrams"— featuring just the Mahatma's enlarged portrait and the barest details of his death. The flimsy sheets, pasted up in the windows of homes and shops, turned into impromptu shrines. Crowds gathered at each one, lighting candles and praying, while others huddled fearfully around radio loudspeakers. "There was everywhere an air of stunned silence," recorded U.S. consul Charles Thompson, "broken only by the muted noises of traffic, by the occasional blaring of radio news broadcasts and by the unashamed weeping of countless men, women and children."[12] Until it was announced that the killer was a Hindu, panic prevailed across the border in Pakistan. "What does this mean? Will it be war?" officials and ordinary citizens cried, according to British ambassador Sir Laurence Grafftey-Smith.[13]

Nehru reeled. Racing to Birla House as soon as he heard the news, he fell to his knees at the sight of Gandhi's lifeless body and sobbed like a child. A huge crowd had gathered outside, swelling and crashing into the walls and French doors of the mansion like a tidal wave. Nehru's voice shook as he went outside to try and calm them. "The light has gone out of our lives," he announced tearfully, perched atop the wall of the compound. "A glory has departed and the sun that warmed and brightened our lives has set and we are left to shiver in the cold and dark."[14] He broke down three times during his short speech.

Partition's furies had claimed their most prominent victim. The shock seemed to bring Hindus and Muslims back to their senses. Reports that RSSS cadres had greeted Gandhi's death joyously, setting off firecrackers and distributing sweets, revolted most Indians. Five days later, the RSSS was formally banned, as were all other communal organizations. Patel's police began raiding the group's offices. That same day, the Sardar told Indian legislators that any suggestion of a split between him and Nehru at this fraught moment was "inconceivable"; privately, he assured Nehru of his unfeigned loyalty.[15] Already dwindling, communal killings now largely ceased on both sides of the border.

The morning after Gandhi's death, the United Nations held its first-ever moment of silence. Afterward, delegates from nation after nation prayed that the tragedy might lead to reconciliation between India and

Pakistan. Jinnah perhaps did not help that cause with his unsentimental condolence message, in which he praised Gandhi as merely "one of the greatest men produced by the *Hindu* community."[16]

The real roadblock to better relations, however, remained Kashmir. The drift of debate at the United Nations had infuriated Nehru no less than it had Hindu extremists. He focused his ire on the Americans more than Noel-Baker and Britain, still convinced that Jinnah had offered Washington air bases and other concessions in Kashmir. "He particularly resented the way in which America belittled India and assumed an air of moral superiority," recorded a visiting British official who met with Nehru the day after the assassination.[17] To Mountbatten, Nehru condemned the UN as "an American racket."[18]

In recent weeks, Nehru had visited Gandhi almost daily, to relieve his mind and seek advice. The Mahatma, too, had viewed the struggle in Kashmir as a moral one. "Any injustice on our land, any encroachment on our land should ... be defended by violence, if not by non-violence," he had told Sardar Patel right after the first Indian troops landed in Srinagar. "Every airplane that goes [to Kashmir] with materials and arms and ammunition and requirements of the Army, I feel proud."[19] The British writer Kingsley Martin had interviewed Gandhi just three days before his assassination and found him "very stiff about Kashmir ... and absolutely adamant about fighting it out [there]."[20] Gandhi sharply rebuked Martin for even suggesting that India might share the state with Pakistan.

Nehru now invoked the martyred Mahatma when he argued for continuing the fight in Kashmir. The first time he visited Jammu after Gandhi's funeral, Nehru confidently assured one audience, "Whatever we have done in Kashmir has been based on the principle of truth and honesty. ... At every step we have taken so far we have consulted Gandhiji and secured the approval of the saint of truth and nonviolence."[21]

On 6 February, a week after the assassination, Nehru received welcome news from the front. Tribesmen from Dir state in Pakistan had launched one last, desperate offensive before the winter snows deepened. Thousands of insurgents had attacked the Indian contingent holding the town of Naushera, in Jammu, from three sides, using mountain guns provided by the Dir state forces to pound Indian positions. The Indians

were well-entrenched, though, and backed up by planes and artillery. Their big guns mowed through the waves of attackers: one medium machine gun reportedly fired nine thousand rounds at point-blank range into the charging tribesmen. Indian commanders counted 963 corpses, while press reports boasted that another thousand fighters had either been blown to bits or had their bodies carried away.[22] While such figures were no doubt exaggerated, even Brig. Sher Khan — the Pakistan Army's director of military operations, who had just taken over from Col. Akbar Khan as commander of the insurgency — admitted that the rout had resulted in the "complete disorganization and melting away of the *lashkars*."[23] From Nehru's perspective, the best news of all was that the commander who led the Indian resistance was a Muslim — Brig. Mohammad Usman.

The battlefield seemed to offer the possibility of a cleaner victory than the Security Council did. Two days after the Naushera victory, Nehru recalled India's UN delegation to Delhi for indefinite "consultations." Although fighting now paused for the winter, the Indian Army continued pouring troops and supplies into Kashmir. Pakistan military observers assumed they were building up for a major spring offensive to break the back of the insurgency. India now had the equivalent of three divisions in the state, with more on the way.[24]

Pakistan faced the prospect of losing Kashmir for good before the slow-moving UN could act. Sher Khan warned that come spring, the scattered and undisciplined tribesmen would be little match for India's bolstered forces. Sources at Pakistan General Headquarters in Rawalpindi also claimed to British diplomat C. B. Duke that Sikh jathas had infiltrated the state in large numbers, preparing "to treat the Muslims in Jammu and Kashmir in the same way as they did those in the East Punjab." If unchecked, such pogroms could drive as many as 3 million Muslim refugees across the border into an already reeling Pakistan. "The results . . . would be as fatal for Pakistan as a defeat in war," Duke reported on 27 February.[25]

Although Pakistanis had won their freedom from the British, a "grimmer battle" was now underway to preserve that liberty, Jinnah told members of an anti-aircraft regiment in Karachi.[26] The Pakistan Army

began making a "psychological effort [to] show armed might to population and create confidence in Army," a U.S. military attaché reported.[27] Commanders conducted flag marches along the border and started flying combat air patrols from Peshawar to Lahore to Karachi and back. Some Pakistani officers began arguing for a more dangerous course of action as well — sending regular troops into Kashmir to reinforce the tribesmen. As Duke noted, "This would amount to war between the two Dominions."[28]

Even India's top commanders appeared uneasy about the risks of escalation. At the end of February, Lieutenant-General Cariappa, who had just been assigned command over forces in Kashmir, and East Punjab's Major-General Thimayya were invited by their former comrades in Pakistan to observe a military "week" of drills and parades in Rawalpindi. The sight released a burst of pent-up frustration from the Indians. In contrast to the spit-and-polish Pakistani troops, they lamented, the Indian Army had been almost constantly deployed since Partition, either in Kashmir or on internal security duties. Soldiers had had no time to train. Morale was low. Forces were burning through equipment as if engaged in a world war; Cariappa estimated that the army would run out of functioning motor transport in two months.[29] On 28 February, NWFP governor Sir George Cunningham noted in his diary, "The Indian Army people at Delhi are said to be thoroughly tired of the Kashmir operations. But Nehru won't give up."[30]

Sidney Cotton's trim little Lockheed lifted off from Bombay on 18 February in brilliant sunshine. He and his Polish engineer kept a wary eye on the thunderclouds to either side of them as they guided the plane southeast. Spitting rain and long filaments of lightning, the storm closed in as they approached Hyderabad's Hakimpet airfield, 400 miles from Bombay. Oddly, the nizam's capital remained untouched. "A brilliant white shaft of sunlight [raised] it into bold relief from the surrounding gloom," Cotton recalled in a memoir.[31] He taxied his plane to a halt near the foot of one of three rainbows that arched over the city.

A tall, charismatic Australian, the fifty-two-year-old Cotton boasted a colorful past. In his early twenties, he had flown English Channel patrols during World War I. He then spent several years as an itinerant

adventurer, seal-spotting and searching for lost explorers in Newfound-land and Greenland. He became a pioneer in the field of aerial recon-naissance: in the run-up to World War II, he photographed German military installations on covert missions for MI6. Churchill loved his derring-do, a feeling not universally shared by Cotton's commanding officers. They eventually got him booted out of the Royal Air Force (ac-cording to one version of the story, for airlifting the head of the Dior empire out of occupied France for a tidy fee). Working various schemes after the war, he had come to Hyderabad looking to buy peanuts for export.

Cotton would play a small but critical role in Nehru and Jinnah's last battle. Tensions between India and Hyderabad were rising again. The loan to Pakistan — ostensibly negotiated before the signing of the November 1947 standstill agreement — had infuriated India's leaders and revived fears that the nizam was plotting to ally himself with Jin-nah's dominion. The erratic monarch had compounded suspicions by banning the use of Indian currency within his state and restricting the export of precious metals. Hyderabad had posted a diplomatic represen-tative in Karachi, and talked of dispatching others to Washington, D.C., and London. Patel and Nehru had intended the standstill agreement simply to offer a cooling-off period, during which His Exalted Highness could accommodate himself to the idea of merging with India. Instead, the nizam seemed intent on using the lull to establish Hyderabad's bona fides as a sovereign power.

In India, wild stories circulated about the activities of the fire-breath-ing Ittehad leader, Qasim Razvi. He was supposed to be building up an army of Muslim militants called Razakars (Volunteers) to terrorize Hyderabad's Hindus. Reports put the number of Razakar cadres at as many as 100,000; some claimed they were receiving weapons as well as money from the nizam's officials. BBC correspondent Robert Stimson, invited by Razvi to observe a Razakar parade, wasn't terribly impressed by these supposed storm troopers. Only four hundred militants turned up to the "big show," he said — a couple dozen of them children under ten, others graybeards, most youths in their late teens clad in ill-fitting khaki bush jackets and tin hats. "All in all, it was a sorry exhibition," Stimson wrote. "When the parade was over three truckloads of volun-

teers ... drove off, firing blanks in the air. Others marched off behind a drum-and-fife band."[32] Still, other independent observers acknowledged Razvi's thugs were developing into an ugly new factor, roaming around demanding tribute from Hindu villagers and beating up those who refused to pay.[33]

Razvi claimed his little army had sprung up to defend Hyderabad's Muslims against attacks from armed Congress infiltrators based in camps across the border. Mohammed Hyder, the civilian official in charge of the Osmanabad district in northwestern Hyderabad, was no fan of the Ittehad leader, whom he described from personal experience as "both absurd and frightening." But in his memoir, Hyder also complained of covert bases in India from which irregulars would launch raids on villages and customs posts inside Hyderabad; Indian officials at a minimum seemed to tolerate the camps. The attacks embittered feelings inside Hyderabad, where both Razakars and "even ... little Muslim children" harassed Hindus in retaliation. When Hyder took up his post in January, he recalled, "there seemed to be a general loss of nerve in the district. The administrative structure was beginning to totter. ... Communal feeling was rapidly reaching a flash point."[34] Meanwhile, the Communist rebels that infested southern portions of the state appeared also to enjoy safe haven inside India's Madras province.

After news of the Pakistan loan emerged, India quietly tightened an unofficial cordon around Hyderabad. Indian border officials intercepted any goods with possible military uses: arms and ammunition, trucks and jeeps and even "soft" vehicles, spare parts, machinery, technical equipment, radio transmitters, paint, gasoline.[35] When Mountbatten demanded to know what was going on, Nehru pleaded ignorance — and, in fact, Patel and V. P. Menon may have kept the prime minister and the governor-general out of the loop on their activities in the south. Mountbatten learned only by accident that Indian military commanders had started to draw up plans for an armed takeover of Hyderabad, dubbed "Operation Polo."[36]

The officials whom Sidney Cotton met in Hyderabad, including the commander in chief, "Peter" El-Edroos, badly wanted weapons — to defend against the Communists and Congress raiders, they said; to fight for independence, India suspected. Despite the rumors about a huge

order for Czech arms, El-Edroos had had no luck finding anyone in Europe willing to sell guns to a nonstate and to transport them across several hundred miles of Indian territory into Hyderabad.[37]

With typical bravado, Cotton suggested that "it would be quite a simple operation" for him to smuggle in arms by air, and he volunteered to try as long as someone else could procure the weapons.[38] His hosts responded eagerly. In November, the nizam had replaced his prime minister with Mir Laik Ali, a noted Hyderabad industrialist and close confidant of Jinnah's; the Quaid had entrusted him with the mission of seeking a loan for Pakistan from the Americans. A civil engineer by training, the forty-five-year-old Laik Ali had no particular political or administrative experience. His chief recommendation seemed to be his negotiating ability, and his friendliness with both the Ittehad and Jinnah.[39] Laik Ali drafted a letter of introduction for Cotton to Iskander Mirza, Pakistan's defense secretary and one of the cabal involved with the Kashmir jihad.

According to Cotton, when they met in Karachi in the middle of March, Mirza eagerly approved the plot and agreed to secure the necessary weapons in Pakistan's name. Hyderabad transferred some 2 million pounds to an account in London for buying the arms and planes to transport them.[40] A shopping list was drawn up. The plan envisioned a short, intense airlift — 500 tons delivered in three days, too quick for Pakistan's involvement to come to light. The goal was simply to supply Hyderabad the means to hold out against an Indian invasion long enough for some outside body like the United Nations to intervene. All that was needed now was the Quaid's sign-off.

Up to this point, Jinnah had not granted Hyderabad anything more than moral support. He had even objected when the nizam first proposed Laik Ali as his new premier, fearing the tycoon would look like a Pakistani puppet.[41] At the beginning of March, to try and relieve tensions with India, Laik Ali had asked Jinnah to hold off on cashing the huge Hyderabad loan; the Quaid had readily agreed.[42] (The decision was made easier by the fact that Pakistan's finances were no longer so desperate by then.)

Since Gandhi's assassination, though, Jinnah's moodiness and isolation had deepened. High walls now ringed Government House. On a

visit to the Pakistani capital, India's new commander in chief General Bucher found it "astonishing how everyone there mentioned Jinnah's unapproachableness, and his uncompromising attitude. These days, he evidently considers he has always been right, is always infallible and will never be in the wrong."[43] While Bucher may not have been the most objective source, an American diplomat reported that even some of the Quaid's own lieutenants had begun to complain that his "bitterness and bias" toward India was hobbling Pakistan.[44] After dinner one night at Government House, Sir George Cunningham described Jinnah as "very rabid against Patel and Nehru, Miss Jinnah backing him up." The Pakistani leader attributed virtually all of his dominion's many troubles to Indian machinations. "I felt sometimes that he was talking in order to convince himself that he was not partially to blame for what has happened in recent months," Cunningham mused in his diary.[45]

Outside of its finances, Pakistan's troubles were multiplying. The Kashmir jihad had deeply unsettled Cunningham's Northwest Frontier Province. The tens of thousands of tribesmen — many of them Afghans — milling about on their way to or from the front were becoming a positive menace to law and order. Murders in the NWFP were up 50 percent.[46] Robberies in December 1947 were double the previous year's. Some Pakistani officials suspected that Afghanistan — which had never recognized the British-drawn Durand Line that served as its frontier with Pakistan — was deliberately stirring up trouble along the border in hopes of regaining lost territory. British ambassador Grafftey-Smith relayed rumors that "Hindu gold" was being spread liberally around the tribal areas.[47] Indian spies were supposedly trying to strike an alliance with the Faqir of Ipi, an infamous Pathan warlord who had led a long-running insurgency against the British.[48]

Other provinces seemed to be challenging the Quaid's vision for Pakistan with their own. In West Punjab, the pirs and mullahs who had helped win Pakistan had begun to demand that the nation live up to its Islamic principles; legislators voted to ban alcohol in the province and imposed new restrictions on women. A thousand miles away in Pakistan's eastern wing, Bengalis were growing increasingly resentful of the Karachi government, which was dominated by migrants from India, or *mohajirs,* like Jinnah and Liaquat. In mid-March, Bengali students

staged several days of strikes and protests to demand that their mother tongue be made one of two official languages along with Urdu.[49] Hundreds of young Bengalis were beaten or imprisoned.

On 19 March, when Jinnah landed in the capital, Dacca, for a previously scheduled visit, feelings across East Bengal were still raw. Two days later, he addressed a mammoth crowd outdoors at the racecourse, estimated at more than 300,000 people. His speech, like his mood, was uncompromising:

> Let me make it very clear to you that the state language of Pakistan is going to be Urdu and no other language. Anyone who tries to mislead you is really the enemy of Pakistan.... Unfortunately, you have fifth-columnists — and I am sorry to say they are Muslims — who are financed by outsiders. But they are making a great mistake. We are not going to tolerate sabotage any more; we are not going to tolerate the enemies of Pakistan; we are not going to tolerate quislings and fifth-columnists in our State.[50]

At Dacca University on 24 March, students jeered when Jinnah repeated the same hard-line message in a convocation address. They leaped onto their seats and shouted, "No, no!" as he spoke. The Quaid seemed taken aback, and paused for a moment before resuming his speech. He held no other public meetings before returning to Karachi at the end of the month. It was his first and last visit to East Bengal.

Upon his return, Jinnah made two fateful decisions. First, though there remains no firm proof, he appears to have sanctioned the gunrunning operation in Hyderabad. According to Cotton's memoir, in the latter half of March, Laik Ali and El-Edroos "sent a representative to see Mr. Jinnah ... to seek his approval of the action they were taking." When Cotton passed through Karachi again in early April, Iskander Mirza told him that the Pakistan Cabinet had signed off on the smuggling operation.[51] They would almost certainly not have dared to do so without consulting Jinnah. By 15 April, Mirza and several other officials from Pakistan's Defense Ministry had joined Cotton in London, ready to start buying arms.

Jinnah's second decision concerned Kashmir, where the snows had begun to melt. Indian forces were on the move, looking to reoccupy

rebel-held territory. As the insurgents fell back, lurid reports emerged from the battlefield. On 16 April, Pakistani newspapers claimed that after retaking the town of Rajauri, Indian troops deliberately blinded four thousand Kashmiri Muslim men. No evidence of such an atrocity ever emerged, of course. But the damage was done. "Great panic and confusion prevails in the area," reported Gen. Douglas Gracey, who had replaced Messervy as Pakistan's commander in chief at the beginning of the year.[52] Fears revived that a wave of refugees might flee before the Indian advance, inundating West Punjab.

By Gracey's count, the Indians had eight brigade groups in Kashmir, with supporting artillery, tanks, and aircraft. On 20 April, he warned that with its vast superiority in air and armor, India would soon very likely be able to break through the insurgent lines and march all the way to the Pakistan border. This would put Indian troops on high ground overlooking the road-and-rail artery that connected Lahore to Peshawar — the key communications lifeline of western Pakistan. That prospect, Gracey argued, was untenable:

If PAKISTAN is NOT to face another serious refugee problem of about 2¾ million people uprooted from their homes; if INDIA is NOT to be allowed to sit on the Doorsteps of PAKISTAN to the rear and on the flank at liberty to enter at her will and pleasure; if the civilian and military morale is NOT to be effected [sic] to a dangerous extent; and if subversive political forces are NOT to be encouraged and let loose within Pakistan itself, it is imperative that the Indian army is not allowed to advance.

Gracey now formally recommended that in order to give Pakistan a proper defensive buffer, "regular units of PAK ARMY must be employed to hold this line at all costs."[53]

At the outset, Jinnah and Liaquat had only intended to support the tribesmen long enough to win Pakistan's case diplomatically. They had set December as an end point, then March 1948.[54] The debate in the Security Council had turned against them, however. Pressured heavily by Mountbatten, the British Cabinet had reined in its New York delegation, which was judged to have leaned too heavily in Pakistan's favor.[55] A

new resolution put forward by the Chinese essentially accepted India's position. It called on all "foreign" fighters to withdraw from Kashmir first, then for India to reduce but not eliminate its troop presence there. Abdullah would hold power in Srinagar until a plebiscite could be organized.

Accepting Gracey's recommendation, Jinnah now ordered the Pakistan Army to enter the fray. There would no longer be any doubt; the subcontinent's two nations were at war. A month earlier, British diplomat C. B. Duke had picked up rumors that three Pakistani battalions had begun operating inside Kashmir. Grafftey-Smith had relayed these suspicions to London but dismissed them as "unconfirmed": the units in question were "almost certainly still on Pakistan side of border." By the end of April, though, Duke had proof. An officer recently returned from the Poonch front had made "clear that there are formed units of the Pakistan Army involved in the Kashmir fighting."[56]

After checking with General Gracey directly, Grafftey-Smith confirmed his deputy's report on 4 May. While preventing a refugee crisis remained the troops' primary mission, the ambassador wrote, a "secondary consideration seems to be that, having been accused of official intervention in the Kashmir dispute, Pakistan might as well be hanged for a sheep as for a lamb."[57] Cables burned between London and Washington, although neither the British nor the Americans chose to alert India or the United Nations to the Pakistani intervention.

Back in October, Jinnah had been convinced that India lacked the appetite or the capacity for an all-out war. He was about to find out whether that still held true.

By April, Hyderabad's Mir Laik Ali had become a semiregular fixture in Delhi. Every few weeks, he could be found in the Indian capital, holding another round of talks to sort out the kingdom's long-term relationship with India. The premier spent most of his evenings negotiating with V. P. Menon, who "continuously moisten[ed] his throat with large doses of sherry," in Laik Ali's envious description.[58] Menon propounded various formulae and "Heads of Agreement" to nudge Hyderabad toward a more democratic government and eventual accession to India. Officially Mountbatten led the talks, while behind the scenes, Sardar Patel, who

was recovering from a serious heart attack on 5 March, kept a watchful eye on the proceedings.

Although they met regularly, Nehru seemed to Laik Ali only tangentially involved — or interested — in the negotiations. Their conversations rambled aimlessly. "Every one of our talks was preceded by a comprehensive survey by Nehru of the world situation on a highly philosophic level," Laik Ali recalled in his memoir. The discussion would then proceed to touch upon several predictable themes — the advent of atomic energy and its impact on human civilization; "the theory of human emotions, individual and collective, and the shape they take when checked or allowed to run in certain channels"; the shrinking of the world in the jet age.[59] Most of the time the Hyderabad premier found himself thoroughly bored.

When Laik Ali trekked back to the Indian capital on 15 April, however, a great change seemed to have come over Nehru. That night when the two men met, "Panditji appeared to be carried away by emotion," Laik Ali recalled in his memoir. The Hyderabadi made the mistake of complaining yet again about India's unofficial blockade of his state. Nehru instantly "burst out in fury": "[He] said if Hyderabad persisted in its refusal to accede, he would still more tighten the ring of blockade and make it impossible even for a blade of grass to enter Hyderabad. He then worked himself up to a high pitch of excitement and snapping his fingers in my face added, 'I shall reduce Hyderabad to smithereens.' I had never before been so abjectly conscious of the physical weakness of Hyderabad against the military might of India."[60] The very next day, Nehru instructed Defense Minister Baldev Singh to move a full armored brigade — "quietly, without any precipitateness" — into position along the Hyderabad border.[61]

Nehru was fed up with the long-winded Hyderabad talks. While negotiations in Delhi dragged on, the situation on the ground appeared to be deteriorating badly. India's representative in the state, K. M. Munshi, was a devout Hindu who shared Patel's impatience with the nizam; upon arrival he had set up a network of informants of varying reliability. Their highly colored reports described a widespread campaign of "murder, arson and loot" being waged by Razvi's thugs out in the Hyderabad countryside. Between October and April, Munshi counted "no less than

260 incidents in which the Razakars acted with savage brutality."[62] The militants were supposedly harassing Indian passengers on buses and trains in transit through the state, even raiding villages across the border in India itself.

Indeed, the reports made it sound as though the Razakars were growing into a formidable guerrilla force. Munshi claimed that Laik Ali's government was funneling crude, locally made guns to the militants. Indian Army officers in the region warned that the irregulars were receiving training from British ex-commandos.[63] According to rumor, the Razakars were even secretly negotiating an alliance with the well-armed Communists — a theory that gained credence in early May when the nizam abruptly lifted the ban on Communist activity in the state.

One of Munshi's spies claimed to have overheard Razvi deliver an especially inflammatory speech to Razakar commanders at the end of March, attacking Nehru's government directly. "A Hindu who is a Kafir [unbeliever], a worshipper of stone and monkey, who drinks cow's urine and eats cow dung in the name of religion, and who is a barbarian, in every sense of the word, wants to rule us! What an ambition and what a daydream!" Razvi had allegedly thundered. "Koran is in one hand, and the sword is in the other, let us march forward; cut our enemies to pieces; establish our Islamic supremacy."[64] He supposedly promised that Muslims in other parts of India would "be our fifth-columnists" in the coming conflict. While Laik Ali hotly denied that any such speech had been made, Razvi's more public utterances were nearly as bad. At one gathering, he boastfully assured his audience that the nizam's flag would soon fly, like the Mughals', over the Red Fort in Delhi.

Accounts from more reliable figures within Hyderabad make clear that this was all mostly bluster. (Munshi's informants also claimed that the nizam had hidden a fleet of bombers in the Middle East, and possessed a cache of atomic weapons.)[65] To Nehru's eyes, though, Hyderabad must have looked more and more like another metastasizing cancer in the heart of India. While Razvi fulminated, Laik Ali and the nizam appeared to have adopted Jinnah's negotiating tactics — reaching agreements, then reversing themselves shortly thereafter and raising new demands. The latest draft deal that Laik Ali took back with him — which would have involved establishing a representative government in Hy-

derabad with a Hindu majority — was renounced by the nizam within a week.

Nehru began to echo the more hard-line Patel, who had long thought a military solution might be necessary in Hyderabad. At a closed-door party meeting on 24 April, the prime minister told Congress leaders that he saw only two choices left for the nizam: accession or "the path of war."[66] Army commanders were told to be ready to move against Hyderabad on ten days' notice if need be.[67]

News from Kashmir only increased the urgency to act. With the insertion of Pakistani troops, the Indian advance bogged down by the middle of May. On the 19th, Bogey Sen's men took heavy fire from 4.2-inch mortars, which they were certain the tribesmen and Kashmiri rebels did not possess. At first army headquarters in Delhi was disbelieving, telling Sen "to cease making wild statements."[68] But after being presented with tail fins from the mortar shells and, a few days later, a live prisoner of war, Indian commanders could no longer deny the obvious. Ironically, the Pakistani brigadier shelling Sen was none other than Akbar Khan, now back in uniform rather than masquerading as "General Tariq."[69]

Sen wanted reinforcements. But with troops tied up in the south, there were none to be had. "The situation is not so good as we had hoped and hard fighting is going on [in Kashmir]," Nehru wrote to Patel on 27 May, after receiving a long, depressing briefing from General Bucher. "Our air resources have been severely tried and we have practically no reserves left. The demand is for more and more troops. Undoubtedly with more troops we could clear up this place this summer. But we just cannot spare them so long as there is danger of warlike developments in Hyderabad with other consequences in other parts of the country."[70]

Mountbatten had just a few weeks left in his term as governor-general. He had hoped to crown his tenure by peacefully winning over Hyderabad before he left India on 21 June. Now he had to worry about his ministers launching an unprovoked invasion on his watch. When Laik Ali returned to Delhi yet again at the end of May, Mountbatten sought to shock him out of his "mulishness" much as he had tried with the Sikhs before Partition.[71] According to Laik Ali, the governor-general sat him

down and immediately started describing how if India invaded, "the numerous tanks left over by the British would start over-running the territory of Hyderabad and how helplessly the Hyderabad army with their rifles would stand before the march of tanks and get mowed down by their heavy gunfire and by incessant bombing and machine-gunning."[72]

The message got through, but not exactly as Mountbatten had intended. As soon as Laik Ali returned home, one of his first calls was to Karachi. By this point, Sidney Cotton had assembled his own little air force in the Pakistani capital. He had bought and flown over three big Lancaster transports from England, using flight crews hired away from Aer Lingus.[73] On 25 May, he had signed a contract for 400,000 pounds to fly "freight of any description weighing approximately 500 tons" into Hyderabad before the end of July.[74]

Some Pakistani officials were rushing Cotton to begin the airlift immediately, while others — afraid of being found out by the Indians, he suspected — appeared to be putting roadblocks in his way. Instead of letting him fly out of Karachi's civil airport as a regular cargo flight, they had shunted him off to the military airfield at Drigh Road, and forced him to lease a hotel and two villas out of his own pocket to house his men. A 2 June note signed by Cotton seems to indicate Jinnah was aware of the interference and disapproved. A complaint from Hyderabad's agent-general in Karachi, Cotton wrote, "upset J very much. He asked the AG who specifically was not giving help. The answer of course is that everybody is promising everything, but nothing happens."[75]

The next day, a message from Hyderabad informed Cotton "that negotiations with India looked like breaking down and that they wanted the airlift to start immediately."[76] The first Lancaster, loaded with Swiss anti-tank guns and ammunition, lifted off at eight o'clock on 4 June with Cotton himself at the controls. He flew through clouds most of the way, encountering no Indian planes. An ecstatic El-Edroos greeted him on the runway in Hyderabad.

Laik Ali now thought that 500 tons of arms would be nowhere near enough; he suggested expanding the airlift to 3,000 tons. Cotton readily agreed. Over the next fortnight, the Australian wrote in his memoir, his men flew in another sixteen planeloads of weapons, mostly small arms and ammunition.[77]

Although the fast, high-flying Lancasters managed to avoid detection, such a large operation could not remain secret for long. By the middle of June, Nehru had received reports of planes shuttling between Karachi and Hyderabad "full of war materiel." Combined with the evidence of Pakistani troops fighting in Kashmir, Cotton's flights seemed to confirm fears that Jinnah was trying to tie down Indian forces in the south as well as the north. "Hyderabad has been hand in glove with Pakistan and it is Pakistan that has prevented them from coming into line with us," Nehru wrote to Sri Prakasa, the Indian high commissioner in Karachi, on 16 June.[78] The next day, the nizam rejected India's latest offer — to hold a plebiscite in the state — balking over the demand that he first disband the Razakars and arrest Qasim Razvi.

Nehru was done negotiating. At a press conference that afternoon, he left no doubt that the Indian leaders did not intend to be as energetic as Mountbatten had been in seeking a peaceful compromise. "We are not going to discuss anything with the representatives of Hyderabad anymore," Nehru told reporters. At best India would leave the current offer on the table, unchanged. "If they wish to sign on the dotted line, they are welcome to do so."[79] Dickie and Edwina Mountbatten left Delhi four days later.

Nehru instructed the Defence Department to find a way to track and ground Cotton's planes, but he did not order immediate action against Hyderabad.[80] In a few weeks' time, the Security Council would be sending a fact-finding commission to the subcontinent to try to mediate the Kashmir conflict. Nehru did not want to antagonize the international community with an invasion now. "I would rather allow matters to remain where they are for another two months or so," he wrote to Patel.[81] By that point, the monsoons and the UN observers would have passed through, and India could take care of the threat from Hyderabad once and for all.

On 1 July, the Quaid rode in full panoply through the streets of Karachi. He sat, ramrod-straight, alongside his sister Fatima in the old viceregal carriage, surrounded by mounted outriders in crimson livery. Crowds lined the streets and gathered on the low rooftops for a rare glimpse of Pakistan's leader, six weeks before the nation's first anniversary. Jinnah

had come to inaugurate the new State Bank of Pakistan — an important symbol of his infant nation's viability. The building's imposing stone facade exuded strength and permanence. In a scratchy radio recording of his speech, Jinnah's voice soars with theatrical élan.

Watching from the side of the dais, though, Lt. Ahmed Mazhar could see the lines of exhaustion on the Quaid's face. On doctor's orders, Jinnah had spent the past several weeks resting in the cool, dry hills of Baluchistan. Karachi's seaside heat was humid and wilting. When they returned to Government House, Jinnah abruptly dismissed Mazhar, his naval aide-de-camp, at the top of the stairs. Looking back as he walked away, Mazhar saw the Quaid's frail form "staggering towards his door," wracked by a fit of coughing.[82] Pakistan's founder collapsed into bed still wearing his sherwani and shiny pump shoes.[83]

Jinnah's smoke-charred lungs had betrayed him at last. A few days later, he and his small entourage returned to Baluchistan, to the old British Residency at Ziarat. Once again government business had to be conducted long-distance. A succession of black dispatch boxes, monogrammed with the gold letters "M.A.J.," slowly made their way to him from Karachi. "There is nothing wrong with me," he protested to anyone who would listen, including the London-trained physician sent to examine him.[84] The Quaid's gray, ashen complexion and shrunken frame — one biographer claims he had wasted away to only 70 pounds — told the doctor otherwise. X-rays confirmed the diagnosis of tuberculosis. Two-thirds of one lung seemed to be gone already, and a quarter of the other.[85]

Jinnah forbade his doctors to reveal anything about his condition. "I . . . will tell the nation about the nature and gravity of my illness when I think it proper," he intoned.[86] Even when Liaquat came to see him a few weeks later, the Quaid refused to admit he was dying.

Jinnah's fading condition cast an air of unreality over the events of that summer. Members of the United Nations Commission for India and Pakistan landed in Karachi just days after the Quaid had departed. They knew that all major decisions continued to be referred to him in Ziarat. Yet in weeks of shuttle diplomacy in the region, they never once saw or spoke with Pakistan's leader.[87]

In Kashmir, the undeclared war between two armies, no longer hid-

den behind Pakistan's tribal proxies, continued on autopilot. Since May, the two sides had pummeled each other with echoing artillery barrages. "The way they waste their ammunition is amazing," Nehru wrote to Mountbatten in London. "It is not pleasant to think that we are one of the main suppliers."[88] Indian and Pakistani troops battled fiercely for hilltops and ridges, and the front bulged and contracted. Insurgents captured a swathe of territory in the desolate north, cutting off the Ladakh capital of Leh for months. But neither side could land a decisive blow. By the end of July, monsoon rains again made fighting difficult.

The UN diplomats were shocked to learn that Pakistani troops were now engaged in the battle; the admission dramatically undercut Pakistan's claim to be the aggrieved party. In Delhi, Nehru failed to see what else there was to discuss: "Their whole case in regard to Kashmir . . . has been based on deceit and falsehood throughout," he argued to Czech delegate Josef Korbel. As far as India's prime minister was concerned, the United Nations' job was to compel Pakistan to withdraw. He grew livid when Korbel suggested that India, as the stronger party, make some gesture of concession as well: "Pandit Nehru reacted vehemently. In a flash of bitterness he leaped onto a chair, shouting, 'You do not seem to understand our position and our rights. We are a secular state which is not based on religion. . . . Pakistan is a mediaeval state with an impossible theocratic concept. It should never have been created, and it would never have happened had the British not stood behind this foolish idea of Jinnah.'"[89]

The commission largely came down in Nehru's favor, suggesting in mid-August that both sides cease hostilities, and Pakistan withdraw its troops and the tribesmen. Then India was to draw down its own forces to a token presence before a UN-sponsored plebiscite was held. Nehru accepted the deal on 20 August.

Without Jinnah's sanction, however, the Pakistanis seemed unable to commit themselves. Foreign Minister Zafarullah Khan harassed commission members for "hours on end and touched upon almost every word [in the resolution] and its exact meaning," Korbel recalled. "What would happen . . . ? What would the Commission do if . . . ? Did you bear in mind the possibility of . . . ?" Pakistan did not issue its official

reply for weeks, and then "attached so many reservations, qualifications, and assumptions" that the commission judged the answer "tantamount to rejection."[90]

Hyderabad's Mir Laik Ali couldn't get any clear answers out of Pakistan either. In August, he secretly flew to Karachi aboard one of Cotton's Lancasters. India's stranglehold on Hyderabad had tightened. Delhi had re-routed trains to bypass the state and banned local Deccan Airways from Indian airspace, effectively cutting off Hyderabad's citizens from the rest of the subcontinent. Indian armored units were stationed along the state's borders. Laik Ali needed to know what help he could expect from Pakistan if India invaded. He heard impassioned declarations in Karachi — one minister boasted that Pakistani troops would overrun Delhi before the Indians ever reached the nizam's capital — but no concrete assurances.[91] Only the Quaid could provide those.

In desperation, Laik Ali flew up to Baluchistan. Jinnah's doctors had moved him to Quetta, the region's capital, a few days before. The Quaid's absence from view on the first anniversary of independence had fueled rumors of his imminent demise. "It is a question of weeks," Nehru wrote to Mountbatten on 23 August.[92] When Laik Ali arrived a little before eleven o'clock, the Hyderabadi later recalled, he "could see anxiety on everyone's face."[93] Doctors huddled in consultation. Jinnah had reacted badly to an injection and was in a great deal of pain and only semiconscious. Laik Ali waited all morning and into the afternoon. A worried Fatima kept emerging from the Quaid's bedroom, shaking her head. At last, she said that Jinnah had waved his hand in agony and indicated he could not see the visitor. Laik Ali flew home empty-handed.

In his memoirs, Laik Ali claims that he informed the nizam that the mission had been unsuccessful. Other Hyderabad officials, however, recall the premier feigning confidence on his return from Karachi. "He told me that Pakistan had assured air support in case Indian Union troops entered Hyderabad," El-Edroos wrote in his own memoir.[94] With others Laik Ali was less specific, but his implication was clear. Mohammed Hyder met with the premier on 28 August. If India attacked, Laik Ali assured the district official, "'Do you really think we would find ourselves isolated? Do you think we have no friends? If it came to a fight

after all, Hyderabad will not find itself alone.'"⁹⁵ He told Hyder that he did not expect an Indian invasion until late November at the earliest, after the one-year standstill agreement had expired.

Perhaps Laik Ali really believed that Pakistan would come to Hyderabad's rescue in the end, or that the United Nations might. A delegation appointed by the nizam snuck away on one of Cotton's planes to try and put Hyderabad's case before the Security Council. Laik Ali thought if troops and Razakars could hold out against any attack for a month at least, world powers would intervene.⁹⁶ Given the tens of thousands of .303 rifles and Sten guns smuggled in by Cotton's operation — "by now we had begun receiving arms in relatively large quantities," Hyder wrote at the end of August — that seemed eminently possible.⁹⁷

But time had run out, for Hyderabad no less than for Jinnah. Left unchecked all summer long, Qasim Razvi's threats had reached a hysterical pitch. Now he talked of turning Hyderabad into a smoking wasteland if India invaded, littered with the bones of millions of Hindus. Razakar gangs had reportedly started marauding through Hindu villages, dragging out suspected Congress sympathizers and executing them. The thugs beheaded one defiant village headman and paraded his skull on a pike. A Muslim newspaper editor who had criticized the Razakars had his hands chopped off.⁹⁸ At one border crossing Razakars sparked an hours-long gun battle with Indian troops.

The provocations gave Indian leaders the excuse they needed. The only way to deal with the nizam, V. P. Menon told an American diplomat, was "to hit him over the head with a hammer."⁹⁹ Patel threatened to resign if Nehru didn't order Indian tanks to roll.¹⁰⁰

On 7 September, Delhi laid down an ultimatum. The nizam had to ban the Razakars and allow Indian troops to take up positions in the old British cantonment at Secunderabad. Three days later, a grimly determined Nehru met with reporters. Asked what India intended to do if the nizam's troops resisted, he said simply, "With great regret we shall still occupy Secunderabad." And if Hyderabad tried to drag things out by involving the United Nations? "We march."¹⁰¹

Laik Ali still thought Nehru was bluffing. Later that day, in his official reply, the premier called India's ultimatum "extraordinary" and warned that any infringement of Hyderabad's territorial sovereignty would have

"very serious consequences."[102] He defiantly ordered Hyderabad's armed forces to mobilize.

The following morning, three planes landed at Quetta's airport in far-off Baluchistan. The Quaid, dressed in a new suit and wearing freshly shined shoes, was carried to his sleek new Viking on a stretcher, weakly saluting the plane's British crew.[103] He had developed a bad case of pneumonia; doctors urgently needed to get him back to the capital for treatment.

The trip was kept secret. In Karachi, the Viking was met by an army ambulance but no officials. On the drive into town, the truck broke down near a camp full of rag-clad Punjabi refugees. For an hour, Jinnah lay in the sweltering ambulance, a nurse fanning the flies away, before another vehicle arrived. By the time the convoy reached Government House, whatever strength he had left had ebbed away. Doctors propped him up and tried to give him an injection, but his veins had collapsed. "God willing, you are going to live," a doctor told him at 9:50 p.m. "No, I am not," Jinnah murmured. A half-hour later he was dead.[104]

News of the Quaid's demise was broadcast late that evening. It came as a shock to Pakistanis, in spite of the long rumors about his illness. No preparations had been made for his funeral. When a mob swarmed Government House the next morning, 12 September, "the pandemonium and the crush were indescribable," one British diplomat recorded. Jinnah's body lay on a simple bier in the center of the grand Durbar Hall, surrounded by shoving, wailing mourners. The Briton "saw one man, in no way disrespectfully, jump across the body to get a better view from the other side."[105]

Jinnah was to be buried on the site of a planned mosque — a stony hill outside of town that had never been used as a cemetery before. Gravediggers could make no headway with picks and shovels; they hastily sent back to town for a pair of pneumatic drills.[106] That afternoon, when the long column of mourners — perhaps a half-million in all — started to wend its way up the hillside, the workers were still hammering away at the hard, unforgiving mountain.

There is little question that Jinnah was the most polarizing figure in the Partition drama. He is easy to blame. His forbidding personality

made compromise difficult, if not impossible, and he was criminally negligent about thinking through the consequences of the demand for Pakistan. A vindictive streak ensured that he was surrounded mostly by sycophants, rather than independent-minded subordinates who might have moderated his views.

Yet from the moment in 1937 when the Congress Party rejected any partnership with the Muslim League, Nehru — suave, sensitive, handsome Nehru — contributed very nearly as much as Jinnah to the poisoning of the political atmosphere on the subcontinent. His attitude toward the Quaid — and by implication, toward Jinnah's millions of Muslim followers — was all too often arrogant and dismissive, rather than understanding. "The more Nehru spoke contemptuously and violently about the League and Jinnah, the more I disliked the Congress," wrote one Muslim leader who had once been extremely close to the Nehru family. "This feeling was shared by a large number of the Muslims I knew who, but for this, would have shown less antipathy to the Congress."[107]

Nehru misread the battle over Pakistan much as he later did the fight for Kashmir — as an ideological contest in which he and India were morally unimpeachable. For three decades before Partition, he had seen himself thus — as one of Gandhi's nonviolent warriors, leading the assault on the British Empire. He did not seem to understand that he was no longer battling a foreign power, and that he needed to accommodate his countryman Jinnah as a statesman would: with pragmatism, generosity, and an appreciation for the gray areas of diplomacy.

Even now, with Jinnah dead, Nehru would deliver one final blow in their decades-long rivalry. As Pakistan's founder was being laid to rest, Nehru gave his commanders the green light to advance into Hyderabad.[108] India's leaders were unsentimental about the passing of their old adversary. (When Bengal's governor asked if he should lower flags to half-mast in Jinnah's honor, Sardar Patel retorted, "Why, was he your relative?")[109] Before dawn the next morning, Indian forces pierced Hyderabad's borders at five different points. Columns of Sherman and Stuart tanks clanked through dusty border villages. Indian fighter planes roared low overhead.

In Pakistan, the radio was still broadcasting recitations from the Koran in mourning for Jinnah when announcers broke in with frantic up-

dates of the invasion. India seemed to be taunting its grief-stricken sister dominion, almost daring Pakistan to respond. "You cowards!" a crowd shouted in front of the Indian High Commission in Karachi. "You have attacked us just when our Father has died."[110] Demonstrators clamored for the Pakistan Army to rush to Hyderabad's aid.

It had always all been talk, though. Jinnah's vows of Muslim solidarity, the threats of a pan-Islamic jihad to defend the nizam's throne — it was never serious. No Pakistani planes took to the skies to provide the "air support" that Mir Laik Ali had promised. No Pathan tribesmen charged down from the hills to march on Delhi. The nizam produced no atom bombs nor hidden fleets of fighters. In fact, El-Edroos had built wooden replicas of planes and camouflaged them, to fool the Indians into thinking that Hyderabad actually possessed an air force.[111] Laik Ali talked crazily of fresh shipments of Swiss-made arms that were about to be delivered at any moment, but Cotton's airlift had effectively ended.[112] His last Lancaster barely made it out of Hyderabad before the Indians bombed the airfield where he had parked it.

The nizam's forces held out for little more than a hundred hours. India's victory was too fast for the United Nations even to debate the matter, and it was total. "This is a surrender. This is not a tea party," Patel raged when India's agent-general, K. M. Munshi, suggested that Indian and Hyderabadi generals meet to arrange a face-saving end to hostilities.[113] Instead, the commander of Indian ground forces, Maj.-Gen. J. N. Chaudhuri, accepted Hyderabad's sword of surrender at 5:00 p.m. on 17 September. He assumed full control over the state as military governor. "That wretched fox," as Patel called the nizam, was allowed to remain on his throne but sidelined. Indian troops detained Laik Ali and Qasim Razvi.

Hyderabad's quick collapse deeply rattled Pakistan. There were real fears that as soon as India's armored forces could be redeployed, they would sweep westward next. "Easy conquest Hyderabad has completely changed former conviction that India would not undertake destruction Pakistan by invasion," a U.S. diplomat in Karachi reported tersely.[114] The papers were filled with such headlines as AFTER HYDERABAD, WHAT?[115]

Angry crowds besieged Liaquat's house to condemn his government's

fecklessness. However emotionally devastating it had been to Nehru and Patel personally, the Mahatma's assassination had not disrupted India's political leadership. By contrast, Jinnah had cultivated weak lieutenants; his death now left Pakistan confused and rudderless. The day after Hyderabad's surrender, Nehru appealed to Pakistanis "to cast aside their fear and suspicion and to join us in the work of peace."[116] Instead, Liaquat's cabinet responded by launching a high-profile witch hunt to root out Indian "spies"—"partly, doubtless, with the object of diverting public activity from more dangerous channels," a British diplomat reported.[117] Police arrested two dozen "enemy agents" in Karachi, more than half of them Hindu.

The Pakistanis made a show of looking to their defenses as well. British diplomats reported talk in Rawalpindi of expanding the army to four divisions and the air force to six fighter-bomber squadrons, and of buying another destroyer for the navy.[118] The military halted all releases from service, and veterans were encouraged to reenlist. Rifle training was offered to ordinary citizens. Liaquat hinted to Cotton that Pakistan might want to buy his Lancasters and hire his Irish crews for its own use. Addressing the army brass at the end of September, Pakistan's prime minister vowed that, if necessary, the 70 percent share of the budget devoted to defense would be raised to 100 percent.[119] "Pakistan, too, wants peace," U.S. chargé d'affaires Charles W. Lewis cabled sardonically to Washington.[120]

It had been just over two years since Lord Wavell's letter had thrust Nehru into power over India. Jinnah was gone. But the anxieties that the Quaid had so skillfully exploited had not disappeared. Now Pakistanis feared domination by a militarily superior India, rather than by Gandhi's Congress Party or Hindus more broadly. As he had in the 1930s, Nehru still failed to appreciate how deep such suspicions ran — and how little difference his own good intentions made.

In the middle of October, at a Commonwealth prime ministers' conference in London, Nehru again proposed that India and Pakistan make a fresh start. He was willing to partition Kashmir more or less along the current front lines, with Poonch and parts of the remote northern territories going to Pakistan. Liaquat rejected the offer. In their current, besieged mood, Pakistanis could hardly have accepted such a bargain,

which would have left the Vale to India, with Pakistan's borders vulnerable. Frustrated, Nehru belittled Liaquat's stance as "a frightened man's approach and not a strong, confident man's approach."[121] In private, Nehru was even more cutting. "Evidently [Pakistani leaders] are terribly jittery and are in a peculiar mental state which requires careful medical treatment," he wrote to Dickie Mountbatten at the end of November.[122]

As the Kashmir war ground on, Washington and London worried that the combination of Indian arrogance and Pakistani insecurity would lead one side or the other to risk a broader conflict. "It seems to me hardly less important that public opinion here should believe that India's intentions are immediately hostile than that they should in fact be so," British ambassador Grafftey-Smith warned. "The result is a mood of complete desperation in which anything is possible."[123]

Indian forces finally relieved their besieged garrison in the town of Poonch at the end of November. They secured Ladakh — somehow getting tanks up and over the 12,000-foot Zoji La Pass — and were firmly entrenched in the Vale. In spite of India's military advantage, though, Nehru knew that India could not progress much further in Kashmir without provoking a full-scale war. "If there isn't going to be a ceasefire, then it seems to me that we may be faced with an advance into Pakistan," he told General Bucher, who was nearing the end of his one-year term as India's commander in chief.[124]

By now Nehru also had a pretty good idea of how ugly a wider conflict might become. Back in October, Pakistan had accused Indian forces of presiding over a massacre of Muslim civilians in Hyderabad. Nehru had denied the charge vehemently. Yet privately, he, too, was receiving reports from trusted friends — including his onetime lover Padmaja Naidu, a native Hyderabadi — that "Hindu hooligan elements were misbehaving" in the aftermath of the invasion, as he wrote to Sardar Patel on 5 October.[125]

Nehru quietly dispatched a fact-finding mission to the state; their devastating report landed in Delhi at the end of December. The investigation confirmed that RSSS militants and Congress volunteers — some of the same armed men who had been conducting raids from across the border for months — had flooded into Hyderabad in the wake of the

Indian Army and launched a reign of terror.[126] "Razakar 'suspects' who tried to give themselves up or even those who were herded together by the army, were, in many instances, slaughtered by the thugs," wrote Mohammed Hyder, echoing the panel's findings.[127] While not partaking in the killings themselves, some Indian troops were accused of encouraging the looting of Muslim shops and houses, and the rape of Muslim girls.

The twenty-four-page report documented incidents of forced conversions, abductions, rapes, desecration of mosques, beatings, and forced imprisonment. Panel members would conclude "at a very conservative estimate that in the whole state at least 27,000 to 40,000 people lost their lives during and after" the invasion. "When we talk of killed we do not include those who died fighting, but only those murdered in cold blood," the authors added.[128] The Indian government would suppress the report for more than half a century.

In the last week of December, Nehru asked General Bucher to cable his counterpart General Gracey and say that the Indian government "was of the opinion that senseless moves and counter-moves with loss of life and everything else were achieving nothing in Kashmir."[129] To the eternal outrage of Indian and Pakistani commanders on the ground — all of whom believed they could have won the war given a few more weeks and a few more men — the two British generals agreed to stop the shooting one minute before midnight on 1 January 1949. Nehru's long battle with Jinnah had ended. The rivalry they had bequeathed their nations, and the world, had barely begun.

Deadly Legacy

B Y NOVEMBER 1949, UN mapmakers had drawn a formal ceasefire line in Kashmir. Over the years, with some adjustments, this would settle into the Line of Control that now serves as the de facto border between India and Pakistan. The frontier mirrors the conflict between the two countries — it is confused, contested, and indefinite. It wends its way north from the Punjab, leaving Poonch town in Indian hands and the rest of the district in Pakistan's, skirts the Indian-occupied Vale of Kashmir, and eventually trails off and disappears in the far north and east, swallowed up by the Himalayan vastness of ice, rock, and snow. On maps the border begins — but it does not end.

The American journalist Phillips Talbot visited both India and Pakistan exactly one year after the cease-fire was signed. In contrast to the chaos and confusion of the early Partition months, he found the government in Karachi functioning reasonably well. Pakistanis had enjoyed a good harvest. They appeared cautiously optimistic about their nation's prospects.

The notion that had seized Jinnah and his citizens within weeks of independence, however — the sense that India hoped to "strangle" its sister dominion — had congealed into an idée fixe. Talbot heard it not only from Pakistan's top leaders but from "petty officials, university instructors, business men, and — in simple form — even taxi drivers, cycle-rickshaw peddlers, and refugee hawkers." Whereas many Indians, particularly those in the south and east of the country who had escaped

Partition's worst horrors, seemed ready to strike a deal over Kashmir, the idea of compromise appeared to most Pakistanis as ignoble surrender. If Jinnah's death had left them with any sort of national mission, it was to defy their bigger neighbor and survive. "Hatred of India," wrote Talbot, voicing a common sentiment, "is the cement that holds Pakistan together."[1]

Unfortunately, subsequent developments would not erode this animosity—quite the opposite. Throughout his tenure as prime minister over the next decade and a half until his death in 1964, Nehru offered few concessions on Kashmir. He refused to contemplate holding a plebiscite in the state unless all of Pakistan's troops had withdrawn and its proxy forces had been disbanded. Even former compatriots suffered his wrath: in 1953, he approved the detention of his old ally Sheikh Abdullah, who was accused of promoting Kashmiri independence. "The most difficult thing in life is what to do with one's friends," Nehru wrote sadly to his sister Nan.[2]

India could afford stalemate. The country had started out more fortunate than Pakistan. Its economy was bigger and more diversified. Its political and judicial institutions were stronger. Whatever one thinks of his economic stewardship, with its heavy emphasis on centralized planning, Nehru's long stint in office blessed India with the kind of continuity and stability that Pakistan would never enjoy.

At the same time, Pakistan's unsettled internal politics made rapprochement no easier. After Jinnah, a succession of weak and uninspiring politicians took turns trying to lead the country. Many had spent all their lives in what was now India and had little connection to their adopted homeland. All the perplexing questions and inconsistencies about Pakistan that Jinnah had so cavalierly brushed aside since 1940 could no longer be ignored. Regional resentments flared, especially between Bengali eastern Pakistan and the Punjabi-dominated western half of the country. Class divides split farmers and landlords on the question of land reform, while pressure for greater autonomy bred tensions between provincial leaders and Karachi.

Conflict and political drift left the door open for the army, which was easily the most powerful and capable institution in Pakistan. The military swallowed up the bulk of the national budget. Its top officers,

now Pakistani rather than British, considered themselves to be the true guardians of the nation's sovereignty and territorial integrity. Many remained bitter about the way Liaquat and civilian leaders had halted the fighting in Kashmir before India had been ousted from the Vale. In 1951, Akbar Khan — the former "General Tariq" and now a major-general — tried to overthrow Liaquat's government, in part because of resentment over Kashmir. A successful putsch in 1958 — led by Gen. Ayub Khan, Pakistan's first non-British commander in chief — would usher in the first of several long stretches of military rule. Pakistani generals would helm the country for thirty-two of the next fifty years.

The soldiers gave many justifications for their dominance, from the incompetence and corruption of civilian leaders to the need to combat regional separatism and ethnic strife. Above all, though, they elevated the "threat" from India. Ironically, the army's own misadventures would inflate this sense of menace. In 1965, less than a year after Nehru's death, Ayub would try to retake Kashmir by using Pakistani troops to stage a covert rebellion within the state. The Indian response included a successful thrust across the Punjab border to the gates of Lahore, which brought a humiliating end to the hostilities and redoubled Pakistanis' fears for their security. Six years later, when another military dictator, Gen. Yahya Khan, sent troops to suppress an uprising in East Pakistan, the Indian intervention didn't just injure Pakistan's psyche but redrew the map. After an ugly conflict in which as many as 300,000 Bengali civilians were slaughtered by West Pakistan troops, Bangladesh emerged as an independent nation, shrinking Jinnah's "moth-eaten" Pakistan by more than half.

Embarrassed on the battlefield, Ayub and subsequent dictators needed some other appeal with which to unite their populace behind junta rule. They settled on Islam, striking an implicit bargain with Pakistan's mullahs to promote religious fervor and, as a result, antipathy toward India. "Pakistan's secular elite used Islam as a national rallying cry," writes Pakistani historian and diplomat Hussain Haqqani in his incisive book *Pakistan: Between Mosque and Military*:

Unsure of their fledgling nation's future, the politicians, civil servants, and military officers who led Pakistan in its formative years decided to

exacerbate the antagonism between Hindus and Muslims that had led to partition as a means of defining a distinctive identity for Pakistan, with "Islamic Pakistan" resisting "Hindu India." . . . Ironically, religious fervor did not motivate all Pakistani leaders who supported this strategy; in most cases, they simply embraced Islam as a politico-military strategic doctrine that would enhance Pakistan's prestige and position in the world.[3]

From its defeats, the military also learned the necessity of having powerful allies. Ayub thrust Pakistan firmly into the West's camp in the Cold War, joining as many anti-USSR alliances as possible and convincing American officials like Secretary of State John Foster Dulles that Pakistanis were ready to battle Communists with their "bare hands" if necessary.[4] The tens of millions of dollars in U.S. aid and equipment this attracted did more to feed Pakistan's delusions about confronting India than to challenge the Soviets. (Unfortunately, Washington quickly realized as much and temporarily suspended military aid to Pakistan as well as India during the 1965 and 1971 wars.)

Any chance Pakistan might break free of this self-destructive dynamic dissolved in the 1980s. Dictator Zia ul-Haq accelerated the Islamization of the army and society, funding madrassas and promoting especially devout officers. The Soviet invasion of Afghanistan presented an opportunity to further all of his goals. In exchange for hundreds of millions of dollars in U.S. aid annually — which he could use to build up Pakistan's arsenal against India, including a covert nuclear weapons program — General Zia armed, trained, and provided logistical support for a jihad against the Soviets. Nearly 100,000 mujahedin passed through Pakistani training camps on their way to the front.[5] A "Kalashnikov culture" came to dominate the Northwest Frontier.

From its inception, Pakistan had looked upon Muslim proxy warriors as legitimate tools of state, given India's overwhelming advantage in conventional forces. "Lack of military formalities in the eyes of military experts seems to detract from the respectability of irregular warfare. But actually, it is this lack of formal logic and system which is making it increasingly important in this age of missiles and nuclear weapons,"

reads an intelligence report produced during Ayub Khan's dictatorship.[6] The Afghan jihad not only attracted extremists from around the Muslim world, including a twentysomething Osama bin Laden, but gave a renewed boost to militants seeking to liberate Kashmir from Indian rule. Thousands of them trained in the same camps as the Afghan mujahedin, sponsored by Pakistan's fearsome Inter-Services Intelligence spy agency.

For Pakistan, unlike the United States, the jihad thus did not end with the Soviet withdrawal in 1989. In the 1990s, the ISI would throw its support behind the budding Taliban movement in Afghanistan, hoping to thrust into power an ally that would ensure the country fell within Pakistan's sphere of influence and not India's. At the same time, the agency fueled a vicious cross-border insurgency in Kashmir using militants like Lashkar-e-Taiba. In 1999, a year after tit-for-tat nuclear tests had made clear to the world that both India and Pakistan were nuclear powers, then–Army Chief Gen. Pervez Musharraf nearly provoked another war by sending regular Pakistani troops disguised as homegrown rebels to retake the high ground in Kashmir's snowy Kargil district.

Musharraf, who seized power himself after having been forced by civilian leaders to withdraw from Kargil, promised the United States after 9/11 that he would cut off any Pakistani support for the Taliban and other militant groups. What Washington failed to appreciate at the time was how little Pakistan's strategic calculus had changed. The enemy remained India, not the Taliban or Osama bin Laden or some vaguely defined threat like "Islamo-fascism." Kashmiri militant groups changed their names but continued to raise funds and recruit openly in Pakistan. The ISI gave safe haven to fleeing Taliban leaders and helped to rebuild their movement. While happily accepting billions of dollars in aid from the United States, Pakistan for years refused to divert troops from the border with India in order to confront these extremists. Indeed, American officials have described the Pakistan-based Haqqani network of jihadists, which has been responsible for some of the deadliest attacks on U.S. and Indian targets in Afghanistan, as a "veritable arm" of the ISI.[7]

A decade of war and insurgency in the region has vastly complicated the task of improving relations between India and Pakistan. Fitful at-

tempts have been made to resolve their differences over the years, even under Musharraf, who reportedly reached a rough agreement with Indian negotiators over Kashmir in 2008.[8] By now, though, the nexus of jihadist groups has grown dramatically and extended its tentacles throughout the country. The militants share recruits, equipment, intelligence, and training. Groups like Lashkar, previously focused on the fight in Kashmir, are feared to have developed global ambitions. India accuses the ISI of sponsoring the Lashkar attack on Mumbai in 2008 and is loathe to negotiate on other issues until such covert support is definitely ended.

The emergence of the so-called Pakistani Taliban — militants dedicated to the overthrow of the Pakistani government and imposition of sharia law throughout the country — has begun to change Islamabad's calculus somewhat. By 2014 these Waziristan-based terrorists had launched direct attacks on army bases, ISI headquarters, and even the country's largest airport. Army commanders now acknowledge that the jihadists pose a greater threat to Pakistan's stability than India does. Yet the Pakistani state continues to distinguish between extremists like Lashkar — who are still seen as potential proxies in any war with India — and the Pakistani Taliban. Islamabad's support for the Afghan Taliban is complex but enduring, and won't change until Pakistan is convinced that whatever government holds sway in Kabul after U.S. forces finally leave will be friendly.

Now no less than in 1947, India does not gain from Pakistan's internal difficulties. Having a weak, unstable state on its border distracts strategic attention in Delhi and drains resources that could be better invested elsewhere. The conflict prevents India from playing the leadership role in Asia that Nehru and others hoped for after independence, and weakens its global clout. Kashmir remains a cauldron of discontent — and not just because of Pakistani meddling.

A deal there is hardly inconceivable. The arrangement discussed in 2008 would reportedly have made the Line of Control a "soft" border, open to the free flow of Kashmiri goods and people. Both halves of the former kingdom would be gradually demilitarized and granted a loose autonomy. John Kenneth Galbraith, then U.S. ambassador to India, proposed something similar as far back as 1962, suggesting that Kashmir

be made a zone of peace and prosperity between the two nations, much like the Saar region between France and Germany.

What's needed is a dose of realism and political courage — both of which have been sorely lacking, in both capitals, since 1947. Indeed, today, the border that divides India and Pakistan should be what brings them together. Trade between them stood at a paltry $3 billion in 2011 — less than a tenth of its potential. Lowering tariffs and other licensing barriers, and improving transport links, would open up vast new possibilities for cross-border commerce. Just as important, closer economic ties would create constituencies on both sides of the border that have more invested in peace than in conflict. Until that happens, continued tensions are inevitable.

The world can afford that no more than India or Pakistan can. By this point, the cold war between them may seem like a natural and immutable feature of the landscape in South Asia. But the rivalry is getting more, rather than less, dangerous: the two countries' nuclear arsenals are growing, militant groups are becoming more capable, and rabid media outlets on both sides are shrinking the scope for moderate voices. It is well past time that the heirs to Nehru and Jinnah put 1947's furies to rest.

SINGAPORE

OCTOBER 2014

ACKNOWLEDGMENTS

I T WOULD NOT have been possible to tell the stories in this book without the notes, letters, diplomatic cables, and diaries of participants in the tragic events of 1947. For access to them, I would like to thank the following archives and their exceptionally helpful staffs: the Broadlands Archive at Hartley Library, University of Southampton; the Trustees of the Liddell Hart Centre for Military Archives at King's College London; the Council of the National Army Museum of the United Kingdom; the Centre of South Asian Studies at Cambridge University; the Master and Fellows of University College and Balliol College at Oxford University, as well as the Modern Papers Department at the Bodleian Library; the department of Asian and African Studies at the British Library, home to the India Office Records; the British National Archives at Kew; the National Archives of India and the Nehru Memorial Library, both in New Delhi; and the U.S. National Archives and Records Administration in College Park, Maryland.

It would have been equally impossible to write this book without the unstinting support, advice, and patience of two people in particular: my agent, Howard Yoon, at the Ross Yoon Literary Agency, and my editor, Bruce Nichols, at Houghton Mifflin Harcourt. Their faith in me and in this project was strong and sustaining, and I will be forever grateful for it.

Gail Ross provided encouragement at key moments, while Miranda Kennedy's eyes and edits helped to carve a story line out of a sprawling first draft. I would also like to thank Ben Hyman, Lisa Glover, Martha

Kennedy, and Laura Gianino at Houghton Mifflin Harcourt, as well as copyeditor Margaret Hogan for shepherding the manuscript into being with such grace and care.

Fareed Zakaria has been my most unfailing champion and greatest professional inspiration; this project would never have come to fruition were it not for his backing and years of friendship. Daniel Klaidman helped me to fulfill a lifelong ambition with his generous counsel and example. Scott Malcomson, Jeffrey Bartholet, and Joel Simon read early chapters and, most importantly, kept me going past early stumbles.

In the three years it took to research and write this volume, many people in many parts of the world extended bountiful assistance, guidance, meals, and hospitality. In India, Parrita Engineer and Viral Mehta provided not just wonderful companionship but a home, while the rest of the Engineer clan offered irrepressible cheer and motivation. I am indebted to Nandan Nilekani and Ramachandra Guha for their thoughts on Partition and on writing, and to Sudip Mazumdar for helping me to navigate the Delhi bureaucracy.

In London, Alison Green, Robert Maxwell, Alex von Tunzelmann, Patrick French, and Meru Gokhale shared friendship, research tips, and welcome, always penetrating insights. In the middle of a Maine winter, Sis Hoy-Tuholski conjured up a miraculous writing retreat washed by Atlantic waves. My talented former *Newsweek* colleagues Leah Purcell, Jamie Wellford, and Amy Pereira-Frears helped immensely in putting together artwork for the book. I am grateful to David Shipley for his understanding and moral support through the last months of this project, and to William Schwalbe and William Dobson for their early encouragement.

I have been fortunate in many things, not least in having bighearted families on both coasts of the United States. The Pages — Lee, Paula, and Jennifer — gave up their homes and their time to make this project logistically possible, and did so with great cheer. Lopa, Arun, Kiran, and Leela Jacob buoyed me with transcontinental video chats and words of encouragement. My parents, Jagdish and Sarla Hajari, have supported my desire to write since childhood, and their pride, boundless affection, and brave example have both humbled and inspired me for a lifetime. I

wrote this book for them most of all, though it can hardly compare to the gifts they have always been to me.

When I embarked on this project, I had no idea the journey would transplant my wife, Melinda, and me from Brooklyn to the Seychelles, New Delhi, London, York Harbor, Maine, and eventually, Singapore. Neither did she, of course. Yet with her endless adaptability and resourcefulness, her perceptive comments on equally endless drafts, her unfathomably deep reservoir of love and faith, she more than anyone in the world willed this volume into being. I am unaccountably blessed and inexpressibly grateful to have her by my side.

NOTES

✕ ✕ ✕ ✕

PROLOGUE: A TRAIN TO PAKISTAN

1. Details of this scene were pieced together from various after-action reports, including "Report of D. W. McDonald, Additional Deputy Commissioner, Ferozepore, on the Derailment of Pakistan Special near Giddarbaha on the Night of 9th August 1947," Sir Francis Mudie Papers, India Office Records and Private Papers, British Library (hereafter IOR): MSS Eur F164/47; George Abell to Saiyid Hashim Raza, 10 August 1947, *Quaid-i-Azam Mohammad Ali Jinnah Papers,* 18 vols. to date, ed. Z. H. Zaidi et al. (Islamabad: Quaid-i-Azam Papers Project, 1993–), 4:426 (hereafter *QMJP*); and Swarna Aiyar, "'August Anarchy': The Partition Massacres in Punjab, 1947," in *Freedom, Trauma, Continuities: Northern India and Independence,* ed. D. A. Low and Howard Brasted (New Delhi: Sage, 1998), 18–19.

2. Phillips Talbot, *An American Witness to India's Partition* (New Delhi: Sage, 2007), 330.

3. Lionel Carter, ed., *Partition Observed: British Official Reports from South Asia,* 2 vols. (New Delhi: Manohar, 2011), 1:102.

4. Speech in New Delhi, 9 August 1947, *Selected Works of Jawaharlal Nehru,* 2nd ser., 55 vols. to date, ed. Sarvepalli Gopal et al. (New Delhi: Jawaharlal Nehru Memorial Fund, 1985–), 3:134 (hereafter *SWJN,* 2nd ser.).

5. Penderel Moon, *Divide and Quit* (Berkeley: University of California Press, 1962), 293.

6. 3 June Broadcast, *SWJN,* 2nd ser., 3:98–99.

1. FURY

1. Archibald Wavell to Frederick Pethick-Lawrence, 6 August 1946, *Transfer of Power 1942–47,* 12 vols., ed. Nicholas Mansergh et al. (London: Her Majesty's Stationery Office, 1970–1983), 8:194.

2. Pamela Mountbatten, *India Remembered* (London: Pavilion, 2008), 54.

3. Jawaharlal Nehru, *Toward Freedom: The Autobiography of Jawaharlal Nehru* (New York: John Day, 1941), 26.

4. Durga Das, *From Curzon to Nehru and After* (London: Collins, 1969), 202.

5. Edgar Snow, *People on Our Side* (New York: Random House, 1944), 45, 48.

6. Nehru to Padmaja Naidu, 8 August 1946, *Selected Works of Jawaharlal Nehru,* 1st ser., 15 vols., ed. Sarvepalli Gopal et al. (New Delhi: Orient Longman, 1972–1982), 15:602 (hereafter *SWJN,* 1st ser.).

7. Ibid.

8. "Mr. Gandhi in Touch with Viceroy," *Times of India,* 9 August 1946, 1.

9. Nicklaus Thomas-Symonds, *Attlee: A Life in Politics* (London: I. B. Tauris, 2010), 270.

10. Jawaharlal Nehru, *Before Freedom: Nehru's Letters to His Sister, 1909–1947,* ed. Nayantara Sahgal (New York: HarperCollins, 2000), 395.

11. Bernard Fergusson, *Wavell: Portrait of a Soldier* (London: Collins, 1961), 47.

12. *A British Tale of Indian and Foreign Service: The Memoirs of Sir Ian Scott,* ed. Denis Judd (London: Radcliffe Press, 1999), 143.

13. Lawrence James, *The Rise and Fall of the British Empire* (New York: St. Martin's Griffin, 1994), 549.

14. Peter Clarke, *The Last Thousand Days of the British Empire: Churchill, Roosevelt, and the Birth of the Pax Americana* (New York: Bloomsbury Press, 2008), 313, 399.

15. *Wavell: The Viceroy's Journal,* ed. Penderel Moon (London: Oxford University Press, 1973), 330–332.

16. L. C. Hollis to Sir David Taylor Monteath, 13 March 1946, *Transfer of Power,* 6:1166.

17. Memo by Ernest Bevin, 14 June 1946, ibid., 7:930.

18. *Wavell,* 98.

19. *Sarojini Naidu: Selected Letters, 1890s to 1940s,* ed. Makarand Paranjape (New Delhi: Kali for Women, 1996), 194–195.

20. Beverley Nichols to Jinnah, 11 January 1944, *QMJP,* 10:119–124.

21. Statement to Press, 19 January 1937, *SWJN,* 1st ser., 8:119–122.

22. Prison Diary 1943, 28 December 1943, ibid., 13:323–324.

23. *Some Recent Speeches and Writings of Mr. Jinnah,* vol. 2, ed. Jamil-ud-din Ahmad (Lahore: Muhammad Ashraf, 1947), 364.

24. Press Release by India Office, n.d., *Transfer of Power,* 8:238–239.

25. Ibid.

26. Ibid.

27. *Wavell,* 334.

28. *SWJN,* 1st ser., 15:298n2.

29. Interview to Press in Bombay, 16 August 1946, ibid., 15:289.

30. *Wavell,* 334.

31. *Some Recent Speeches,* 419.

32. Talbot, *An American Witness,* 188–189.

33. Ibid., 189.

34. Pyarelal, *Mahatma Gandhi: The Last Phase,* 2 vols. (Ahmedabad: Navajivan, 1956), 1:241.

35. Christopher Bayly and Tim Harper, *Forgotten Wars: The End of Britain's Asian Empire* (London: Penguin, 2008), 245.

36. Leonard Mosley, *The Last Days of the British Raj* (London: Weidenfeld and Nicolson, 1961), 32, 31.

37. Bayly and Harper, *Forgotten Wars,* 244.

38. Margaret Bourke-White, *Halfway to Freedom* (New York: Simon and Schuster, 1949), 16–17.

39. Richard D. Lambert, *Hindu-Muslim Riots* (Oxford: Oxford University Press, 2013), 180.

40. Anthony Read and David Fisher, *The Proudest Day: India's Long Road to Independence* (London: Pimlico, 1998), 394.

41. Bayly and Harper, *Forgotten Wars,* 246.

42. See especially "Report on the Disturbances in Calcutta Commencing on August 16th, 1946," Roy Bucher Papers, National Army Museum (hereafter NAM): 7901–87/2.

43. "Report of the Muslim-Hindu Conflict in Calcutta Following 'Direct Action Day' 16th August 1946," Bucher Papers, 7901–87/2. Bucher quotes Suhrawardy as saying, "I have made the necessary arrangements with the police and the military not to interfere."

44. "Report on the Disturbances in Calcutta," Bucher Papers, 7901–87/2.

45. Frederick Burrows to Wavell, 22 August 1946, enclosure, *Transfer of Power,* 8:293–303.

46. Mosley, *The Last Days of the British Raj,* 35.

47. Arthur Dash Diary, vol. 6, 1942–1947, IOR: MSS Eur C188/6.

48. Taya Zinkin, *Reporting India* (London: Chatto and Windus, 1962), 17.

49. "Report on the Disturbances in Calcutta," Bucher Papers, 7901–87/2.

50. Ibid. See also Lambert, *Hindu-Muslim Riots,* 189.

51. "Report of the Muslim-Hindu Conflict," Bucher Papers, 7901–87.

52. Ibid.

53. M. A. H. Ispahani, *Qaid-e-Azam as I Knew Him* (Karachi: Forward Publications Trust, 1967), 234.

54. "Mr. Nehru on Riots," *Times of India,* 19 August 1946, 7.

55. Bayly and Harper, *Forgotten Wars,* 248. Gurkhas were Nepalese soldiers employed by the British, renowned for their fighting abilities.

56. Talbot, *An American Witness,* 190–191.

57. Ian Stephens, *Pakistan* (London: Ernest Benn, 1963), 105.

58. Talbot, *An American Witness,* 192. Richard Lambert estimates the number of injured at more than 25,000. Lambert, *Hindu-Muslim Riots,* 183.

59. Lambert, who conducted interviews shortly after the riots with local Leaguers, concludes that Suhrawardy had planned for small outbreaks of violence to be controlled quickly by the police, but that a radical wing of the League spurred more widespread attacks. Ibid., 181.

60. Bourke-White, *Halfway to Freedom,* 19.

61. Mosley, *The Last Days of the British Raj,* 38.

62. Talbot, *An American Witness,* 185.

63. Bourke-White, *Halfway to Freedom,* 20.

64. *Wavell,* 341n1.

2. JINNAH AND JAWAHARLAL

1. *Sarojini Naidu: Selected Letters,* 305.

2. Saadat Hasan Manto, *Fifty Sketches and Stories of Partition,* trans. Khalid Hasan (New Delhi: Penguin, 1997), 119.

3. *Wavell,* 349.

4. Fatima Jinnah, *My Brother,* ed. Sharif al Mujahid (Karachi: Quaid-e-Azam Academy, 1987), 80; Sarvepalli Gopal, *Jawaharlal Nehru: A Biography,* 2 vols. (London: Jonathan Cape, 1975–1979), 1:27.

5. *In Quest of Jinnah: Diary, Notes and Correspondence of Hector Bolitho,* ed. Sharif al Mujahid (Oxford: Oxford University Press, 2007), 27.

6. Stanley Wolpert, *Jinnah of Pakistan* (New York: Oxford University Press, 1984), 25.

7. *The Collected Works of Quaid-e-Azam Mohammad Ali Jinnah,* 3 vols., comp. Syed Sharifuddin Pirzada (Karachi: East and West Publishing, 1984–1986), 1:252.

8. Iris Butler, *The Viceroy's Wife: Letters of Alice, Countess of Reading, from India, 1921–1925* (London: Hodder and Stoughton, 1969), 133.

9. K. H. Khurshid, *Memories of Jinnah,* ed. Khalid Hasan (Karachi: Oxford University Press, 1990), 68.

10. Ruttie Jinnah to Padmaja Naidu, 4 July 1916, Naidu Papers, Nehru Memorial Museum and Library (hereafter NMML).

11. M. C. Chagla, "Politics," in *Islam in South Asia,* vol. 6, *Soundings on Partition and Its Aftermath,* ed. Mushirul Hasan (New Delhi: Manohar, 2010), 84.

12. Kanji Dwarkadas, *Ruttie Jinnah: The Story of a Great Friendship* (Bombay: Kanji Dwarkadas, n.d.), 11.

13. Jaswant Singh, *Jinnah: India-Partition-Independence* (New Delhi: Rupa, 2009), 103.

14. Some of the key negotiating sessions took place at Anand Bhavan, Nehru's home, although young Jawaharlal does not seem to have attended them.

15. Wolpert, *Jinnah of Pakistan,* 51.

16. Louis Fischer, *The Life of Mahatma Gandhi* (New York: Harper and Row, 1950), 117.

17. *Collected Works of Quaid-e-Azam Mohammad Ali Jinnah,* 1:396.

18. M. R. A. Baig, "Jinnah and Pakistan," in Hasan, ed., *Islam in South Asia,* 6:92–93.

19. Patrick French, *Liberty or Death* (London: Flamingo, 1998), 39.

20. Nirad C. Chaudhuri, *Thy Hand, Great Anarch! India 1921–1952* (Reading, Mass.: Addison-Wesley, 1987), 19.

21. Joseph Lelyveld, *Mahatma Gandhi and His Struggle with India* (New York: Knopf, 2011), 157.

22. Singh, *Jinnah,* 125.

23. *Collected Works of Quaid-e-Azam Mohammad Ali Jinnah,* 1:404.

24. Interview with James Cameron, Oral History Archive, NMML.

25. *Plain Mr. Jinnah: Selections from Shamsul Hasan Collection, Volume 1,* ed. Syed Shamsul Hasan (Karachi: Royal Book Company, 1976), 49.

26. Interview with Durga Das, Oral History Archive, NMML.

27. See Wolpert, *Jinnah of Pakistan.*

28. *In Quest of Jinnah,* 213.

29. Dwarkadas, *Ruttie Jinnah,* 54.

30. *In Quest of Jinnah,* 89.

31. Krishna Nehru Hutheesing, with Alden Hatch, *We Nehrus* (New York: Holt, Rinehart and Winston, 1967), 175.

32. Dwarkadas, *Ruttie Jinnah,* 58, 59–60.
33. *Foundations of Pakistan: All-India Muslim League Documents, 1906–1947,* 2 vols., ed. Syed Sharifuddin Pirzada (Karachi: National Publishing House, 1969–1970), 1:xxi; Khalid bin Sayeed, *Pakistan: The Formative Phase, 1857–1948* (Karachi: Oxford University Press, 1968), 176.
34. Das, *From Curzon to Nehru,* 154–155.
35. Jawaharlal Nehru, *Eighteen Months in India: 1936–1937: Being Further Essays and Writings* (Allahabad: Kitabistan, 1938), 97–98.
36. Nehru to Naidu, 5 June 1936, *SWJN,* 1st ser., 13:645.
37. Nehru to Naidu, 9 October 1936, ibid., 13:652.
38. Nehru, *Toward Freedom,* 39.
39. B. R. Nanda, *The Nehrus: Motilal and Jawaharlal* (London: Allen and Unwin, 1962), 90.
40. Nehru, *Toward Freedom,* 44, 30.
41. Gopal, *Jawaharlal Nehru,* 1:66.
42. Hutheesing, *We Nehrus,* 57.
43. Nehru, *Toward Freedom,* 69.
44. Hutheesing, *We Nehrus,* 83.
45. Jawaharlal Nehru, *The Discovery of India* (Delhi: Oxford University Press, 1985), 44.
46. Nehru to Naidu, 10 November 1936, *SWJN,* 1st ser., 13:655.
47. Nehru to Naidu, 12 February 1937, ibid., 13:669.
48. Nehru to Naidu, 22 January 1937, ibid., 13:666.
49. Nehru to Naidu, 1 April 1937, ibid., 13:678.
50. Speech at Public Meeting, 5 November 1936, ibid., 7:538.
51. Speech on Palestine Day at Allahabad, 27 September 1936, ibid., 7:586.
52. Choudhry Khaliquzzaman, *Pathway to Pakistan* (Lahore: Longman, Green, 1961), 157.
53. Read and Fisher, *The Proudest Day,* 273.
54. Akbar S. Ahmed, *Jinnah, Pakistan and Islamic Identity: The Search for Saladin* (London: Routledge, 1997), 16.
55. Das, *From Curzon to Nehru,* 180–181.
56. Read and Fisher, *The Proudest Day,* 275.
57. Sayeed, *Pakistan,* 201.
58. Pirzada, ed., *Foundations of Pakistan,* 2:265–273.
59. Nehru to Naidu, 8 November 1937, *SWJN,* 1st ser., 13:692.
60. Nehru to Choudhry Khaliquzzaman, 1 July 1937, ibid., 8:143.
61. Singh, *Jinnah,* 249.
62. Walter Henry John Christie Diary, 3 September 1939, Christie Papers, IOR: MSS Eur D718/2.
63. Frank Moraes, *Jawaharlal Nehru: A Biography* (New York: Macmillan, 1956), 293.
64. Gopal, *Jawaharlal Nehru,* 1:252.
65. Rajmohan Gandhi, *Gandhi: The Man, His People and the Empire* (London: Haus, 2007), 255.
66. War Cabinet Paper: India and the War, 31 January 1940, IOR: L/PO/6/101.
67. K. K. Aziz, *Rahmat Ali: A Biography* (Lahore: Vanguard, 1987), 380.

68. V. P. Menon, *The Transfer of Power in India* (Princeton, N.J.: Princeton University Press, 1957), 82.

69. Read and Fisher, *The Proudest Day*, 295.

70. Moon, *Divide and Quit*, 21

71. "Congress and the Muslim League: A Study in Conflict," IOR: L/PJ/12/644.

72. Hutheesing, *We Nehrus*, 159.

73. William Roger Louis, *Imperialism at Bay: The United States and the Decolonization of the British Empire, 1941–1945* (New York: Oxford University Press, 1978), 130.

74. Menon, *Transfer of Power*, 93.

75. Snow, *People on Our Side*, 47.

76. Edgar Snow, *Journey to the Beginning* (London: Victor Gollancz, 1959), 257.

77. Fischer, *Life of Mahatma Gandhi*, 375.

78. Weekly Report of the Director, Intelligence Bureau (hereafter DIB), 13 June 1942, IOR: L/PJ/12/484.

79. Victor Hope, 2nd Marquess of Linlithgow, to Leopold Amery, 15 June 1942, *Transfer of Power*, 2:204–205.

80. Weekly Report of the DIB, 1 August 1942, IOR: L/PJ/12/484.

81. Auriol Weigold, *Churchill, Roosevelt and India: Propaganda During World War II* (New York: Routledge, 2008), 134.

82. William Phillips, *Ventures in Diplomacy* (Portland, Maine: Anthoensen Press, 1952), 390.

83. Robert E. Sherwood, *Roosevelt and Hopkins: An Intimate History* (New York: Enigma, 2008), 420.

84. Francis Wylie to Wavell, 19 February 1946, *Transfer of Power*, 6:1019.

85. R. W. Sorensen, *My Impression of India* (London: Meridian, 1946), 96, 93.

86. Snow, *People on Our Side*, 261–262.

87. Linlithgow to Amery, 10 June 1943, *Transfer of Power*, 3:1052.

88. Ayesha Jalal, *The Sole Spokesman: Jinnah, The Muslim League and the Demand for Pakistan* (Cambridge: Cambridge University Press, 1985), 118.

89. Pirzada, ed., *Foundations of Pakistan*, 2:428.

90. Shaista Suhrawardy Ikramullah, *From Purdah to Parliament* (Karachi: Oxford University Press, 1998), 104–105.

91. Aziz Beg, *Jinnah and His Times* (Islamabad: Babur and Amer, 1986), 628–629.

92. Office of Strategic Services, Research and Analysis Branch, Report No. 112, "Pakistan: A Muslim Project for a Separate State in India, 5 February 1943," IOR: L/PJ/12/652.

93. Speech at Muslim University Union, Aligarh, 2 November 1941, Speeches and Statements by Jinnah 1941–1942, https://sites.google.com/site/cabinetmission plan/speeches-and-statements-by-jinnah-1941---1942.

94. "Pakistan: A Muslim Project for a Separate State in India, 5 February 1943," IOR: L/PJ/12/652.

95. Phillips, *Ventures in Diplomacy*, 230.

96. *Collected Works of Quaid-e-Azam Mohammad Ali Jinnah*, 1:xxi; Sayeed, *Pakistan*, 178.

97. Prison Diary 1942, *SWJN*, 1st ser., 13:7.

98. Gopal, *Jawaharlal Nehru*, 1:297.

99. Prison Diary 1943, *SWJN*, 1st ser., 13:244, 122, 154.

100. Ibid., 13:244, 323–324.

101. Moon, *Divide and Quit*, 21.

102. "Punjab Premier Refuses to Accept Mr. Jinnah's Demand for League Coalition," *Times of India*, 29 April 1944, 9.

103. Sardar Shaukat Hyat Khan, *The Nation That Lost Its Soul* (Lahore: Jang, 1995), 126.

104. I. A. Talbot, "The 1946 Punjab Elections," *Modern Asian Studies* 14, no. 1 (1980): 75.

105. Aiyar, "'August Anarchy,'" 25.

106. Census of India, 1941, http://www.censusindia.gov.in/Census_And_You/old_report/TABLE_1941_1.HTM.

107. E. W. R. Lumby, *The Transfer of Power in India, 1945–7* (London: Allen and Unwin, 1954), 62.

108. H. V. Hodson, *The Great Divide: Britain-India-Pakistan* (Karachi: Oxford University Press, 1997), 113.

109. Reply to Debate on All-India Congress Committee Resolution (hereafter AICC) in Bombay, 23 September 1945, *SWJN*, 1st ser., 14:90–91.

110. Bertrand Glancy to Wavell, 16 August 1945, *Transfer of Power*, 6:71.

111. David Gilmartin, *Empire and Islam: Punjab and the Making of Pakistan* (London: I. B. Tauris, 1988), 219.

112. Talbot, "The 1946 Punjab Elections," 75.

113. Gilmartin, *Empire and Islam*, 218.

114. Habib to K. H. Khurshid, 3 February 1946, *QMJP*, 12:545.

115. Glancy to Wavell, 27 October 1945, *Transfer of Power*, 6:413–414.

116. "Defence Implications of a Partition of India into Hindustan and Pakistan," 1 April 1946, IOR: MSS Eur D714/72.

117. Record of Interview between Jinnah and Arthur Smith, 28 March 1946, IOR: MSS Eur D714/72.

118. Woodrow Wyatt, *Confessions of an Optimist* (London: Collins, 1985), 155–156.

119. Hatim A. Alavi to Jinnah, 10 June 1946, *QMJP*, 13:235–236.

120. Concluding Remarks at AICC Meeting, 7 July 1946, *SWJN*, 1st ser., 15:237, emphasis added.

121. Vallabhbhai Patel to D. P. Mishra, 29 July 1946, *Sardar Patel and the Partition of India*, ed. Prabha Chopra (Delhi: Konark, 2010), 147.

122. Bourke-White, *Halfway to Freedom*, 14.

123. Ibid., 15.

124. Ispahani, *Qaid-e-Azam as I Knew Him*, 228.

3. MADHOUSE

1. "League Hostility to Mr. Nehru," *Times of India*, 17 October 1946, 1.

2. Address to *Jirga* of Tribal Leaders at Razmak, 17 October 1946, *SWJN*, 2nd ser., 1:308.

3. *Wavell*, 353.

4. Jinnah to Wavell, 15 October 1946, *Jinnah-Wavell Correspondence: 1943–1947*, ed. Sher Muhammad Garewal (Lahore: Research Society of Pakistan, 1986), 110.

5. Olaf Caroe to Wavell, 23 October 1946, *Transfer of Power*, 8:786.
6. Note on Tribal Visit, 24 October 1946, *SWJN*, 2nd ser., 1:324.
7. Caroe to Wavell, 23 October 1946, *Transfer of Power*, 8:786.
8. Fortnightly Summaries and Weekly Reports, DIB, India, National Archives, Kew, London (hereafter TNA): WO 208/5007.
9. "Tribesmen Acclaim Pakistan," *Times of India*, 19 October 1946, 1.
10. Nehru to Wavell, 23 October 1946, *SWJN*, 2nd ser., 1:194.
11. Gandhi, *Gandhi*, 535.
12. Roy Bucher to Chief of the General Staff, 26 October 1946, Bucher Papers, 7901–87.
13. Tour Diary by Bucher's Assistant, Bucher Papers, 7901–87.
14. Pyarelal, *Mahatma Gandhi*, 1:277.
15. "Strong Steps to Restore Order in Noakhali," *Times of India*, 16 October 1946, 1.
16. "Mob Marching on Chandpur Town," *Times of India*, 18 October 1946, 1.
17. Nehru to Wavell, 15 October 1946, *SWJN*, 2nd ser., 1:51.
18. Nehru to Wavell, 8 September 1946, ibid., 1:156.
19. Abell to Wavell, 18 November 1946, *Transfer of Power*, 9:96.
20. "Mob Marching on Chandpur Town."
21. Talbot, *An American Witness*, 203.
22. Ibid.
23. Tour Diary by Bucher's Assistant, Bucher Papers, 7901–87.
24. "Mob Marching on Chandpur Town."
25. Talbot, *An American Witness*, 204.
26. *A British Tale of Indian and Foreign Service*, 154.
27. Pyarelal, *Mahatma Gandhi*, 1:303.
28. Jad Adams, *Gandhi: Naked Ambition* (London: Quercus, 2010), 223.
29. Speech at Prayer Meeting, 17 October 1946, *Collected Works of Mahatma Gandhi*, 97 vols. to date (New Delhi: Publications Department of the Government of India, 1958–), 92:344 (hereafter *CWMG*).
30. Speech at Prayer Meeting, 18 October 1946, ibid., 92:355.
31. Interview with Jinnah, 22 October 1946, Wavell Papers, IOR: MSS Eur D977/17.
32. "Mr. Jinnah Condemns Disturbances," *Times of India*, 25 October 1946, 1.
33. Fortnightly Summaries and Weekly Reports, DIB, India, TNA: WO 208/5007.
34. Interview to Press at Dum Dum Airport, 2 November 1946, *SWJN*, 2nd ser., 1:53.
35. "Steps to Prevent the Growth of Private Armies," 14 November 1946, IOR: L/PJ/8/679.
36. "Volunteer Organisations in India," Intelligence Bureau, 28 March 1947, TNA: DO 133/58.
37. "Steps to Prevent the Growth of Private Armies," 14 November 1946, IOR: L/PJ/8/679.
38. George E. Jones, *Tumult in India* (New York: Dodd, Mead, 1948), 211.
39. "Indian Communal Strife — The Autumn Massacres in Bihar," *Times*, 11 February 1947.
40. "Viceroy's Talks on Bihar Riots," *Times of India*, 4 November 1946, 1.
41. Report on Bihar Riots by Niranjan Singh Gill, 20 February 1947, *QMJP*, 1, part 2:53.

42. Speech at Taregna, 5 November 1946, *SWJN,* 2nd ser., 1:60.

43. Nehru to Naidu, 5 November 1946, ibid., 1:65.

44. Interview with Roy Bucher, Oral History Archive, NMML.

45. Jones, *Tumult in India,* 212.

46. Confidential Note, 8 November 1946, *SWJN,* 2nd ser., 1:83.

47. Nehru to Sardar Patel, 5 November 1946, ibid., 1:63.

48. Nehru to Naidu, 5 November 1946, ibid., 1:65.

49. Extract from a Secret Letter from Wavell to Pethick-Lawrence, 22 November 1946, IOR: L/PJ/8/679.

50. Nehru to Patel, 5 November 1946, *SWJN,* 2nd ser., 1:63.

51. Report on the Recent Events and Disturbances in Bihar, 6 November 1946, ibid., 1:71.

52. Nehru to V. K. Krishna Menon, 11 November 1946, ibid., 1:207.

53. Gandhi to H. S. Suhrawardy, 5 December 1946, *CWMG,* 93:108.

54. Gyanendra Pandey, *Remembering Partition: Violence, Nationalism and History in India* (New Delhi: Cambridge University Press India, 2003), 99.

55. Notes by Woodrow Wyatt, n.d., *Transfer of Power,* 9:247.

56. Interview with Jinnah, 19 November 1946, Wavell Papers, IOR: MSS Eur D977/17.

57. Fortnightly Summaries and Weekly Reports, DIB, India, TNA: WO 208/5007; "Volunteer Organisations in India," Intelligence Bureau, 28 March 1947, TNA: DO 133/58.

58. Carter, ed., *Partition Observed,* 2:802.

59. Frank Messervy to Bucher, 1 March 1969, Bucher Papers, 7901–87(2).

60. "Volunteer Organisations in India," Intelligence Bureau, 28 March 1947, TNA: DO 133/58, from which information for the rest of this paragraph was also drawn.

61. Hugh Dow to John Colville, 10–11 December 1946, *Transfer of Power,* 9:328.

62. Fortnightly Summaries and Weekly Reports, DIB, India, TNA: WO 208/5007.

63. "Volunteer Organisations in India," Intelligence Bureau, 28 March 1947, TNA: DO 133/58.

64. Mosley, *The Last Days of the British Raj,* 50.

65. This idea, promoted by Wavell's successor, Lord Louis Mountbatten, has been called into question. But the truth may never be known. A document from General Headquarters India dated 29 July 1947, in IOR: L/WS/1/1057, orders that "All papers in connection with INDIA COMMAND JOINT OPERATION INSTRUCTION NO. 2 (FIRST REVISION)—'MADHOUSE'—WILL BE DE-STROYED."

66. "Flight to Nowhere?," *Time,* 16 December 1946, http://content.time.com/time/subscriber/article/0,33009,934710-1,00.html.

67. Madhav Godbole, *The Holocaust of Indian Partition: An Inquest* (New Delhi: Rupa, 2011), 57.

68. See Bevin to Clement Attlee, 1 January 1947, TNA: PREM 8/564.

69. Abell to Wavell, 18 November 1946, *Transfer of Power,* 9:96.

70. Patel to Stafford Cripps, 15 December 1946, Chopra, ed., *Sardar Patel and the Partition of India,* 170.

71. George Merrell to State Department, 11 December 1946, U.S. Department of State

Records, Central Files 1910–January 1963, Record Group 59, National Archives, College Park, Md. (hereafter US): 845.00/12–1146.

72. Alex von Tunzelmann, *Indian Summer: The Secret History of the End of an Empire* (New York: Picador, 2007), 151.

73. *Wavell,* 390.

74. Notes by Woodrow Wyatt, n.d., *Transfer of Power,* 9:247.

75. John McLaughlin Short to Louis Mountbatten, 18 March 1947, Mountbatten Papers, Hartley Library, University of Southampton: MB1/E159.

76. Minutes of Conference on 6 December, *SWJN,* 2nd ser., 1:139.

77. *Wavell,* 391.

78. R. J. Moore, *Escape from Empire: The Attlee Government and the Indian Problem* (Oxford: Clarendon Press, 1983), 205.

79. Winston Churchill to Jinnah, 11 December 1946, Jinnah Papers, IOR: MSS Eur IOR Neg 10762/8.

80. Mosley, *The Last Days of the British Raj,* 53.

81. Dean Acheson to Waldemar Gallman, 30 November 1946, *Foreign Relations of the United States, 1946: The British Commonwealth, Western and Central Europe* (Washington, D.C.: U.S. Government Printing Office, 1946), 97.

82. Talbot, *An American Witness,* 201.

83. Lelyveld, *Mahatma Gandhi,* 301.

84. Adams, *Gandhi,* 255.

85. Nehru to Gandhi, 28 February 1947, *SWJN,* 2nd ser., 2:621.

86. See appendices VI and VII, *CWMG,* 93:417–422.

87. "Extract from Secret Information," 9 January 1947, enclosure, *Transfer of Power,* 9:508–509.

88. Moore, *Escape from Empire,* 305–306.

89. Discussion between Sir Frederick Burrows and Khawaja Nazimuddin, 8 January 1947, enclosure, *Transfer of Power,* 9:535.

90. Merrell to George Marshall, 22 April 1947, US: 845.00/4–2247.

91. Mountbatten's Aides-Memoire, Part 3, Situation in the Provinces, TNA: PREM 8/1450.

92. Merrell to Marshall, 27 January 1947, US: 845.00/1–2747.

93. Jack Morton, "Indian Episode: A Personal Memoir," unpublished, IOR: MSS Eur D1003/1.

94. Khan, *The Nation That Lost Its Soul,* 153.

95. Ibid., 152.

96. Lionel Carter, ed., *Punjab Politics: Governors' Fortnightly Reports and Other Key Documents,* 2 vols. (New Delhi: Manohar, 2007), 1:233.

97. Evan Jenkins to Wavell, 15 February 1947, IOR: R/3/1/178.

98. Glancy to Wavell, 16 August 1945, *Transfer of Power,* 6:71.

99. Jenkins to Wavell, 29 February 1947, IOR: R/3/1/178.

100. Rajmohan Gandhi, *Punjab: A History from Aurangzeb to Mountbatten* (New Delhi: Aleph Book Company, 2013), 57.

101. Stephens, *Pakistan,* 133.

102. Weekly Reports of DIB, India, 21 January 1939, IOR: L/PJ/12/481.

4. "PAKISTAN MURDABAD!"

1. Ian Talbot, *Khizr Tiwana: The Punjab Unionist Party and the Partition of India* (Oxford: Oxford University Press, 2002), 211.
2. Final Draft Statement of Britain's India Policy, 20 February 1947, TNA: FO 371/63529.
3. *The Political Diary of Hugh Dalton: 1918–40, 1945–60,* ed. Ben Pimlott (London: Jonathan Cape, 1986), 389.
4. *Wavell,* 423.
5. Jenkins to Wavell, 29 February 1947, IOR: R/3/1/178.
6. Carter, ed., *Punjab Politics,* 1:49–50.
7. Viceroy's Personal Report No. 11, 4 July 1947, IOR: MSS Eur IOR Neg 15563/6.
8. Gopal Singh, *A History of the Sikh People* (New Delhi: Allied, 1979), 699. Many reports emphasize Singh's drawing his sword, although he himself always denied having done so.
9. Lambert, *Hindu-Muslim Riots,* 211.
10. Memoir of A. J. V. Arthur, Deputy Commissioner of Multan, IOR: MSS Eur F180/63.
11. Carter, ed., *Punjab Politics,* 1:62.
12. "Volunteer Organisations in India," Intelligence Bureau, 28 March 1947, TNA: DO 133/58.
13. John J. Macdonald, U.S. Consul General in Bombay, to Marshall, 8 March 1947, US: 845.00/3–847(b).
14. Merrell to Marshall, 8 March 1947, US: 845.00/3–847(a).
15. Minutes of Viceroy's Thirteenth Miscellaneous Meeting, 11 May 1947, *Transfer of Power,* 10:759.
16. Lord Wavell's map even shows the Punjab district of Gurdaspur — a bone of contention at independence — where it would eventually end up, in India. See Wavell to Pethick-Lawrence, 7 February 1946, ibid., 6:912–913.
17. Nehru to Menon, 23 February 1947, *SWJN,* 2nd ser., 2:45.
18. Nehru to Gandhi, 24 February 1947, ibid., 2:53.
19. Carter, ed., *Punjab Politics,* 1:71, 73.
20. Stephens, *Pakistan,* 145.
21. Richard Mead, *Churchill's Lions: A Biographical Guide to the Key British Generals of World War II* (Stroud: Spellmont, 2007), 298.
22. Stephens, *Pakistan,* 145.
23. Ibid., 145–146.
24. Carter, ed., *Punjab Politics,* 1:87.
25. G. D. Khosla, *Stern Reckoning: A Survey of the Events Leading Up To and Following the Partition of India,* reprinted in *The Partition Omnibus* (New Delhi: Oxford University Press, 2002), 110–111.
26. Carter, ed., *Punjab Politics,* 1:72.
27. Ibid., 1:137.
28. Short to Mountbatten, 3 November 1947, Mountbatten Papers, MB1/E159.
29. Gopal, *Jawaharlal Nehru,* 1:338.
30. Maharajah of Patiala to Mountbatten, 18 May 1947, Kirpal Singh, ed., *Select Documents on Partition of the Punjab 1947* (Delhi: National Book Shop, 1991), 86–87.

31. Jones, *Tumult in India,* 225.

32. Reginald Schomberg to Attlee, 11 May 1947, Clement Richard Attlee Papers, Bodleian Library, Oxford University: MS Attlee, Box 53, f. 268.

33. Mountbatten Interview with the Rajah of Faridkot, 17 April 1947, enclosure, IOR: MSS Eur IOR Neg 15554/8.

34. Reginald Savory Diary, 19 April 1947, Savory Papers, NAM: No. 89.

35. Carter, ed., *Punjab Politics,* 1:111, 118.

36. Ibid., 1:120, 122.

37. Ibid., 1:89.

38. Interview with Raja Ghazanfar Ali Khan, 20 March 1947, Jenkins Papers, IOR: R/3/1/176.

39. Ibid.

40. John Terraine, *The Life and Times of Lord Mountbatten* (London: Hutchinson, 1968), 126.

41. Brian Hoey, *Mountbatten: The Private Story* (London: Sidgwick and Jackson, 1994), 189; Tom Driberg, *Ruling Passions* (London: Jonathan Cape, 1977), 214.

42. Christopher Thorne, *Allies of a Kind: The United States, Britain and the War against Japan, 1941–1945* (London: Hamish Hamilton, 1978), 336–337.

43. *Wavell,* 419.

44. Mountbatten to Attlee, 17 February 1947, TNA: PREM 8/563.

45. Moore, *Escape from Empire,* 225.

46. Comments by Reginald Brockman on Draft of November 1968 Nehru Memorial Lecture, "Reflections on the Transfer of Power and Jawaharlal Nehru," Mountbatten Papers, MB1/K202(1).

47. Alan Campbell-Johnson, *Mission with Mountbatten* (London: Hamish Hamilton, 1951), 45–46.

48. Jack Bazalgette, *The Captains and the Kings Depart: Life in India 1928–46* (Oxford: Arnate Press, 1984), 131.

49. Savory Diary, 17 April 1947, Savory Papers, No. 89.

50. Abell to Jenkins, 31 March 1947, IOR: MSS Eur IOR Neg 15551/3.

51. Donald Foster, "The Sunlit Silences: An Experience of India," unpublished, IOR: MSS Eur C380/1.

52. Bayly and Harper, *Forgotten Wars,* 180.

53. Viceroy's Personal Report No. 1, 2 April 1947, IOR: MSS Eur IOR Neg 15562/9.

54. Hastings Ismay to Laura Ismay, 28 March 1947, Ismay Papers, Liddell Hart Centre for Military Archives, King's College London: 3/8/3.

55. Speech at Opening Plenary of Asian Relations Conference, 23 March 1947, *SWJN,* 2nd ser., 2:506.

56. Nehru to Asaf Ali, 7 April 1947, ibid., 2:517.

57. Campbell-Johnson, *Mission with Mountbatten,* 49.

58. Note by F. V. Duckworth, Commissioner of Labour, Malaya, 4 April 1946, IOR: L/PJ/8/636.

59. Mountbatten Interview with Nehru, 24 March 1947, IOR: MSS Eur IOR Neg 15560/4.

60. Tunzelmann, *Indian Summer,* 177.

61. *QMJP,* 1, part 1:286n.

62. Viceroy's Fourth Staff Meeting, 28 March 1947, IOR: MSS Eur IOR Neg 15562/2.
63. Mountbatten Interview with Jinnah, 6 April 1947, IOR: MSS Eur IOR Neg 15560/4.
64. Lord Mountbatten's Reflections on Mr. Jinnah 29 Years Later, Mountbatten Papers, MB1/K137A.
65. Viceroy's Seventh Staff Meeting, 3 April 1947, IOR: MSS Eur IOR Neg 15562/2.
66. Mountbatten Interview with Jinnah, 8 April 1947, IOR: MSS Eur IOR Neg 15560/4.
67. Mountbatten Interview with Jinnah, 10 April 1947, IOR: MSS Eur IOR Neg 15560/4.
68. Viceroy's Thirteenth Staff Meeting, 11 April 1947, IOR: MSS Eur IOR Neg 15562/3.
69. Mountbatten Interview with Jinnah, 10 April 1947, IOR: MSS Eur IOR Neg 15560/4.
70. Governors' Conference, 1st Day, 15 April 1947, IOR: L/PO/6/123.
71. Mountbatten Interview with Nehru, 24 March 1947, IOR: MSS Eur IOR Neg 15560/4.
72. Viceroy's Thirteenth Staff Meeting, 11 April 1947, IOR: MSS Eur IOR Neg 15562/3.
73. Viceroy's Eighteenth Staff Meeting, 21 April 1947, IOR: MSS Eur IOR Neg 15562/3.
74. Merrell to Marshall, 21 April 1947, US: 845.00/4-2147.
75. Ibid.
76. Viceroy's Staff Meeting, 19 April 1947, IOR: MSS Eur IOR Neg 15562/3.
77. Viceroy's Eighteenth Staff Meeting, 21 April 1947, IOR: MSS Eur IOR Neg 15562/3.
78. *Plain Mr. Jinnah*, 288.
79. Mountbatten Interview with Liaquat, 19 April 1947, IOR: MSS Eur IOR Neg 15560/6.
80. Minutes of the Viceroy's Seventh Miscellaneous Meeting, 23 April 1947, *Transfer of Power*, 10:380.
81. Ibid.
82. Hastings Ismay to Mountbatten, 10 May 1947, ibid., 10:755.
83. Mountbatten Interview with Jinnah, 26 April 1947, IOR: MSS Eur IOR Neg 15560/6.
84. Merrell to Marshall, 2 May 1947, US: 845.00/5-247.
85. Herbert Lawrence Hill, "Life in Bombay," unpublished, Hill Papers, NAM: 2004-11-112.
86. Mosley, *The Last Days of the British Raj*, 86-87.
87. Moore, *Escape from Empire*, 250.
88. Hastings Ismay to Laura Ismay, 6 April 1947, Ismay Papers, 3/8/5a.
89. Speech in New Delhi, 13 April 1947, *SWJN*, 2nd ser., 2:89.
90. Minutes of the Viceroy's Ninth Miscellaneous Meeting, 1 May 1947, *Transfer of Power*, 10:508.
91. Campbell-Johnson, *Mission with Mountbatten*, 87-88.
92. Mosley, *The Last Days of the British Raj*, 123-124.
93. Extract from Punjab Fortnightly Report for the Second Half of April 1947, 8 May 1947, IOR: R/3/1/90.
94. Tara Singh to S. E. Abbott, 13 May 1947, *Transfer of Power*, 10:803.
95. Note by Jenkins, 23 April 1947, IOR: R/3/1/176.
96. Jenkins to Mountbatten, 18 May 1947, IOR: R/3/1/90.

97. Maharajah of Patiala to Mountbatten, 18 May 1947, Singh, ed., *Select Documents on Partition of the Punjab,* 86–87, 85.
98. Note by Jinnah on Revised Draft Proposals, 17 May 1947, *QMJP,* 1:776.
99. Campbell-Johnson, *Mission with Mountbatten,* 94.
100. Interview with Norman Cliff, 25 May 1947, *SWJN,* 2nd ser., 2:179–180.
101. Jenkins to Mountbatten, 18 May 1947, IOR: R/3/1/90.
102. Carter, ed., *Punjab Politics,* 1:206.
103. Mountbatten Interview with Lt.-Gen. Sir Arthur Smith, 15 May 1947, IOR: MSS Eur IOR Neg 15560/6.
104. Carter, ed., *Punjab Politics,* 1:208.
105. Extract from Letter Sent to U.S. Ambassador in London, 3 June 1947, Ismay Papers, 3/7/60/2.

5. INDIAN SUMMER

1. Patrick Brendon, "Disaster in Gurgaon," unpublished, Brendon Papers, Centre of South Asian Studies, Cambridge University, 41.
2. Viceroy's Personal Report No. 8, 5 June 1947, IOR: MSS Eur IOR Neg 15563/2.
3. Brendon, "Disaster in Gurgaon," Brendon Papers, 18, 12.
4. Nehru to Agatha Harrison, 22 May 1947, *SWJN,* 2nd ser., 2:337.
5. Hastings Ismay to Laura Ismay, 19 June 1947, Ismay Papers, 3/8/10b.
6. Mountbatten to Provincial Governors, 31 May 1947, *Transfer of Power,* 11:30.
7. Lewis Douglas to Marshall, 2 June 1947, US: 845.00/6–247.
8. Douglas to Marshall, 29 May 1947, US: 845.00/5–2947.
9. Record of 2 June Meeting, 2 June 1947, IOR: MSS Eur IOR Neg 15562/4.
10. Ibid.
11. Eric Mieville to Mountbatten, 26 May 1947, *Transfer of Power,* 10:991.
12. Merrell to Marshall, 29 May 1947, US: 845.00/5–2947.
13. Jinnah to Yahya M. Merchant, 15 May 1947, and Brenda Blencowe to Jinnah, 31 May 1947, *QMJP,* 2:790, 798.
14. Mountbatten Interview with Churchill, 22 May 1947, IOR: MSS Eur IOR Neg 15560/6.
15. Samuel H. Day to Marshall, 3 June 1947, US: 845.00/6–347.
16. Christie Diary, 2 June 1947, Christie Papers, IOR: MSS Eur D718/3.
17. Howard Donovan to Marshall, 13 June 1947, US: 845.00/6–1347.
18. Christie Diary, 4 June 1947, Christie Papers, IOR: MSS Eur D718/3.
19. Campbell-Johnson, *Mission with Mountbatten,* 114.
20. Ibid., 106.
21. Note by Hastings Ismay, "India: 18 March 1947–18 July 1947," Christie Papers, IOR: MSS Eur D718/3.
22. Jinnah's Broadcast on the Partition of India, 3 June 1947, IOR: L/PJ/10/81.
23. Nehru's Broadcast on the Partition of India, 3 June 1947, IOR: L/PJ/10/81.
24. Viceroy's Personal Report No. 8, 5 June 1947, IOR: MSS Eur IOR Neg 15563/2.
25. Ismay to Mountbatten, 23 May 1947, Mountbatten Papers, MB1/E83.
26. Press Conference, 4 June 1947, Singh, ed., *Select Documents on Partition of the Punjab,* 101.
27. Note to Scott about Sketch Map, 1967, Jenkins Papers, IOR: MSS Eur D807.

28. Report on the Situation in the Punjab for the First Half of June 1947, National Archives of India (hereafter NAI): F. No. 18/6/1947 Home Pol (I).
29. Carter, ed., *Punjab Politics,* 2:99.
30. Ibid., 2:100.
31. Ishtiaq Ahmed, *The Punjab Bloodied, Partitioned and Cleansed: Unravelling the 1947 Tragedy Through Secret British Reports and First Person Accounts* (New Delhi: Rupa, 2011), 303–306.
32. "Lahore Civic Life Paralysed," *Times of India,* 23 June 1947, 1.
33. Ahmed, *The Punjab Bloodied,* 305.
34. Pyarelal, *Mahatma Gandhi,* 2:296–297.
35. Nehru to Mountbatten, 22 June 1947, *SWJN,* 2nd ser., 3:180.
36. Ian Talbot, *Divided Cities: Partition and Its Aftermath in Lahore and Amritsar, 1947–1957* (Oxford: Oxford University Press, 2006), 44.
37. Note by H. Gordon Minnigerode, U.S. Consul in Karachi, 8 July 1947, US: 845.00/7–847.
38. Anonymous to Liddell, 8 July 1947, *QMJP,* 3:157.
39. Carter, ed., *Punjab Politics,* 2:101.
40. Mountbatten Interview with V. K. Krishna Menon, 22 April 1947, IOR: MSS Eur IOR Neg 15560/7.
41. Mountbatten to Wilfred Francis Webb, 28 June 1947, *Transfer of Power,* 11:720.
42. Christie Diary, 25 June 1947, Christie Papers, IOR: MSS Eur D718/3.
43. George Frederick Heaney, "The Winding Trail," unpublished, Heaney Papers, Centre of South Asian Studies, Cambridge University, 291.
44. Mountbatten to William Hare, 5th Earl of Listowel, 2 July 1947, *Transfer of Power,* 11:826.
45. Meeting of the Partition Council, 27 June 1947, ibid., 11:676.
46. Viceroy's Personal Report No. 10, 27 June 1946, IOR: MSS Eur IOR Neg 15563/4.
47. Ibid.
48. Mountbatten to Jinnah, 2 July 1947, *QMJP,* 3:75.
49. Viceroy's Personal Report No. 11, 4 July 1947, Mountbatten Papers, MB1/D28/4.
50. Ibid.
51. V. Shankar, *My Reminiscences of Sardar Patel,* vol. 1 (Delhi: Macmillan India, 1974), 27.
52. Viceroy's Personal Report No. 14, 25 July 1947, IOR: MSS Eur IOR Neg 15563/7.
53. Mountbatten Interview with Jinnah, 12 July 1947, IOR: MSS Eur IOR Neg 15560/7.
54. Meeting between Jinnah and Ismay, 24 July 1947, IOR: MSS Eur IOR Neg 15560/7.
55. Note of Mountbatten Interview with Jinnah, 4 July 1947, Walter Turner Monckton Papers, Bodleian Library, Oxford University: Dep. Monckton Trustees 29, No. 60.
56. Donovan to Marshall, 22 July 1947, US: 845.00/7–2247.
57. A. G. Noorani, *The Destruction of Hyderabad* (New Delhi: Tulika, 2013), 146.
58. Campbell-Johnson, *Mission with Mountbatten,* 142, 140.
59. Christie Diary, 25 July 1947, Christie Papers, IOR: MSS Eur D718/3; Henry Grady to Marshall, 28 July 1947, US: 845.00/7–2847.
60. Lawrence James, *Raj: The Making and Unmaking of British India* (New York: St. Martin's Griffin, 1997), 628.
61. Campbell-Johnson, *Mission with Mountbatten,* 143.

62. Record of Interview with Mr. Jinnah on 26 July 1947 (by Ali Yavar Jung), Monck-ton Papers, Dep. Monckton Trustees 29, No. 114.

63. Ibid.; Mountbatten to Ismay, 8 July 1947, *Transfer of Power,* 12:22.

64. Mosley, *The Last Days of the British Raj,* 60.

65. Bourke-White, *Halfway to Freedom,* 196–197.

66. Nehru to Menon, 31 July 1945, *SWJN,* 1st ser., 14:385.

67. Nehru to Naidu, 20 June 1946, ibid., 15:385.

68. Mountbatten Interview with Gandhi, Nehru, and Patel, 29 July 1947, IOR: MSS Eur IOR Neg 15560/7.

69. Nehru to Gandhi, 28 July 1947, *SWJN,* 2nd ser., 3:265.

70. Ibid.

71. Grady to Marshall, 5 August 1947, US: 845.00/8–547.

72. Carter, ed., *Punjab Politics,* 2:190.

73. Fortnightly Report for the Punjab, Second Half of July 1947, NAI: F. No. 18/7/47 Poll (I).

74. Lambert, *Hindu-Muslim Riots,* 214.

75. Michael Edwardes, *The Last Years of British India* (London: New English Library, 1963), 227.

76. Carter, ed., *Punjab Politics,* 2:178.

77. Tara Singh to Ian Stephens, 21 January 1948, Stephens Papers, Centre of South Asian Studies, Cambridge University: Box 32.

78. Mountbatten Interview with Giani Kartar Singh and Baldev Singh, 30 June 1947, enclosure, IOR: MSS Eur IOR Neg 15554/8.

79. Carter, ed., *Punjab Politics,* 2:146.

80. Ibid., 2:249, emphasis added.

81. Penderel Moon to Short, 11 July 1947, John McLaughlin Short Papers, IOR: MSS Eur F189/18; Moon to his father, 12 July 1947, Moon Papers, IOR: MSS Eur F230/20.

82. Interview with Ismay, 17 August 1964, Singh, ed., *Select Documents on Partition of the Punjab,* 740.

83. Moon, *Divide and Quit,* 87.

84. French, *Liberty or Death,* 333.

85. Nehru to Mountbatten, 21 July 1947, *Transfer of Power,* 12:285–286.

86. O. H. K. Spate Diary, 7 August 1947, Spate Papers, Centre of South Asian Studies, Cambridge University.

87. French, *Liberty or Death,* 321.

88. Mosley, *The Last Days of the British Raj,* 200.

89. Ibid., 197.

90. Listowel to Mountbatten, 9 May 1947, *Transfer of Power,* 10:712.

91. Interview with Cyril Radcliffe, 23 July 1964, Singh, ed., *Select Documents on Parti-tion of the Punjab,* 744.

92. Mountbatten Interview with Patel, Jinnah, Liaquat, and Capt. Gerald Savage, 5 August 1947, IOR: MSS Eur IOR Neg 15560/7.

93. Donovan to Marshall, 29 December 1947, US: 845.00/12–2947.

94. *In Quest of Jinnah,* 41.

95. Carter, ed., *Punjab Politics,* 2:223.

96. Ibid., 2:221–222.
97. Jenkins to Aloys Michel, 27 November 1967, enclosure, Mountbatten Papers, MB1/K34.
98. Carter, ed., *Punjab Politics*, 2:219.
99. Campbell-Johnson, *Mission with Mountbatten*, 139.
100. Note by Ismay, "India: 18 March 1947–18 July 1947," Christie Papers, IOR: MSS Eur D718/3.
101. Claude Auchinleck to Ismay, 20 June 1947, IOR: MSS Eur IOR Neg 15563/3.
102. Carter, ed., *Punjab Politics*, 2:219, 230.
103. Grady to Loy W. Henderson, 9 August 1947, US: 845.00/8–947.

6. OFF THE RAILS

1. Moon, *Divide and Quit*, 110–111.
2. Carter, ed., *Partition Observed*, 1:133.
3. Hector Bolitho, *Jinnah: Creator of Pakistan* (London: Oxford University Press, 2006), 174.
4. Allan Perry-Keene, "Reflected Glory," unpublished, Perry-Keene Papers, Centre of South Asian Studies, Cambridge University.
5. Talbot, *An American Witness*, 357.
6. Ikramullah, *From Purdah to Parliament*, 157.
7. Singh, *Jinnah*, 572.
8. Jinnah Press Conference, 13 July 1947, *QMJP*, 3:1004.
9. Interview in *Bombay Chronicle*, 12 August 1947. Chopra, ed., *Sardar Patel and the Partition of India*, 179.
10. Spate Diary, 15 August 1947, Spate Papers.
11. Viceroy's Personal Report No. 17, 16 August 1947, Mountbatten Papers, MB1/D32/1.
12. Ibid.
13. Nehru to Mountbatten, 9 August 1947, *Transfer of Power*, 12:618.
14. Maharajah of Bikaner to Mountbatten, 10 August 1947, ibid., 12:662.
15. Note about Sketch Map, Jenkins Papers, IOR: MSS Eur D807.
16. Christie Diary, 12 August 1947, Christie Papers, IOR: MSS Eur D718/3.
17. Remarks on boundary award from *Pakistan Times*, 21 August 1947, *QMJP*, 5:404–405.
18. Viceroy's Personal Report No. 17, 16 August 1947, Mountbatten Papers, MB1/D32/1.
19. Talbot, *An American Witness*, 331.
20. Shahid Amin, *Disastrous Twilight: A Personal Record of the Partition of India* (London: Leo Cooper, 1986), 229.
21. Carter, ed., *Punjab Politics*, 2:233.
22. Ibid., 2:229.
23. Typescript of Draft for a Talk by George Maconachie Brander, IOR: MSS Eur F409.
24. Fikr Taunsvi, "The Sixth River — A Diary of 1947," in *Lahore 1947*, ed. Ahmad Salim (Lahore: Sang-e-Meel, 2003), 27, 28.
25. Carter, ed., *Punjab Politics*, 2:228, 230, 227, 226.

26. Ibid., 2:231, 233.
27. Grady to Marshall, 14 August 1947, US: 845.00/8–1447.
28. Grady to Henderson, 9 August 1947, US: 845.00/8–947.
29. Larry Collins and Dominique Lapierre, *Freedom at Midnight* (New York: Avon, 1975), 284–285.
30. Gopal, *Jawaharlal Nehru*, 1:362.
31. "Mr. Nehru's Message," *The Hindu*, 15 August 2010, 1.
32. Charles Thompson to Marshall, 27 August 1947, US: 845.00/8–2747.
33. Das, *From Curzon to Nehru*, 262.
34. Talbot, *An American Witness*, 337.
35. Report of the Punjab Boundary Force, IOR: L/MIL/17/5/4319, p. 24.
36. Informal Minutes of Joint Defence Council Meeting, 16 August 1945, Singh, ed., *Select Documents on Partition of the Punjab*, 490.
37. Speech at Red Fort, 16 August 1947, *SWJN*, 2nd ser., 4:2.
38. Note by Conference Secretary on Meeting at Ambala, 17 August 1947, IOR: MSS Eur IOR Neg 15549/2.
39. Lord Mountbatten's Note on Discussion with Nehru, 19 August 1947, *SWJN*, 2nd ser., 4:11.
40. Nehru to Gandhi, 22 August 1947, ibid., 4:14.
41. The account here and over the next four paragraphs is taken from an untitled article by D. G. Harington-Hawes in *Blackwood's Magazine*, February 1948, 81–91, IOR: D1225/20.
42. R. C. B. Bristow, *Memories of the British Raj: A Soldier in India* (London: Johnson, 1974), 153, 159.
43. Situation in the Punjab Boundary Force Area, 25 August 1947, IOR: MSS Eur IOR Neg 15565.
44. Report of the Punjab Boundary Force, IOR: L/MIL/17/5/4319, p. 34.
45. Ian Morrison, "Moslem Slaughter by Sikhs Reported," *New York Times*, 25 August 1947, 1.
46. Carter, ed., *Partition Observed*, 1:94.
47. Bristow, *Memories of the British Raj*, 153.
48. Jasdev Singh Sandhu, *Giani Kartar Singh: A Commemorative Volume* (Patiala: S. Jasdev Singh Sandhu Foundation, 2001), 82–83.
49. Carter, ed., *Punjab Politics*, 2:147.
50. Note by E. G. Willan of Conversation with BBC's H. R. Stimson, 5 September 1947, TNA: DO 133/59.
51. Nehru to Gandhi, 22 August 1947, *SWJN*, 2nd ser., 4:14; Nehru to Gandhi, 25 August 1947, ibid., 4:23.
52. Ian Copland, "The Master and the Maharajas: The Sikh Princes and the East Punjab Massacres of 1947," *Modern Asian Studies* 36, no. 3 (July 2002): 657–704.
53. Donovan to Marshall, 18 September 1947, US: 845.00/9–1847.
54. Carter, ed., *Partition Observed*, 1:135.
55. Report of the Punjab Boundary Force, IOR: L/MIL/17/5/4319, p. 27.
56. Note by Conference Secretary on Meeting at Ambala, 17 August 1947, IOR: MSS Eur IOR Neg 15549/2.
57. B. S. Grewal to Commissioner, Ambala Division, 20 August 1947, Singh, ed., *Select Documents on Partition of the Punjab*, 499.

58. Moon, *Divide and Quit*, 119.
59. Donovan to Marshall, 29 August 1947, enclosure, US: 845.00/8–2947.
60. Moon, *Divide and Quit*, 121.
61. Carter, ed., *Partition Observed*, 1:143, 90, 226.
62. M. S. M. Sharma, *Peeps into Pakistan* (Patna: Pustak Bhandar, 1954), 146.
63. Statement by Jinnah, 24 August 1947, *QMJP*, 5:530.
64. Carter, ed., *Partition Observed*, 1:81.
65. Statement by Jinnah, 24 August 1947, *QMJP*, 5:530.
66. Ibid.
67. Moon, *Divide and Quit*, 217, 139.
68. Humphrey Evans, *Thimayya of India: A Soldier's Life* (New York: Harcourt, Brace, 1960), 256–257, 259.
69. Jon Stallworthy, *Louis MacNeice* (New York: Norton, 1995), 358.
70. Evans, *Thimayya of India*, 257.
71. Ahmed, *The Punjab Bloodied*, 428.
72. Ibid., 427.
73. Donovan to Marshall, 27 August 1947, US: 845.00/8–2747.
74. Nehru to Mountbatten, 31 August 1947, *SWJN*, 2nd ser., 4:44.
75. Morrison, "Moslem Slaughter by Sikhs Reported."
76. Nehru to Mountbatten, 27 August 1947, *SWJN*, 2nd ser., 4:25–26.
77. Sampuran Singh to Patel, 27 August 1947, *Sardar Patel's Correspondence, 1945–50*, 10 vols., ed. Durga Das and Vallabhbhai Patel (Ahmedabad: Navajivan, 1971–1972), 4:256.
78. Carter, ed., *Partition Observed*, 1:396.
79. Chandulal Trivedi to Mountbatten, 28 August 1947, IOR: MSS Eur IOR Neg 15552/1.
80. Interview to the Press, 28 August 1947, *SWJN*, 2nd ser., 4:33, 37.
81. Cable to Menon, 28 August 1947, ibid., 4:29.
82. Interview to the Press, 28 August 1947, ibid., 4:31.
83. Note for the Joint Defence Council by Auchinleck on the Future of the Punjab Boundary Force, 29 August 1947, IOR: MSS Eur IOR Neg 15552/1.
84. Governor-General's Personal Report No. 1, 2 September 1947, Mountbatten Papers, MB1/D86.
85. Nehru to Mountbatten, 31 August 1947, *SWJN*, 2nd ser., 4:44.
86. "Pandit Nehru's Pledge to Punjab Minorities," *Times of India*, 2 September 1947, 1.
87. Ibid.
88. Thompson to Marshall, 17 September 1947, US: 845.00/9–1747.
89. Gandhi to Patel, 1–2 September 1947, *CWMG*, 96:319.
90. Gandhi to Nehru, 30 August 1947, ibid., 96:305.
91. A. J. Wilson, "Transfer of Power: A Personal Narrative of Events in India from August–October 1947," William Robin Palmer Ridgeway Papers, NAM: 1963–05–49.
92. Patel to Govind Ballabh Pant, 23 October 1947, *Sardar Patel's Correspondence*, 4:430.
93. Heaney, "The Winding Trail," 301.
94. Rajmohan Gandhi, *Patel: A Life* (Ahmedabad: Navajivan, 1990), 427.
95. Pandey, *Remembering Partition*, 122, 124.
96. "The Disturbances in Delhi," 3 October 1947, IOR: L/WS/1/748.

97. H. M. Patel, *Rites of Passage: A Civil Servant Remembers*, ed. Sucheta Mahajan (Delhi: Rupa, 2005), 80.

98. Patel to Rajendra Prasad, 5 September 1947, *Sardar Patel's Correspondence*, 4:338.

99. Zahid Hussain to Mohammed Ikramullah, 2 September 1947, *QMJP*, 5:465.

100. Note by Ismay of His Conversations with Jinnah, 12–14 September 1947, IOR: MSS Eur IOR Neg 15561/2.

101. George Cunningham Diary, 4 September 1947, IOR: MSS Eur D670/6.

102. Savory Diary, 2 September 1947, Savory Papers, No. 89.

103. Christie Diary, 4 September 1947, Christie Papers, IOR: MSS Eur D718/3.

104. Mountbatten Interview with Auchinleck, 15 July 1947, IOR: MSS Eur IOR Neg 15560/7.

105. Savory Diary, 2 September 1947, Savory Papers, No. 89.

106. Ismay to Mountbatten, 2 October 1947, Mountbatten Papers, MB1/E6.

107. Donovan to Marshall, 11 September 1947, US: 845.00/9–1147.

108. Nehru to Patel, 31 August 1947, *SWJN*, 2nd ser., 4:43.

109. Sarah Ismay to Hastings Ismay, n.d., Ismay Papers, 3/8/28b.

110. Statement on Delhi Disturbances Made by a Military Officer on 21 September 1947, Mudie Papers, IOR: MSS Eur F164/47.

111. Remarks at a Cabinet Meeting, 4 September 1947, *SWJN*, 2nd ser., 4:48.

112. Contrary to his later claims that both Nehru and Patel were "almost pathetic in their joy at seeing him," as U.S. ambassador Henry Grady put it, Mountbatten initially described the Sardar as "very gloomy and unforthcoming" when he learned of Mountbatten's return to Delhi. Governor-General's Personal Report No. 2, 11 September 1947, Mountbatten Papers, MB1/D86.

7. "STOP THIS MADNESS"

1. Louis Heren, *Growing Up on the* Times (London: Hamish Hamilton, 1978), 43.

2. Pandey, *Remembering Partition*, 128.

3. Carter, ed., *Partition Observed*, 1:367–368, 173.

4. Savory Diary, 7 September 1947, Savory Papers, No. 89.

5. Minutes of the Fourth Emergency Committee Meeting, Appendix A, 8 September 1947, Mountbatten Papers, MB1/D33/5.

6. Chaudhuri, *Thy Hand, Great Anarch!*, 840.

7. "The Disturbances in Delhi," 3 October 1947, IOR: L/WS/1/748.

8. Patel to Nehru, 12 October 1947, *Sardar Patel's Correspondence*, 4:301.

9. Patel, *Rites of Passage*, 84.

10. Carter, ed., *Partition Observed*, 1:176, 221.

11. Hastings Ismay to Laura Ismay, 8 September 1947, Ismay Papers, 3/8/18.

12. Campbell-Johnson, *Mission with Mountbatten*, 181.

13. Carter, ed., *Partition Observed*, 1:215.

14. Campbell-Johnson, *Mission with Mountbatten*, 183.

15. Governor-General's Personal Report No. 2, 11 September 1947, Mountbatten Papers, MB1/D86.

16. Mountbatten Interview with Auchinleck, 8 September 1947, IOR: MSS Eur IOR Neg 15561/1.

17. Carter, ed., *Partition Observed*, 1:178.

18. Minutes of the Fourth Emergency Committee Meeting, 8 September 1947, Mountbatten Papers, MB1/D33/5.

19. Chaudhuri, *Thy Hand, Great Anarch!*, 845.

20. Maulana Abul Kalam Azad, *India Wins Freedom: An Autobiographical Narrative* (Bombay: Orient Longman, 1959), 233, 232.

21. Ibid., 232.

22. Gopal, *Jawaharlal Nehru*, 2:15–16.

23. Patel, *Rites of Passage*, 93–94.

24. Macdonald to Marshall, 11 September 1947, US: 845.00/9–1147.

25. Campbell-Johnson, *Mission with Mountbatten*, 186.

26. Hastings Lionel Ismay, *The Memoirs of General Lord Ismay* (London: Viking, 1960), 437.

27. Interview with Nayantara Sahgal, Oral History Archive, NMML.

28. Badruddin Tyabji, "Memoirs of an Egoist," in Hasan, ed., *Islam in South Asia*, 6:40.

29. See Tunzelmann's *Indian Summer*, 273–292, for a particularly good account of their budding relationship during this period.

30. Mian Abdul Aziz to Ikramullah, 16 September 1947, *QMJP*, 5:504–508.

31. Pandey, *Remembering Partition*, 140.

32. Carter, ed., *Partition Observed*, 1:216.

33. Ismay to Mountbatten, 23 September 1947, IOR: R/3/1/173.

34. Grady to Marshall, 14 September 1947, US: 845.00/9–1447.

35. Pandey, *Remembering Partition*, 124.

36. Savory Diary, 12 September 1947, Savory Papers, No. 89.

37. Carter, ed., *Partition Observed*, 1:371.

38. Donovan to Marshall, 18 September 1947, US: 845.00/9–1847.

39. Carter, ed., *Partition Observed*, 1:361.

40. See cables from Zahid Hussain, 2–10 September 1947, *QMJP*, 5:465, 479, 484–488, 492.

41. Ibid., 5:492, 479.

42. Carter, ed., *Partition Observed*, 1:182, 177.

43. Charles Lewis to Marshall, 8 September 1947, US: 845f.00/9–847.

44. Carter, ed., *Partition Observed*, 1:157, 168, 177.

45. Ibid., 1:156.

46. Hussain to Ikramullah, 9 September 1947, *QMJP*, 5:492.

47. Carter, ed., *Partition Observed*, 1:169.

48. Ibid., 1:196–197.

49. Dennis Kux, *Disenchanted Allies: The United States and Pakistan, 1947–2000* (Baltimore: Johns Hopkins University Press, 2001), 20.

50. Jinnah to Shah Nawaz Bhutto, 8 September 1947, *QMJP*, 5:584.

51. Campbell-Johnson, *Mission with Mountbatten*, 192.

52. "Passion Royale for Pampering Pets," *The Tribune*, 24 May 2003, www.tribune india.com/2003/20030524/windows/main2.htm.

53. Narendra Singh Sarila, *The Shadow of the Great Game: The Untold Story of India's Partition* (New Delhi: HarperCollins India, 2005), 318–319.

54. Bhutto to Jinnah, 4 September 1947, *QMJP*, 5:579.

55. Nawab of Junagadh to Jinnah, 15 August 1947, ibid., 5:542.

56. Bhutto to I. H. M. Abrahani, 6 September 1947, ibid., 5:584.

57. Report of the First Governor-General of India, Part D: Junagadh, Mountbatten Papers, MB1/D2.
58. Hastings Ismay to Laura Ismay, 16 September 1947, Ismay Papers, 3/8/20a.
59. Carter, ed., *Partition Observed*, 1:192; Mountbatten to Jinnah, 29 September 1947, *QMJP*, 5:618.
60. Note by Hastings Ismay of His Conversations with Jinnah, 12–14 September 1947, IOR: MSS Eur IOR Neg 15561/2.
61. Ismay, *Memoirs*, 440.
62. Note by Ismay of His Conversations with Jinnah, 12–14 September 1947, IOR: MSS Eur IOR Neg 15561/2.
63. Ibid.
64. Carter, ed., *Partition Observed*, 1:360–361.
65. Bourke-White, *Halfway to Freedom*, 3–4.
66. Mudie to Jinnah, 11 September 1947, Mudie Papers, IOR: MSS Eur F164/17.
67. Mudie to Jinnah, 13 September 1947, Mudie Papers, IOR: MSS Eur F164/17.
68. Meeting in Delhi, 25 September 1947, IOR: MSS Eur IOR Neg 15562/1.
69. Minutes of the Eleventh Emergency Committee Meeting, 15 September 1947, Mountbatten Papers, MB1/D34/3.
70. Carter, ed., *Partition Observed*, 1:498.
71. Record of Conversation between Ismay and Nehru, 2 October 1947, TNA: PREM 8/588.
72. Report by E. De V. Moss of Visit to East Punjab, 20 September 1947, Mudie Papers, IOR: MSS Eur F164/17.
73. Swaran Singh to Trivedi, 17 September 1947, IOR: MSS Eur IOR Neg 15554/8.
74. Col. Sher Khan's Report of East Punjab Situation, 24 September 1947, Singh, ed., *Select Documents on Partition of the Punjab*, 536.
75. Ismay to Cunningham, 30 September 1947, Ismay Papers, 3/7/67/40.
76. Carter, ed., *Partition Observed*, 1:210.
77. Ibid., 1:196.
78. Donovan to Marshall, 23 September 1947, US: 845.00/9–2347.
79. Mudie to Jinnah, 23 September 1947, *QMJP*, 5:274–279.
80. Messervy to Cunningham, 18 September 1947, ibid., 5:304.
81. Das, *From Curzon to Nehru*, 268.
82. "Interview with Tara Singh," *The Liberator*, 21 September 1947, 2.
83. Trivedi to Swaran Singh, 26 September 1947, Singh, ed., *Select Documents on Partition of the Punjab*, 538.
84. Daily Security Summary, 23 September 1947, TNA: WO 208/3820; Liaquat to Nehru, 21 September 1947, Mudie Papers, IOR: MSS Eur F164/17.
85. Daily Security Summary, 25 September 1947, TNA: WO 208/3820.
86. Bourke-White, *Halfway to Freedom*, 6.
87. Mudie to Jinnah, 23 September 1947, *QMJP*, 5:274–279.
88. Deputy High Commissioner, Lahore, to Foreign, Delhi, 25 September 1947, IOR: MSS Eur IOR Neg 15552.
89. Carter, ed., *Partition Observed*, 1:320.
90. Grady to Marshall, 5 October 1947, US: 845.00/10–547.
91. Grady to Marshall, 14 September 1947, US: 845.00/9–1447.
92. Nehru to Naidu, 7 April 1938, *SWJN*, 1st ser., 13:698.

93. Notes on Junagadh Crisis, 29 September 1947, IOR: MSS Eur IOR Neg 15561/2.
94. Campbell-Johnson, *Mission with Mountbatten,* 190.
95. Note to Cabinet on Refugee Policy, 12 September 1947, *SWJN,* 2nd ser., 4:64.
96. Nehru to Prasad, 17 September 1947, ibid., 4:83.
97. Speech in Delhi, 29 September 1947, ibid., 4:105.
98. Nehru to Patel, 30 September 1947, *Sardar Patel's Correspondence,* 4:297.
99. Mountbatten to Ismay, 4 October 1947, Mountbatten Papers, MB1/E83A.
100. Grady to Marshall, 5 October 1947, US: 845.00/10–547.
101. Grady to Marshall, 23 September 1947, US: 845.00/9–2347.
102. Notes on Junagadh Crisis, 29 September 1947, IOR: MSS Eur IOR Neg 15561/2.
103. Untitled Note, November 1947, Ismay Papers, 3/7/66/5.
104. Notes on Junagadh Crisis, 29 September 1947, IOR: MSS Eur IOR Neg 15561/2.
105. Report of the First Governor-General of India, Part D: Projected Operations in Kathiawar, Appendix 2, Mountbatten Papers, MB1/D2.
106. Governor-General's Personal Report No. 3, 26 September 1947, Mountbatten Papers, MB1/D86.
107. Das, *From Curzon to Nehru,* 269.
108. Grady to Marshall, 15 October 1947, US: 845.00/10–1547.
109. Thompson to Marshall, 28 November 1947, US: 845.00/11–2847.
110. Untitled Note, 22 September 1947, Monckton Papers, Dep. Monckton Trustees 39, pp. 181–183.
111. Syed Ahmed El-Edroos, *Hyderabad of "The Seven Loaves"* (Hyderabad: Laser Prints, 1994), 126–128.
112. Governor-General's Personal Report No. 1, 2 September 1947, Mountbatten Papers, MB1/D86.
113. Walter Monckton to Mountbatten, 24 September 1947, Monckton Papers, Dep. Monckton Trustees 39, p. 189.
114. Savory Diary, 18 September 1947, Savory Papers, No. 89.
115. Report of the First Governor-General of India, Part D: Projected Operations in Kathiawar, Mountbatten Papers, MB1/D2.
116. Ibid.
117. Notes on Junagadh Crisis, 29 September 1947, IOR: MSS Eur IOR Neg 15561/2.
118. Report of the First Governor-General of India, Part D: Projected Operations in Kathiawar, Mountbatten Papers, MB1/D2.
119. Messervy to Auchinleck, 1 October 1947, Mountbatten Papers, MB1/E106.
120. Laurence Grafftey-Smith to Commonwealth Relations Office, 7 October 1947, IOR: L/PS/13/1845(B).
121. Carter, ed., *Partition Observed,* 1:290–291.
122. Ibid., 1:331, 93.
123. Bourke-White, *Halfway to Freedom,* 11.
124. Jinnah to Attlee, 1 October 1947, TNA: PREM 8/568.
125. Record of Conversation between Ismay and Jinnah at Karachi, 3 October 1947, IOR: MSS Eur IOR Neg 15561/2.
126. Statement by Ismay on the Situation in India and Pakistan, 8 October 1947, IOR: MSS Eur IOR Neg 15549/2.
127. Record of Conversation between Ismay and Jinnah at Karachi, 3 October 1947, IOR: MSS Eur IOR Neg 15561/2.

128. Lieutenant Colonel G. S., MI2, to P. C. Bamford, MI5, 19 September 1947, TNA: WO 208/3820.

129. Secret Note by Sir Archibald Carter of Conversations in Karachi, 1–3 October 1947, IOR: MSS Eur IOR Neg 15549/2.

130. Record of Meeting between Ismay and Jinnah, 3 October 1947, TNA: PREM 8/588.

131. Bristow, *Memories of the British Raj*, 182.

132. Shankar, *My Reminiscences of Sardar Patel*, 112.

133. "Discussions with Nehru and Liaquat Before and After Lunch," 1 October 1947, IOR: MSS Eur IOR Neg 15561.

134. Governor-General's Personal Report No. 4, 10 October 1947, Mountbatten Papers, MB1/D86.

8. AD HOC JIHAD

1. Khurshid, *Memories of Jinnah*, 9.

2. Note by Khurshid, Srinagar, 12 October 1947, *QMJP*, 9:247.

3. Victoria Schofield, *Kashmir in the Crossfire* (London: I. B. Tauris, 1996), 56.

4. Note by Khurshid, Srinagar, 12 October 1947, *QMJP*, 9:247.

5. Ibid.

6. Gandhi, *Patel*, 439.

7. Ibid.

8. Shuja Nawaz, *Crossed Swords: Pakistan, Its Army, and the Wars Within* (Oxford: Oxford University Press, 2008), 49.

9. Nehru to M. C. Mahajan, 21 October 1947, *SWJN*, 2nd ser., 4:273.

10. Richard Symonds, *In the Margins of Independence: A Relief Worker in India and Pakistan* (Oxford: Oxford University Press, 2001), 77.

11. Record of Conversation with General Scott, Chief of Staff, Kashmir State Forces, 8 October 1947, IOR: L/PS/13/1845(B).

12. All Jammu and Kashmir Muslim Conference to Jinnah, 13 September 1947, *QMJP*, 5:594.

13. Akbar Khan, *Raiders in Kashmir* (Karachi: Pak, 1970), 16.

14. Ibid., 20.

15. Ibid., 17.

16. Cunningham Diary, 6 October 1947, IOR: MSS Eur D670/6.

17. Newspaper Clipping, 5 October 1947, IOR: L/PS/13/1845(B).

18. Record of Conversation with General Scott, Kashmir State Forces, 8 October 1947, IOR: L/PS/13/1845(B).

19. Report from M. K. Sinha, 9 October 1947, NAI: F. No. 85(9)–PR/47.

20. Nehru to Patel, 27 September 1947, *SWJN*, 2nd ser., 4:263.

21. Nawaz, *Crossed Swords*, 46–48.

22. Khan, *Raiders in Kashmir*, 23.

23. Cunningham Diary, 25 October 1947, IOR: MSS Eur D670/6.

24. Correspondence with the External Affairs Department regarding Propaganda through Mullahs, etc., Cunningham Papers, IOR: MSS Eur D670/19.

25. Cunningham Diary, 13 October 1947, IOR: MSS Eur D670/6.

26. Cunningham Diary, 15 October 1947, IOR: MSS Eur D670/6.

27. Khan, *The Nation That Lost Its Soul,* 214.
28. Cunningham Diary, 22 September 1947, IOR: MSS Eur D670/6.
29. Carter, ed., *Partition Observed,* 2:542.
30. Cunningham Diary, 15 October 1947, IOR: MSS Eur D670/6.
31. Carter, ed., *Partition Observed,* 2:734.
32. Cunningham Diary, 18 October 1947, IOR: MSS Eur D670/6.
33. Messervy to Mountbatten, 6 October 1965, Mountbatten Papers, MB1/K161.
34. Cunningham Diary, 20 October 1947, IOR: MSS Eur D670/6.
35. Cunningham to Mountbatten, 8 May 1948, Mountbatten Papers, MB1/E199.
36. Schofield, *Kashmir in the Crossfire,* 138.
37. Cunningham Diary, 23 October 1947, IOR: MSS Eur D670/6.
38. Cunningham Diary, 24 October 1947, IOR: MSS Eur D670/6.
39. Wilfrid Russell, *Merchant in a Mirror* (London: Asia Publishing, 1961), 131.
40. Andrew Whitehead, *A Mission in Kashmir* (New Delhi: Viking, 2007), 122, 123.
41. Ibid., 62–63.
42. Carter, ed., *Partition Observed,* 2:564.
43. M. C. Mahajan, *Looking Back: The Autobiography of Mehr Chand Mahajan* (London: Asia Publishing, 1963), 147.
44. Karan Singh, *Heir Apparent: An Autobiography,* vol. 1 (Oxford: Oxford University Press, 1982), 57
45. Nicol Smith, "American Traveler's Observations on Developments in Kashmir and Western Tibet," enclosure in Donovan to Marshall, 27 October 1947, US: 845.00/11–347.
46. Ibid.
47. Minutes of Defence Committee Meeting No. 8, 25 October 1947, Mountbatten Papers, MB1/D42/9.
48. Ibid.
49. Minutes of Defence Committee Meeting No. 9, 26 October 1947, Mountbatten Papers, MB1/D42/10.
50. Prem Shankar Jha, *Kashmir 1947: The Origins of a Dispute* (London: Pluto Press, 2003), 187.
51. French, *Liberty or Death,* 375.
52. Mahajan, *Looking Back,* 151–152.
53. Ibid., 152.
54. Minutes of Defence Committee Meeting No. 9, 26 October 1947, Mountbatten Papers, MB1/D42/10.
55. Notes by A. C. B. Symon, 27 October 1947, *QMJP,* 9:303.
56. William Cranston to Alexander Symon, 27 October 1947, ibid., 9:292.
57. Talbot, *An American Witness,* 352.
58. Meeting between Mountbatten and Jinnah, 1 November 1947, IOR: MSS Eur IOR Neg 15561; Untitled Note, November 1947, Ismay Papers, 3/7/66/5.
59. Carter, ed., *Partition Observed,* 2:560.
60. Ibid., 2:599.
61. Mohammed Hyder, *October Coup: A Memoir of the Struggle for Hyderabad* (New Delhi: Roli, 2012; digital edition), 224.
62. Report of the First Governor-General of India, Part F: Hyderabad, Mountbatten Papers, MB1/D2.

63. Meeting among Mountbatten, Auchinleck, and Ismay, 28 October 1947, IOR: MSS Eur IOR Neg 15561/2.
64. Cunningham Diary, 28 October 1947, IOR: MSS Eur D670/6.
65. Meeting among Mountbatten, Auchinleck, and Ismay, 28 October 1947, IOR: MSS Eur IOR Neg 15561/2.
66. Cunningham Diary, 28 October 1947, IOR: MSS Eur D670/6.
67. Auchinleck to Chiefs of Staff, 28 October 1947, TNA: PREM 8/1455/1.
68. Cunningham Diary, 28 October 1947, IOR: MSS Eur D670/6.
69. Minutes of the Tenth Meeting of the Defence Committee, 28 October 1947, Mountbatten Papers, MB1/D43/1.
70. Meeting among Mountbatten, Auchinleck, and Ismay, 28 October 1947, IOR: MSS Eur IOR Neg 15561/2.
71. "Parley on Kashmir Called by Jinnah," *New York Times*, 29 October 1947, 21.
72. Cunningham Diary, 28 October 1947, IOR: MSS Eur D670/6.
73. Account of Attempt to Get Nehru to Lahore, 28 October–1 November 1947, IOR: MSS Eur IOR Neg 15561/2.
74. Grady to Marshall, 20 October 1947, US: 845.00/10–2047.
75. Account of Attempt to Get Nehru to Lahore, 28 October–1 November 1947, IOR: MSS Eur IOR Neg 15561/2.
76. Cunningham Diary, 29 October 1947, IOR: MSS Eur D670/6.
77. Ibid.
78. Ibid.
79. Carter, ed., *Partition Observed*, 2:743.
80. Ibid., 2:804.
81. Messervy to Mountbatten, 6 October 1965, Mountbatten Papers, MB1/K161.
82. Nehru to Attlee, 1 November 1947, *SWJN*, 2nd ser., 4:303.
83. Campbell-Johnson, *Mission with Mountbatten*, 227–228.
84. Governor-General's Personal Report No. 5, 7 November 1947, Mountbatten Papers, IOR: L/PO/6/123.
85. Untitled Note, November 1947, Ismay Papers, 3/7/66/5.
86. Meeting between Mountbatten and Jinnah about Kashmir, 1 November 1947, IOR: MSS Eur IOR Neg 15561/2.
87. Ibid.
88. Ramachandra Guha, *India After Gandhi: The History of the World's Largest Democracy* (New York: HarperCollins, 2007), 83–84. See also Nehru to V. Pandit, 28 October 1947, Nehru Papers, NMML.
89. Whitehead, *A Mission in Kashmir*, 144.
90. Ibid., 157.
91. Khan, *Raiders in Kashmir*, 35.
92. Whitehead, *A Mission in Kashmir*, 145.
93. Khan, *Raiders in Kashmir*, 43–44.
94. S. N. Prasad and Dharam Pal, *Operations in Jammu and Kashmir: 1947–48* (Dehra Dun: Natraj, 2005), 48.
95. L. P. Sen, *Slender Was the Thread: Kashmir Confrontation, 1947–48* (New Delhi: Orient Longman, 1969), 76.
96. Governor-General's Personal Report No. 5, 7 November 1947, Mountbatten Papers, IOR: L/PO/6/123.

97. Nehru to V. Pandit, 28 October 1947, Nehru Papers, NMML.
98. Minutes of the Thirteenth Meeting of the Defence Committee, 5 November 1947, Mountbatten Papers, MB1/D43/4.
99. Nehru to Sheikh Abdullah, 4 November 1947, *SWJN*, 2nd ser., 4:318a.
100. Khan, *Raiders in Kashmir,* 43–44.
101. Sen, *Slender Was the Thread,* 98–99.
102. Khan, *Raiders in Kashmir,* 77.
103. Whitehead, *A Mission in Kashmir,* 159.
104. Abdul Mannan to Jinnah, 9 November 1947, *QMJP,* 6:293.

9. HIMALAYAN QUAGMIRE

1. Khan, *Raiders in Kashmir,* 37.
2. Terence Shone Interview with Sydney Smith, 11 November 1947, TNA: DO 142/494.
3. Whitehead, *A Mission in Kashmir,* 85.
4. Bourke-White, *Halfway to Freedom,* 210–211.
5. Shone Interview with Smith, 11 November 1947, TNA: DO 142/494.
6. Whitehead, *A Mission in Kashmir,* 43.
7. Speech at a Public Meeting in Baramulla, 12 November 1947, *SWJN,* 2nd ser., 4:323.
8. Smith, "American Traveler's Observations on Developments in Kashmir and Western Tibet."
9. Speech at a Public Meeting in Srinagar, 11 November 1947, *SWJN,* 2nd ser., 4:322.
10. R. J. Moore, *Making the New Commonwealth* (Oxford: Oxford University Press, 1987), 67.
11. Nehru to Bucher, 7 August 1949, Bucher Papers, 7901–87(2).
12. Speech at Prayer Meeting, 29 October 1947, *CWMG,* 97:186.
13. Hastings Ismay Diary, 19 November 1947, Ismay Papers, 3/8/23.
14. "Kashmir Raiders Flee West," *Times of India,* 9 November 1947, 1.
15. Terence Shone to Commonwealth Relations Office, 27 December 1947, TNA: PREM 8/1455/1.
16. Donovan to Marshall, 5 December 1947, US: 845.00/12–547.
17. WestIndia (Rajkot) to Desai, 22 October 1947, NAI: F. No. 26–PR/47.
18. Carter, ed., *Partition Observed,* 2:558.
19. Ismay Diary, 11 November 1947, Ismay Papers, 3/8/20i.
20. Governor-General's Personal Report No. 6, 11 December 1947, Mountbatten Papers, MB1/D87.
21. Nizam of Hyderabad to Monckton, 7 November 1947, Monckton Papers, Dep. Monckton Trustees 30, No. 178.
22. Nizam of Hyderabad to Monckton, 1 November 1947, Monckton Papers, Dep. Monckton Trustees 30, No. 164.
23. Nehru to Abdullah, 21 November 1947, *SWJN,* 2nd ser., 4:337.
24. "Nehru in Kashmir; Pledges Defense," *New York Times,* 12 November 1947, 17.
25. Shone to Archibald Carter, 18 November 1947, TNA: PREM 8/1455/1.
26. Cunningham Diary, 12 November 1947, IOR: MSS Eur D670/6.
27. Bolitho, *Jinnah,* 186.

28. Carter, ed., *Partition Observed,* 2:696.
29. Ibid.
30. Sir Dalip Singh to Nehru, 18 November 1947, NAI: F. No. 178–P/48.
31. Record of a Meeting Convened by Lord Mountbatten, 8 November 1947, *SWJN,* 2nd ser., 4:362.
32. Macdonald to Marshall, 22 November 1947, enclosure, US: 845.00/11–2247.
33. Symonds, *In the Margins of Independence,* 68.
34. Nehru to Dalip Singh, 21 November 1947, *SWJN,* 2nd ser., 4:331.
35. Minutes of the Sixteenth Meeting of the Defence Committee, 25 November 1947, Mountbatten Papers, MB1/D43/7.
36. Ibid.
37. Donovan to Marshall, 8 December 1947, US: 845.00/12–847.
38. Nehru to Dwarkanath Kachru, 7 November 1947, *SWJN,* 2nd ser., 4:320e.
39. Interview with Francis Mudie, 27 August 1964, Singh, ed., *Select Documents on Partition of the Punjab,* 733.
40. Ismay's Meeting with Patel, 24 November 1947, IOR: MSS Eur IOR Neg 15561/2.
41. Ibid.
42. Carter, ed., *Partition Observed,* 2:739.
43. Ismay to Shone, 27 November 1947, IOR: MSS Eur IOR Neg 15549/3.
44. Shone to Carter, 28 November 1948, IOR: L/PO/12/12.
45. Ibid.
46. Ismay to Mountbatten, n.d., Ismay Papers, 3/7/67/23.
47. Carter, ed., *Partition Observed,* 2:763.
48. Note by Jinnah, 30 November 1947, *QMJP,* 9:430.
49. Bolitho, *Jinnah,* 187.
50. Lewis to Marshall, 17 December 1947, US: 845.00f/12–1747.
51. Bourke-White, *Halfway to Freedom,* 101.
52. High Commissioner for India, Karachi, to Nehru, 11 November 1947, NAI: Home Deptt-Pol(I) No. 57/25/1947.
53. Grafftey-Smith to Carter, 3 November 1948, IOR: L/PO/12/14.
54. Donovan to Marshall, 29 December 1947, US: 845.00/12–2947.
55. Sharma, *Peeps into Pakistan,* 160.
56. Interview with Robert Stimson, 16 December 1947, *QMJP,* 6:471.
57. Khan, *Raiders in Kashmir,* 90.
58. Minutes of the Eighteenth Meeting of the Defence Committee, 3 December 1947, Mountbatten Papers, MB1/D43/9.
59. Sen, *Slender Was the Thread,* 143.
60. Minutes of the Eighteenth Meeting of the Defence Committee, 3 December 1947, Mountbatten Papers, MB1/D43/9.
61. Vernon Erskine-Crum Visit to Lahore, 4 December 1947, IOR: MSS Eur IOR Neg 15549/4.
62. Bucher Diary, 6 December 1947, Bucher Papers, 7901–87; Nehru to Liaquat, 3 December 1947, *SWJN,* 2nd ser., 4:358.
63. Minutes of the Eighteenth Meeting of the Defence Committee, 3 December 1947, Mountbatten Papers, MB1/D43/9.
64. Nehru to the Maharajah of Kashmir, 1 December 1947, *SWJN,* 2nd ser., 4:352.

65. Speech at Jammu, 6 December 1947, ibid., 4:360.
66. Minutes of the Eighteenth Meeting of the Defence Committee, 3 December 1947, Mountbatten Papers, MB1/D43/9.
67. Nehru to Abdullah, 12 December 1947, *SWJN,* 2nd ser., 4:370.
68. Talks with Mountbatten and Liaquat, 21 December 1947, ibid., 4:386.
69. Record of a Meeting Convened by Mountbatten, 8 December 1947, ibid., 4:367.
70. Nehru to Abdullah, 12 December 1947, ibid., 4:368.
71. Sen, *Slender Was the Thread,* 150.
72. Ibid., 159.
73. Pakistan Arms Buying, IOR: L/WS/1/1698.
74. Wolpert, *Jinnah of Pakistan,* 359.
75. Gopal, *Jawaharlal Nehru,* 2:24.
76. Campbell-Johnson, *Mission with Mountbatten,* 252.
77. Carter, ed., *Partition Observed,* 2:872.
78. Talks with Mountbatten and Liaquat, 21 December 1947, *SWJN,* 2nd ser., 4:384.
79. Mountbatten Interview with Nehru, 21 December 1947, IOR: MSS Eur IOR Neg 15561/3.
80. Talks with Mountbatten and Liaquat, 21 December 1947, *SWJN,* 2nd ser., 4:382.
81. Ibid., 4:386–387.
82. Governor-General's Personal Report No. 7, 3 January 1948, Mountbatten Papers, MB1/D88.
83. Note on Kashmir, 19 December 1947, *SWJN,* 2nd ser., 4:376–377.
84. Ibid, 4:378, emphasis added.
85. Carter, ed., *Partition Observed,* 2:895.
86. Mountbatten to Nehru, 25 December 1947, enclosure in Shone to Commonwealth Relations Office, 28 December 1947, TNA: PREM 8/1455/1.
87. Nehru to Mountbatten, 26 December 1947, *SWJN,* 2nd ser., 4:399–403.
88. Ibid., 4:403.
89. Shone to Commonwealth Relations Office and enclosures, 28 December 1947, TNA: PREM 8/1455/1.
90. Gandhi, *Patel,* 458.
91. Nehru to Patel, 30 December 1947, *SWJN,* 2nd ser., 4:412–413.
92. Commonwealth Relations Office to Shone, 29 December 1947, TNA: PREM 8/1455/1.
93. Liaquat to Mudie, 30 December 1947, Mudie Papers, IOR: MSS Eur F164/15.
94. Carter, ed., *Partition Observed,* 2:907.
95. Governor-General's Personal Report No. 7, Appendix 8, Mountbatten Papers, MB1/D88.
96. Talbot, *An American Witness,* 345.
97. Lionel Carter, ed., *Weakened States Seeking Renewal, Part 1: British Official Reports from South Asia, 1 January–30 April 1948,* 2 vols. (New Delhi: Manohar, 2013), 161.
98. Shankar, *My Reminiscences of Sardar Patel,* 145.
99. Ibid.
100. Speech at Prayer Meeting, 12 January 1948, *CWMG,* 98:220.
101. Meeting between Mountbatten and Patel, 13 January 1948, IOR: MSS Eur IOR Neg 15561/3.

102. Gandhi, *Patel,* 463.
103. Ibid.
104. Fischer, *Life of Mahatma Gandhi,* 497.
105. "Refugees Demonstrate," *New York Times,* 15 January 1948, 14.

10. THE LAST BATTLE

1. Speech at Prayer Meeting, 16 January 1948, *CWMG,* 98:246.
2. Fischer, *Life of Mahatma Gandhi,* 501.
3. Speech at Prayer Meeting, 20 January 1948, *CWMG,* 98:273; Lady Dodo Symon's Diary, IOR: MSS Eur E367/5.
4. Memorandum of Conversation, 10 January 1948, *Foreign Relations of the United States, 1948: The Near East, South Asia, and Africa* (Washington, D.C.: U.S. Government Printing Office, 1948), 277.
5. Carter, ed., *Weakened States,* 1:116.
6. *SWJN,* 2nd ser., 5:21n1.
7. Carter, ed., *Weakened States,* 1:261.
8. Bourke-White, *Halfway to Freedom,* 232.
9. Meeting between Mountbatten and Patel, 4 February 1948, IOR: MSS Eur IOR Neg 15561/3.
10. Gandhi, *Gandhi,* 651.
11. Mir Laik Ali, *Tragedy of Hyderabad* (Karachi: Pakistan Cooperative Book Society, 1962), 120.
12. Thompson to Marshall, 1 February 1948, US: 845.00/2–148.
13. Carter, ed., *Weakened States,* 1:295.
14. Kuldip Nayar, *Scoop! Inside Stories from the Partition to the Present* (New Delhi: HarperCollins India, 2006), 19.
15. Carter, ed., *Weakened States,* 1:310–311.
16. "Jinnah Sorrows for His Hindu Foe," *New York Times,* 31 January 1948, 2, emphasis added.
17. Carter, ed., *Weakened States,* 1:268.
18. Meeting between Mountbatten and Nehru, 1 February 1948, IOR: MSS Eur IOR Neg 15561.
19. B. Krishna, *Sardar Vallabhbhai Patel: India's Iron Man* (New Delhi: HarperCollins, 1996), 377.
20. Noorani, *The Destruction of Hyderabad,* xv.
21. Carter, ed., *Weakened States,* 1:385.
22. Prasad and Pal, *Operations in Jammu and Kashmir,* 121.
23. Nawaz, *Crossed Swords,* 56.
24. Carter, ed., *Weakened States,* 1:451.
25. Ibid.
26. Ibid., 1:439.
27. Hoskot to Chamberlin, 10 February 1948, US: 845f.00/2–1048.
28. Carter, ed., *Weakened States,* 1:451.
29. Donovan to Marshall, 1 April 1948, US: 845.00/4–148; Carter, ed., *Weakened States,* 1:457–458.

30. Cunningham Diary, 28 February 1948, IOR: MSS Eur D670/6.

31. Sidney Cotton, with Ralph Barker, *Aviator Extraordinary: The Sidney Cotton Story* (London: Chatto and Windus, 1969), 226.

32. Robert Stimson, "Report on Hyderabad–GOI Relations," 18 March 1948, enclosure, US: 845.00/3–2848.

33. Hyder, *October Coup*, 772.

34. Ibid., 270, 434.

35. Stimson, "Report on Hyderabad–GOI Relations."

36. Report of the First Governor-General of India, Part F: Hyderabad, Mountbatten Papers, MB1/D2.

37. El-Edroos, *Hyderabad of "The Seven Loaves,"* 129.

38. Cotton, *Aviator Extraordinary*, 228.

39. Hyder, *October Coup*, 307.

40. Cotton, *Aviator Extraordinary*, 228–231.

41. Nizam of Hyderabad to Monckton, 24 December 1947, Monckton Papers, Dep. Monckton Trustees 30, p. 219.

42. Laik Ali, *Tragedy of Hyderabad*, 156.

43. Bucher to Rob Lockhart, 12 April 1948, Bucher Papers, 7901–87(2).

44. Hoskot to Chamberlin, 10 February 1948, US: 845f.00/2–1048.

45. Cunningham Diary, 10 February 1948, IOR: MSS Eur D670/6.

46. Carter, ed., *Weakened States*, 1:395.

47. Ibid., 1:68.

48. Nawaz, *Crossed Swords*, 63.

49. Carter, ed., *Weakened States*, 1:308, 2:622, 571–572.

50. Speech at Dacca, 21 March 1948, http://m-a-jinnah.blogspot.sg/2010/04/national-consolidation-march-1948.html.

51. Cotton, *Aviator Extraordinary*, 229, 231.

52. Nawaz, *Crossed Swords*, 62–63.

53. Ibid., 62, 64.

54. Ibid., 57.

55. Patrick Gordon-Walker, *Political Diaries, 1932–1971,* ed. Robert Pearce (London: Historians' Press, 1991), 172.

56. Carter, ed., *Weakened States*, 2:570, 902.

57. Grafftey-Smith to Commonwealth Relations Office, 4 May 1948, TNA: PREM 8/819.

58. Laik Ali, *Tragedy of Hyderabad*, 183.

59. Ibid., 139.

60. Ibid., 185.

61. Nehru to Baldev Singh, 16 April 1948, *SWJN*, 2nd ser., 5:217.

62. K. M. Munshi, *The End of an Era: Hyderabad Memoirs* (Bombay: Bharatiya Vidya Bhavan, 1990), 129.

63. Carter, ed., *Weakened States*, 2:798.

64. Munshi, *The End of an Era*, 141.

65. Ibid., 75; Laik Ali, *Tragedy of Hyderabad*, 202.

66. Speech at AICC Meeting, 24 April 1948, *SWJN*, 2nd ser., 5:165.

67. Minutes of Item 4 of Defence Committee Meeting No. 4 of 1948, 15 May 1948, Mountbatten Papers, MB1/D44/8/2.

68. Sen, *Slender Was the Thread,* 256.
69. Nawaz, *Crossed Swords,* 66.
70. Nehru to Patel, 27 May 1948, *SWJN,* 2nd ser., 5:223.
71. Campbell-Johnson, *Mission with Mountbatten,* 315.
72. Laik Ali, *Tragedy of Hyderabad,* 198.
73. Cotton, *Aviator Extraordinary,* 237.
74. Contract for Aeronautical and Industrial Research Corporation Ltd., Monckton Papers, Dep. Monckton Trustees 36, pp. 3–5.
75. Sidney Cotton to John Graham, 2 June 1948, Monckton Papers, Dep. Monckton Trustees 36, Fol. 18.
76. Cotton, *Aviator Extraordinary,* 237.
77. Ibid., 238–239.
78. Nehru to Sri Prakasa, 16 June 1948, *SWJN,* 2nd ser., 6:75.
79. Press Conference in Delhi, 17 June 1948, ibid., 6:236.
80. Note to States Ministry, 21 June 1948, ibid., 6:244.
81. Nehru to Patel, 6 June 1948, ibid., 6:226.
82. Bolitho, *Jinnah,* 218.
83. Jinnah, *My Brother,* 21.
84. Bolitho, *Jinnah,* 219.
85. Stephens, *Pakistan,* 231.
86. Bolitho, *Jinnah,* 221.
87. Josef Korbel, *Danger in Kashmir* (Oxford: Oxford University Press, 1954), 120.
88. Nehru to Mountbatten, 8 July 1948, Mountbatten Papers, MB1/F39.
89. Korbel, *Danger in Kashmir,* 130.
90. Ibid., 142, 143, 144.
91. Laik Ali, *Tragedy of Hyderabad,* 256.
92. Nehru to Mountbatten, 23 August 1947, Mountbatten Papers, MB1/F39.
93. Laik Ali, *Tragedy of Hyderabad,* 257.
94. El-Edroos, *Hyderabad of "The Seven Loaves,"* 135.
95. Hyder, *October Coup,* 1046.
96. Laik Ali, *Tragedy of Hyderabad,* 260.
97. Hyder, *October Coup,* 1082.
98. Munshi, *The End of an Era,* 204.
99. Donovan to Marshall, 1 September 1948, US: 845.00/9–148.
100. Noorani, *The Destruction of Hyderabad,* 212.
101. Press Conference in New Delhi, 10 September 1948, *SWJN,* 2nd ser., 7:238.
102. Lucien Benichou, *From Autocracy to Integration: Political Developments in Hyderabad State, 1938–1948* (Hyderabad: Orient Longman, 2000), 231.
103. Bolitho, *Jinnah,* 224–225.
104. Ibid.
105. Note by Sir John Cotton, First Secretary in British High Commission, Karachi, IOR: MSS Eur F226/7.
106. Ibid.
107. Rajah of Mahmudabad, "Some Memories," in *The Partition of India: Policies and Perspectives, 1935–1947,* ed. C. H. Philips and Mary Doreen Wainright (Cambridge, Mass.: MIT Press, 1970), 386.
108. Noorani, *The Destruction of Hyderabad,* 210.

109. Gandhi, *Patel,* 482.
110. Guha, *India After Gandhi,* 70.
111. El-Edroos, *Hyderabad of "The Seven Loaves,"* 138–139.
112. Hyder, *October Coup,* 1179.
113. Noorani, *The Destruction of Hyderabad,* 212.
114. Lewis to Marshall, 24 September 1948, US: 845f.00/9–2448.
115. Robert Burnett to Philip Noel-Baker, 4 October 1948, TNA: DO 142/366.
116. "India Takes Over All of Hyderabad," *New York Times,* 19 September 1948, 39.
117. Burnett to Noel-Baker, 4 October 1948, TNA: DO 142/366.
118. Ibid.
119. Hooker Doolittle to Marshall, 30 September 1948, US: 845f.00/9–3048.
120. Lewis to Marshall, 20 September 1948, US: 845f.00/9–2048.
121. Gopal, *Jawaharlal Nehru,* 2:32, 33.
122. Nehru to Mountbatten, 28 November 1948, Mountbatten Papers, MB1/F7(3).
123. Note by Grafftey-Smith, 1 October 1948, TNA: DO 142/368.
124. Interview with Bucher, Oral History Archive, NMML.
125. Nehru to Patel, 5 October 1948, *SWJN,* 2nd ser., 7:275.
126. See Noorani, *The Destruction of Hyderabad,* appendices 14 and 15, "The Sunder-lal Committee Report on the Massacre of Muslims" and "Confidential Notes Attached to the Sunderlal Committee Report."
127. Hyder, *October Coup,* 1231–1241.
128. Noorani, *The Destruction of Hyderabad,* 239.
129. Interview with Bucher, Oral History Archive, NMML.

EPILOGUE: DEADLY LEGACY

1. Talbot, *An American Witness,* 361, 368.
2. Gopal, *Jawaharlal Nehru,* 2:118.
3. Hussain Haqqani, *Pakistan: Between Mosque and Military* (Washington, D.C.: Carnegie Endowment for International Peace, 2010), 316–317.
4. Bruce Riedel, *Deadly Embrace: Pakistan, America, and the Future of the Global Jihad* (Washington, D.C.: Brookings Institution Press, 2011), 13.
5. Ibid., 24.
6. Haqqani, *Pakistan,* 47.
7. "Pakistan's Spies Are Tied to Raid on U.S. Embassy," *New York Times,* 23 September 2011, A1.
8. Radha Kumar, "Renewing an India-Pakistan Peace Process?," *The Hindu,* 16 November 2013, www.thehindu.com/opinion/lead/renewing-an-indiapakistan-peace-process/article5355247.ece.

BIBLIOGRAPHY

.v.v.v.

MANUSCRIPT COLLECTIONS

Asian and African Studies, formerly the Oriental and India Office Collection, British Library, London
 India Office Records and Private Papers (IOR)
Bodleian Library, Oxford University
 Clement Richard Attlee Papers
 Walter Turner Monckton Papers
Centre of South Asian Studies, Cambridge University
 Patrick Brendon Papers
 George Frederick Heaney Papers
 Allan Perry-Keene Papers
 O. H. K. Spate Papers
 Ian Stephens Papers
Hartley Library, University of Southampton
 Louis Mountbatten Papers
Liddell Hart Centre for Military Archives, King's College London
 Hastings Ismay Papers
National Archives, Kew, London (TNA)
National Archives of India, New Delhi (NAI)
National Army Museum, London (NAM)
 Roy Bucher Papers
 Herbert Lawrence Hill Papers
 William Robin Palmer Ridgeway Papers
 Reginald Savory Papers
Nehru Memorial Museum and Library, New Delhi (NMML)
 Padmaja Naidu Papers

Jawaharlal Nehru Papers
Oral History Archive
U.S. National Archives, College Park, Maryland
 U.S. State Department Records (US)

BOOKS AND ARTICLES

Acheson, Dean. *Present at the Creation: My Years in the State Department.* New York: Norton, 1969.

Adams, Jad. *Gandhi: Naked Ambition.* London: Quercus, 2010.

Ahmed, Akbar S. *Jinnah, Pakistan and Islamic Identity: The Search for Saladin.* London: Routledge, 1997.

Ahmed, Ishtiaq. *The Punjab Bloodied, Partitioned and Cleansed: Unravelling the 1947 Tragedy Through Secret British Reports and First Person Accounts.* New Delhi: Rupa, 2011.

Ahmed, Waheed, ed. *Jinnah-Irwin Correspondence, 1927–1930.* Lahore: Research Society of Pakistan, 1969.

———, ed. *Jinnah-Linlithgow Correspondence, 1939–1943.* Lahore: Research Society of Pakistan, 1978.

Aiyar, Swarna. "'August Anarchy': The Partition Massacres in Punjab, 1947." In *Freedom, Trauma, Continuities: Northern India and Independence,* edited by D. A. Low and Howard Brasted, 15–38. New Delhi: Sage, 1998.

Akbar, M. J. *Nehru: The Making of India.* London: Viking, 1988.

Ali, Chaudhri Muhammad. *The Emergence of Pakistan.* Lahore: Research Society of Pakistan, 1973.

Amin, Shahid. *Disastrous Twilight: A Personal Record of the Partition of India.* London: Leo Cooper, 1986.

Anand, Som. *Lahore: Portrait of a Lost City.* Lahore: Vanguard, 1998.

Attlee, Clement. *Clem Attlee: The Granada Historical Records Interview.* London: Panther, 1967.

———. "Statement by Prime Minister Attlee on the Transfer of Power in India, Feb. 20, 1947." *Middle East Journal* 1, no. 2 (April 1947): 210–212.

Azad, Maulana Abul Kalam. *India Wins Freedom: An Autobiographical Narrative.* Bombay: Orient Longman, 1959.

Aziz, K. K. *Rahmat Ali: A Biography.* Lahore: Vanguard, 1987.

Barnes, John, and David Nicholson, eds. *The Empire at Bay: The Leopold Amery Diaries, 1929–1945.* London: Hutchinson, 1988.

Bayly, Christopher, and Tim Harper. *Forgotten Wars: The End of Britain's Asian Empire.* London: Penguin, 2008.

Bazalgette, Jack. *The Captains and the Kings Depart: Life in India 1928–46.* Oxford: Arnate Press, 1984.

Beg, Aziz. *Jinnah and His Times.* Islamabad: Babur and Amer, 1986.

Benichou, Lucien. *From Autocracy to Integration: Political Developments in Hyderabad State, 1938–1948.* Hyderabad: Orient Longman, 2000.

Bolitho, Hector. *In Quest of Jinnah: Diary, Notes and Correspondence of Hector Bolitho.* Ed. Sharif al Mujahid. Oxford: Oxford University Press, 2007.

———. *Jinnah: Creator of Pakistan.* London: Oxford University Press, 2006.

Bonarjee, N. B. *Under Two Masters.* London: Oxford University Press, 1970.

Bourke-White, Margaret. *Halfway to Freedom.* New York: Simon and Schuster, 1949.

Brass, Paul R. "The Partition of India and Retributive Genocide in the Punjab, 1946–47: Means, Methods and Purposes." *Journal of Genocide Research* 5, no. 1 (2003): 71–101.

Brecher, Michael. *Nehru: A Political Biography.* London: Oxford University Press, 1959.

Brendon, Piers. *The Decline and Fall of the British Empire, 1781–1997.* New York: Knopf, 2007.

Bristow, R. C. B. *Memories of the British Raj: A Soldier in India.* London: Johnson, 1974.

Brown, Judith M. *Modern India: The Origins of an Asian Democracy.* Delhi: Oxford University Press, 1984.

Brown, Judith M., William Roger Louis, and Alaine Low, eds. *The Oxford History of the British Empire.* Vol. 4. Oxford: Oxford University Press, 1999.

Butler, Iris. *The Viceroy's Wife: Letters of Alice, Countess of Reading, from India, 1921–1925.* London: Hodder and Stoughton, 1969.

Campbell-Johnson, Alan. *Mission with Mountbatten.* London: Hamish Hamilton, 1951.

Cantwell, Wilfred. "Hyderabad: Muslim Tragedy." *Middle East Journal* 4, no. 1 (January 1950): 27–51.

Carter, Lionel, ed. *Mountbatten's Report on the Last Viceroyalty, 22 March–15 August 1947.* New Delhi: Manohar, 2003.

———, ed. *Partition Observed: British Official Reports from South Asia.* 2 vols. New Delhi: Manohar, 2011.

———, ed. *Punjab Politics: Governors' Fortnightly Reports and Other Key Documents.* 2 vols. New Delhi: Manohar, 2007.

———, ed. *Weakened States Seeking Renewal, Part 1: British Official Reports from South Asia, 1 January–30 April 1948.* 2 vols. New Delhi: Manohar, 2013.

Casey, R. G. *An Australian in India.* London: Hollis and Carter, 1947.

Chagla, M. C. *Roses in December: An Autobiography.* Mumbai: Bharatiya Vidya Bhavan, 2000.

Chaudhuri, Nirad C. *Thy Hand, Great Anarch! India 1921–1952.* Reading, Mass.: Addison-Wesley, 1987.

Chopra, Prabha, ed. *Sardar Patel and the Partition of India*. Delhi: Konark, 2010.

Clarke, Peter. *The Cripps Version: The Life of Sir Stafford Cripps, 1889–1952*. London: Allen Lane, 2002.

———. *The Last Thousand Days of the British Empire: Churchill, Roosevelt, and the Birth of the Pax Americana*. New York: Bloomsbury Press, 2008.

Clymer, Kenton J. *Quest for Freedom: The United States and India's Independence*. New York: Columbia University Press, 1995.

Cohen, Stephen P. *The Idea of Pakistan*. Washington, D.C.: Brookings Institution, 2004.

Collins, Larry, and Dominique Lapierre. *Freedom at Midnight*. New York: Avon, 1975.

Connell, John. *Wavell: Supreme Commander*. Ed. Michael Roberts. London: Collins, 1969.

Copland, Ian. "The Master and the Maharajas: The Sikh Princes and the East Punjab Massacres." *Modern Asian Studies* 36, no. 3 (July 2002): 657–704.

Cotton, Sidney, with Ralph Barker. *Aviator Extraordinary: The Sidney Cotton Story*. London: Chatto and Windus, 1969.

Dalton, Hugh. *The Political Diary of Hugh Dalton: 1918–40, 1945–60*. Ed. Ben Pimlott. London: Jonathan Cape, 1986.

Darwin, John. *Britain and Decolonisation: The Retreat from Empire in the Post-War World*. London: Macmillan, 1988.

Das, Durga. *From Curzon to Nehru and After*. London: Collins, 1969.

Driberg, Tom. *Ruling Passions*. London: Jonathan Cape, 1977.

Dwarkadas, Kanji. *Ruttie Jinnah: The Story of a Great Friendship*. Bombay: Kanji Dwarkadas, n.d.

———. *Ten Years to Freedom*. Bombay: Popular Prakashan, 1968.

Eagleton, Clyde. "The Case of Hyderabad Before the Security Council." *The American Journal of International Law* 44, no. 2 (April 1950): 277–302.

Edwardes, Michael. *The Last Years of British India*. London: New English Library, 1963.

———. *Nehru: A Political Biography*. London: Allen Lane, 1971.

El-Edroos, Syed Ahmed. *Hyderabad of "The Seven Loaves."* Hyderabad: Laser Prints, 1994.

Evans, Humphrey. *Thimayya of India: A Soldier's Life*. New York: Harcourt, Brace, 1960.

Ferguson, Niall. *Empire: The Rise and Demise of the British World Order and the Lessons for Global Power*. London: Allen Lane, 2002.

Fergusson, Bernard. *Wavell: Portrait of a Soldier*. London: Collins, 1961.

Fischer, Louis. *The Life of Mahatma Gandhi*. New York: Harper and Row, 1950.

Foreign Relations of the United States, 1946: The British Commonwealth, Western and Central Europe. Washington, D.C.: U.S. Government Printing Office, 1946.

Foreign Relations of the United States, 1948: The Near East, South Asia, and Africa. Washington, D.C.: U.S. Government Printing Office, 1948.

French, Patrick. *Liberty or Death.* London: Flamingo, 1998.

Gandhi, Mahatma. *Collected Works of Mahatma Gandhi.* 97 vols. to date. New Delhi: Publications Department of the Government of India, 1958–.

Gandhi, Rajmohan. *Eight Lives: A Study of the Hindu-Muslim Encounter.* Albany: State University of New York Press, 1986.

———. *Gandhi: The Man, His People and the Empire.* London: Haus, 2007.

———. *Patel: A Life.* Ahmedabad: Navajivan, 1990.

———. *Punjab: A History from Aurangzeb to Mountbatten.* New Delhi: Aleph Book Company, 2013.

Garewal, Sher Muhammad, ed. *Jinnah-Wavell Correspondence: 1943–1947.* Lahore: Research Society of Pakistan, 1986.

Ghosh, Sudhir. *Gandhi's Emissary.* Boston: Houghton Mifflin, 1967.

Gilbert, Martin. *Road to Victory: Winston S. Churchill, 1941–1945.* London: Minerva, 1989.

Gilmartin, David. *Empire and Islam: Punjab and the Making of Pakistan.* London: I. B. Tauris, 1988.

Glendevon, John. *The Viceroy at Bay: Lord Linlithgow in India, 1936–1943.* London: Collins, 1971.

Godbole, Madhav. *The Holocaust of Indian Partition: An Inquest.* New Delhi: Rupa, 2011.

Gopal, Sarvepalli. *Jawaharlal Nehru: A Biography.* 2 vols. London: Jonathan Cape, 1975–1979.

Gordon, Leonard. *Brothers Against the Raj: A Biography of Sarat and Subhas Chandra Bose.* New Delhi: Viking, 1989.

Gordon-Walker, Patrick. *Political Diaries, 1932–1971.* Ed. Robert Pearce. London: Historians' Press, 1991.

Guha, Ramachandra. *India After Gandhi: The History of the World's Largest Democracy.* New York: HarperCollins, 2007.

Gupta, Partha Sarathi. *Imperialism and the British Labour Movement, 1914–1964.* New York: Holmes and Meier, 1975.

———. "Imperial Strategy and the Transfer of Power, 1939–51." In *Myth and Reality: The Struggle for Freedom in India, 1945–47,* edited by Amit Kumar Gupta, 1–53. New Delhi: Manohar, 1987.

Haqqani, Hussain. *Pakistan: Between Mosque and Military.* Washington, D.C.: Carnegie Endowment for International Peace, 2010.

Harbutt, Fraser J. *The Iron Curtain: Churchill, America and the Origins of the Cold War.* New York: Oxford University Press, 1986.

Harriman, W. Averell, and Elie Abel. *Special Envoy to Churchill and Stalin, 1941–1946.* London: Hutchison, 1976.

Harris, Kenneth. *Attlee.* London: Weidenfeld and Nicolson, 1982.

Hasan, Mushirul, ed. *Islam in South Asia.* Vol. 6, *Soundings on Partition and Its Aftermath.* New Delhi: Manohar, 2010.

Heren, Louis. *Growing Up on the* Times. London: Hamish Hamilton, 1978.

Herman, Arthur. *Gandhi and Churchill: The Epic Rivalry That Destroyed an Empire and Forged Our Age.* New York: Bantam, 2008.

Hess, Gary R. *America Encounters India, 1941–1947.* Baltimore: Johns Hopkins University Press, 1971.

Hodson, H. V. *The Great Divide: Britain-India-Pakistan.* Karachi: Oxford University Press, 1997.

Hoey, Brian. *Mountbatten: The Private Story.* London: Sidgwick and Jackson, 1994.

Hough, Richard. *Mountbatten: Hero of Our Time.* London: Weidenfeld and Nicolson, 1980.

Hutheesing, Krishna Nehru, with Alden Hatch. *We Nehrus.* New York: Holt, Rinehart and Winston, 1967.

Hyder, Mohammed. *October Coup: A Memoir of the Struggle for Hyderabad.* New Delhi: Roli, 2012.

Ikramullah, Shaista Suhrawardy. *From Purdah to Parliament.* Karachi: Oxford University Press, 1998.

Ismay, Hastings Lionel. *The Memoirs of General Lord Ismay.* London: Viking, 1960.

Ispahani, M. A. H. *Qaid-e-Azam as I Knew Him.* Karachi: Forward Publications Trust, 1967.

Jalal, Ayesha. *The Sole Spokesman: Jinnah, the Muslim League and the Demand for Pakistan.* Cambridge: Cambridge University Press, 1985.

Jamal, Arif. *Shadow War.* Brooklyn, N.Y.: Melville House, 2009.

James, Lawrence. *Raj: The Making and Unmaking of British India.* New York: St. Martin's Griffin, 1997.

———. *The Rise and Fall of the British Empire.* New York: St. Martin's Griffin, 1994.

Jeffrey, Robin. "The Punjab Boundary Force and the Problem of Order, August 1947." *Modern Asian Studies* 8, no. 4 (1974): 491–520.

Jha, Prem Shankar. *Kashmir 1947: The Origins of a Dispute.* London: Pluto Press, 2003.

Jinnah, Fatima. *My Brother.* Ed. Sharif al Mujahid. Karachi: Quaid-e-Azam Academy, 1987.

Jinnah, Mohammad Ali. *The Collected Works of Quaid-e-Azam Mohammad Ali Jinnah.* 3 vols. Comp. Syed Sharifuddin Pirzada. Karachi: East and West Publishing, 1984–1986.

———. *Plain Mr. Jinnah: Selections from Shamsul Hasan Collection.* Vol. 1. Ed. Syed Shamsul Hasan. Karachi: Royal Book Company, 1976.

———. *Quaid-i-Azam Mohammad Ali Jinnah Papers.* 18 vols. to date. Ed. Z. H. Zaidi et al. Islamabad: Quaid-i-Azam Papers Project, 1993–.

———. *Some Recent Speeches and Writings of Mr. Jinnah.* Vol. 2. Ed. Jamil-ud-din Ahmad. Lahore: Muhammad Ashraf, 1947.

Jones, George E. *Tumult in India.* New York: Dodd, Mead, 1948.

Kalhan, Promilla. *Kamala Nehru: An Intimate Biography.* Delhi: Vikas, 1973.

Kennedy, Paul. *Rise and Fall of Great Powers: Economic Change and Military Conflict from 1500 to 2000.* New York: Random House, 1987.

Khaliquzzaman, Choudhry. *Pathway to Pakistan.* Lahore: Longman, Green, 1961.

Khan, Akbar. *Raiders in Kashmir.* Karachi: Pak, 1970.

Khan, Liaquat Ali. *Dear Mr. Jinnah: Selected Correspondence and Speeches of Liaquat Ali Khan, 1937–1947.* Ed. Roger D. Long. Oxford: Oxford University Press, 2005.

Khan, Mohammad Ayub. *Friends Not Masters: A Political Autobiography.* Lahore: Oxford University Press, 1967.

Khan, Sardar Shaukat Hyat. *The Nation That Lost Its Soul.* Lahore: Jang, 1995.

Khosla, G. D. *Stern Reckoning: A Survey of the Events Leading Up To and Following the Partition of India.* 1989. Reprinted in *The Partition Omnibus.* New Delhi: Oxford University Press, 2002.

Khurshid, K. H. *Memories of Jinnah.* Ed. Khalid Hasan. Karachi: Oxford University Press, 1990.

Korbel, Josef. *Danger in Kashmir.* Oxford: Oxford University Press, 1954.

Krishna, B. *Sardar Vallabhbhai Patel: India's Iron Man.* New Delhi: HarperCollins, 1996.

Kuwajima, Sho. *Muslims, Nationalism and the Partition: 1946 Provincial Elections in India.* New Delhi: Manohar, 1998.

Kux, Dennis. *Disenchanted Allies: The United States and Pakistan, 1947–2000.* Baltimore: Johns Hopkins University Press, 2001.

Laik Ali, Mir. *Tragedy of Hyderabad.* Karachi: Pakistan Cooperative Book Society, 1962.

Lambert, Richard D. *Hindu-Muslim Riots.* Oxford: Oxford University Press, 2013.

Larres, Klaus. *Churchill's Cold War: The Politics of Personal Diplomacy.* New Haven, Conn.: Yale University Press, 2000.

Lelyveld, Joseph. *Mahatma Gandhi and His Struggle with India.* New York: Knopf, 2011.

Loewenheim, Francis L., Harold D. Langley, and Manfred Jonas, eds. *Roosevelt and Churchill: Their Secret Wartime Correspondence.* New York: Saturday Review; E. P. Dutton, 1975.

Louis, William Roger. *Imperialism at Bay: The United States and the Decolonization of the British Empire, 1941–1945.* New York: Oxford University Press, 1978.

Louis, William Roger, and Ronald Robinson. "The Imperialism of Decolonization." *Journal of Imperial and Commonwealth History* 22, no. 3 (1994): 462–522.

Lumby, E. W. R. *The Transfer of Power in India, 1945–7.* London: Allen and Unwin, 1954.

Mahajan, M. C. *Looking Back: The Autobiography of Mehr Chand Mahajan.* London: Asia Publishing, 1963.

Mahajan, Sucheta. "British Policy, Nationalist Strategy and Popular National Upsurge, 1945–6." In *Myth and Reality: The Struggle for Freedom in India, 1945–47,* edited by Amit Kumar Gupta, 54–98. New Delhi: Manohar, 1987.

Malik, H. S. *A Little Work, A Little Play: The Autobiography of H. S. Malik.* New Delhi: Bookwise, 1972.

Mansergh, Nicholas, et al., eds. *Transfer of Power 1942–47.* 12 vols. London: Her Majesty's Stationery Office, 1970–1983.

Manto, Saadat Hasan. *Fifty Sketches and Stories of Partition.* Trans. Khalid Hasan. New Delhi: Penguin, 1997.

Mathai, M. O. *Reminiscences of the Nehru Age.* New Delhi: Vikas, 1978.

McGarr, Paul M. *The Cold War in South Asia: Britain, the United States and the Indian Subcontinent, 1945–1965.* Cambridge: Cambridge University Press, 2013.

McGhee, George C. *On the Frontline in the Cold War: An Ambassador Reports.* Westport, Conn.: Praeger, 1997.

McKie, Ronald. *Echoes from Forgotten Wars.* Sydney: Collins, 1980.

McNay, John T. *Acheson and Empire: The British Accent in American Foreign Policy.* Columbia: University of Missouri Press, 2001.

Mead, Richard. *Churchill's Lions: A Biographical Guide to the Key British Generals of World War II.* Stroud: Spellmont, 2007.

Menon, V. P. *The Story of the Integration of the Indian States.* London: Longman, Green, 1956.

———. *The Transfer of Power in India.* Princeton, N.J.: Princeton University Press, 1957.

Moon, Penderel. *Divide and Quit.* Berkeley: University of California Press, 1962.

Moore, R. J. *Escape from Empire: The Attlee Government and the Indian Problem.* Oxford: Clarendon Press, 1983.

———. *Making the New Commonwealth.* Oxford: Oxford University Press, 1987.

Moraes, Frank. *Jawaharlal Nehru: A Biography.* New York: Macmillan, 1956.

———. *Witness to an Era: India 1920 to the Present Day.* London: Weidenfeld and Nicolson, 1973.

Mosley, Leonard. *The Last Days of the British Raj.* London: Weidenfeld and Nicolson, 1961.

Mountbatten, Pamela. *India Remembered.* London: Pavilion, 2008.

Mukerjee, Madusree. *Churchill's Secret War: The British Empire and the Ravaging of India During World War II.* New York: Basic, 2011.

Munshi, K. M. *The End of an Era: Hyderabad Memoirs.* Bombay: Bharatiya Vidya Bhavan, 1990.

Naidu, Sarojini. *Sarojini Naidu: Selected Letters, 1890s to 1940s.* Ed. Makarand Paranjape. New Delhi: Kali for Women, 1996.

Nair, Neeti. *Changing Homelands: Hindu Politics and the Partition of India.* Cambridge, Mass.: Harvard University Press, 2011.

Nanda, B. R. *The Nehrus: Motilal and Jawaharlal.* London: Allen and Unwin, 1962.

Nawaz, Shuja. *Crossed Swords: Pakistan, Its Army, and the Wars Within.* Oxford: Oxford University Press, 2008.

Nayar, Kuldip. *Scoop! Inside Stories from the Partition to the Present.* New Delhi: HarperCollins India, 2006.

Nayar, Sushila. *Mahatma Gandhi: Final Fight for Freedom.* Vol. 7. Ahmedabad: Navajivan, 1997.

Nehru, Jawaharlal. *Before Freedom: Nehru's Letters to His Sister, 1909–1947.* Ed. Nayantara Sahgal. New York: HarperCollins, 2000.

———. *China, Spain and the War: Essays and Writing.* Allahabad: Kitabistan, 1940.

———. *The Discovery of India.* Delhi: Oxford University Press, 1985.

———. *Eighteen Months in India: 1936–1937: Being Further Essays and Writings.* Allahabad: Kitabistan, 1938.

———. *Independence and After: A Collection of Speeches, 1946–1949.* New York: John Day, 1950.

———. *Selected Works of Jawaharlal Nehru.* 1st series. 15 vols. Ed. Sarvepalli Gopal et al. New Delhi: Orient Longman, 1972–1982.

———. *Selected Works of Jawaharlal Nehru.* 2nd series. 55 vols. to date. Ed. Sarvepalli Gopal et al. New Delhi: Jawaharlal Nehru Memorial Fund, 1985–.

———. *Toward Freedom: The Autobiography of Jawaharlal Nehru.* New York: John Day, 1941.

Nehru, Krishna. *With No Regrets: An Autobiography.* New York: John Day, 1945.

Noon, Firoz Khan. *From Memory.* Islamabad: National Book Foundation, 1993.

Noorani, A. G. *The Destruction of Hyderabad.* New Delhi: Tulika, 2013.

Owen, Hugh F. "Negotiating the Lucknow Pact." *Journal of Asian Studies* 31, no. 3 (May 1972): 561–587.

Pandey, B. N. *Nehru.* London: Macmillan, 1976.

Pandey, Deepak. "Congress-Muslim League Relations 1937–39: The Parting of the Ways." *Modern Asian Studies* 12, no. 4 (1978): 629–654.

Pandey, Gyanendra. *Remembering Partition: Violence, Nationalism and History in India.* New Delhi: Cambridge University Press India, 2003.

Pandit, Vijaya Lakshmi. *The Scope of Happiness: A Personal Memoir.* New Delhi: HarperCollins India, 1979.

Panigrahi, D. N. *India's Partition: The Story of Imperialism in Retreat.* New York: Routledge, 2004.

Patel, H. M. *Rites of Passage: A Civil Servant Remembers.* Ed. Sucheta Mahajan. Delhi: Rupa, 2005.

Patel, Vallabhbhai. *Sardar Patel's Correspondence, 1945–50.* 10 vols. Ed. Durga Das. Ahmedabad: Navajivan, 1972.

Philips, C. H., and Mary Doreen Wainwright, eds. *The Partition of India: Policies and Perspectives, 1935–1947.* Cambridge, Mass.: MIT Press, 1970.

Phillips, William. *Ventures in Diplomacy.* Portland, Maine: Anthoensen Press, 1952.

Pirzada, Syed Sharifuddin, ed. *Foundations of Pakistan: All-India Muslim League Documents, 1906–1947.* 2 vols. Karachi: National Publishing House, 1969–1970.

Prasad, S. N., and Dharam Pal. *Operations in Jammu and Kashmir: 1947–48.* Dehra Dun: Natraj, 2005.

Pyarelal. *Mahatma Gandhi: The Last Phase.* 2 vols. Ahmedabad: Navajivan, 1956.

Rao, B. Shiva. *India's Freedom Movement: Some Notable Figures.* New Delhi: Orient Longman, 1972.

Read, Anthony, and David Fisher. *The Proudest Day: India's Long Road to Independence.* London: Pimlico, 1998.

Riedel, Bruce. *Deadly Embrace: Pakistan, America, and the Future of the Global Jihad.* Washington, D.C.: Brookings Institution Press, 2011.

Roberts, Andrew. *Eminent Churchillians.* London: Weidenfeld and Nicolson, 1994.

Roosevelt, Elliott. *As He Saw It.* Bombay: Asia Publishing, 1947.

Russell, Wilfrid. *Merchant in a Mirror.* London: Asia Publishing, 1961.

Saiyid, Matlubul Hasan. *Mohammad Ali Jinnah: A Political Study.* Lahore: Sh. Muhammad Ashraf, 1962.

Salim, Ahmad, ed. *Lahore 1947.* Lahore: Sang-e-Meel, 2003.

Sandhu, Jasdev Singh. *Giani Kartar Singh: A Commemorative Volume.* Patiala: S. Jasdev Singh Sandhu Foundation, 2001.

Sarila, Narendra Singh. *The Shadow of the Great Game: The Untold Story of India's Partition.* New Delhi: HarperCollins India, 2005.

Sayeed, Khalid bin. *Pakistan: The Formative Phase, 1857–1948.* Karachi: Oxford University Press, 1968.

Schofield, Victoria. *Kashmir in the Crossfire.* London: I. B. Tauris, 1996.

———. *Wavell: Soldier and Statesman*. London: John Murray, 2006.

Scott, Ian. *A British Tale of Indian and Foreign Service: The Memoirs of Sir Ian Scott*. Ed. Denis Judd. London: Radcliffe Press, 1999.

Sen, L. P. *Slender Was the Thread: Kashmir Confrontation, 1947–48*. New Delhi: Orient Longman, 1969.

Setalvad, Chimanlal. *Recollections and Reflections: An Autobiography*. Bombay: Padma, 1946.

Shankar, V. *My Reminiscences of Sardar Patel*. Vol. 1. Delhi: Macmillan India, 1974.

Sharma, M. S. M. *Peeps into Pakistan*. Patna: Pustak Bhandar, 1954.

Sherwood, Robert E. *Roosevelt and Hopkins: An Intimate History*. New York: Enigma, 2008.

Singh, Anita Inder. *The Limits of British Influence: South Asia and the Anglo-American Relationship, 1947–50*. London: Pinter, 1993.

———. *The Origins of the Partition of India, 1936–1947*. 1987. Reprinted in *The Partition Omnibus*. New Delhi: Oxford University Press, 2002.

Singh, Durlab. *The Valiant Fighter: A Biographical Study of Master Tara Singh*. Lahore: Hero, 1942.

Singh, Gopal. *A History of the Sikh People*. New Delhi: Allied, 1979.

Singh, Jaswant. *Jinnah: India-Partition-Independence*. New Delhi: Rupa, 2009.

Singh, Karan. *Heir Apparent: An Autobiography*. Vol. 1. Oxford: Oxford University Press, 1982.

Singh, Kirpal, ed. *Select Documents on Partition of the Punjab 1947*. Delhi: National Book Shop, 1991.

Snedden, Christopher. "What Happened to Muslims in Jammu? The 'Massacre' of 1947 and the Roots of the 'Kashmir Problem.'" *Journal of South Asian Studies* 24, no. 2 (2001): 111–134.

Snow, Edgar. *Journey to the Beginning*. London: Victor Gollancz, 1959.

———. *People on Our Side*. New York: Random House, 1944.

Sorensen, R. W. *My Impression of India*. London: Meridian, 1946.

Spate, O. H. K. "The Partition of India and the Prospects of Pakistan." *Geographical Review* 38, no. 1 (1948): 5–29.

Stafford, David. *Roosevelt and Churchill: Men of Secrets*. London: Little, Brown, 1999.

Stallworthy, Jon. *Louis MacNeice*. New York: Norton, 1995.

Stephens, Ian. *Monsoon Morning*. London: Ernest Benn, 1966.

———. *Pakistan*. London: Ernest Benn, 1963.

Stevens, G. R. *Fourth Indian Division*. Toronto: McLaren and Son, n.d.

Symonds, Richard. *In the Margins of Independence: A Relief Worker in India and Pakistan*. Oxford: Oxford University Press, 2001.

———. *The Making of Pakistan*. London: Faber and Faber, 1950.

Talbot, Ian. *Divided Cities: Partition and Its Aftermath in Lahore and Amritsar, 1947–1957.* Oxford: Oxford University Press, 2006.

———. "The Growth of the Muslim League in the Punjab, 1937–46." In *India's Partition: Process, Strategy, Mobilization,* edited by Mushirul Hasan, 233–257. Delhi: Oxford University Press, 1993.

———. *Khizr Tiwana: The Punjab Unionist Party and the Partition of India.* Oxford: Oxford University Press, 2002.

———. "The 1946 Punjab Elections." *Modern Asian Studies* 14, no. 1 (1980): 65–91.

———. *Pakistan: A Modern History.* New York: St. Martin's Press, 1998.

Talbot, Ian, and Gurharpal Singh. *The Partition of India.* New York: Cambridge University Press, 2009.

Talbot, Phillips. *An American Witness to India's Partition.* New Delhi: Sage, 2007.

Tan, Tai Yong. "Punjab and the Making of Pakistan: The Roots of a Civil-Military State." In *Freedom, Trauma, Continuities: Northern India and Independence,* edited by D. A. Low and Howard Brasted, 199–215. New Delhi: Sage, 1998.

Tan, Tai Yong, and Gyanesh Kudaisya. *The Aftermath of Partition in South Asia.* New York: Routledge, 2000.

Terraine, John. *The Life and Times of Lord Mountbatten.* London: Hutchinson, 1968.

Thomas-Symonds, Nicklaus. *Attlee: A Life in Politics.* London: I. B. Tauris, 2010.

Thorne, Christopher. *Allies of a Kind: The United States, Britain and the War Against Japan, 1941–1945.* London: Hamish Hamilton, 1978.

Toye, Richard. *Churchill's Empire: The World That Made Him and the World He Made.* New York: Henry Holt, 2010.

Tuker, Francis. *While Memory Serves.* London: Cassell, 1950.

Tunzelmann, Alex von. *Indian Summer: The Secret History of the End of an Empire.* New York: Picador, 2007.

Wallace, Henry A. *The Price of Vision: The Diary of Henry A. Wallace, 1942–1946.* Ed. John Morton Blum. Boston: Houghton Mifflin, 1973.

Warner, Philip. *Auchinleck: The Lonely Soldier.* London: Buchan and Enright, 1981.

Wavell, Lord Archibald. *Wavell: The Viceroy's Journal.* Ed. Penderel Moon. London: Oxford University Press, 1973.

Weigold, Auriol. *Churchill, Roosevelt and India: Propaganda During World War II.* New York: Routledge, 2008.

Whitehead, Andrew. *A Mission in Kashmir.* New Delhi: Viking, 2007.

Williams, Francis. *A Prime Minister Remembers: The War and Post-War Memoirs of the Rt. Hon. Earl Attlee.* London: Heinemann, 1961.

Wolpert, Stanley. *Jinnah of Pakistan.* New York: Oxford University Press, 1984.

———. *Nehru: A Tryst with Destiny.* New York: Oxford University Press, 1996.

———. *Shameful Flight: The Last Years of the British Empire in India.* Oxford: Oxford University Press, 2006.

Woods, Randall Bennett. *A Changing of the Guard: Anglo-American Relations, 1941–1946.* Chapel Hill: University of North Carolina Press, 1990.

Wyatt, Woodrow. *Confessions of an Optimist.* London: Collins, 1985.

Young, Desmond. *Try Anything Twice.* London: Hamish Hamilton, 1963.

Zachariah, Benjamin. *Nehru.* London: Routledge, 2004.

Zakaria, Rafiq. *The Man Who Divided India: An Insight into Jinnah's Leadership and Its Aftermath.* Mumbai: Popular Prakashan, 2001.

Ziegler, Philip. *Mountbatten.* London: Collins, 1985.

Zinkin, Taya. *Reporting India.* London: Chatto and Windus, 1962.

PHOTO CREDITS

INDEX

❦❦❦❦

Page numbers in italics refer to maps.

financial reserves and, 212, 218, 224;
Raj's government tasks and, 112;
refugees and, 149, 169, 174; RSSS and,
66, 222–23, 229; sectarian violence
and, 66, 149–50, 176; on self-rule/
independent Pakistan, 129; Sikhs and,
157, 167, 176
Pathan tribes, 38, 52, 63, 150, 183–84, 189,
236. See also *lashkar*
Patiala, 83–84, 139, 165–66
Patiala, Yadavindra Singh of, 83–84,
87–88, 98, 166, 209
Patna, 60
Peshawar, 50, 184, 186, 232, 238
Petit, Dinshaw, 24
politics: Akali Dal and, 73, 77, 83–84, 98;
class in India and, 23, 28; Gandhi and,
26–28; Hindus as officials and, 34;
India's role in British politics and, 67,
69; Jinnah and, 22–26, 26–30, 27–28,
33–34, 34–35, 41–43; Muslims as
officials in, 34; Nehru and, 3; Pakistan
Army and, 256–60; Pakistan post-
Jinnah, 256–60; religion and, 27–28,
34–35
Poona, 37–38, 42, 228
Poonch, 179, 181–85, 205, 210, 215–17, 220,
239, 252–53
Potter, I. L., 141
princely states, *ix*, 115–19, 149, 161–62,
171–74, 176. See also *specific princely
states*
Punjab: acronym "Pakistan" and, 36–37;
Boundary Commission and, 107,
122–23, 129–31, 137, 180–81, 211,
276n16; Boundary Force, 124–26, 134,
137–39, 141, 144, 146, 150; British aid
and, 168; British compromise and,
47–48, 92, 95; camps for refugees
in, 109–10, 175–76, 202; Congress
and, 78–79, 108, 122–23; cross-

border warfare and, 221; economy
of, 99; elections and, 35, 46–47;
government of, 79, 140, 236; Hindus
and, 148–49, 165, 209; history of, xvii,
74; independence day and, 133–34;
Indian Army and, 45, 48, 78, 101,
107–8, 110–11, 124–25, 150, 165, 201,
210, 221, 232; Kashmir war and, 183,
188, 196, 209, 211, 221, 238; Muslims
and, 44–47, 51, 121, 164–65, 174, 209,
231; Muslim League National Guards
and, 78, 81, 132; Pakistan demand and,
ix, 44–47, 79; Partition and, xvii, 79,
92, 96, 107–11, 121–23, 130, 135, 236,
276n16; Partition timetable and,
119–23; population exchange and,
120–21, 147, 157; population statistics
and, 148, 179; refugees and, 109–11,
141, 145–46, 148–49, 155–56, 164–65,
164–67, 165, 174–76, 202, 209, 238;
sectarian violence in, 64, 73, 75–85,
89, 98–99, 101–2, 107–11, 124–25,
131–36, 137–45, 139–45, 150, 163,
165–68, 176, 231; Sikh migration
in, 166–68; Sikhs and, 121–23, 124,
148–49, 165, 166–67, 167–68, 209;
Unionist coalition in, 44–47, 51.
See also East Punjab; Lahore;
Sikhs; West Punjab; *and specific cities
and states*
Punjab Boundary Force, 124–26, 134,
137–39, 141, 144, 146, 150

Qayyum Khan, Khan Abdul, 186
Quaid-i-Azam, 41
Quetta, 247, 249
Quit India campaign, 40, 59

Radcliffe, Cyril, 122–24, 129–30, 137, 179,
181
Rai, Dewan Ranjit, 199–200